PELICAN BOOKS

A SHORT HISTORY OF AFRICAN ART

Werner Gillon was born in Germany and studied engineering, art history and European history in Berlin. In 1926 he left Germany to settle in Palestine, and after practising engineering for a number of years became a merchant shipper. In 1951 he came to London and since then has lived in the U.S.A. and Britain, becoming a leading figure in international trade with the Eastern bloc. In all these years he continued his studies in Art History.

For the past twenty-five years he and his wife, Sarah, have shared an interest in African art and have built up a large collection. Since retiring from business, he has devoted his time to research, lecturing and writing in this field. His book *Collecting African Art* was published in 1979 and has become a standard handbook for dealers and collectors.

Werner Gillon is a Fellow of the Royal Anthropological Insitute, a member of the Association of Art Historians and a member of the Arts Council of the African Studies Association.

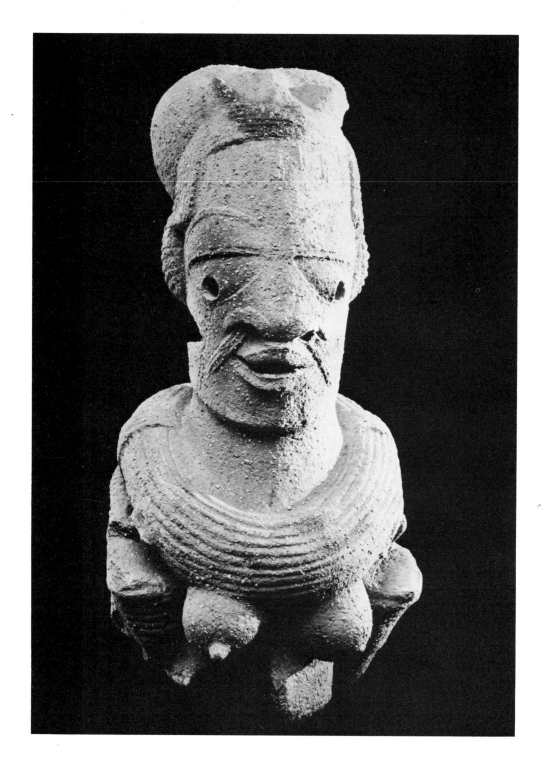

WERNER GILLON

A SHORT HISTORY OF AFRICAN ART

PENGUIN BOOKS

Penguin Books Ltd, Harmondsworth, Middlesex, England
Viking Penguin Inc., 40 West 23rd Street, New York, New York 10010, U.S.A.
Penguin Books Australia Ltd, Ringwood, Victoria, Australia
Penguin Books Canada Limited, 2801 John Street, Markham, Ontario, Canada L3R 1B4
Penguin Books (N.Z.) Ltd, 182–190 Wairau Road, Auckland 10, New Zealand

First published by Viking 1984
Published in Pelican Books 1986

Made and printed in Great Britain by
Butler & Tanner Ltd, Frome and London
Set in 10/12 Monophoto Ehrhardt

To Sally

Contents

List of Maps

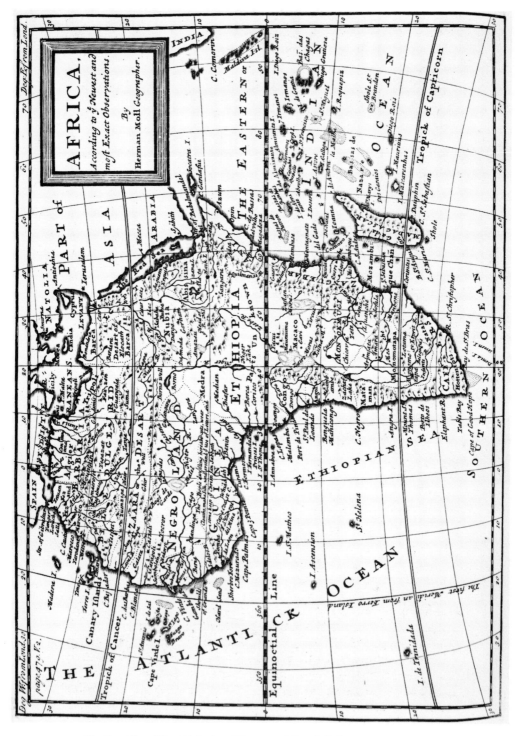

1. Map from Churchill, *A Collection of Voyages and Travels*, Vol. 2, 1745.

Preface

In 1950, nearly a half-century after African art – *l'art nègre* – had been 'discovered' by avant-garde artists and critics, Marcel Griaule wrote:

In reality, Negro art is beyond our horizons. It is steeped in a climate of which we have no experience, and about which, in spite of appearances, we have only a minimum of factual data . . .

The various studies of the art of Negro Africa are almost all characterized by a constant preoccupation with the avoidance of precise details. As with everything else concerning the country, our documentation about the manifestations of art is considerable on the surface, but in reality rather shallow: so shallow that it would seem superficial to wish to deal with it.

(*Folk Art of Black Africa*, 1950, pp. 16, 17)

The years since Griaule published this rather dispirited view have given rise to a remarkable burst of intense interest that has resulted in a great number of serious publications. Well over eighty per cent of the articles and books found listed in the Bibliography for this book postdate Griaule's comments. Much that has appeared during these last three decades has sprung either from an admiration for the arts and particularly the sculpture of Africa or from a scholarly concern with the arts as they functioned in their traditional context. That admiration, the heritage of the 'discovery' dating from the first years of the twentieth century, has been expressed in the amassing of private collections and in what might be termed the scholarship of style which had its beginning in the thirties and has flourished since the Second World War. At the same time some courageous art museums have added the arts of Africa and Oceania to their collections. Early pivotal scholarship, such as Kjersmeier's *Centres de style de la sculpture nègre africaine* (1935-8), was concerned with proper identification of the geographical and ethnic location of sculptural styles, giving rise to the useful, but limited, concept of tribal style. It is limited because it fails to address often complex problems of historical relationships between adjacent groups or the effect of long-range contacts or influences through trade routes or migrations. In addition, with the rise of nation states the concept of tribe has become politically unpopular among Africans. Nevertheless, the term remains useful because it offers

a convenient handle for naming discrete styles; provided, of course, that we do not equate it with the misconception that tribes are, or were, hermetically sealed ethnic units without historical depth or relationships.

Scholarly concerns, to distinguish them from the equally serious concerns of style connoisseurship, have focused, since the Second World War, on studying the use and function of the arts in their parent cultures – a legacy of anthropology. Scholarship in this area has also tended to ignore historical aspects of the arts and the cultures under investigation. Many anthropological theories imply a cultural timelessness and, focusing upon the fiction of an ethnographic present, ignore the cumulative effect of changes, large and sudden or small and pervasive, upon the shape of a culture and its art.

Both of these areas have become, to a large degree, the bailiwick of art historians; often giving rise to monographs which focus upon the context of the arts of a single style group or to texts and catalogues which are arranged in style groupings essentially unchanged since Kjersmeier, though augmented by crisp summaries of use and meaning.

None the less, the *historical* aspects are less developed for the arts of Africa than for other periods or areas of art history because they depend on the work of archaeologists who have been sadly under-supported in sub-Saharan Africa, and on historians who have had to counter opposition to and distrust of oral histories by their colleagues. Indeed, as the author of this short history notes in his Introduction, serious investigations of African art, whether such studies are anthropological, archaeological, historical, stylistic, or, ideally, a combination of all four, lag a century behind comparable studies of other world arts. Thus African art historians are, in a very real sense, only beginning to get their act together.

On one hand there has been a burgeoning of data and a flourishing of connoisseurship in the recent past. Yet, at the same time, Griaule's lament is still appropriate: for a broad interdisciplinary theoretical grasp still eludes us; and, more pertinent to this volume, the full command of history seems remote.

Two major problems that the author of this history of African art has had to deal with are first, the unevenness of data from almost any period and second, the absence of clear linkages across time. For example, the well-known Nok terracotta sculptures (Chapter 4) are supported by remarkably few archaeological data. Although we can assume a date around 500 B.C., we know next to nothing of the parent culture or of the importance of the sculptures in that culture. Further, nothing is known with confidence of the origins of the culture, its art or its development, or of its influence on later arts (despite attempts to link the much later art of Ife to origins at Nok). There are many other examples that could be adduced, ranging from the remote Saharan rock art, which seems unrelated to any existing traditions, to the art of the Ashanti, which clearly springs from a

pre-1700 base to flourish for over two centuries and to survive in royal ceremonial today.

Much of what we know of the historical context of the arts was preserved in the form of oral histories, which range from stories of origin and migration to reports of wars and dynasties. Some report only that the group was always 'here', that the ancestors had emerged from a hole in the ground or descended from the sky. These autochthonous myths are usually held by groups that are politically uncentralized. In contrast, centralized political leadership is a form of governance given to the keeping of history, of oral historians, king lists and the concept of dynasties. The less centralized states seem not to reach back into the past with the same sense of receding generational order. Further, wooden masks and figure sculptures, which served as agents of social control, were predominantly the perquisite of men's societies and councils, the form of governance found in acephalous groups, while kingship gave rise to arts of pomp and circumstance and the commemoration of dead leaders.

Quite differing histories are at times intertwined, as in northern Ghana and Burkina Faso, where the indigenous uncentralized farming populations were conquered by invading horsemen. Christopher Roy has shown that as a result there exist among the Mossi, for example, two systems of art, one, predominantly masking, among the indigenous population (the Nioniossi), another, predominantly figural, among the ruling overlords (the Mossi). Clearly, historical overlays and interruptions must have occurred many times, and we must be alert to clues that would lead to their recovery.

Although archaeology has proved to be of great use in reconstructing African cultural history, it often proves of little help in recovering the arts. For much of Africa, sculpture, dress and crafts (except pottery and metal) were of perishable materials. Most sculpture is, and we assume was, of wood, which does not long survive underground. In fact, we may assume on the basis of recent evidence that terracotta, bronze and stone sculptures, which make up the majority of archaeological arts, were the exception rather than the rule. Further, it would seem that centralized states tended to prefer terracotta and lost wax bronzes, if we can extrapolate from the arts of Ife and Benin, for instance. Thus their survival may lend a double distortion to our understanding of the history of African arts: with respect first to types (dynastic shrines would seem to outnumber masquerades), and, second, to techniques and materials (terracotta and bronze would seem to outnumber wood carvings).

It should be clear that any attempt to recover the history of the arts of Africa is fraught with peril, and that no small amount of courage has gone into this volume. Most introductions to African art deal predominantly with wooden masks and sculptures produced during the past few generations and offer at best a brief digression on the historical arts of Nigeria.

Preface

Obviously the author of a short introduction to the history of African arts must place severe limitations on his work. Even a reasonably full exposition of the arts of a large continent, over a timespan of 30,000 years, would be neither introductory nor short. As a result, some geographical areas are omitted and some art forms slighted. Similarly, because the sweep of the book is so broad, there are bound to be unresolved problems, unsettled questions that will one day – we must hope soon – be answered. We might wish for a chapter on the Maghreb or the Gabon or contemporary painting, but these are unfair expectations, considering that we have been given Nubia, Ethiopia and the Swahili coast. Further, rock engravings and paintings are almost never discussed elsewhere; for the most part, they either predate more familiar forms or were produced – like those of southern Africa – by peoples whose other artistic accomplishments were not considered noteworthy or were unknown. Yet they are an important fragment of Africa's artistic past. Indeed, the range of the artistic heritage of the African continent is a significant aspect of any responsible view of the history of world art.

We cannot ignore the contribution of African art to twentieth-century art and aesthetics, any more than we can ignore African music in a history of jazz or, indeed, modern music. From a larger historical perspective, the arts of Africa constitute a major aspect of human accomplishment, worthy of serious study for that reason alone.

ROY SIEBER

Acknowledgements

One of the many pleasures the writing of this book provided was the generous co-operation of old friends and colleagues, and new ones, who gave so willingly their most valuable advice and their time reading and correcting parts of the manuscript. My thanks go to Roy Sieber, who wrote the Preface, for his support and supervision, and to William Fagg for his unflagging encouragement and assistance. Of much help in their respective fields of special interest were Paula Ben-Amos, Ezio Bassani, Nigel Barley, Marie-Louise Bastin, Renée Boser-Sarivaxévanis, Ulrich Braukämper and Karl-Heinz Striedter of the Frobenius Institute, Margret Carey, John Donne, Perkins Foss, Huguette Van Geluwe, Peter Göbel, R.R. Inskeep, Ed Lifschitz, John Mack, Malcolm McLeod, Keith Nicklin, Philip Peek, David W. Phillipson, John Picton, Arnold Rubin, Thurstan Shaw, Janet Stanley, Susan Vogel, Zdenka Volavka and Frank Willett.

With his artist's eye, my friend, the painter Josef Herman, helped in the final selection of the photographs.

My thanks to my tireless editors Michael Dover and Ronald Segal for their advice and constant encouragement. Also to Catriona Luckhurst, Jessica Smith and Annie Lee for their enthusiastic co-operation.

It is a pleasure to acknowledge with thanks the efficient help, always given with a smile, of the staff of the R A I - Museum of Mankind Library and in particular of Audrey Gregson, the librarian, Christopher Spring, Jean Arrowsmith and Sheila Mackay.

Last, but by no means least, to my wife Sally for her active help, co-operation and advice. Without her great patience and support the work of writing this book would not have been possible.

W.G.

Chapter	2 Rock Art	3 Nubia	4 Nok	5 Kingdoms of W. Sudan	6 Sherbro Bulom and Kissi	7 Kanem-Bornu and 'Sao'	8 Kororofa Jukun	9 Akan

B.C.
30 000 —

8 500 —

Namibia

6 500 —

5 000 —

Sahara

Khartoum Neolithic

A–group *Terminal Classic Early*

3 500 —

3 000 —

2 500 —

2 000 —

Kerma

C–group

Egyptian domination

Tilemsi

1 500 —

Eastern and Southern Africa

W Sudanic states ?

Kintampo culture

1 000 —

Meroë Napata

Kingdom of Kush

500 —

Daima

B.C. 0
A.D.

Nok

Ballana

Christian period

Ghana

500 —

Segou,Kaarta Mali

Jenne

Songhai *Lurum*

Tellem

Mossi

1 000 —

Islamic period

Mende Kissi Sherbro

Temne Bulom

Dogon

Kanem–Borno

Kororofa

Jukun

1 500 —

Fali *'Sao'*

Akan

1 900 —

10 Igbo–Ukwu Niger Delta Cross River	11 12 Yoruba and Benin	13 Southern Savanna	14 Eastern Africa	15 Southern Africa	Egypt	N. Africa (West of Egypt)	Europe	

B.C.
—30,000

Rock art Namibia

Franco-Cantabrian rock art 38 000–10000 B.C.

—8500

—6500

—5000

Naqada

—3500

—3000

Early dynasties

—2500

Njoro River caves

Pre–Aksumite

2nd Intermediate period
Old Kingdom
1st Intermediate period

Minoan

—2000

—1500

Mycenaean

Rock art

Urewe

Aksum

3rd Intermediate period
New Kingdom

Kabyle – Berber

—1000

Byzantium Rome Persian Kush dom.

Greek
Archaic
Classical

—500

Ptolemaic

Lydenburg

Zimbabwe

Hellenistic
Etruscans

Roman Republic

B.C.
0
A.D

Mapungubwe K2

Christian Ethiopia

Byzantium Rome Carthage

—500

Igbo–Ukwu
Niger Delta and Cross River
Cameroon

Swahili

Islam

Vikings Anglo-Saxons
ravage Europe invade Britain

Roman Empire

—1000

Luba Jokwe
Kongo
Sanga

Islam

Yoruba

Kuba

Renaissance

—1500

Benin

Baroque to Rococo

—1900

2. Political map of Africa, 1983.

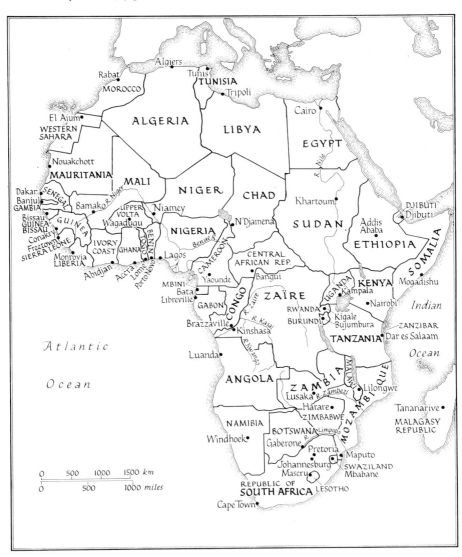

ONE

Introduction:
An Approach to the History
of Africa's Visual Arts

Matter and Method

The exploration of African arts, with their ethnographical and historical background, is barely as old as this century, while archaeological research into the subject is even more recent. The advances made during that short period have been remarkable, but considerable gaps remain in our knowledge of the arts in whole regions, of the purpose for which artefacts were made, and of many other aspects of historical research.

Yet, in the light of the enormous progress made during the last eighty years, it is feasible to summarize the known facts into the framework of an art history for some regions of Africa and attempt to show the relationship between areas and nations by finding common denominators. Where pieces of the puzzle are missing, we shall attempt constructive synthesizing, but avoid guesswork. In contemplating the problems to be faced in the reconstruction of Africa's art history, we should consider how recent is our detailed knowledge of many aspects of Greek, Mesopotamian and Egyptian art. As short a time ago as the mid nineteenth century, it was commonly believed that 'no authentically Greek art existed before the Parthenon',[1] i.e. before about 450 B.C. The sensational discoveries made after 1870 have provided us with evidence of splendid pre-hellenic art from mainland Greece, Crete and other islands [1]. The Cycladic, Minoan and Mycenaean cultures were first revealed in the fifty-year period ending with the outbreak of the First World War; these excavations were resumed in the twenties and are still proceeding. The accumulation of archaeological data revealed in this way brought into focus the facts previously learned from history, literature and other Mediterranean and Asian sources.

Although fully aware of the immensely greater difficulties involved in attempting to construct a history of the arts of Africa, I am convinced that the time has come to make such an attempt.

With the exception of Egypt, Nubia, Aksum and Ethiopia, Africans had no written records of any kind until the arrival of the Arabs in the seventh century.[2] Archaeological discoveries are few and mostly accidental. The size of the continent, its geological problems, the absence in

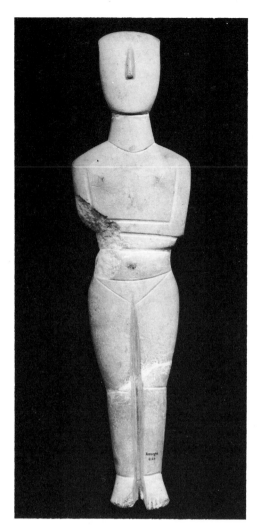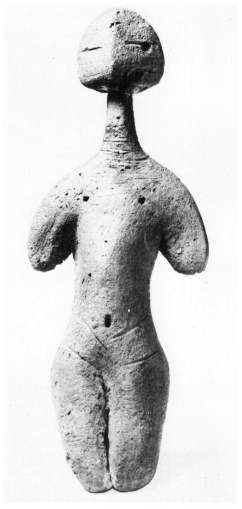

1. Idol. Cycladic art. From Amorgos. *c.* 2000 B.C. Marble. 35 cm (13.78 ins). Musée d'Art et d'Histoire, Geneva. Photo: André Held.

2. Young girl with scarifications. From the grave of a young girl at Ariba. C-group, Nubia. 1900–1550 B.C. Fired clay, dark brown. 10.5 cm (4.13 ins). Ägyptisches Museum, Karl-Marx-Universität, Leipzig, 4403. Photo: courtesy Ägyptisches Museum.

most areas of tumuli, tels, ancient buildings, architectural ruins or guidance by historical narrative (such as Homer gave to Greek studies), make exploration by scientific excavations most difficult; and in some cases, where guidance *is* available, the lack of funds or recent political disturbances have constituted obstacles. Another difficulty, peculiar to

Africa, is the fact that wood, extensively used by sculptors, rarely survives for more than about fifty years the humid climate and the rapacious termites in most parts of the continent. The few objects which have survived are evidence that use of wood dates back to antiquity [3].[3] Objects made of clay, metals, ivory, stone, glass and other relatively durable materials, found in archaeological excavations, are consequently the main basis for our research.

The material and methods available to the student of the history of African art are now of considerable volume and variety, although written records are extremely sparse for the whole of western black Africa. The writings of Herodotus, Polybius, Ptolemy and others give some valuable information on history, but they say nothing on the arts. From the eighth century onwards there are the reports of Arab chroniclers and geographers

3. Head and part of body of an unidentified animal, the oldest known African figure carved in wood. Found near Liavela, Angola, in a waterlogged gravel pit. Radiocarbon dating (GrN 6110): A.D. 750 ± 35. Length 50.5 cm (20 ins). Musée Royal de l'Afrique Centrale, Tervuren. Photo: courtesy Musée Royal de l'Afrique Centrale.

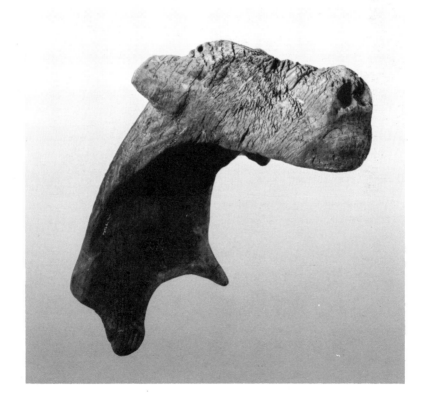

as well as literature, official records and private documents; some of major historical significance for this study, but very few, alas, with any description of art works, or of the artists and their role. Writings by Portuguese and other Europeans are of limited help.

On the other hand, the written records of Egypt, Greece, Rome, Coptic documents, the Bible, and Sabaean inscriptions are rich material for the study of the history and art of Nubia, Aksum, Ethiopia and some other parts of eastern Africa.

Of great importance are archaeology and related scientific investigations by archaeometry, which includes microscopy, use of X-rays, analysis by spectrometry, use of lead isotopes and the various methods of dating by radiocarbon (carbon 14) and thermoluminescence. The classification of domestic pottery from controlled excavations is a major source of information.

The study of linguistics gives clues to migrations and their influence on the spread of art styles and symbols.

Folklore and oral traditions are valuable sources, but must be used with great discretion and careful judgement of the methods employed in collecting the material and of the timespan to which it can be applied. The 'griot', or official transmitter of the oral history of his society, is the equivalent of the European court chronicler. His stories are rarely tied to any chronology and are seldom of immediate help in dating events or dynasties. But Torday, for example, was able to use the stories of the Kuba king's 'griot' to establish a Kuba chronology, by linking the oral history with events dated elsewhere.

Study of the vast amount of materials now available in African, European and American museums and private collections will help to establish patterns of styles and iconography; records of acquisitions by museums assist in dating art in some cases.

Observations in the field by ethnographers and social anthropologists led to the discovery that contemporary art production was related in style and iconography to the art of bygone times and helped to identify the people who had made the ancient artefacts. Such research provided data on more recent use of art objects for socio-religious purposes, regalia for royal courts and chiefs and those made for prestige or for trading. The role of music and dance and masquerades as related to the 'visual arts' is another important factor.

Explorations of trade routes and trade may throw light on the social and economic background of the ancient artists and on outside influences on techniques, styles and iconography.

By applying the lessons to be learned from all these fields of study, we hope to be able to correlate the art history of a number of regions and to establish a relationship between the styles of nations who now live or who

used to live in those areas. Archaeological discoveries alone will not give us the answers. A reconstructed art history based on all available elements may help to find some of the answers, or at least point to ways for future inter-disciplinary research.

A few words of explanation are required on the approach of this guide to the history of the visual arts of Africa and on the scope of this book. Ideally, it should have included the arts of all African nations. But the aim, as expressed in its title, is to provide a short initial exploration. I accordingly decided to select some of those areas for which a significant measure of relevant information is available. Thus some regions, including the Dan complex, the Ibo and Ibibio corpus, Cameroon, the Fang group, Gabon and northern Zaïre, which produced some of the finest art in more recent times, have had to be omitted. And to keep the project within reasonable bounds, I have had to omit as well any in-depth treatment of Egyptian and North African art history, although both Egypt and other areas north of the Sahara play a role in the narrative because of their far-reaching cultural influences.

I have included the Nubians of the Upper Nile Valley, that 'corridor to Africa',[4] Aksum, Christian Ethiopia, Swahili culture, southern Africa, the most important concentrations of rock art on the continent, and ten areas selected for their special art-historical significance. The subject matter, visual arts, includes sculpture, painting, architecture, textiles, pottery and other household objects, jewellery and body art, all in the context of an art history. Sources for further study are recommended in the extensive Bibliography. Music, dance, masquerades and story-telling, vital as they are for the full interpretation of Africa's visual arts, can only be touched upon here.

The chapters on rock art, the Nubians and Nok, all dealing with the oldest known African visual arts, are examined in chronological order. The sequence of the other chapters is based on geographical, cultural and chronological considerations. To show the time, area and style relationship, a chart is provided (pp. 16–17).

African art, like all non-European art, presents special difficulties to Western students, who are advised not to judge solely by their own artistic standards. They must try to understand the purpose for which the paintings, sculpture and other objects were produced, by exploring the social and religious backgrounds of the artists who made them.

Recent research seems to confirm that 'man' first emerged on the African continent. Cultural development can be traced back to the paleolithic, and Africans started to use well-fashioned stone implements in the neolithic era. Domestication of animals and cultivation of plants were started in Egypt about 5000 B.C., probably brought there from the Levant and Mesopotamia through trade contacts. Within 1,500 years, the Lower

Nile region was developed into a land of farming communities and growing urban civilization which culminated in the emergence of dynastic Egypt and a sophisticated culture in the Nubian areas of the Upper Nile Valley. It cannot be established with certainty whether agriculture and the raising of domestic animals came to West Africa by diffusion from Egypt or whether, as Murdock[5] asserts, it resulted from indigenous development. It seems, however, that the culture of the Sahara in prehistoric times preceded that of Egypt by many millennia. It also seems certain that plants such as guinea rice and fonio were cultivated in the western Sudan as early as 4000 B.C., and domestication of cattle may go back to the same period. At one of the Tassili sites in the southern Algerian Sahara, a skull of what is believed to have been a domestic bull has been found and dated to 4000 B.C. \pm 120 years.

Many peoples from both North and Central Africa lived in the Sahara when it was verdant, crossed by rivers and supporting a rich variety of game and plants. Through climatic changes, the area started to dry up about 2500 B.C. and became largely uninhabited by the middle of the first millennium B.C. The desiccation of this once fertile area led to extensive movements of populations. Those who migrated east to find arable land in the Nile Valley were met by fierce Egyptian resistance, although this decreased with the decline of Egyptian power; and in the last centuries B.C., greater numbers of Saharians found new homes in the Upper and Lower Nile Valley. They brought with them their own culture, and those who managed to enter the land of the Pharaohs in the early stages of the migration may have influenced the course of Egyptian civilization.

Other waves of migrants from the Sahara moved south into the savanna, merged with the indigenous population, and started agricultural settlements. They cultivated yams, sorghum, watermelons and probably other crops, while developing a well-organized village society. It is doubtful whether cattle breeding could have succeeded here because of the presence of tsetse fly.

According to archaeological evidence found at Taruga, in the area of the 'Nok culture', the Iron Age made its debut in sub-Saharan Africa by about 500 B.C. The change from the neolithic to the Iron Age had, of course, great repercussions. Iron was forged into weapons and into tools for agriculture. Other implements allowed the forest to be penetrated and ground cleared for cultivation; and the resultant increase in food production led to a rapid rise in population. The Sahara continued to be an important transit route, with caravans carrying gold, ivory and other products of the Guinea Coast and Western Sudan, to North Africa and Europe. Salt, cattle, grains, and manufactured goods, including arms, moved in the opposite direction. Even today, large camel caravans loaded with salt and other essentials cross the Sahara on these routes.

North Africa and Islam

North of the Sahara, the population consisted mainly of Berbers, a Mediterranean people. One of their large sub-groups, the Kabyles of Algeria, still produce beautiful pottery in the style and character of the ware made by their ancestors as early as 2000 B.C.,[6] when it was presumably introduced to them from the eastern Mediterranean. The astonishing Berber architecture of the Atlas and South Morocco dates back to pre-Islamic times, and the use of stone, air-dried mud bricks and pisé walls was described by early Islamic chroniclers [4, 5, 6]. It is not known how old the tradition is; but since the large silos and homes for entire extended families and clans were a necessity for the social structure of the Berbers, this type of architecture may go back to pre-Christian times.[7]

4. Fortified silos, divided for extended families, at Agadir-Tasguient, South Morocco. Pre-Islamic Berber architecture (i.e. before 8th century A.D.). Stone. Photo: K.-H. Striedter.

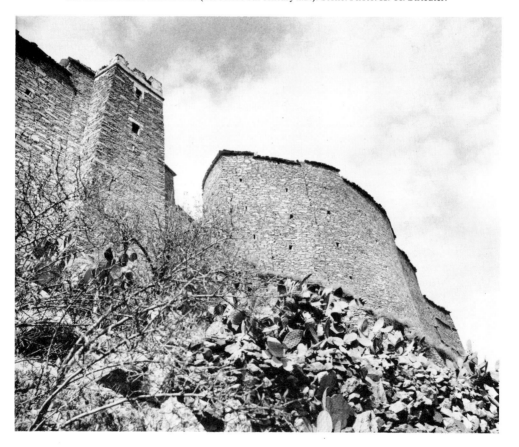

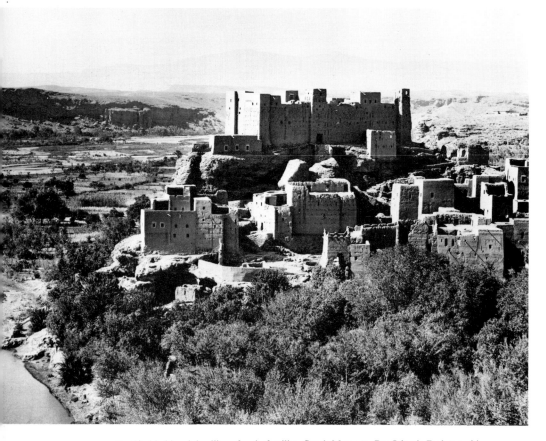

5. Fortified hold and dwellings for six families, South Morocco. Pre-Islamic Berber architecture. Cob and pisé walls. Photo: K.-H. Striedter.

In the last millennium before the Christian era, the Greeks developed some colonies along the coast. In 814 B.C. the Phoenicians (and with them Jews from ancient Israel and Judah) arrived and founded the powerful city state of Carthage, which became paramount in Mediterranean trade. They were defeated by Rome in the third Punic war in 146 B.C., and Rome (followed 500 years later by Byzantium) took over the territories of Carthage and soon spread into Libya, Morocco and Egypt. When the Arab and Bedouin invasions began in the seventh century A.D., the Berbers, weakened by centuries of foreign domination, were soon subdued. They and other nations along the coast embraced Islam without much resistance. By the fourteenth century, North Africa had become a stronghold of the orthodox Muslim faith; and from then to the seventeenth century, Islam spread explosively in the wake of conquering armies. Hand in hand with conversion came the widespread adoption of the Arabic language, which, like

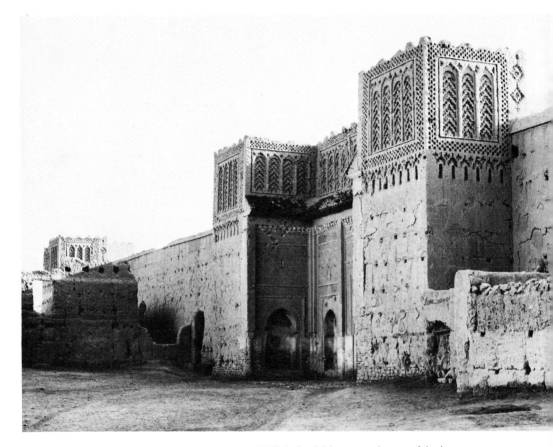

6. Former Royal Palace at Dar El Makhzen, Tafilalt, South Morocco. 17th century? Ancient Berber technology, using cob and pisé walls, air dried bricks. Photo: K.-H. Striedter.

the religion of Islam, took root most deeply on the east and north coast, where contact with the outside world was greatest. In areas far from the Holy City of Mecca and where indigenous cultures were entrenched, the success of orthodox Islam was more limited. In such areas, a pragmatic approach resulted in an interaction of Muslim and indigenous religions.

Islam brought to Africa a new political stability after a long period of upheaval and strife caused by Vandal conquests in the Mediterranean area, including North Africa. The new religion carried with it the promise of membership in a broad community, united by language and the Muslim faith. New approaches to trade and methods of government resulted in prosperity and centralized power in northern and parts of western Africa. In these areas and on the east coast, Islam's gifts included growing literacy and new forms and styles in architecture and design. The increase in the slave trade and Muslim strictures on sculpture were the negative results.

The Bantu Migrations

The great Bantu[8] migration, starting at about the same time as the Christian era, caused a complete change in the population of the greater part of sub-Saharan Africa, profoundly affecting its cultural development.

A vast part of sub-Saharan Africa is today inhabited by Bantu-speaking peoples. From linguistic[9, 10, 11, 12] and archaeological evidence,[13] it can be deduced that the origin of the Bantu-speakers was somewhere in the area of Chad and Cameroon; and that these peoples spread, with relative speed, in southern and eastern directions. A need for land always existed in tribal societies when enlarged families had to leave their places of residence to start new groupings or when drought restricted the number of people that the land could feed. The constant migration by small groups of Bantu became a rapid expansion once they had mastered the use of iron and had succeeded in cultivating suitable food plants. In addition to the cultigens that they brought from their regions of origin, they were further assisted in their eastward expansion by the introduction of the Asian banana and yam, which were instrumental in the support of larger and more densely settled populations.

The first migrations took a route north of the dense equatorial forest and reached the Great Lakes in the first half of the first millennium B.C. There they settled, and the Early Iron Age culture that they developed is associated with the Urewe type of pottery found near Lake Victoria (Chapter 14). A second wave of migrants is believed to have moved southwards and, after crossing the Zaïre river, reached northern Angola and the Kwango-Kwilu region in the last quarter of the first millennium B.C. Some of the Bantu-speakers continued the migrations from the area of the Lakes, turned westwards, and linked up with the previous groups in the Kwango-Kwilu belt. They brought with them their Early Iron Age culture, symbolized by Urewe ware, and at the end of the first millennium B.C. spread southward through Angola into Namibia. Two other streams of migrants moved away from the Lakes. One turned east towards the Indian Ocean, where in the Shimba Hills, south-west of Mombasa, Kwale type pottery originated, and then southwards to Mozambique and eastern Transvaal, where they arrived in the first centuries of the Christian era. Others proceeded due south from the Urewe area, moving west of Lake Tanganyika, and reached Shaba and western Zambia in the middle of the first millennium A.D. The Sanga culture in Shaba province (Chapter 13) is associated with those Bantu people who had settled there. Finally, the Bantu expansion, which had such important influences on a very large part of Africa, continued in all directions from Shaba, its focal point, bringing with it the cultures of the Late Iron Age which developed at the end of the first millennium A.D.

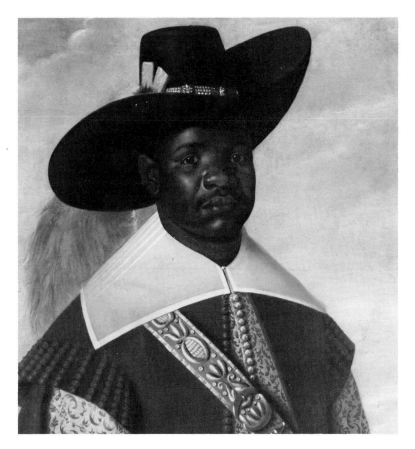

7. *Portrait of an Envoy from the Kingdom of Kongo*, painted in Brazil by Albert Eckhout in 1643. Donated by Prince Moritz of Nassau to King Frederick III of Denmark, 13 July 1654. Oil on canvas, 72 cm (28.35 ins). On permanent loan to the National Museum of Denmark from the Royal Museum of Fine Arts, Copenhagen. Photo: courtesy National Museum of Denmark, Department of Ethnography.

The Arrival of the Europeans

The arrival of the Europeans in the fifteenth century had profound effects on all aspects of African life, including the arts. The Portuguese were the first Europeans to come to Africa in search of trade, and their initial landings were on the Senegambian coast, where profitable commerce in gold, cotton goods and slaves developed. They obtained concessions on the Guinea coast and built a fortified trading station at Elmina, from where contacts were later made with the city of Benin. The Portuguese explorer Diego Cão entered the estuary of the Congo (Zaïre) river in

1482 and proceeded to the capital of the divine kingdom of Kongo, Mbanza, which was subsequently renamed São Salvador. The Portuguese were astonished to find a well-established state extending into the northern parts of what later became Angola, a Portuguese colony. Mutual respect and a high degree of co-operation ensued almost immediately between the Portuguese and the Kongo peoples, their leaders and, above all, their king, Nsinga Mbemba, who was converted to Christianity in 1491 and renamed Alfonso. Many nobles and commoners embraced the faith with him. The relations with traders, missionaries and soldiers grew rapidly into a partnership of benefit to both sides. But after some years of harmony and prosperity, Portuguese greed led to exploitation and to slave raids deep into the kingdom's territory, contrary to the agreements between the courts of Lisbon and São Salvador. Resentments grew, and war broke out, with disastrous results for the people of Kongo. They were defeated, and their state disintegrated. The hold of Christianity was weakened, and many reverted to their ancient faith and customs.

The Portuguese presence in Kongo had opened up trade routes to neighbouring peoples and to countries overseas. The introduction of maize, cassava and sweet potatoes from South America brought about an era of agricultural success and growth of population, compensating in part for the depletion caused by the disastrous and vicious slave trade.

The profound influence that this first European intrusion had on the social, religious and commercial life of Africans was also evident in the field of the visual arts. The Christian influence in Kongo caused the adaptation of ritual objects and icons for African socio-religious purposes, even after the Kongo people had abandoned the new faith. A cross, in a simple unadorned form, is said to have been an indigenous symbol long before the European missionaries arrived in Kongo;[14] but crucifixes became a Kongo icon with conversion and, africanized, remained a powerful fetish after reversion to the old Kongo religions. The steatite tombstone carvings known as *mintadi* or *bitumba* were also influenced by European customs, but these, too, are intensely African in style and character. Portuguese dignitaries and warriors were shown on Benin bronze plaques and ivory carvings. Commissioned by Portuguese patrons, Sherbro and Benin carvers produced magnificent ivory condiment sets, spoons and hunting horns. These objects depicted knights, sometimes on horseback, Portuguese coats of arms, and Christian iconography as specified in the orders of the patrons overseas. Yet they are clearly African, and the Sherbro or Benin style is quite evident [8, 9]. They have been dubbed 'the first tourist trade objects' and became known as the Afro-Portuguese Ivories. Quite clearly, a well-developed ancient art of sculpting ivory had existed in Africa long before the arrival of the Europeans.

Apart from the many carvings made for the Portuguese royalty and nobility, there are those acquired (possibly also through the Portuguese)

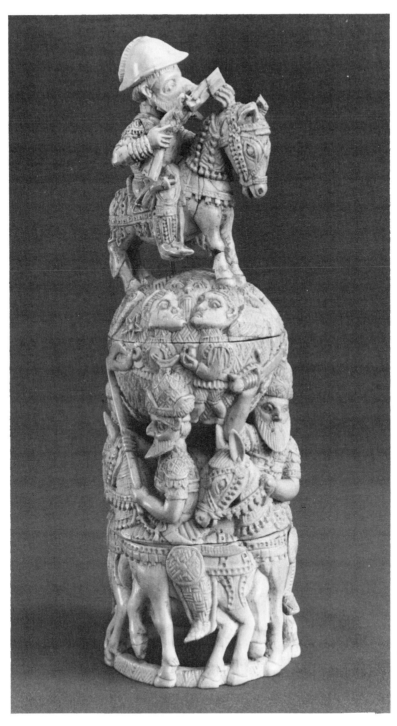

8. Condiment bowl carved in three parts. From Benin. *c.* A.D. 1500. Made for Portuguese patrons. Ivory. 28 cm (11 ins). Registered in the Royal Kunstkammer, Copenhagen, in 1674. Photo: courtesy National Museum of Denmark, Department of Ethnography.

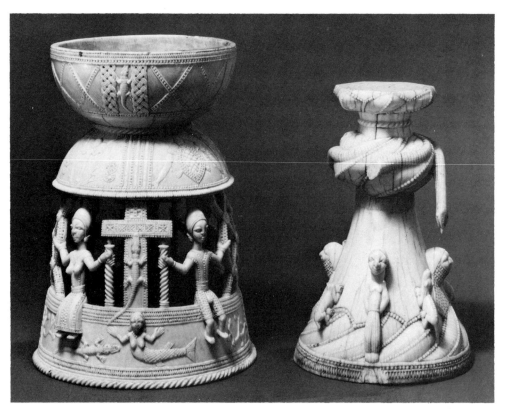

9. A salt cellar and a lid, both with intricate carvings, depicting human figures, lizards, a snake, a 'mermaid' and fine geometrical decorations. Sherbro-Portuguese ivory. *Left:* 16 cm (6.3 ins). *Right:* 14 cm (5.5 ins). Registered in the Royal Kunstkammer, Copenhagen, in 1743. National Museum of Denmark, EDC 67. Photo: courtesy National Museum of Denmark, Department of Ethnography.

by the Medici, who were among the most avid collectors of these works. Among other royal collectors was Augustus, Duke of Saxonia, one of whose acquisitions in 1590 was recorded in 1595 by the Kunstkammer of Dresden.[15] The Museum für Völkerkunde in Vienna has ivory spoons and a fork from the collection of the Castle of Ambrass in Tyrol, started by Archduke Ferdinand in the second half of the sixteenth century. Several fine ivory spoons and other objects are in the Wieckmann Collection in Ulm, and a collection in the Städtisches Museum of Braunschweig is said to go back to 1600, though it was only recorded in 1805.

The Songo of Angola, neighbours of the Jokwe, created a cult based on their Nzambi figures portraying a white man riding an ox, which had

magic powers and assisted the devotee in all his enterprises. It is believed to have developed out of friendly relations with white explorers who succeeded in crossing the country on oxen – better suited than horses to withstand the rigours of the climate and the attacks of insects.

The African continent is inhabited by a great variety of peoples, organized in societies of considerable diversity. Based on nuclear and extended families, they live together in one household, and several of these, related by blood, form kinship groups. The next step in social organization is the tribe, no longer totally tied to family or blood relationship, but born out of economic and political necessities for both nomads and villagers. Tribes often constituted early democracies; some had elected, others hereditary chiefs; they were bound together by language, religion, music, dance and their own visual arts closely connected with ancestral faith. In spite of the hostility in modern Africa to 'tribalism', it is clear that art linked to the life and organization of specific tribes, expressed in their recognizable style and iconography, *is* tribal art. But the tribe is not a tightly closed group; and its art is not static, however traditional it may be. It is – and always was – exposed to contacts with other tribes or nations, through wars and migrations. Travellers and nomads visited tribal groups, and itinerant carvers and other artists exchanged ideas which in time made their mark on the art of the tribes visited, while the visitors were in turn influenced by the art they found.

3. Main trade routes of Northern Africa in ancient times.

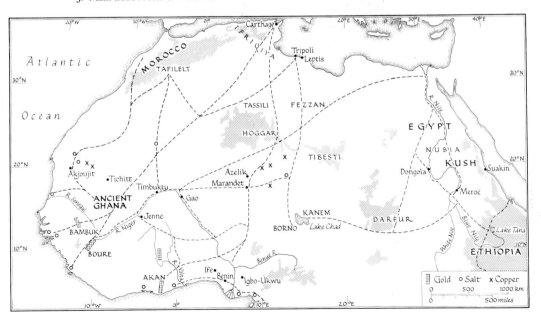

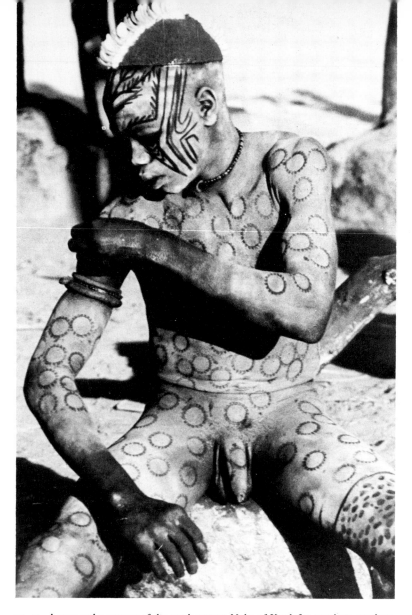

10, 11. A man and a woman of the south-eastern Nuba of Kordofan province, southern region of the Republic of Sudan (not related to the Nubians of the Nile Valley). Most Africans practise some sort of body art, but for these Nuba it is their only form of visual art; it is related to their dances, wrestling and fighting. Photos: Helene Riefenstahl, *The People of Kau*, London, 1976.

These influences were absorbed, and the character of the tribal style still retained its individuality, though tribes often shared stylistic traits and iconography as a result of these contacts.

The greatest contribution to stylistic changes and to the evolution of technology was trade within Africa and beyond. Egypt, through the

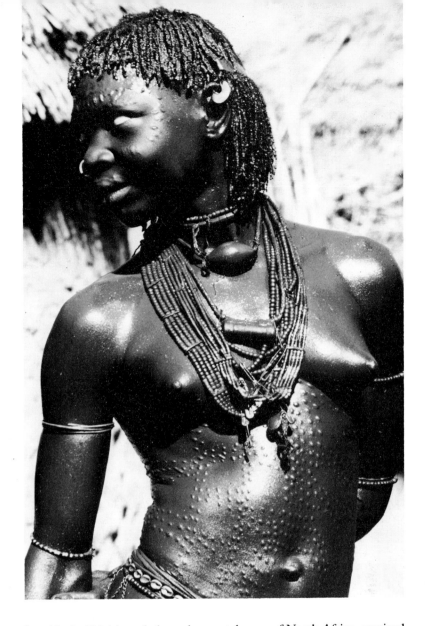

'corridor' of Nubia and along the coastal ways of North Africa, received and dispensed enlightenment and new concepts.[16] The trade along the caravan routes through the Sahara had the same effects. Civilizations developed parallel to each other in the world beyond, as they did here, and wherever there were contacts between different cultures there was also diffusion of knowledge, ideas and forms, all of which contributed to the great arts of the peoples of Africa.

The student of the visual arts and their history, whatever the region or culture, can no longer exclude from his curriculum the arts of Africa, which are now the heritage of the entire world.

The Rock Art of Africa

On the walls of rock shelters, in the mountainous wilderness, from the Sahara Atlas to the Cape, African neolithic man created tens of thousands of beautiful paintings and engravings.[1] In sheer quantity, variety and artistic quality, they surpass all other known rupestral art.

The population of the Sahara is made up of Berbers (including Tuareg), Negroids, Arabs and, until quite recently, descendants of those Jews who arrived with the Phoenicians between 1000 and 800 B.C. After the much earlier exodus due to climatic changes, the negroid people in the western Sahara were forced by Berber and Arab pressure to move south, into Sahel and Savanna; but in Tibesti, Ennedi and further east, the negroid element prevailed. In the rock art of the Sahara, both black and fair-skinned people are depicted; the artists appear to be telling the stories of their peoples in ancient times, their struggle with the hostile environment, the life of their society, and their fear of the unknown. The San (Bushmen) people, who are believed to have been the creators of rock art in some eastern areas and in most of southern Africa, presumably had similar motivations for engraving and painting on rock. They all recorded myth-ical symbols, rituals designed to overcome danger, invoke fertility and combat the threat of the supernatural. They tell of initiation and other ceremonials, for which the clans probably assembled in the rock shelters. The rites centred on, and were inspired by, the art on the wall which depicted symbols known to all.

This ancient art, with its potent symbolism and aesthetic conventions, may well be the root of that African art which has stretched through the millennia, up to our time. The paintings in the grottoes and shelters are based 'on primary colours such as red, ochre, white, black and yellow with the addition of blue and green. To this day this range of colours turns up in masks and dancers' regalia.'[2] Large human figures in the rock paintings are often shown side by side with small humans (some may be palimp-sests); and the holy eland of the Bushmen is depicted oversized, sur-rounded by tiny men. Similar considerations of primacy are evident in more recent times. The emphasis in sculpture, from Nok to modern Yoruba, is on the head, depicted larger than in nature; and the figure of a ruler is shown taller than his attendants. Symbolic abstraction and

naturalistic rendition of sculpted subjects are features of both rock and tribal art [12]; as is dance with masks, often using animal heads [13]. In short, African art (like other early artistic manifestations) has, since ancient times, been traditional and integrated with the cosmology of the society and its order of values. The prehistoric rock art of Africa is, in fact, the opening chapter in the history of African art and its first history book.

The existence of rock art in Africa was first reported in 1721 by a Portuguese missionary, who told the Royal Academy of History in Lisbon

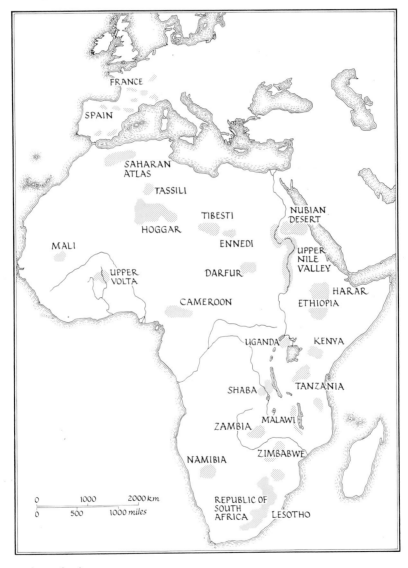

4. Areas of rock art.

of paintings representing animals found in rock shelters in Mozambique.[3] Since then multitudes of engravings and paintings on rough rock surfaces have been discovered, all over southern and eastern Africa.

Rock engravings in the Fezzan and Hoggar areas of the Sahara had been known for some time before a French army officer saw some paintings in the rocky wilderness of the Tassili plateau. Henry Lhote, the French archaeologist, was alerted and started cataloguing and copying the paintings in 1933. This work was interrupted by the outbreak of war in 1939, but was resumed in 1956 by a French expedition, again under the

12. Painting of cosmological (?) symbols with one human figure on the left and two seated in a circle, believed to represent a hut; several superimpositions. Inaouanrhat, Tassili-n'Ajjer, Algeria. Age unknown. Photo: J.-D. Lajoux.

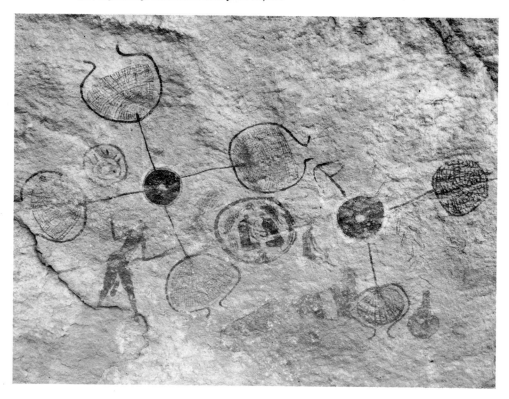

leadership of Lhote, and the fascinating story of the discoveries was published shortly afterwards.[4, 5] No scientific data were included or, indeed, have ever been made public. Difficulties of terrain, climate, communications and, more recently, political unrest have impeded re-

search in many parts of the Sahara. We can only hope that once stability has returned to the region, archaeological/ethnographical expeditions, fitted out with modern equipment, will provide us with the material needed to reconstruct the history of the people who created this rich treasury of Stone Age art.

Curiously, European rock art[6] was discovered later than the first African examples. Altamira in Spain was found accidentally in 1879, as was the cave of Lascaux in southern France in 1940. The paintings in the French Pyrenees and in northern Spain are dated between 30,000 and

13. Giant masked figure with superimpositions (or superhuman being?). Sefar, Tassili-n'Ajjer, Algeria. c. 7th–6th millennium B.C. Painting. Height of figure about 250 cm (98.5 ins). Photo: J.-D. Lajoux.

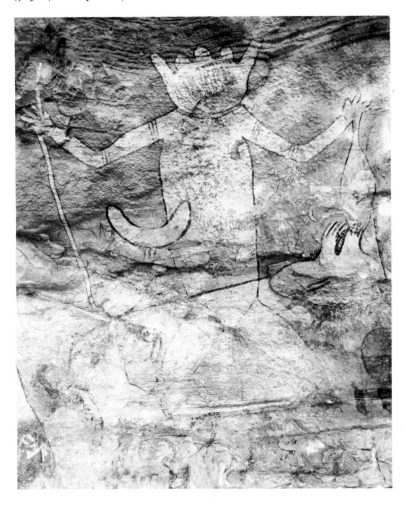

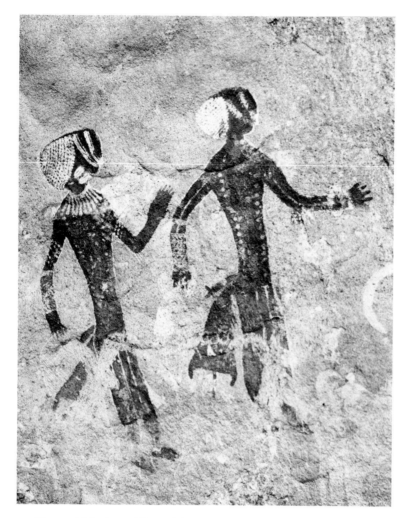

14. Figures with intricate coiffure and dress (or body decoration?). Centre of large group of human and animal figures. Tan Zoumaitak, Tassili-n'Ajjer, Algeria. 7th-6th millennium B.C., roundhead period. Painting, red and white. Height of figures about 100 cm (39 ins). Photo: K.-H. Striedter.

10,000 B.C., compared with the most ancient African dates, from 8000 to 6500 B.C. for the Sahara and around 27,000 B.C. for Namibia.[7, 8] The European prehistoric art includes many sculptures - rare in Africa[9, 10] - and the beautiful paintings and engravings represent almost exclusively animals, mostly in a naturalistic style. Human figures, which dominate the scene in many African rock paintings, are hardly ever depicted in European rupestral art. The character of Franco-Cantabrian and African

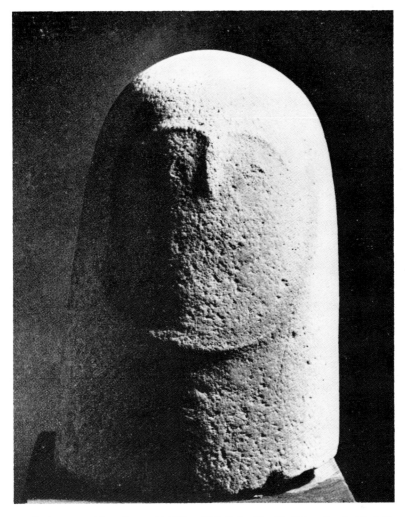

15. Anthropomorphic sculpture. Idol? From Tabelbalet, Tassili-n'Ajjer, Algeria. Neolithic (cattle herdsmen period). Stone. 50 cm (19.68 ins). H. Camps-Fabrer, 'Matière et art mobilier dans la préhistoire nord-africaine et saharienne', *Memoirs du Centre de Recherches Anthropologiques, Préhistoriques et Ethnographiques*, v, Paris, 1966, pl. xxvi. Photo: M. Bovis.

rock art is so very different (with the possible exception of examples in south-eastern Spain) that any derivation or diffusion must be considered most doubtful.

The sites of North African rock art are spread over an area spanning nearly the entire width of the desert – 5,700 kilometres from the Atlantic coast to the Red Sea – and from the Saharan Atlas in the north to the Sahel, a distance of 1,500 kilometres. The recorded engravings and paint-

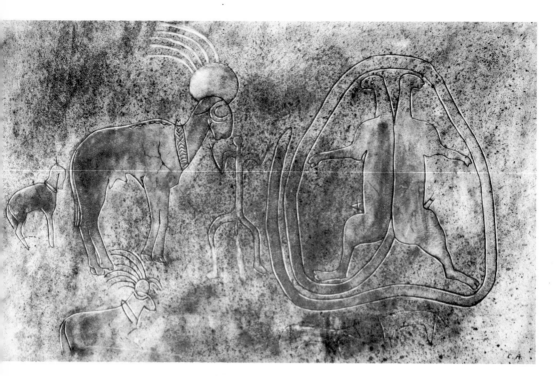

16. Rams with sundiscs and Janus creature. Djebel Bes Seba, Sahara-Atlas, Algeria. Bubalus hunter period, 7th–6th millennium B.C. Engraving. About 150 × 90 cm (59 × 35 ins). Photo (of a painting): courtesy Frobenius Institute.

ings number well over 40,000, of which, based on present information, about one quarter are in the area of Tassili n'Ajjer. The most westerly sites are in Mauritania and Morocco, and those furthest to the east range from Tibesti to sites in the Nile Valley, to the Egyptian desert between the Nile and the Red Sea, and to the Nubian desert.

The entire Sahara region is a moonscape of stone and shifting sands, waterless except for occasional artesian wells, with sparse flora and fauna. It was once fertile land, crossed by many rivers and with lakes rich in fish. Game was plentiful, and the inhabitants spent their lives hunting, fishing and gathering food. Much of this can be gleaned from the magnificent art which remained when, as a result of climatic change, a reduction of rainfall and the drying up of lakes and rivers, plant and animal life was destroyed. This happened between 3000 to 1000 B.C., and the people migrated to the Nile Valley in the east and the Sahel in the south. No clear data are available on previous climatic changes in the Sahara, but recent research has shown that the latest wet period began

17. Hunter with bow. Jabbaren, Tassili-n'Ajjer, Algeria. Cattle herdsmen period, *c.* 5th–4th millennium B.C. Painting, red. Height about 18 cm (7 ins). Photo: K.-H. Striedter.

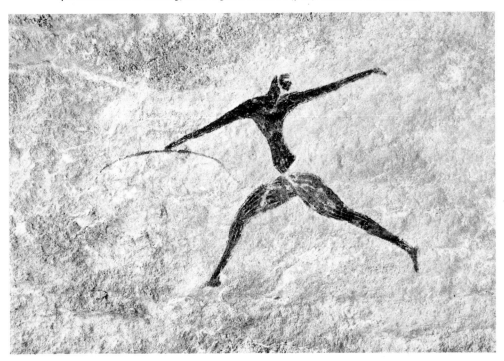

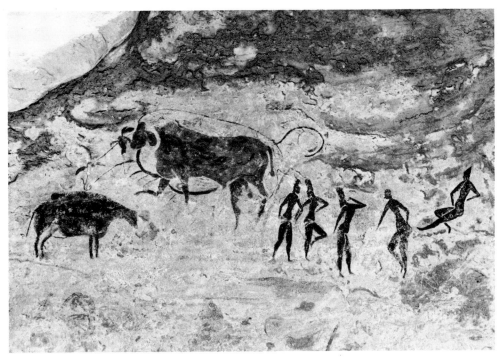

18. Pastoral scene. Jabbaren, Tassili-n'Ajjer, Algeria. Cattle herdsmen period, *c.* 5th–4th millennium B.C. Painting, reddish-brown and orange-brown. Width about 140 cm (55 ins). Photo: K.-H. Striedter.

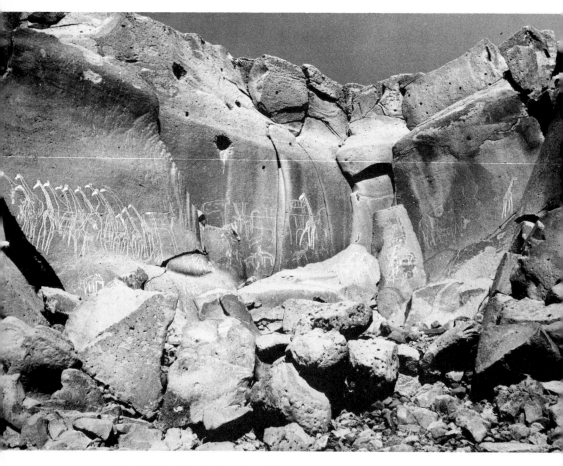

19. Rock shelter with giraffes and various other animals. Gonoa, Tibesti. Hunter period, c. 7th-6th millennium B.C. Engravings. Height of giraffes about 120 cm (47 ins). Photo: Dr C. Staewen.

about 6500 B.C. Men and animals could, however, have lived in some climatically favourable zones even earlier,[11] and this has led to the assumption that the art created there started about 8000 to 7000 B.C. and continued into quite recent times.[12]

Engravings are believed to precede paintings. These petroglyphs are of various sizes, some measuring up to 7 metres, and they represent elephants, giraffes, rhinoceros and other animals [19, 20].

Paintings vary from miniatures of a few centimetres to those of 760 × 360 centimetres[13] or even larger, and are in monochrome or polychrome [21, 22]. The artists used iron oxides, zinc oxides and kaolin for their main pigments, and charcoal or burnt bones for black pigment. The colours include deep red, purple, yellow, green, white and black, and

20. Bovine with spirals. Gonoa, Tibesti. *c*. 4th-3rd millennium B.C., cattle herdsmen period (?). Engraving. Length about 80 cm (31.5 ins). Photo: Dr C. Staewen.

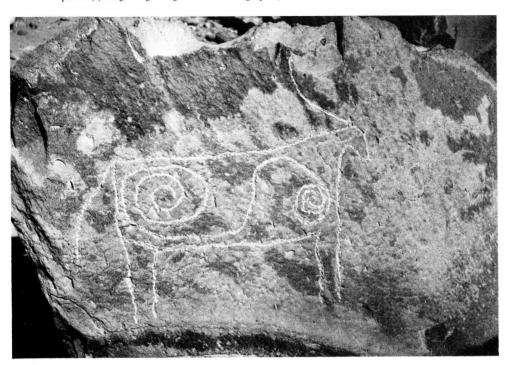

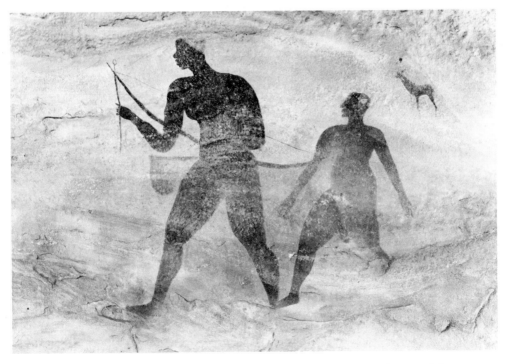

21. Hunters and antelope. Tin Aboteka, Tassili-n'Ajjer, Algeria. Cattle herdsmen period, 5th-4th millennium B.C. Painting, red. Height about 140 cm (63 ins). Photo: K.-H. Striedter.

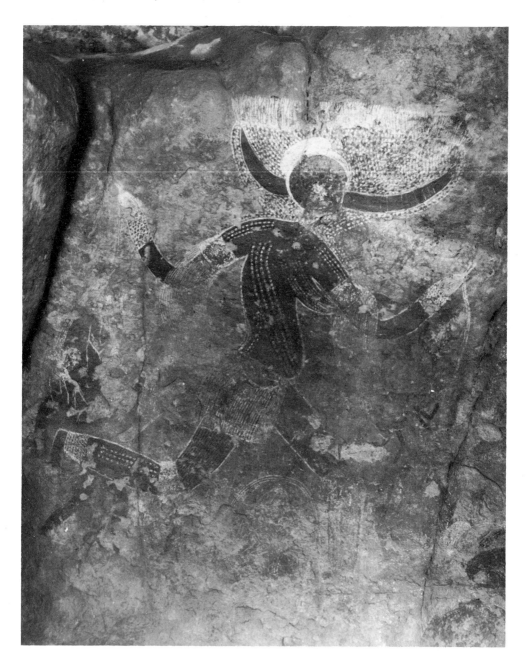

22. Masked figure in a group of males and females (or supernatural beings?). Inaouanrhat, Tassili-n'Ajjer, Algeria. *c.* 7th–6th millennium B.C. (? roundhead period). Painting, red and white. Height about 120 cm (47 ins). Photo: J.-D. Lajoux.

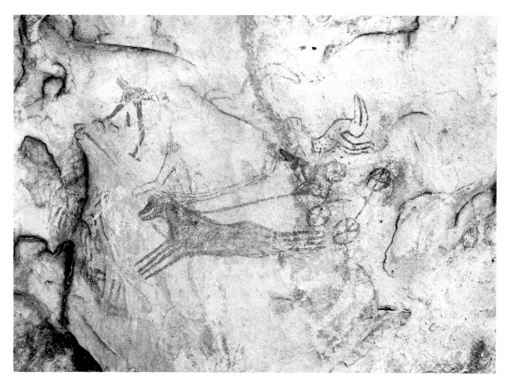

23. Horse-drawn chariot. Titera N'Elias, Tassili-n'Ajjer, Algeria. Horse period, *c.* 1st millennium B.C. Painting, red. Width about 80 cm (31.5 ins). Photo: K.-H. Striedter.

binders are believed to have been egg-white, milk and honey. As absolute dating has in most areas as yet been impossible, the main periods into which the rock art in the Sahara has been divided[14] are those of the bubalus hunter (pre-neolithic), the roundheads (early neolithic), the cattle herdsmen (neolithic), the horse period (protohistoric) and that of the dromedary (beginning of the Christian era).

Excavations in the Acacus mountain range in the Fezzan have resulted in what Mori calls a 'proposed absolute chronology', based on carbon 14 datings: 5095 B.C. to 2780 B.C. for a number of paintings and engravings related to the 'cattle herdsmen' period; and 6122 B.C. for paintings of the late 'roundheads' group.[15] It has not yet been possible to establish a date for the 'bubalus' period, but Mori believes a Pleistocene dating is probable.

The subjects include mythical figures; masked men (or supernatural beings?), some of them with body painting; giant round-headed figures;[16] hunters with bows; hunting, dancing and camp scenes; abstract symbols;[17] and a variety of animals – cattle, hippopotami, antelopes, goats,

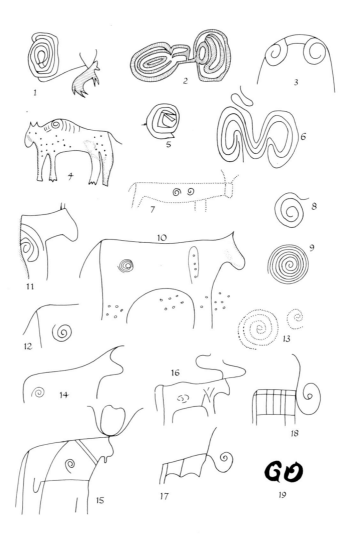

Fig. 1. Spiral motifs used by prehistoric pastoral societies in Egypt, Tibesti, Tassili and elsewhere. After P. Huard and L. Allard, 'Contributions à l'étude des spirales au Sahara central et nigéro-tchadien', *Bulletin de la Société Prehistorique Française*, 63, 2, 1966. 1, 2 Egypt. 3 Tassili. 4, 5 Hoggar. 6-9 Aïr. 10-19 Tibesti.

dogs, giraffes and ostriches. Some paintings have as their subject chariots, drawn by horses shown in 'flying gallop' [23], and these could have been used for war or hunting or both. Many of the scenes show both humans and animals in wonderfully depicted movement.

One of the unifying motifs for the rock art of the Sahara is the spiral, a symbol possibly representing the snake, which became a widespread decorative pattern throughout Africa (Fig. 1). It appears in paintings and engravings in Hoggar, Tassili, Tibesti, Ennedi, Fezzan and throughout the valley of the Nile. The earliest appearance of the spiral motif was in the central Sahara and has been dated about 6000 B.C. In the Nile Valley it goes back to pre-dynastic times. As a symbol it is also known in other countries and is documented in the Cycladic, Cretan, Minoan and Mycenaean cultures of ancient Greece, from the third millennium onwards, i.e. much later than on the African continent.[18] It is assumed that these were parallel developments, although a diffusion from Africa to Greece cannot be excluded.

Many other symbols and cultural traits are shared by all Saharan people, including those in the Nile Valley, pointing to contacts from earliest times onwards.[19]

Though much rarer than the paintings and engravings on rock, sculptures in stone, bone, clay and painted or engraved ostrich eggs have been encountered in many parts of the Sahara.[20] The ostrich eggshell was also widely used in southern Africa.

Rock art has also been found south of the Sahara in Cameroon, Burkina Faso, the Central African Republic and Mali. Some 'pagan' tribes of northern Nigeria have been reported to be still painting for initiation ceremonies in which gongs fashioned from rocks, probably the oldest of musical instruments, were used.[21] The Dogon, too, still paint on stones for their initiations. The ritual is concerned with the introduction of the initiates into the secrets, history, cult and symbolism of the tribe. The use of rock gongs has also been recorded from Lolui, a site in the Lake Nyanza (Victoria) area,[22] and from Tanzania.[23]

More sites are being discovered in different regions of the continent; but a complete listing of these cannot be attempted in the limited space available in this survey. In eastern Africa, important concentrations of paintings in shelters were recorded in the Harar area of Ethiopia; these portray cattle without humps, from which we can assume that the art is over 2,000 years old, since at that time humped cattle were introduced. Other paintings depicting humped cattle and camels probably date from the beginning of the Christian era. There are several sites with ancient rock art around Darfur in the Republic of Sudan; these mostly depict animals, but occasionally human figures and equestrian groups appear, all in black and red. Highly stylized paintings of hunters and animals were

discovered in Tanzania, and rock art from ancient times has been found in Kenya and Uganda. An important concentration of rock art, mainly engravings, exists in the Nubian desert. This area extends from Wadi Hammamat, which connects the Nile with the Red Sea, is bordered in the west by the Nile, in the east by the coast, and reaches southwards to the 20th parallel. Furthermore, both paintings and petroglyphs were uncovered all along the Nile Valley, from Luxor in the north to Meroitic Nubia in the south. Many of these works were recorded and photographed in the 1960s by Unesco expeditions, prior to the flooding of large areas during the construction of Lake Nasser. Apart from Scandinavian and Spanish publications, no documentation of this important work is yet available.[24]

The epochs during which the Egyptian and Nubian engravings and paintings are believed to have been created date back to pre-dynastic times of 4000 to 3000 B.C.; continued through the Old, Middle and New Kingdoms and on into the period following the Arab invasion in the second half of the first millennium A.D.[25] Some engravings depict elephants, rhinos, giraffes and other animals which had vanished from the area in times of dynastic Egypt. Those made after the pre-dynastic era picture boats, antelope, cattle and other animals, humans on their own and in hunting scenes.[26, 27]

Was there a diffusion of art from west to east; or from east to south and west? Were rock painting and engraving parallel evolutions in various parts of Africa? These are questions that so far have no definite answers, but inspire a multitude of speculations.

All over southern Africa are areas with paintings and engravings in caves and open shelters. In Malawi and Zambia,[28, 29] the majority are non-representational, and the abstract designs constitute another African enigma. Middens below paintings in Zambia were radiocarbon dated from 5590–2280 B.C.,[30] but this does not prove the age of the art work.

Further south, an abundance of rock art is to be found in Zimbabwe, the Republic of South Africa and Namibia; and in these countries we have also the best records of exploration and research. In Zimbabwe, concentrations are found in the Matopo Hills in the vicinity of Bulawayo, near Harare, and not far from the ruins of Great Zimbabwe. The subjects are varied: animated scenes show hunting or dancing; elephants, antelope and other game are interspersed with human figures, floral and strange abstract patterns or dotted lines. The variety of subject matter and the diversity of style and colouring may mean that the vast corpus of Zimbabwe rock art was produced over a very long period. Here again, suggested dates cannot be accepted until archaeological proof has been obtained, and this is extremely difficult for rock paintings. However, in

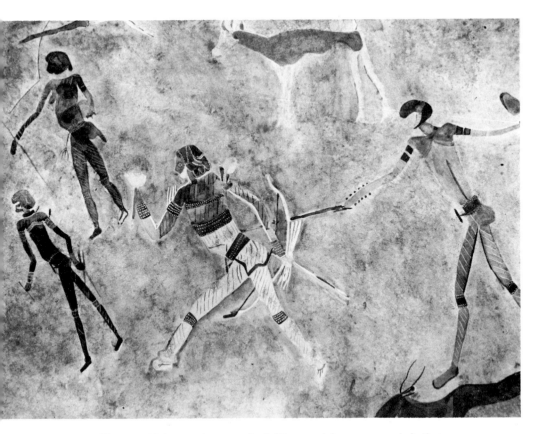

24. Hunters with bows and arrows, eland. The central figure was popularly (but erroneously) called the 'White Lady' of Brandberg. Brandberg, Zisab Gorge, Namibia. Not dated. Painting, reddish-brown, red, yellow and white. Height 40 cm (15.75 ins). Photo (of a painting): courtesy Frobenius Institute.

Namibia several fragments of painted stone slabs were found in the Apollo 11 cave and were dated between 27,500 and 25,500 B.C. - so far the earliest date for any African rock art.[31]

In South Africa, in Zimbabwe, and possibly in areas further north, the San were the artists who painted and engraved their symbols and mythical figures on the walls of the shelters in which they congregated for their rites. We do not yet know whether the San originated in southern Africa or came from the north. But they are believed to be one group among the original inhabitants of Africa. Their presence in southern Africa is said to date back to the middle or late Stone Age or to the beginning of the Iron Age - about 2,000 years ago in most parts of Africa. They were hunters, fishermen and gatherers of food; and remnants of these 'little people',

persecuted by Bantus and whites alike, live now in the Kalahari desert, where they still pursue their ancient mode of life. The shelters, with their beautiful rock paintings, were – we may surmise – a focal point of their initiation ceremonies, involving their famous rain-making rituals, their religious myths centred on the eland, and their complicated systems of family relations and taboos.

From Transvaal to the Cape and from the north of Orange Free State to the Drakensberg in Lesotho, a wealth of rock art has been discovered, recorded and analysed.[32] The Drakensberg escarpment and adjacent sites contain some of the greatest San art, and these were admirably researched by Vinnicombe in her extensive fieldwork.[33] She is reticent on the origin of the art or of the San: both, in her opinion, are still unknown;[34] and though human occupation of Lesotho has been dated to about 40,000 B.C., there are no archaeological associations with the art.

25. Pastoral scene with human and animal figures, trees and plants. Marandellas, Zimbabwe. Probably 1st millennium A.D. Painting, red. Photo of copy: courtesy Frobenius Institute.

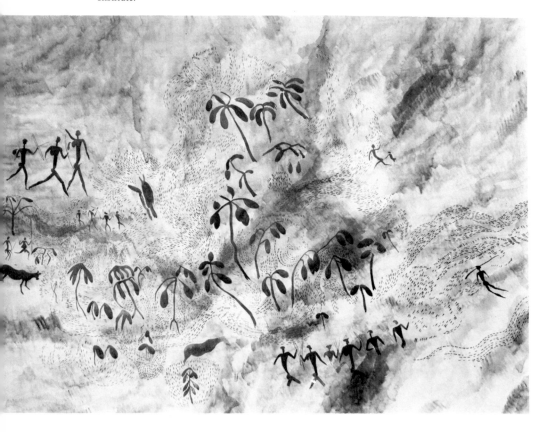

Of the subject matter in the Drakensberg petroglyphs and paintings, a small percentage is composed of abstract symbols, while human figures and a great variety of animals are depicted in about equal numbers. Men and women are shown carrying weapons, gathering food, hunting, dancing, and in ritual activities.[35, 36, 37]

The eland, which plays an important role in San mythology, is very frequently depicted, followed by antelopes, domestic animals, elephants, predators, wildebeest, snakes and winged creatures. There are also fishing scenes; and at a place called Ezelzacht in Cape Province is a painting[38] of a group of 'mermaids', fish to the waist and human above, in a scene reminiscent of a waterdance. The colours are dominated by black and red with some white, orange and yellow. The majority of paintings are in monochrome, with bichrome and shaded polychrome in equal proportions. They range from 1.3 centimetres to 243 centimetres (for giant

26. Scene with human figures and elands. Loskop, Iditima Cave, Natal, South Africa. Not dated. Painting, red, red-brown and white. About 110 × 70 cm (43.3 × 27.5 ins). Photo of copy: courtesy Frobenius Institute.

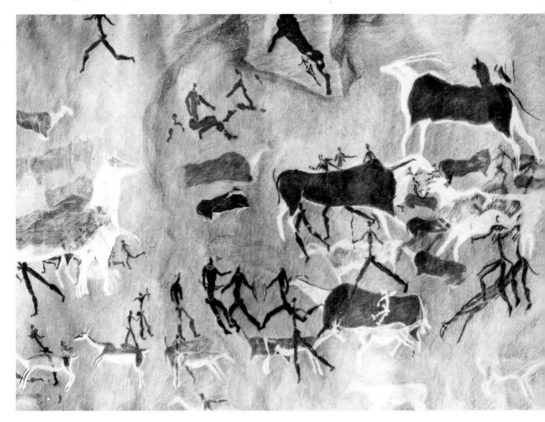

mythological serpents and elands), but the average size of humans and animals in the paintings is about 18 centimetres. Petroglyphs may be divided into engravings where the outlines are incised, those made by pecking and stippling, to produce effects of bas-relief, or by intaglio technique.

As elsewhere in Africa (and in Europe), the artist painted his work high up on the wall or even on the ceiling of cave or shelter; so high up that it is difficult to imagine how the work was actually done without scaffolding. Equally widespread is the superimposition of paintings – sometimes up to six layers have been discerned – while next to the heavily painted and overpainted area are large expanses of wall space obviously never used. Of 150 fully recorded paintings on the Drakensberg, 57 per cent were found to have superimpositions.[39] The conclusion must be that the paintings or petroglyphs were rarely secular graffiti but a part of the socio-religious life of the respective African communities, requiring symbols of their rituals and myths to be portrayed in specific traditional places inside the caves that were their shrines.

The Ancient Nubians

The rock art of the Sahara and Tibesti, surveyed in the previous chapter, has many links with that of Nubia and Egypt. Certain iconographic symbols appearing in Saharan paintings have their counterparts in Egyptian and Nubian art. Rams with spheres on their heads seem reflected in the symbol of the god Amun of the Nile Valley in a much later period.[1] The spiral in conjunction with animals is found in the rock engravings of Wadi Hammamat as well as in the paintings and petroglyphs of the Tassili and Tibesti.[2]

In ancient times, the Nubians occupied a large part of the Upper Nile Valley - roughly the area between Aswan and Khartoum. Their art was for long considered only a cultural appendix of dynastic Egypt, and it was for that reason usually excluded from surveys of sub-Saharan black African art, even though the area is south of the Sahara and its inhabitants are black.

The Nubians had organized societies and a culture of their own as early as the seventh to sixth millennium B.C.[3] Their language - still spoken in the Upper Nile Valley - is related to those of tribes to the east, and to others living in the Darfour and Kordofan areas to the west of the river. The Nile was not only the purveyor of life but also a unique corridor of communication between the Nubians and the Egyptians, opening two-way trade with many Mediterranean and Asian nations. The caravan routes to the south, east, and west meant direct contacts with other black African nations, not only for the Nubians but for Egypt, and trade with countries beyond the seas.

Nubia is the cradle of sub-Saharan art, where the first sculptures in clay, metal and ivory were produced. The earliest pottery was excavated in the Khartoum area and labelled 'Early Khartoum'. The art of making it is believed to have spread from there to the Lower Nile Valley in the north; to Chad in the heart of Africa; and to Tibesti, Borkou and Ennedi in the Sahara, then still green and populated.[4] By the time of the Early Dynastic Period in Egypt (starting 2955 B.C.), the indigenous art of Nubia was already well developed. The A-group culture, distinctly Nubian and without Egyptian equivalents,[5] was past its greatness and in decline, as was the parallel Egyptian Naqada culture (4000-3000 B.C.).

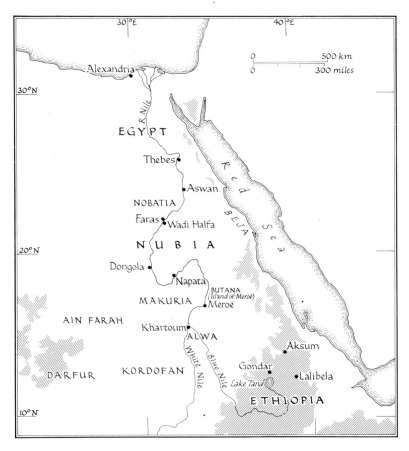

5. The Nile Valley.

In the last phases of the Nubian C-group culture (1800-1500 B.C.), Egyptian influence in religion, patterns of government, architecture and art made itself felt and reached its greatest height in the New Kingdom and during the subsequent Kushite domination of Egypt (twenty-fifth dynasty). This was followed by changes brought about by the ascendancy of the Persians, Ptolemies, Romans and Byzantines. These outside influences – and in particular those of the Egyptians – were strongest on royal, noble and religious institutions. The art, burial customs and general culture of the ordinary people were hardly affected, except during the New Kingdom, when they too copied Egyptian customs. Indeed, outside influences were absorbed into a distinctive Nubian culture, just as in the rest of black Africa the influences of neighbours, conquerors, missionaries and others were assimilated to become part of the culture of the nations affected.

For all these reasons, Nubian art has been included in this survey as a key element in reconstructing the art history of sub-Saharan black Africa.

After early explorations by French and British geographers and archaeologists, the first breakthrough came with excavations under the sponsorship of Harvard University led by George Reisner, in the framework of the Archaeological Survey of Nubia.

Reisner started excavating in 1907-8 in Lower Nubia and unearthed fine art objects - well designed and decorated clay vessels and statuary. He ascribed them to the A-group culture, a label which - *faute de mieux* - is still being used. This culture, which reached its peak in about 3000 B.C., was of distinctive Nubian character and lasted until the beginning of the Old Kingdom in the twenty-fifth century B.C., when Egyptian influence spread. A female figure[6] made of unfired clay was found in a grave and may have had a magic function; it was dated about 3000 B.C.

27. Basin with geometric decoration. Nubia. A-group, early 3rd millennium B.C. Fired clay, painted light brown, decoration dark red-brown, interior black polished. Height 19.4 cm (7.6 ins). Fitzwilliam Museum, Cambridge, E.G.A. 4668, 1943. Photo: courtesy Fitzwilliam Museum.

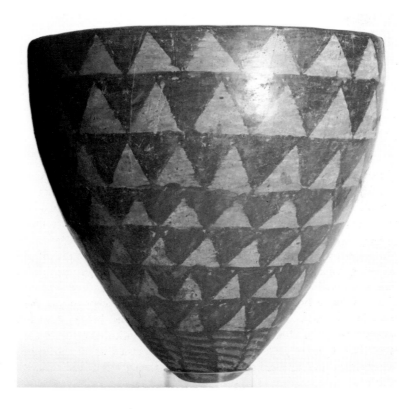

Like most female statues made by mesolithic and neolithic people, it is steatopygous and also emphasizes the breasts, symbols of life and fertility.

The earliest known representation of an animal made by the A-group people in fired clay is the head of a hippopotamus, probably broken off a large sculpture.[7] The 'domestic' pottery of the group excelled in thin-walled polished vessels of fired clay, painted usually in reddish colours outside, with the inside and the rim polished black [27].

The end of the A-group culture, which had moved from Lower Nubia southwards, coincided with the Early Dynastic Period of Egypt. There is a time gap of about 700–800 years, for which no discoveries of artefacts have yet been made and for which the denomination of B-group had been reserved. This is now considered to have been 'archaeological fiction'. Such a group never existed, and finds awaiting clarification probably belong to a declining A-group, whose culture became impoverished under Egyptian domination during the Old Kingdom.[8, 9]

The next era of artistic development evidenced by archaeological finds is shared by two groups: the Kerma group, starting about 2200 B.C. in Upper Nubia, and expanding into Lower Nubia towards its end in 1500 B.C.; and the C-group of Lower Nubia, producing its art during the same period. Both terminated around 1500 B.C., when the New Kingdom brought large parts of Nubia under its rule.

Egypt exerted its influence on the culture of the Nubians to a greater or lesser degree, depending on the power of the dynasties. During the three 'Intermediate Periods', the underlying Kushite character showed itself strongly. Thus the C-group and Kerma cultures grew and came to full flower during the first and second 'Intermediate Periods', with some wilting during Egyptian political domination of Lower Nubia at the time of the Middle Kingdom (2040–1785 B.C.). But the greatest period of the C-group and Kerma cultures clearly developed in the second 'Intermediate Period', when the Kerma civilization even spread from Upper to Lower Nubia.

It was a time in which the hereditary Kushite Kingdom asserted itself and became the centre of political power in the Upper Nile Valley. Burial customs reverted from the stone sarcophagus of Egypt to the distinctly Kushite burial bed. The very fine black-topped red pottery replaced the much coarser Egyptian-type clay vessels. With the advent of the New Kingdom and renewed Egyptian domination, the process of acculturation resumed, but Kushite customs and artistic expression remained always strongly alive in the villages with the ordinary people,[10] while royalty and nobility became very Egyptianized. This accelerated during the Kushite rule in Egypt (twenty-fifth dynasty, 747–656 B.C.). When the Assyrians invaded Egypt in the second half of the seventh century B.C., the Kushites withdrew to their own country. This was followed by a great flourishing of art in Napata and later in Meroë.

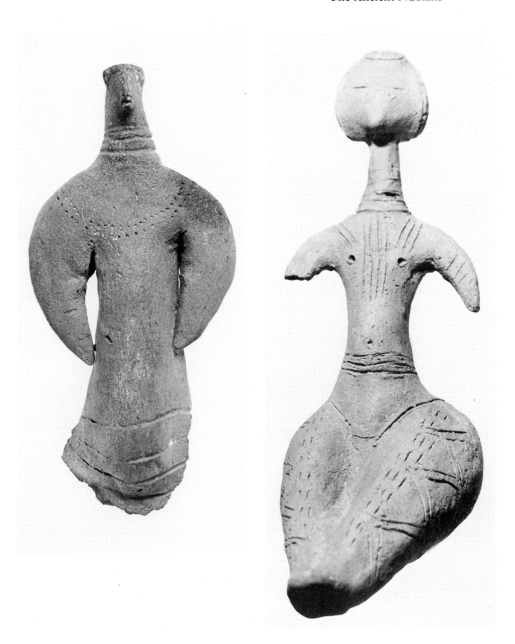

28. Anthropomorphic figure with sheep's head; probably pregnant female; fertility goddess. From Askut. C-group, 1900–1550 B.C. Fired clay. 10 cm (2.9 ins). Museum of Cultural History, University of California, Los Angeles. Photo: courtesy Museum of Cultural History.

29. Seated female with scarifications. From Aniba. C-group, 1900–1550 B.C. Fired clay, greyish-brown. 11.7 cm (4.57 ins). Egyptian Museum, Cairo, JE 65192.

The anthropomorphic figure found in Lower Nubia [28] has been attributed to the C-group,[11,12] and appears to represent a pregnant woman (although there is no hint of breasts) with the head of a sheep. This, it is believed, indicates that the figure depicted a goddess of fertility.

The seated female figure [29] is a fine sculpture produced in the late period of the C-group. The body scarifications are of particular interest, as they show that this is a very ancient body art in Africa.[13]

The animal shown below [30] is most probably bovine. It is poorly sculpted, but has historical importance: the sphere on the head may link it with the rock art of the Sahara at Borkou and Tibesti[14,15] and show a possible relationship between the cattle breeds of the Sahara and those of the Nubian C-group; even, indeed, between the peoples of these two areas.[16]

A typical C-group bowl, in hemispherical shape, brownish-red outside with black rim and interior, decorated with hatched bands, has a wall thickness of only 6 millimetres. In a later period (1900–1650 B.C.), the potters of C-group made the first attempts at decorating vessels with representations of animals, although these are rather crude in comparison with rock drawings and sculpted bovines from the same general area and

30. Bovine animal with sphere on head. From Aniba. C-group, 1900–1550 B.C.; style related to rock paintings at Borkou, Tibesti, suggesting link between people there and C-group people, both cattle breeders. Fired clay, light brown. Length 6.8 cm (2.68 ins). Ägyptisches Museum, Karl-Marx-Universität, Leipzig, 4373. Photo: courtesy Ägyptisches Museum.

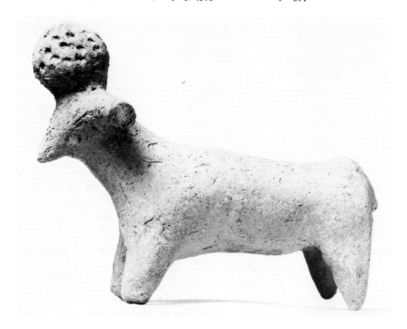

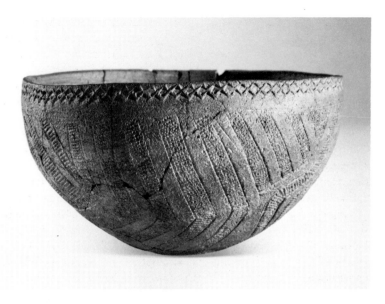

31. Bowl with incised decorations. From Faras. 2000-1900 B.C. Fired clay, light to medium brown. Diameter 17.6 cm (6.9 ins). British Museum, 51788. Photo: courtesy Trustees of the British Museum.

period.[17] Many polished bowls [31] with a great variety of geometrical patterns, mainly hemispherical but also in goblet form,[18] and bird-shaped examples (unpolished) have been excavated, practically all of them from cemeteries.

The footboards of burial beds were often lavishly decorated with inlaid animal figures or abstract patterns in ivory, copper or mica. Even for this characteristic Nubian custom, some of the decorations were Egyptian motifs or images of Egyptian gods who had become members of the Nubian pantheon.

The artists and craftsmen of ancient Nubia were masters in the use of many different materials and made splendid jewellery of gold and cornelian. A plaque in the shape of a scorpion in blue faience was found at Kerma; it was probably an amulet worn as a pendant.[19] During that same period of the Kerma culture, the art of making eggshell polished beakers with 2-millimetre wall thickness reached its perfection. Vessels with spouts, others in graceful animal forms or with sculpted rams' heads and other inventive shapes, were uncovered, some in considerable quantities, during excavations before the First World War.[20]

The period of Kushite rule over Egypt, constituting the twenty-fifth dynasty, was the period of greatest acculturation. Yet however widely Egyptian style, regalia, customs and religion were adopted by kings and

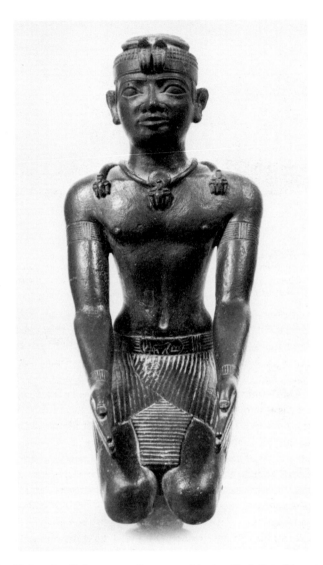

32. King Shabaqo in offering gesture. From area of Ancient Kush. Late 8th century B.C.
(XXVth dynasty). Solid cast bronze, dark brown. 15.6 cm (6 ins). National Museum, Athens,
632. Photo: courtesy National Museum.

courts, identification with the cult of the Nubian homeland and pride in
its traditions and artistic forms can be clearly discerned in many of the
sculptures, buildings and other manifestations of art. The fine sculpture
in solid bronze of a kneeling king of the twenty-fifth dynasty [32] –
identified by the name on the buckle of his belt as King Shabaqo – is
a beautiful naturalistic work of art. Showing him in a position of religious

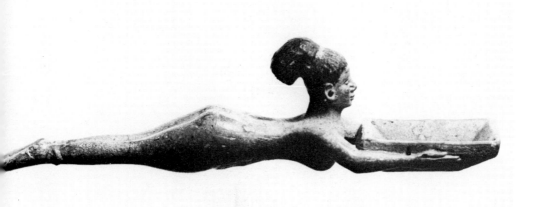

33. Ceremonial spoon in form of a swimming girl with a basin. From Sanam. 8th-7th century B.C. Faience, yellowish-brown; hair on head and pubic hair black. Length 10.8 cm (4.25 ins). Ashmolean Museum, Oxford, 1921.735. Photo: courtesy Ashmolean Museum.

offering, it may well have been created as a receptacle for the king's soul and so correspond with the purpose of much West African sculpture. Several details in this portrait of a pharaoh are clearly Nubian in character. There is the close-fitting cap and the manner in which the rams' heads attached to his necklace are fashioned. On the cap he bears two uraei, symbols of his rule over the twin nations of Egypt and Nubia. The folds in his face, running from the tip of the nose horizontally towards the ears, constitute another characteristic of Nubian sculpture.

A great variety of materials – apart from bronze – were used by the artists of that period. They worked in granite, calcite, diorite and other stones. They also made beautiful artefacts in faience, gold and electrum.

The stunning faience sculpture of a nude girl, seemingly in a swimming position and holding a basin in her outstretched hands [33], has been described as an implement for dispensing myrrh or wine in cult or burial ceremonies.[21] It was found in Upper Nubia, just south of the fourth cataract: and as it is non-Egyptian in character and resembles stylistically later Meroitic sculpture, this figure is most probably of pure Kushitic origin from the Napatan period. The bronze figure of a goose has Egyptian decorations [34]; but it is, in fact, the leg of a burial bed, the function of which was definitely Kushitic.

A gold earring in the shape of a ram's head was found in Meroë and has been dated to the sixth century B.C. – i.e. before the move of the royal seat from Napata to Meroë in 270 B.C.[22] Though Kushitic in style and workmanship, it has an Egyptian sundisc and the double uraei symbolizing the union of Kush with Egypt.

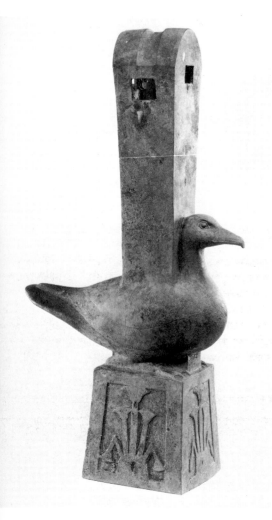 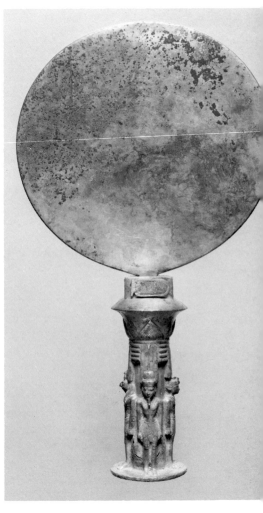

34. Leg of Kushitic funeral bed in form of a goose; base has Egyptian papyrus motifs, though such beds are purely Nubian. From El Kurru. Bronze, grey-green. 56 cm (22 ins). Museum of Fine Arts, Boston, 21.2815. Photo: courtesy Museum of Fine Arts.

35. Mirror of King Amani-natake-lebte. From pyramid at Nuri. Napatan/Kushite work. Silver with gold wire cartouches. 31.5 cm (12.4 ins). Diameter of mirror 17.5 cm (6.9 ins). Museum of Fine Arts, Boston, 21.338; Harvard/M.F.A. expedition. Photo: courtesy Museum of Fine Arts.

Many artefacts that were found in the area of Napata (Gebel Barkal and Nuri) cannot be attributed to Kushitic artists with any certainty and might well have been imported from Egypt. Yet a two-piece gold cylinder bears the name of the Nubian King Aspelta, and such cylinders – the

function of which remains unknown – have been found in a number of royal tombs in the Napata area but never in Egypt.[23]

The silver mirror illustrated [35], found in a pyramid at Nuri and representing King Amani-natake-lebte in the company of gods, is another example of the beautiful metalwork of the artists of ancient Napata.

A number of stelae and tablets were found in Napata and Meroë, some with Meroitic script. Most of these, however, are stylistically and icono-graphically in the tradition of the twenty-fifth dynasty, though some incorporate Meroitic characteristics. As most of these objects in sand-stone, granite and steatite are connected with royalty, it appears that customs dating back to the rule of Nubia over Egypt were carried into a period when Meroë's own splendid artists produced many objects of purely Nubian/Meroitic character.

The so-called iron slag heaps of Meroë, often described and illustrated in archaeological or historical works on Nubia, brought about the descrip-tion of Meroë as 'the Birmingham of ancient Africa'.[24] But after extensive excavations in recent years, when very few iron implements were found, several scholars concluded that such implements had either been imported or produced locally from imported iron and that 'only after the decline of Meroë did iron become an essential part of the technology . . .'[25] Amborn, in his very detailed scholarly study,[26] maintains that there is absolutely no evidence of iron smelting even during the Christian era; and that the so-called iron furnaces were, in fact, kilns for firing ceramics. Even in Egypt, iron smelting can be proved only from the Ptolemaic period (330–30 B.C.) onwards. As there was no iron smelting in Meroë until its decline (the slag is described as waste of 'other industries'), diffusion from Meroë to Nok, where iron was produced even before smelting arrived in Egypt, is, in Amborn's opinion, untenable. This conclusion, which puts the beginning of iron production in Meroë into the fourth century B.C., is shared by several other scholars. However, recent radiocarbon dates[27, 28, 29, 30] indicate that the earliest production may have been between 700 and 600 B.C. This result is based on a sample from the bottom of the largest slag heap in context with pieces of iron and iron slag; and the time would roughly coincide with the time at which the Nubian royal court moved to Meroë. The conflicting views on the date of the earliest production of iron on Meroë island remain unreconciled.

The figure of a young girl shown here [36] was made in hollow cast bronze and was once attached to a metallic object for which it served as a handle. It is Napatan in origin but the naturalistic rendering points to Meroitic influence.

Another bronze casting,[31] though this time made of solid metal, repre-sents a prisoner and is clearly of Meroitic origin, both chronologically and stylistically. Yet another image of a bound prisoner,[32] carved in sand-stone, is strongly expressionistic and exemplifies the artistic diversity of

36. Handle of a vessel in form of a young girl. From Kawa. 5th–3rd century B.C. Bronze, hollow cast. 16.9 cm (6.65 ins). British Museum, 63597. Photo: courtesy Trustees of the British Museum.

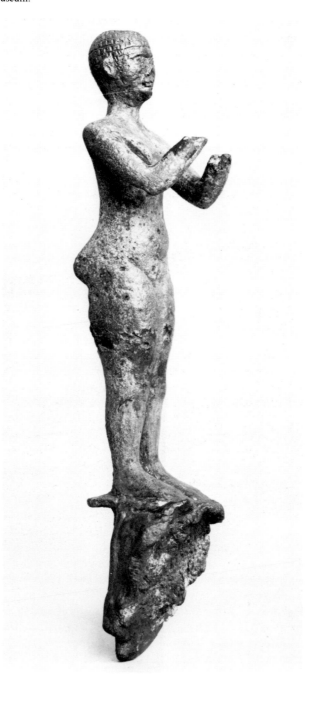

Meroitic craftsmen, who also left behind much outstanding architecture. The Great Enclosure at Musawwarat es-Sufra [37], probably their most important religious centre, is one of the finest examples; it was built and added to over a period spanning hundreds of years. The architectural detail from one of the many temples in the Enclosure - typically Meroitic in building and carving - represents a ram and two lions in the local style, with the specific iconography of the period [38]. The ram, the sacred animal of the Egyptian god, Amun, had become a Nubian symbol when the cult was introduced there in the New Kingdom, and remained dominant in Nubia to the end of Meroitic times.

Ba-statues are tombstones made for non-royal persons of importance, and were placed in the chapel entrance to the tomb or in the chapel itself.

37. The great enclosure at Musawwarates-Sufra. Early Meroitic period. (The Temple of Apedemak at Musawwarat was built about 225 B.C.) Photo: Werner Forman.

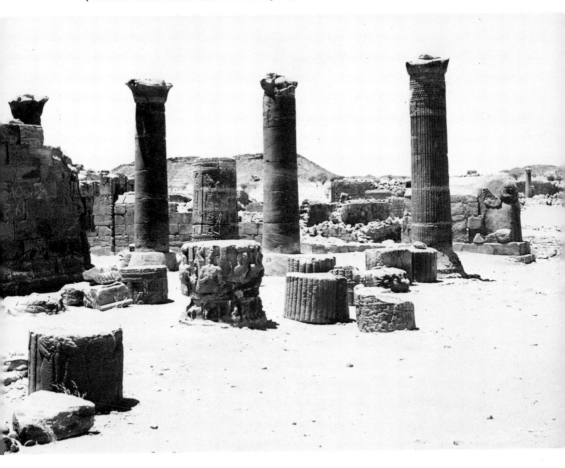

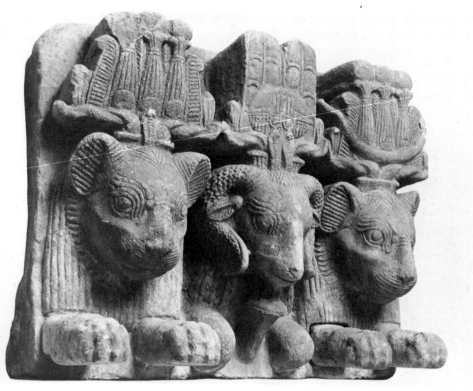

38. Ram and lions. From the Temple of Apedemak. Late 3rd–2nd century B.C. Sandstone, brown with traces of white pigment. Height 64.3 cm (25.3 ins). Width 88.3 cm (34.75 ins). Ägyptisches Museum, Berlin, 24300/HU/1. Photo: Horst Kolo.

They were often rendered as winged figures, and the rank of the people commemorated by them was usually indicated by the position of their arms, clothing and jewellery. The example shown [39] is of a high sculptural quality, but there are many others which are crude and undistinguished. Some memorials on tombs were heads which quite obviously never formed part of a whole figure [40]. The style of these – known as 'reserve heads' – is quite different from that of the Ba-statues.

Greek and Roman influences are evident in the sandstone and stucco figure of a nude woman known as the Venus of Meroë [41]. It belongs stylistically to a group of figures found – like this carving – in the 'Royal Baths' of Meroë. No sculpture comparable with that group is known from other parts of the Meroë Kingdom; they were probably all made by local artists inspired by the art fashion then developing in Alexandria.

Meroitic jewellery, though labelled as 'minor art', has often been of outstanding design and a high quality of workmanship. The ring illustrated [42] belongs to a type called 'shield rings', because of a shield

hinged at a right angle to the actual finger ring. The shield in this example contains a ram's head crowned with a large sundisc, the whole worked in gold with fused glass inlays and a cornelian bead; behind the ram's head is a temple gate. The ring, of the late first century B.C., was found in a pyramid at Meroë in which a queen (Amanishakheto) had been buried. Some ornaments of this kind were worn on the forehead, and similar jewellery is still popular with Nubians today.

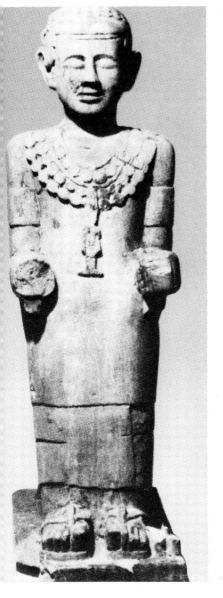

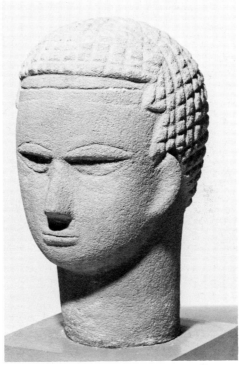

40. Head of a man with horizontal line on forehead, possibly cicatrice. From Argin. 2nd–3rd century A.D. Sandstone. 26.7 cm (10.5 ins). National Museum, Khartoum. Photo: Horst Kolo.

39 (left). Ba-statue. Man in long coat, with necklace and pendant ornament, armlets and bracelets; folded wings on his back. From Karanog. 2nd–3rd century A.D. Sandstone. 74 cm (29 ins). Egyptian Museum, Cairo, JE 40232.

Yet another gold ornament of the first century B.C. is the representation of an animal [43] – the species remains undetermined – which appears stylistically related to Greek geometric art of about 1000–800 B.C. Such art had in all likelihood filtered through Egypt and influenced some Meroitic artists.

41. Nude female torso – 'Venus of Meroë' – in the style of figures in the Royal Baths at Meroë, based on Roman art, ascribed to influence from Alexandria. From Meroë, Royal Baths. 2nd–3rd century A.D. Sandstone and stucco, skin painted red-brown. 78.9 cm (31 ins). Staatliche Sammlung Ägyptischer Kunst, Munich, ÄS 1334. Photo: courtesy Staatliche Sammlung Ägyptischer Kunst.

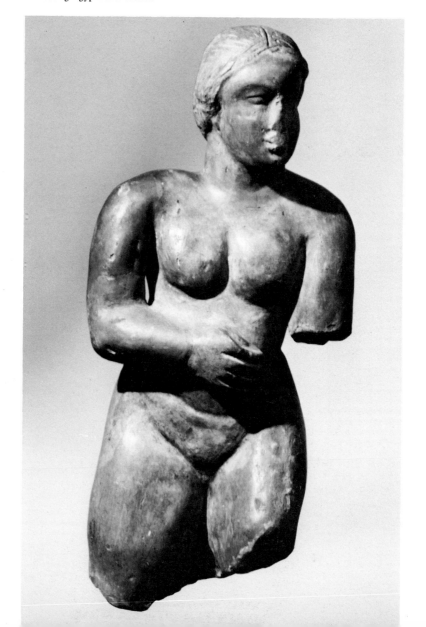

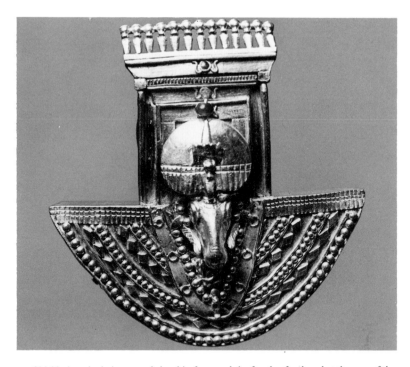

42. Shield-ring, depicting a ram's head in front and the façade of a chapel at the rear of the plaque to which the finger ring is hinged. From Meroë. Late 1st century B.C. Gold with green and blue fused-glass inlays and cornelian bead. Height 5.5 cm (2.16 ins). Staatliche Sammlung Ägyptischer Kunst, Munich, Ant 2446b. Photo: courtesy Staatliche Sammlung Ägyptischer Kunst.

43. Ornament (? pendant) in the shape of (?) canine animal and Uraeus. From Meroë. Late 1st century B.C. Gold. Staatliche Sammlung Ägyptischer Kunst, Munich, Ant 2497. Photo: courtesy Staatliche Sammlung Ägyptischer Kunst.

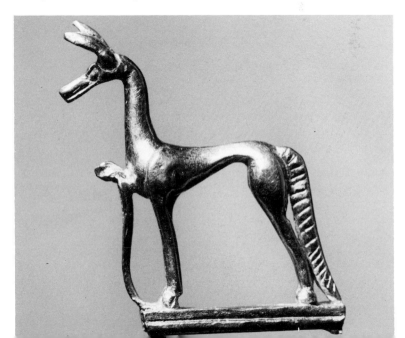

Containers for cosmetics, some made of wood with ivory inlay, were often buried with a dead queen or lady of nobility. The triangular decoration points to West African influence. But the interacting influences of Nubian and other sub-Saharan people have still to be investigated before more definite statements can be made.[33] Some of the large number of terracotta vessels from Meroë have been classified by the types of their decorations, and the wine jug shown [44] has been attributed to the 'Antelope Painter'. Other groups of motifs have been labelled 'vine leaf school', 'altar painter', 'academic school', etc. In a more general classification of Meroitic ceramics, we may distinguish between handmade types and those produced wholly or partly on the wheel. The latter category comprises the very fine eggshell ware and the larger vessels, usually distinctively decorated, which together are considered to be of a quality never surpassed either in any other part of Nubia or in Egypt.

44. Terracotta vessel with painted antelope and vine leaves. From (?) Karanog or Faras. 2nd-3rd century A.D. Fired clay, red-brown; decoration black and white. Height 27.6 cm (10.85 ins). Brooklyn Museum, Charles Edwin Wilbour Fund, 71.84. Photo: courtesy The Brooklyn Museum.

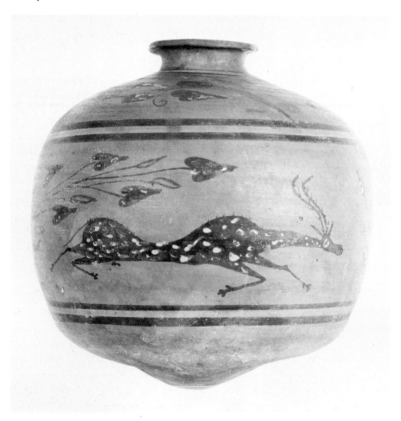

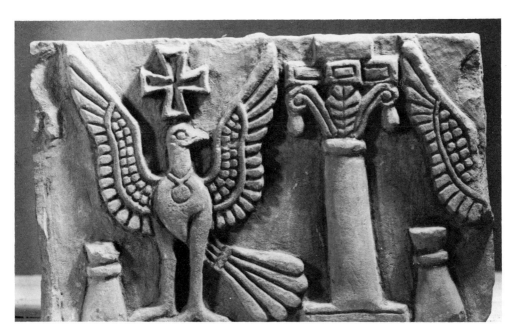

45. Relief with Christian motifs; part of frieze. From Faras. Early 7th century A.D. Sand-
stone, red. Width 42.8 cm (16.85 ins). Museum Naradowe, Warsaw, 234 081. Photo:
courtesy Museum Naradowe.

The greatness of Meroë declined in the fourth century A.D., when the
pressure of the Noba[34] from the south-west wrested political power from
the Kingdom. Indeed, the town of Meroë was sacked by the Noba even
before the Kingdom as a whole was conquered by the Aksumites in about
A.D. 320. The artists of Meroë continued to create fine objects in metal,
clay and other material, though there is little evidence of sculpture in the
round or of important architecture. The art of the period from the fourth
to the sixth century A.D. has been called the 'Ballana Culture', as many
of the objects were found in cemeteries at Ballana, though the area of this
culture is much wider. The objects produced during this period show
mostly a distinctive Meroitic character, with strong Roman but also
Hellenistic and Byzantine influences.

The next development in Nubian art came with the advent of Chris-
tianity; this new era, which started in the late fifth century A.D., spelled
the end of the cultures created during the rule of the Kingdom of Kush.
Three kingdoms of Nubia – Makuria, Nobatia and, later, Alwa – adopted
the Christian faith. The new art which developed around the Christian
creed and liturgy remained, however, Kushitic in style and character and
can be clearly distinguished from Christian art emerging elsewhere. Wall
paintings in churches, architectural elements, ceramic pilgrim bottles,

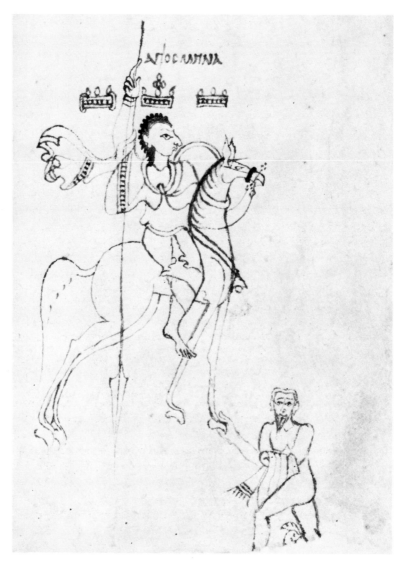

46. Saint Menas on horseback. Found in hills near Edfu, part of manuscript with Old Nubian text; therefore of Nubian origin. *c.* A.D. 1000. Drawing on parchment. 14.9 × 9 cm (5.87 × 3.54 ins). British Library, London, OR 6805. Photo: courtesy British Library.

wooden carvings and parchment manuscripts are some of the many objects found that illustrate Nubia's Christian art [45, 46]. This period came to an end with the Islamic penetration early in the fourteenth century. By that time, astonishingly, the potter's wheel had disappeared from the area, and a new era of fine handmade ceramics with painted and incised decorations emerged.[35]

The Nok Culture

Clay has been formed by man into domestic pottery and sculpted objects ever since he learned to work and fire it. And in Africa, that happened some 8,000–9,000 years ago.[1] The oldest sub-Saharan centre in which sculpted pottery figures have been found is the Upper Nile Valley, where Nubians produced their own art long before Egyptian influence became a factor. From there, it is believed, the art of making ceramics diffused westwards as far as Chad and Tibesti.[2] It may have spread through the Sahara – still verdant at that time – and further south into West Africa. For there, many areas of ancient human occupation have been traced, and potsherds found are evidence that these early Africans had mastered the technique. So far, the most important discovery is that of the terracottas to the west and south of the Jos plateau in northern Nigeria.

In 1928 at Nok, a small mining village, Lt-Col. Dent Young, a partner in a tin-mining company, found some stone implements and a group of terracottas, including images of a human head and foot and of a monkey's head. Later these were given to the newly established museum of Jos. Fifteen years on, in 1943, near Jemaa, a beautiful pottery head [47], which was being used as a scarecrow in a miner's garden, was brought to the notice of Bernard Fagg, at that time an administrative officer and from 1957 to 1963 director of the Nigerian Department of Antiquities. He hypothesized that he was dealing with a single culture, 'Nok', not only because of the geographical situation of the finds but because of their stylistic similarity to the objects already in the Jos Museum.

The archaeological research that followed, supported by 'tributers' (private miners), finally covered an area of 300 miles east to west and 200 miles north to south, in the valley above the confluence of the Niger and Benue rivers.

Erosion in this rocky country had forced tin into alluvial deposits. From there it was recovered in open cast mines, probably for many hundreds of years, and has continued to be extracted by more modern methods in recent times. It may be assumed that masses of archaeological remains, swept there by the force of water from their places of origin, possibly at considerable distances from Nok, were destroyed during the earlier tin-mining operations.

47 (*below*). Head. Nok culture. Found 1943 in tin mine at Tsauni, in hills above Jemaa. Terracotta. Ears, eyes, nostrils and mouth perforated; hollow; three tiers of hair arranged in tresses; disc on forehead. 22 cm (8.66 ins). Courtesy National Commission for Museums and Monuments, Lagos. Photo: André Held.

48 (*right*). Head. Nok culture. Found in tribute mining in sand at depth of about 3.5 metres, north-east of Jemaa. Terracotta. 19 cm (7.48 ins). National Museum, Jos, 57.88.1. Courtesy National Commission for Museums and Monuments, Lagos. Photo: André Held.

The pieces that have come to light during mining and during the prolonged searches – mainly human heads and figures – conformed to the style of the earlier finds, in spite of variations in sub-styles. The pupils of eyes are almost always perforated, set in triangles or segments of circles, with eyebrows stylized and ranging from a half circle to a straight line. The mouths are thick-lipped, sometimes open but rarely showing teeth. The nose is usually broad with perforated wide nostrils; some have elongated bridges. Ears are occasionally of exaggerated size and placed in unnatural positions.

49. Small head with blown-up cheeks. Nok culture. Found in the sump of a gravel pump near Jemaa. Terracotta. Eyes, nostrils and ears perforated. 9.2 cm (3.62 ins). National Museum, Jos, 1948 6.5. Courtesy National Commission for Museums and Monuments, Lagos. Photo: André Held.

Heads have been found of various shapes from spherical to ovoid, with some greatly elongated and angular [50, 51]. And such variations have appeared in a single site. We could be dealing with changes from one time period to another or with different schools of artists. In spite of such diversities, however, there remains throughout a unifying treatment of eyes, noses, mouths, ears and many hairstyles, some of which are still worn by people in the area today.

50. Head, possibly once the handle of a vessel. Nok culture. Terracotta. 10.1 cm (3.98 ins). Australian National Gallery, Canberra. Photo: Horst Kolo.

Figures are shown with decorative dress, male and female pubic coverings, hats and caps [52]. Apparently the people of the culture had no woven textiles but used various knotted or plaited fibres. No shoes or sandals are indicated on any figures found so far.

Much jewellery adorns the sculptures: bracelets, necklets, anklets and beads of various types, but no rings on toes or fingers and no earrings.

51. Elongated head. Nok culture. Found at Katsina Ala. Terracotta. 20.5 cm (8 ins). National Museum, Jos (gift of Tiv Local Authority), 51.24.1. Courtesy National Commission for Museums and Monuments, Lagos. Photo: André Held.

52. Small kneeling male figure. Nok culture. Found in tribute mining at Bwari near Abuja. One of very few complete figures; used as pendant? Solid terracotta. 10.5 cm (4.13 ins). National Museum, Jos, 60.J.2. Courtesy National Commission for Museums and Monuments, Lagos. Photo: André Held.

A number of heads and bodies, depicting deformities or ailments (similar to diseases portrayed in Ibibio masks), may well have been used for magico-medical purposes.

There are zoomorphic heads and figures, including monkeys, elephants and rams; but the greatest number represent snakes of various kinds. The snake is widespread as a cult symbol in Africa, and is often found sculpted on vessels, probably for use in religious cults. Conversion to Islam and Christianity notwithstanding, these cults have survived in many areas of the continent up to the present.

Some Janus figures have also been unearthed, and these, too, were widely used in other parts of Africa. In the mythology of some African nations (like the Dogon of Mali and the Ekoi), they express the male/female duality of human nature.

Most finds have been accidentally made during tin mining, and the use and purpose of the figures (the heads all appear to have been broken off whole figures) can only be guessed. They were rolled and damaged by alluvial washes, and none have ever been found in their original settings, which might have been shrines or graves. Their function could have been connected with funeral ceremonies, ancestor cults or other religious rituals. They might have been conceived as representations of chiefs – though not as their portraits – or as mythical beings and spirits. Ceramic figures are still used today as finials on thatched roofs and on shrines [56], and such a use in antiquity is extremely probable.[3, 4] Others may have served as grave figures like those of the Dakakari[5, 6] or as charms and fertility amulets, possibly worn as pendants. The modelling was always very expert, the figures built up from elements; with head, torso, coiffure, jewellery and other parts being fashioned separately. They were then joined by scoring or key-grooving, and some decorations were added by incisions or by combed, stamped or rouletted impressions.[7] No moulds were used at any time.

The resultant sculptures are very sophisticated and most powerful in facial and bodily expressions. On many sculptures the original smooth surface can still be admired. This was probably achieved by the application of ochre or other slip when the clay was hard, and the surface was then burnished with a smooth object. The size of the figures varies from very small (less than 10 centimetres) to large (125 centimetres in height), and the expertise of the ancient potters extended to the firing of such large figures over an open fire, for no kilns were used. It is possible that the piercing of the eyes, nostrils and mouth was done for technical reasons, to assist in the escape of moisture and to prevent damage to thin-walled clay mouldings,[8] as much as for the expression of aesthetic concepts.

The complete figures all have disproportionately large heads. In nature the ratio of head to body is about one to seven, whereas in Nok sculptures it is about one to three or four. These are the so-called 'African propor-

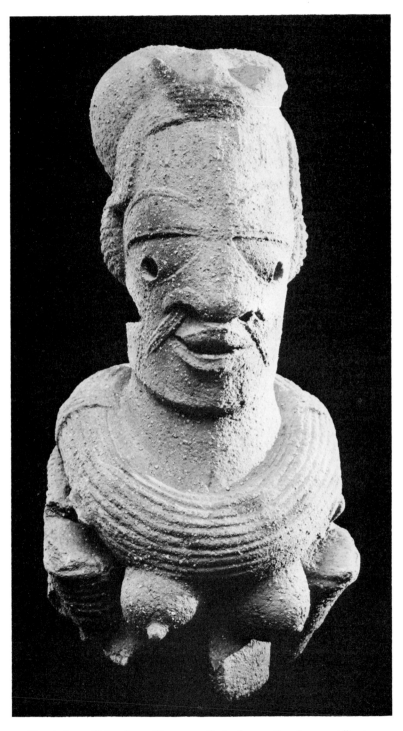

53. Female bust. Nok culture. Terracotta. Snakes? emanating from nostrils. 51.0 cm (20 ins). Australian National Gallery, Canberra.

tions' still used by many tribes and nations; proving that, amazingly, African aesthetic traditions extend over 2,500 years.

The only other known African culture to have produced near life-size pottery figures is that of Ife,[9] which also has other characteristics in common with Nok. Some Yoruba sculptures – and in particular Egungun masks – feature triangular eye shapes and elaborate hairstyles, both

54. Figure of a seated male, possibly broken off a stool. From Yelwa. 2nd–7th century A.D. Terracotta. Eyes and nostrils perforated. 20.5 cm (8.07 ins). National Museum, Kaduna. Courtesy National Commission for Museums and Monuments, Lagos. Photo: André Held.

55. Female seated on upturned pot. Nok culture. Found in tribute mining near Jemaa. Terracotta. 32 cm (12.6 ins). National Museum, Jos, N 806. Courtesy National Commission for Museums and Monuments, Lagos. Photo: André Held.

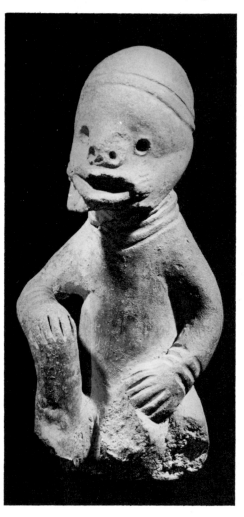
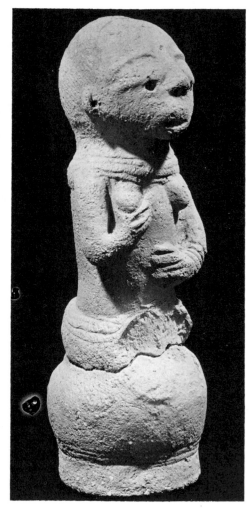

56. Roof finial in form of female figure with head of ape. Gwari (related to Nupe). Northeast Nigeria. Age unknown. Terracotta. 45 cm (17.72 ins). Musée Barbier-Müller, Geneva, 1015/6. Photo: courtesy Musée Barbier-Müller.

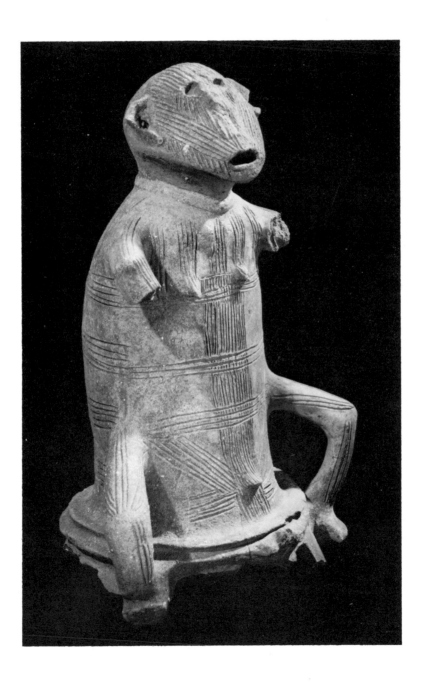

comparable with Nok. The Jemaa head has a disc on the forehead like two Ife terracottas from Ita Yemoo; and limbs or trunks, found as fragments, are almost indistinguishable in the two cultures. The treatment of hems of garments is similar in Ife and Nok sculpture; heavy beads are used in similar arrangements, and so are geometrically stylized heads. Pierced eyes and nostrils, so typical of Nok sculpture, are also noticeable in some Yoruba wood carvings of our time; but the chronological gap in the case of the Yoruba is too great to justify theories of connection.

The dating of the Nok sculpture by carbon 14 and thermoluminescence has produced a consensus of opinion that fixes the period of the culture from 500 B.C. to A.D. 200. As Nok is a highly developed and sophisticated art, it must be concluded that it derived and developed from much earlier ceramic traditions in the area.

Nok is not only the oldest known culture in western Africa to have created sculpture, but may very well have been – though this is still disputed – the oldest sub-Saharan culture to have produced iron in smelting furnaces; and earlier in this than Meroë and Egypt.[10]

As the theory that attributed the diffusion of iron-smelting technology from Meroë is now doubtful, the question arises of how and from where the knowledge may have come to Nok in the middle of the first millennium B.C. Given the intricacy of the process and the high temperature required in smelting, it is most unlikely that the Stone Age people of the Jos plateau discovered it by themselves. It may be assumed that the technology reached them from the north, where the Berbers had possibly learned it from the Carthaginians, whose founding fathers, the Phoenicians, must have brought it to North Africa from the Middle East.

During tin prospecting in 1960 in the Taruga Valley, a non-alluvial site, two headless female figures were discovered; and in the course of trial excavations, objects made of wrought iron, iron slag, domestic pottery and some charcoal were also found. Carbon 14 tests gave readings early in the third century B.C.,[11] and in later excavations further radiocarbon tests yielded datings in the mid fifth century B.C. In the search for evidence of iron smelting, a proton magnetometer was used. This led to the discovery of twenty concentrations of iron slag, many of which contained the structures of furnaces in their original positions;[12] and here a charcoal sample, found below the slag, yielded a date of 300 B.C. ± 100.

Archaeological evidence from the area stretching from Kagara in the north to Katsina Ala in the south, Jemaa in the east and Abuja in the west, suggests that the Nok culture terminated about A.D. 200. But at Yelwa, situated to the north-west of Abuja, terracotta sculptures dated to the second to seventh century A.D.[13] were found, of which at least one appears to be in a late Nok style [54]. As Yelwa and Ife are about equidistant from Abuja, a cultural link between Nok and Ife is credible – geographically, chronologically and stylistically.

The Kingdoms of the Western Sudan

In the territories which constitute today's states of Senegambia, Maure-tania, Mali and Burkina Faso, there developed an early African civiliza-tion which produced a West Sudanic culture, with distinctive art styles. Although some ethnic groups belonging to this culture migrated from their original habitats, stylistic features which had developed in antiquity can be recognized in art produced well into the twentieth century.

There are some data on post-palaeolithic and neolithic occupation, and one report[1] on excavations in the Tilemsi Valley (in the north-east of the great bend of the Niger) records finds of large quantities of domestic pottery with rouletted and dragged-comb designs. It also mentions and illustrates terracotta figurines, both anthropo- and zoomorphic, as well as clay cylinders possibly made for ritualistic uses. Five radiocarbon dates establish the age of these artefacts as from 2010 B.C. \pm 160 to 1670 B.C. \pm 80. Here is proof that the story of art in this part of Mali goes back to very ancient times indeed.[2]

As there is no written record of indigenous origin, our sources for the history – and, in particular, the art history – of the region are thin and often unreliable. Historical records start with the arrival of the Arabs in North Africa; and the first mention of Ghana, the oldest West Sudanic empire, was made late in the eighth century A.D. in the writings of el Fazari, an Arab geographer.

Ghana may have been preceded by the legendary Wagadu, a kingdom said to have been founded by the Soninke, who were northern Mande people with a long record of contact and trading with the North African Berbers.[3] At the time of the islamization of the north which started in the eighth century A.D., Ghana was already a powerful kingdom with its capital at Kumbie (probably Kumbie-Saleh). The divine Ghana or king, according to Arab chroniclers,[4] held court in splendid robes with gold ornaments, his horses' hooves were worked in gold, ivory and silver, and his retinue carried shields and swords embossed with gold. This is one of the infrequent references to visual arts; but, alas, no physical evidence of such robes, adornments and weapons has been preserved or found to date. These chronicles also mention the king's domed pavilion; but neither this description nor the remnants of such buildings on the sites of

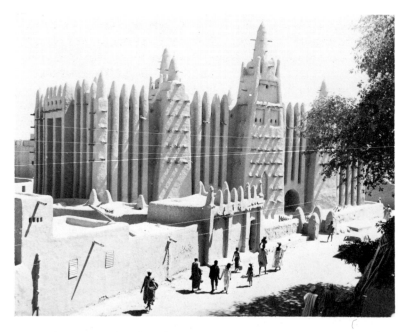

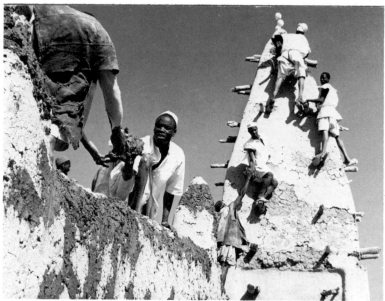

57 (*above*). Great Friday Mosque, Mopti. Built of unbaked clay without reinforcements. Photo: Marli Shamir.

58. Repairs to a village mosque. Photo: Marli Shamir.

ancient cities give us any idea of shape, style or construction of pre-Islamic architecture in the area. There are, of course, ancient mosques and other buildings, in Mopti, Jenne, Timbuktu and various other towns, still extant in typical Sudanic-Islamic style [57, 58, 59]. The great mosque of Jenne dates back to the fourteenth century, though repairs of the mud walls have had to be carried out regularly.[5] The main mosque of Timbuktu is the oldest surviving in the Western Sudan, probably dating back to the twelfth or thirteenth century, though also regularly restored.

59. Private house, Jenne. Photo: Marli Shamir.

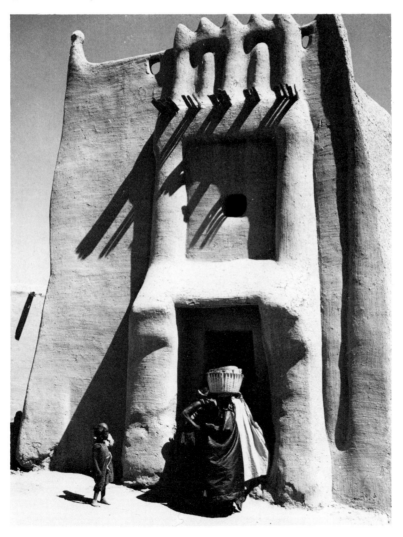

It is now believed that this highly developed state of Ghana which the Arabs found and described was established several centuries earlier, possibly at the beginning of the Christian era.

The Soninke were sedentary agriculturists in an area benefiting from good rainfall and a favourable climate. But the wealth of the Ghana kingdom was based on a trans-Saharan trade in gold and ivory, against imports of salt and other commodities in demand in the Sahel, the Savanna, and the forests to the south. Trade in slaves, grain and a variety of other commodities is presumed to date back to exchanges between Berbers and black Africans of the West Sudan starting about 2000 B.C.[6] Later, perhaps from 1000 B.C. to the sixth century A.D., the first organized West Sudanese states or kingdoms were founded and continued that trade. With the rise of Ghana, the bartering of gold, ivory and salt became the monopoly of the king, who collected taxes on all imports and exports that passed along the caravan routes through his territories. One commodity which became a major import from the north was copper, used for the casting of regalia and other artefacts for personal prestige.

The control of the caravan routes, the key to the wealth of the West Sudanic states, motivated the invasions by the Almoravid Moslems. Wars with several neighbours led to the downfall of Ghana, and it was succeeded by the empire of Mali, which extended the borders of its predecessor very considerably.

Mali, a state ethnically based on Manding and Malinke elements, produced a number of great warrior kings who embraced Islam, possibly to improve relations with their trading partners to the north. The greatest of these kings was Mansa Musa who ruled from 1312 to 1337. Apart from his military successes and the physical growth of his Sudanic empire, he also created a well-organized society 'in which neither the man who travels nor he who stays at home has anything to fear from robbers or men of violence'.[7] The borders of the state now extended to the Atlantic in the west, to Gao in the east, to the approaches of the rain forests in the south, and to the Sahara in the north.

By the capture of Gao, Mali took possession of a key town in another West African state, the Kanem-Borno empire. And at the height of its power, Mali also conquered Timbuktu, the great Islamic centre. Mali was now treated as an equal by the North African states, the kingdom of Portugal and other Mediterranean countries. Its decline began in the mid fifteenth century under pressure from the Tuareg and from the Songhai under their Sunni dynasty. The great leader Sunni Ali came to power in 1464. Under him and his successors, Askia and Askia Dawud, Songhai expanded further to the west and east, invading the Hausa states and occupying Kano before collapsing at the end of the sixteenth century.

These historical data, some of which can be corroborated by other written records, are mentioned in the extensive chronicles of Arab geog-

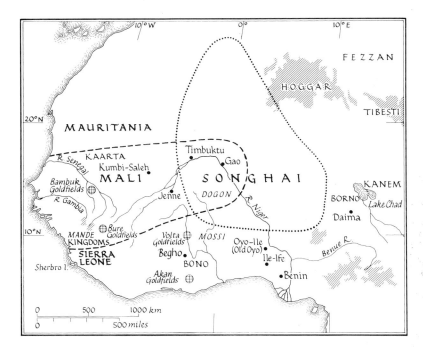

6. The empires of Mali and Songhai.

raphers, merchants and explorers. Unfortunately, such observers have little to say about the visual arts of the West Sudanic nations. They – like many European travellers after them – seem not to have even noticed the existence of sculpted objects or described them simply as 'idols' or 'ridiculous bird-like masks'. But their stories of cities and architecture, events at the royal courts, burial rites of kings, chiefs and common people, served as leads for archaeological investigations which started in the 1920s and have been proceeding ever since.

In what is best described as the Inland Delta, where the Niger makes its great northward bend, an exciting find was made in 1940 of a terracotta figure 30 centimetres high, representing a kneeling woman, which is now in the Ifan Museum at Dakar. The figure, found in the vicinity of Jenne, is so close to the Dogon style that, when exhibited in the Kunsthaus at Zürich in October 1970, it was grouped with the Dogon; not surprisingly since Jenne is, after all, situated at the edge of Dogon country. Since then a considerable number of terracotta sculptures, similar in style, have been found in the area between the towns of Jenne and Mopti by local farmers and European collectors. These were all surface finds in the mud of the Inland Niger Delta, and there are practically no scientific data available on the exact place or area of these discoveries, nor on their age in

stratigraphic context. Some of the sculptures so collected were tested by thermoluminescence, and dates ranging from the ninth to the seventeenth centuries were obtained.[8]

Then, in 1977, Roderick and Susan McIntosh undertook the first controlled archaeological excavation near Jenne-jeno (old Jenne).[9] They found a statue in a kneeling position that corresponded in style with the majority of the Jenne figures previously discovered. Radiocarbon tests at the mound in which the excavations were undertaken showed that the area had been continuously occupied for over 1,000 years and had been abandoned about A.D. 1500. According to the McIntoshes, this implies that the urban dwellers of Jenne-jeno witnessed, and possibly contributed to, the rise of the great empire of Mali. The rise and fall of ancient Ghana occurred within the same time-span. This is the first confirmation that Jenne art was produced during the period of the West Sudanic empires, a fact of great art-historical significance. For the statue and several other objects of pottery, a radiocarbon dating of A.D. 1150 ± 140 was obtained.[10] There is, therefore, a two out of three likelihood that the date when the objects were placed in the pit from which they were excavated falls somewhere between the years A.D. 1000 and 1300.

There are several theories on the purpose and use of these figures; probably differing for the various types of statues found. The figures themselves may be divided into seated, kneeling and standing anthropomorphic sculptures. They are shown in varying poses: hands on knees, on shoulders, or on the head, bodies smooth or covered with clay pastilles, equestrian figures and huntsmen. Among the zoomorphic figures there are monkeys, lizards, dogs, birds, fish and – by far the largest number – snakes, by themselves or as an intrinsic part of sculptures representing humans. Stylistically, the anthropomorphic images may be grouped into two main types. The first, said to have been found in the area of Jenne-jeno, has chins jutting out expressively and heads generally one third of the whole body [60]. The other type, reported to originate from around Bamako and Segou, is termed by de Grunne[11] the 'Bankouni' style. Figures so classified have an elongated cylindrical body and usually a round head of almost natural proportions [61].

Within these two categories there are considerable variations, indicating a number of different artists or schools. Much more archaeological and ethnographical work is required to arrive at a proper stylistic classification.

In the iconography of the Jenne figures, the snake predominates. This image is not unusual in African sculpture in general, and is a major feature in the art and cosmology of the neighbouring Dogon. In the case of the Soninke, the frequent use of snakes enveloping bodies, or decorating vessels, is linked to the nation's primordial myth. Maghan Diabe, the reputed founder of Wagadu and builder of its capital Kumbi-Saleh, made a pact with the legendary snake Bida that the most beautiful virgin would

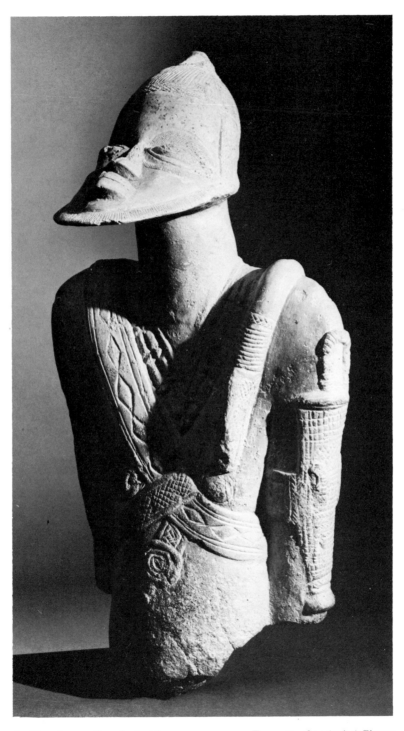

60. Bust of a man. From Ancient Jenne. A.D. 1300–1400. Terracotta. 38 cm (15 ins). Eleanor Clay Ford Fund, Detroit Institute of Art. Photo: courtesy Lance and Roberta Entwistle.

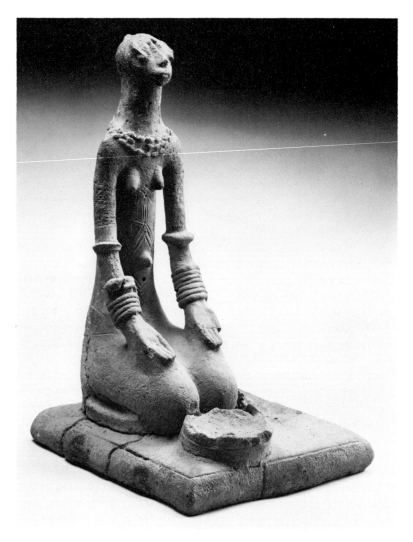

61. Kneeling woman. Bankouni style. Terracotta. 63 cm (24.8 ins). Collection Baudouin de Grunne. Photo: Roger Asselberghs.

be sacrificed to it every year at harvest time to ensure rain and fertility. Oral tradition tells of a magician who had fallen in love with a virgin about to be sacrificed and killed the snake Bida in order to save her. This, it is said, led to a seven-year drought and the moving of the clan to the area of Jenne-jeno.[12, 13]

The sacrifice of a virgin is also said to be connected with the dangerous floods in the Inland Delta of the Niger. To protect buildings against such flooding, a virgin was said to have been immured alive in the foundations.

Possibly virgins were later replaced by terracotta figures; and, in fact, two pottery torsos excavated by the McIntoshes were found near the foundation of a brick building.[14] But in the description of their excavations in 1977, the McIntoshes also suggest that the complete kneeling figure found below the surface may have served an ancestor cult. They base this assumption on Monteil's description[15] of 'ancestor altars' in the entrance to houses in Jenne, where a 'human representation' of the ancestor to which sacrifices were made was placed.

The use of some pottery statues in connection with funerals is also possible. That theory remains uncorroborated. Yet funerary vessels containing food have been found, which leads to the belief that – as in other civilizations – the dead were given not only food but possibly also wives and servants, in the form of pottery images, to accompany them on their way.

Apart from the numerous figures and other objects made of clay, a certain number of brass castings made by the lost wax technique were found in the area. In some cases iron was used to mount bronze objects or for other secondary purposes. No sculpture made of iron has so far come to light, and no wooden masks or statues have survived. Masks, however, were used by the people of the Inland Delta at the time of the Mali empire, when they were worn by musicians and dancers performing before the king.[16]

Such is the short historical and anthropological background to an exciting body of art, ranking with the art of the great African civilizations. It has a very distinctive style, although there are geographical and chronological variations. In many cases, the hand of a single great artist or a local school of artists can be distinguished.

The kneeling figures have been stylized in an astonishing way. The body leans back slightly, the thighs and legs forming the base, with the legs often only indicated by a dividing line. Arms are crossed and hands rest on the shoulders or are lifted and touch the head; other figures have hands resting on their knees. There are a few sculptures of couples with the hands of the seated male placed protectively on the shoulders of the female kneeling in front of him [62]. In the faces of many figures, seated and kneeling, the artists were able to express strong emotions – fear, compassion, anguish, serenity, tenderness.

The embracing couple [63] is a masterpiece in formal concept and rhythm: knees touching, legs (as so often, just indicated) in a straight line, the bodies forming a triangle, and faces cheek to cheek. The medium being clay, shaped by hand, the artists created sculptures in asymmetrical postures with a sense of movement very different from the rigidity that characterizes the majority of African wood sculpture.

The equestrian figures, too, are full of movement and rhythm. The rider is larger than his mount, which in the illustrated example [64] turns

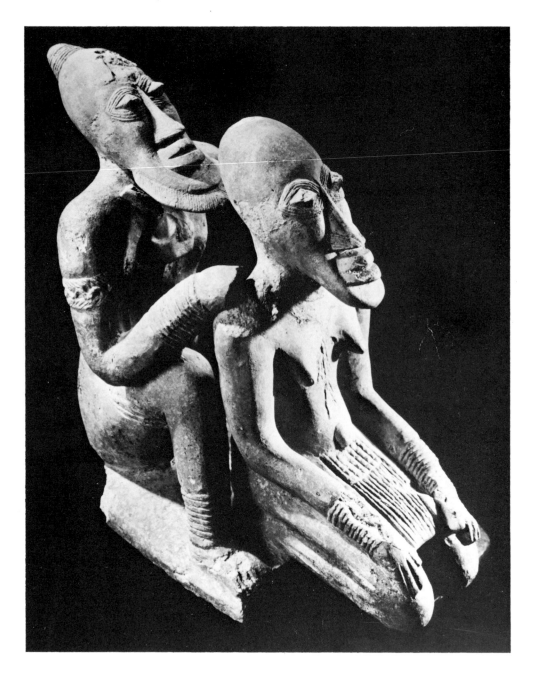

62. Two figures. From Ancient Jenne. 11th–13th century A.D. (Oxford 281 h 57.1). Terracotta. 24 cm (9½ ins). Ex collection Lance and Roberta Entwistle. Photo: courtesy Lance and Roberta Entwistle.

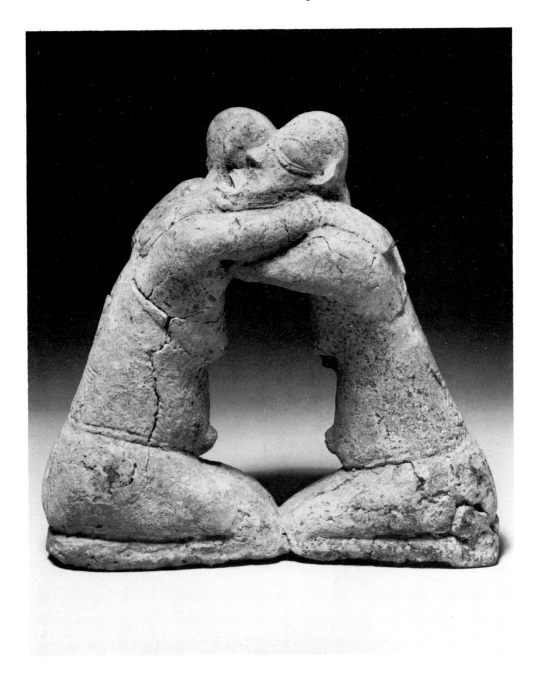

63. Embracing couple. From Ancient Jenne. 13th-15th century A.D. (thermoluminescence test). Terracotta. 19 cm (7½ ins). Stanley Collection. Photo: courtesy Mr and Mrs C. Maxwell Stanley.

its head curiously sideways. Sculptures of mounted riders occur in the Western Sudan among the Senufo, Dogon [65; compare with 66] and Bamana but are also well represented elsewhere, as in the Cameroon (mostly astride animals other than the horse), in Benin and Yoruba art. The meaning and use of these equestrian figures, like the rest of the Jenne sculpture, is unknown, though a number of theories have been advanced. During their wars of expansion, the Sudanic empires developed their

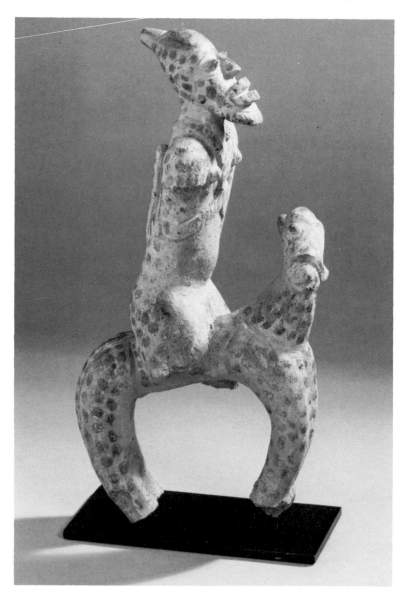

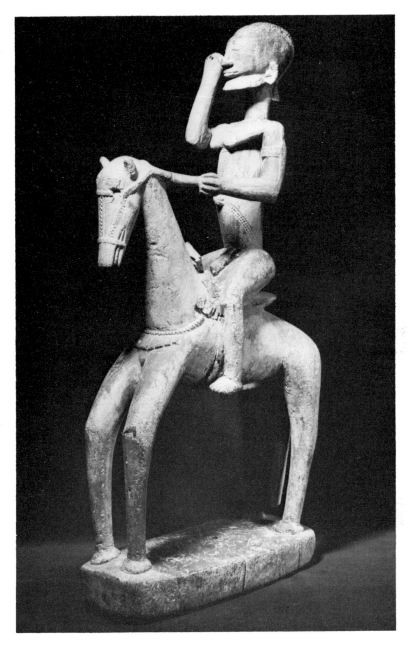

64 (*left*). Equestrian figure. From Ancient Jenne. Terracotta. 24.3 cm (9.75 ins). Courtesy Indiana University Art Museum. Photo: Ken Strothman and Harvey Osterhoudt.

65 (*above*). Equestrian figure. Dogon. Mali. Wood. 82 cm (32.28 ins). Collection Henri Kamer, Cannes. Photo: André Held.

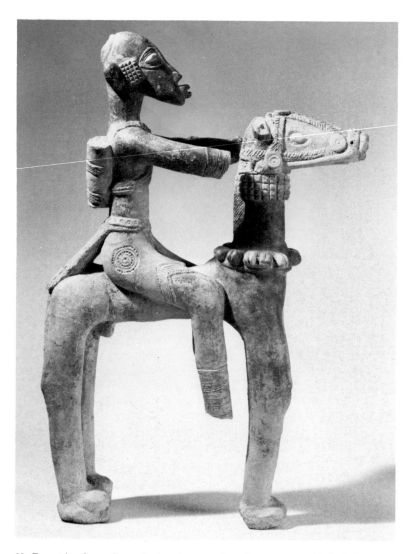

66. Equestrian figure. From Ancient Jenne. 12th-14th century A.D. (Oxford 281 S 39).
Terracotta. 66 cm (26 ins). Australian National Gallery, Canberra. Photo: Horst Kolo,
courtesy Entwistle, London.

cavalry into a formidable fighting force. The statues may be commemor-
ative figures of particular heroes or of victorious battles; or they may have
been memorials to chiefs whose status would have been enhanced by
being portrayed seated on a horse. There are figures of hunters standing
with quivers on their backs, shackled prisoners, maternity groups, repre-
sentations of snakes (on their own or as part of human figures) and of
many animals such as dogs, horses, birds and fish.

Very little is known about the artists of these astonishing works, except that they were members of separate occupational castes called *myamakala*. To these belonged the *dyeli* or bards (*griots*), the smiths (makers of arms and masters of magic and divination), and presumably other artists, all of whom were officials at court, enjoying the emperor's confidence. They were feared, and yet they were at the same time considered inferior and despised by the nobility and freemen.[17]

The potters in today's Mali are women, but there is no record to indicate whether the terracotta figures of ancient times were made by female or male artists.

Bronze or brass castings are rarer than pottery figures. Among pieces found there are anthropomorphic and zoomorphic sculptures (some of which are mounted on iron staffs), miniature masks [67], pendants and

67. Miniature mask. From Ancient Jenne. Bronze. 8 cm (3.15 ins). Collection Baudouin de Grunne. Photo: Roger Asselberghs.

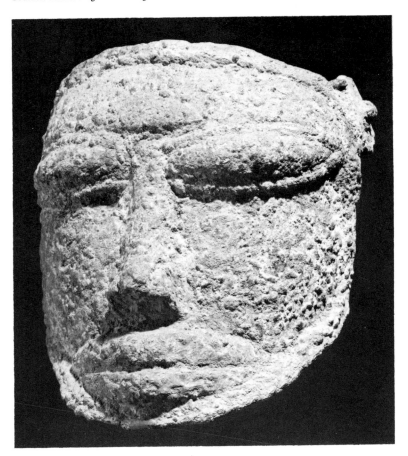

jewellery. Of the latter, very few examples have so far been found, though adornments of bracelets, anklets, necklaces and pendants are widespread on both male and female pottery figures.

Mention should also be made that some body art, at least in the form of scarifications (often cross-hatched lines and squares or lozenges on the temple), existed at the time of the West Sudanic empires and was used until recent times in Dogon wood carving.

68. Pendant depicting a seated male with a snake undulating from throat to abdomen. Dogon. Mali. Bronze. 5.5 cm (2.16 ins). Musée Barbier-Müller, Geneva. Photo: courtesy Musée Barbier-Müller.

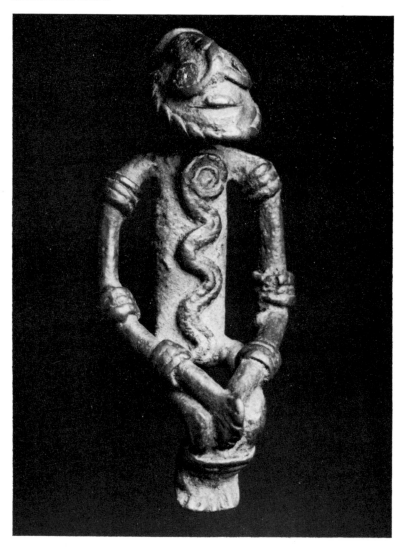

Similarities in style, iconography and decorative motifs point to a close relationship between conquerors and conquered, traders from closely related tribes and nations, and with itinerant artists. This brought about an acculturation which makes it possible to speak of a common heritage in the art of the Western Sudanic peoples, which include the Bamana and a group of Voltaic peoples.

Towards the end of the seventeenth century the Bamana (or Bambara, as they are often – but incorrectly – called), who had been paying tribute to the king of Songhai, cut their links with the dying empire and founded their own states: Segou and Kaarta. These quickly expanded to conquer Jenne and other cities in the Western Sudan, until they in turn were defeated by the Fulani in the middle of the nineteenth century. A British geographer, Mungo Park, visited Segou in 1799 and found there 'a prospect of civilization and magnificence, which I little expected to find in the bosom of Africa'. The 'view of Kamalia' from his book shows the architecture of a Bamana town or village which has changed little. Bamana art has an easily recognizable style of its own.

The Soninke, who founded Ghana, and the Manding, associated with the successor state of Mali, are ethnically and geographically related closely to the Bozo, the Marka and other Mande tribes. The inhabitants of the empires and of the modern state of Mali, with neighbouring Moslem states, also contain strong elements of Fulani, Dyula and Berber people. These all contributed to, and were in turn influenced by, the civilization of the ancient Western Sudanic empires.

The Dogon are said to have arrived in the area of Bandiagara, west of Mopti and of the Inland Niger Delta, in the fifteenth century. Oral traditions vary as to the location from which their forefathers migrated to their present habitat. While one version puts their origin in Mande country, to the south-west of Bandiagara, another insists that they came from the north-west, or roughly the region where the Soninke founded their empire of Ghana. The cause of their migration might have been drought, or the emergence of Islam and the onslaught of warlike neighbours. They found a welcome fortress retreat in the high cliffs of Bandiagara, where they discovered an existing population called the Tellem, who arrived in the Sanga region in the eleventh century,[18] fleeing from the fierce Almoravid *jihad*.

The Tellem are thus not, as was previously assumed, the ancestors of the Dogon but a separate nation. According to the findings of five Dutch scientific expeditions, the art of the area may be divided into three chronological groups:

(a) The art of the Tellem, 11th–15th century A.D. [69]
(b) The mixed art of the two peoples, 15th–17th century A.D. [70]
(c) The art of the Dogon proper, from the 18th century onwards.

By this time the Tellem had disappeared. Their numbers, according to

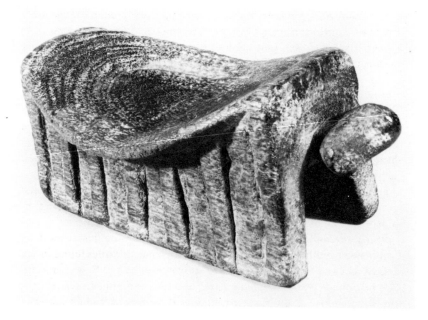

69. Neckrest in the shape of a turtle. Tellem. Mali. 11th–12th century A.D. Wood. Length 22 cm (8.66 ins). Musée Royal de l'Afrique Centrale, Tervuren. Photo: courtesy Musée Royal de l'Afrique Centrale.

70. Neckrest. Tellem/Dogon. Mali. (?) 15th–17th century A.D. Wood. 14.5 cm (5.7 ins). Musée Royal de l'Afrique Centrale, Tervuren. Photo: courtesy Musée Royal de l'Afrique Centrale.

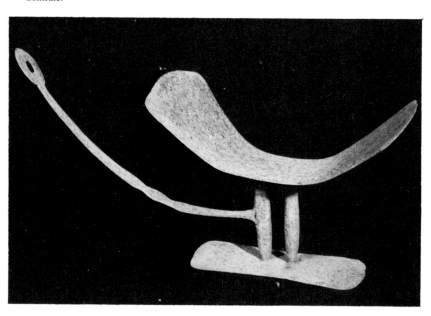

physical anthropological studies by a Dutch group,[19] gradually decreased; and towards the seventeenth century, the process of their extinction was, apparently, complete. These findings rule out the local tradition according to which the Tellem left Bandiagara in the fifteenth century and, migrating to an area in Upper Volta, became the ancestors of the Kurumba. The radiocarbon tests of Tamara Northern on thirty statues of the Tellem/Dogon types[20] have never been published; and their application to determining Tellem or Dogon origin by stylistic criteria must, for the time being, be ignored. Only sculptures which can be reliably dated to the eleventh to fifteenth centuries should be ascribed to the Tellem culture.

However, Tellem/Dogon styles, developed in the period and in the territories of the Sudanic states, have the imprint of Jenne culture as well as many common iconographical trends.

In the development of all Sudanic cultures, there were influences from many close neighbours and more peripheral people. Textiles found in the Tellem caves at Bandiagara were probably woven by the Fulani or more correctly by the Mabube, a caste attached to the settled Fulani. Archaeological dating puts these pieces of cloth in the eleventh to the thirteenth century or earlier.[21, 22, 23, 24]

Pottery, especially footed bowls, was made by the Tellem in the eleventh and twelfth centuries. Such bowls have also been discovered along the Niger from Timbuktu to Niani, where the oldest was dated to the seventh century. Others found in the Buguni area date from the eleventh to twelfth century. The fact that such ceramic bowls were located in Begho, north of Asante country, is due to trading contacts from about the fourteenth century onwards.[25]

The Dogon, concentrated in Mali for hundreds of years, have been grouped with the Voltaic people for linguistic reasons, as have the Senufo (also called Siena), who are now dispersed over a wide area in Mali, Burkina Faso and the Ivory Coast.

The Senufo are believed to have come to their present areas, some 200–300 years ago, from the north. Their northernmost outpost today is in the area of Koutiala, due south of Jenne and south-east of Segou, which could mean that they came from the Inland Niger Delta, or from north of it, and would thus have been part of the development of the West Sudanic culture. Their blacksmiths, who also carved the wooden masks and figures, were members of a separate caste, as is the case with the Dogon and other Sudanic people. The snake, the turtle and the crocodile are common denominators in the iconography of Jenne, Dogon and Senufo art, and the cosmological or mythological stories of these peoples have great similarities. Stylistically, some Senufo sculpture of the recent past – nineteenth to twentieth century – reveals a clear relationship with Jenne features. If we compare the head of a Senufo rhythm pounder[26] with that

of the Jenne equestrian figure [66], the common past and related culture become undeniable. Thus we are able to link yet another group, the Senufo, to the culture of the West Sudanic kingdoms, by virtue of chronology, geography, iconography and style.

The Mossi, a warlike people, said to have come to their present territory from the south, founded two empires during the fourteenth and fifteenth centuries.[27] These were divine kingdoms constituted in a manner similar to the Sudanese empires. One of these Mossi kingdoms was centred on the Yatenga region and the other around Wagadugu, the heart of what is today Burkina Faso. In wars of conquest and widespread raids, they caused many peoples, including probably the Dogon, to flee to other regions.

This was not the case with the Kurumba, who live in the northern Yatenga region, with centres around Belehede and Aribinda. They stayed behind and were recognized by the invading Mossi as 'Nioniossi' or 'the settled people', which acknowledged them as masters of the land. It appears that the ancient Mossi did not at first create much art themselves, but that Kurumba blacksmiths created Mossi masks and other objects for ceremonial use or as royal or chiefs' regalia. However, there is sparse documentary evidence for this; and in more recent times, the Mossi of the Wagadugu area did carve masks and other artefacts in the Kurumba style. This happened at a time of close geographical proximity, and each group later developed more individual characteristics in their sculptural creations, influenced by new neighbours or by peoples whom they conquered. In this way Mossi styles emerged in Wagadugu and Bursa.[28]

In the northern part of Burkina Faso, in Yatenga province to Aribinda in the north-east, the Kurumba had their own state, called Lurum, which was established in about A.D. 1350.[29] Finds of stone sculpture and the research[30] into these and the stone stelae marking the tombs of notables have added to our knowledge of the art history not only of the Kurumba but of a number of people who live – or lived – in their proximity. But after the arrival of other clans in about 1540 – the reference is usually to a family in the Aribinda area called Konfé – the Kurumba, as 'Nioniossi' and rulers over the land, assumed responsibility for its fertility and the well-being of the people. They were the keepers of the masks which gave them the help of the spirits, while the Konfé became the political rulers and provided the chiefs (Ayo).

Kurumba tradition tells of a move to Giou where, in association with other Nioniossi living there, they created a new state, 'Lurum II'.

Nioniossi stone sculptures have been dated on the basis of oral history, with corroboration from the estimated age of stelae on the tombs of rulers (for each reign, a period of twenty years was assumed). The sculptures were owned by individual families or clans, as were the masks. There is, in consequence, a structural or stylistic relationship between the masks,

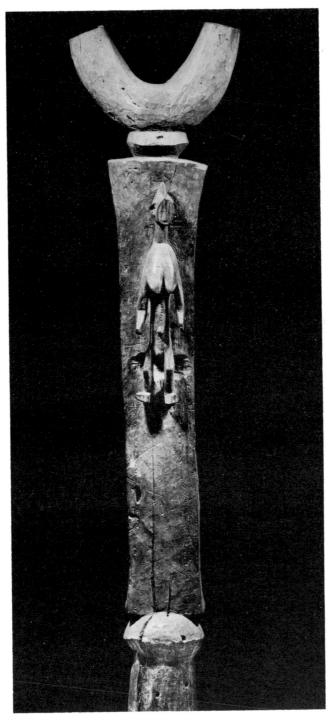

71. Shelter support. Mossi. Burkina Faso. Wood. 173 cm (68.1 ins).
Musée des Arts Africains et Océaniens, Paris. Photo. André Held.

72. Hunter's or warrior's tunic. Dagomba (neighbours of Mossi). Burkina Faso. Cotton, amulets, chains. 90 cm (35.4 ins). Museum für Völkerkunde, Berlin. Photo: André Held.

the sculptures and the tomb stelae. The stone figures of the Oueremi family show characteristics of the family masks,[31] and the tradition of the style appears to go back to the earliest known time of the Kurumba people. Schweeger-Hefel states[32] that in accordance with all the research and interpretations of material and oral evidence, masks similar in form to those of quite recent times were already being made around A.D. 1330, and a Janus figure shown in her book[33] may well be the prototype of Kurumba masks.

Another sculpture in the same book[34] is in the shape of a double phallus and served as grindstone or grater in some ritual context (instruments used for everyday purposes would not have been sculpted). Here again are elements seen in masks of recent times[35] which are also apparent in

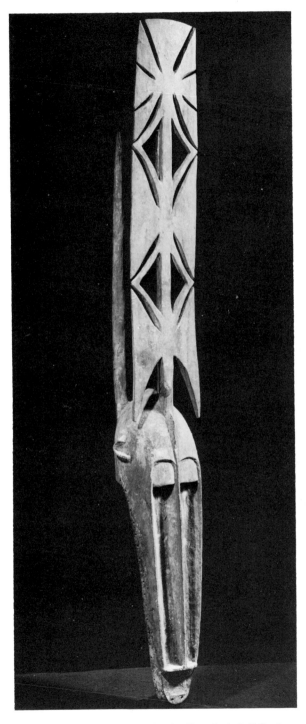

73. Mask. Bobo. Burkina Faso. Wood. 188 cm (74 ins). Collection
Dik, La Tour-de-Plitz. Photo: André Held.

the stone stelae.[36] With the exception of the phallic sculptures, the stone figures and stelae are abstract or symbolic representations of the deceased and fulfil the same purpose as the family masks: to provide a home for the soul – 'that which returns' – and to avoid the ultimate death, that of being forgotten.[37] Though the best-known masks of the Kurumba are the lovely antelope headdresses of the Aribinda and Belehede area,[38] the majority of Nioniossi masks consist of an abstract face mask with a stele-like superstructure.

A comparison with the masks of other Voltaic/West Sudanese people

74. Two bronze pendants in form of snakes, and ivory pendant. Lobi. Burkina Faso. Bronze pendants: *left:* 7 cm (2.75 ins); *right:* 8.5 cm (3.35 ins). Ivory pendant 16.7 cm (6.57 ins). Collection G. and K. Anschel, London. Photo: Horst Kolo.

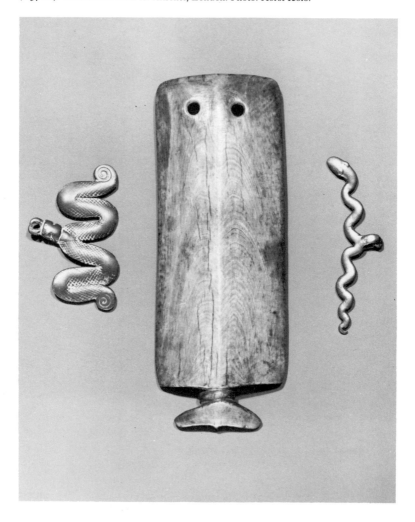

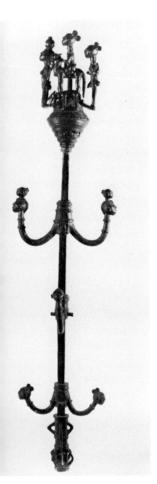

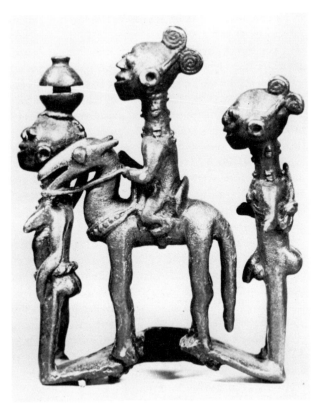

75 a and b. *Sono* staff. From Guinea-Bissau. Bronze. 65.5 cm (25.8 ins). Museo Nazionale Preistorico Etnografico 'L. Pigorini', Rome. Photo: courtesy Museo Nazionale Preistorico Etnografico 'L. Pigorini'.

produces striking stylistic and iconographic similarities. The Dogon 'Great Masks', the Sim, Satimbe, Kanaga and others, are all basically schematic faces with board-like superstructures.[39] Some Senufo headdresses[40] are constructed like the 'Flügelmaske' of the Kurumba,[41] and the use of the antelope on both Bamana and Kurumba headdresses also points to cultural contacts or relationships between these nations. However, the closest inter-relationship and acculturation appears when we compare the Kurumba stelae masks with those of the Dogon, the Gurunsi, the Bobo, the Bwa (one of several Mande groups in the area) and the Mossi.[42] The constant movement of peoples, whether caused by conflict

or by climatic conditions, clearly led to the intermingling of styles and iconography from many tribes.[43]

Along the western Guinea coast, the influence of such movements on art styles is evident. In Guinea-Bissau, the presence of Manding people was recorded by the Portuguese in the sixteenth century; and the carvings of the Baga, who came there about that time, show an affinity with Bamana art. Other migrants from the north-east, known as Soninke by the Fulani, brought with them their knowledge of metal-working; and either they themselves or their indigenous pupils, the Pajadinc and the Beafada, produced staffs called 'sono' made of iron and brass [75]. Although such sculpture has been in the Pigorini Museum in Rome since 1885, nothing much was known about sono until da Mota published his discoveries, made in the fifties and sixties during fieldwork in Guinea-Bissau.[44] The staffs were the regalia of Soninke kings and chiefs during the time of the West Sudanic empires, and may also have been used for religious purposes by the pre-Islamic Manding.[45] The art may have spread to Sierra Leone, or sono may have found their way there from Guinea-Bissau. Such assumptions are based on da Mota's discoveries, in the vicinity of Ro-Ponka in Sierra Leone, of very similar bronze sculptures. These are said to have been used by the Portuguese in the seventeenth century as gifts to Bulom kings.[46] But they actually originated in the West Sudanic empire ruled by northern Mande people. In this connection, Bassani[47] points to the inventory description of the sono in the Museo Nazionale Preistorico Etnografico 'L. Pigorini', which includes this attribution: 'It is of Manding workmanship, a tribe of the western African coast.' The depiction of equestrian figures on most known sono is an iconographical link with the Jenne, Dogon and Bamana. Such links can also be seen in the elongated figures, the treatment of ears as raised circles, and the shapes of buttocks and breasts similar to some Bamana sculpture from the Segou district.[48]

The Art of the Sherbro, Bulom and Kissi

The ancient inhabitants of the areas of Sierra Leone and Guinea belonged to the West Atlantic Coastal forest culture. They include the Sherbro and the Kissi, who may well have arrived in their present habitations as early as the thirteenth century, developing advanced methods of agriculture and in particular the cultivation of rice in the swamplands. There is very little reference to them in early chronicles, as even Portuguese contacts in the fifteenth century were restricted to points along the coastal strip. Invasions of Mande-speaking people strengthened the domination by the ancient Ghana and Mali empires of trade routes west and southwards, and dislodged the Kissi, Bulom, Sherbro and Temne. These pressures increased in the mid fifteenth century with the arrival of the Portuguese and the consequent growth of trading opportunities. Then, in about 1540, Mande warrior bands invaded from the south-east;[1] and finally around 1650 the Mende advanced from the east, effectively separating the ethnically related Sherbro and Kissi. The former now live on Sherbro Island and a narrow coastal strip to its east, while the Kissi occupy an area to the north-east bordering on Toma country. The Bulom are on the mainland of Sierra Leone.

Two stone figures, called *nomoli*, made of chloride-schist, commonly known as steatite or soapstone, were dug up in 1883 on Sherbro Island. They were acquired by the British administrator T.J. Alldridge, who published the first report on such figures,[2] large numbers of which have since found their way into museums and private collections. Other steatite sculptures, known as *pomtan* (singular: *pomdo*) and originating mainly in the Kissi areas of Guinea, were also widely collected [76,77,78]. It is generally assumed that the *nomoli* and *pomtan* are the work of the ancestors of present-day Sherbro or Kissi, although some experts contend that they were made by unknown and more remote inhabitants of the area. Person, who wrote a thorough historical analysis on the subject,[3] thinks that at least the Kissi form part of the oldest population and that their art survived until quite recently in Kissi country.

Although the greatest concentration of *nomoli* was unearthed in central Sierra Leone and of *pomtan* in Kissi areas of Guinea, both types have

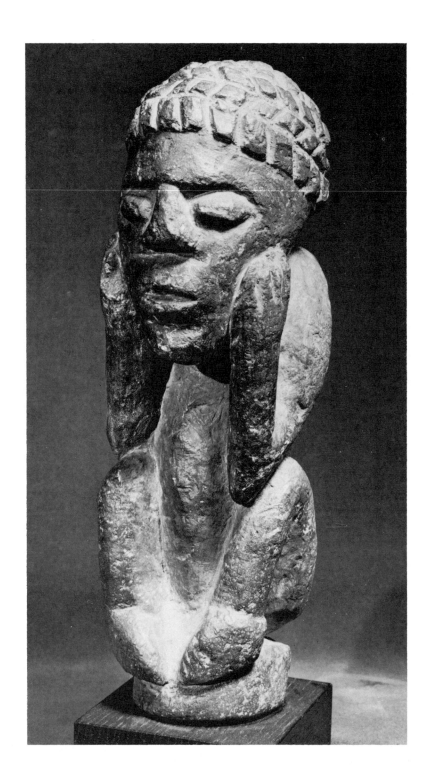

76 (*left*). *Pomdo*. Kissi. Guinea. Soapstone. Height 26 cm (10.25 ins). Musée des Arts Africains et Océaniens, Paris. Photo: André Held.

77 (*below left*). *Pomdo*, said to represent a Portuguese in armour and with ruff. From Sherbro Island. Soapstone. Height 27 cm (10.6 ins). Private collection, Kakata, Liberia. Photo: Mario Meneghini, in A. Tagliaferri and A. Hammacher, *Fabulous Ancestors*, New York, 1974.

78. *Pomdo*. Soapstone. 18 cm (7 ins). Private collection, Milan. Photo: Arno Hammacher, in A. Tagliaferri and A. Hammacher, *Fabulous Ancestors*, New York, 1974.

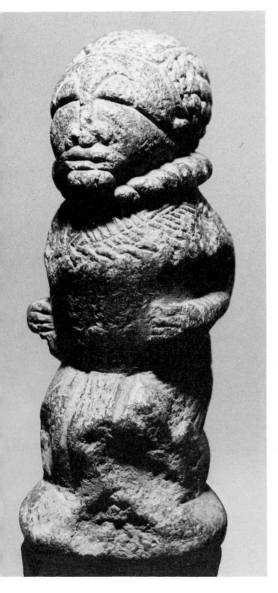
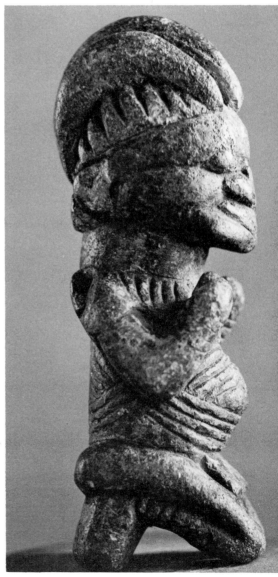

been discovered over wide areas of these states and in Liberia to the south-east.

Most of the carvings have been found by the Kissi and the Mende, both of whom believe in their supernatural power. They are usually unearthed in the course of working the rice fields and in diamond digging, or are accidentally discovered in the bush and along rivers. The Kissi believe that their own ancestors carved them, and by divination establish the identity of the actual descendant of the ancestor represented by the stone figure discovered. Sacrifices made to it cause the spirit of the ancestor to enter the sculpture. It is then placed in a shrine in the house of the newly-found descendant and used in divination and ancestor cult. Kissi legend affirms the use of the sculptures in initiation rites called *toma dugba* – no longer practised, but possibly part of the ancient forest culture to which both Kissi and Toma belonged.[4] The Toma, whatever their cultural influence, cannot be considered producers of the figures, as they – like the Mende – are carvers of wood and did not work in stone. A stone figure, said to be one of a small group, clearly in Toma style, was probably carved by the Kissi for their Toma neighbours.[5] The Mende do not credit their ancestors, but rather the people who owned the land before they arrived, with the making of the figures they find. They adopt them as protective spirits and guardians of their crops, but treat them with little reverence; regarding them rather as magical objects in their service and reportedly flogging or even breaking them if a crop fails or produces low yields.

The Sherbro (and the Bulom) were strongly affected by the Mende conquest and by contacts with the Portuguese. They appear to have ceased carving in stone long before the Kissi, who are known to have practised the art until early this century, though it had degenerated considerably.

The *pomtan* attributed to the Kissi are usually described as cylindrically shaped bodies with spherical heads [78]. But this is an over-simplification, since *pomtan* sculptures vary a great deal in shape of head, hairstyle and facial or body markings. Other features, such as bared teeth and hooked noses, are seen in some figures but are absent in others. Cross-hatching, to decorate the neck or indicate hair, and other markings occur occasionally on both *pomtan* and *nomoli*. These differences may have chronological or geographical significance or they may be individual artistic styles. Archaeological research may in the future lead to more precise classifications.

The *nomoli* of the Sherbro [79], though also showing some individual variations, have clear-cut characteristics: large heads set at an acute angle on a short neck, projecting jaws, bulbous eyes, stylized ropelike beards around the chin and reaching to the top of the head, and ears raised in bas-relief in almost circular shape with a round protuberance closing the rim. The attribution to the Sherbro was originally based on the first

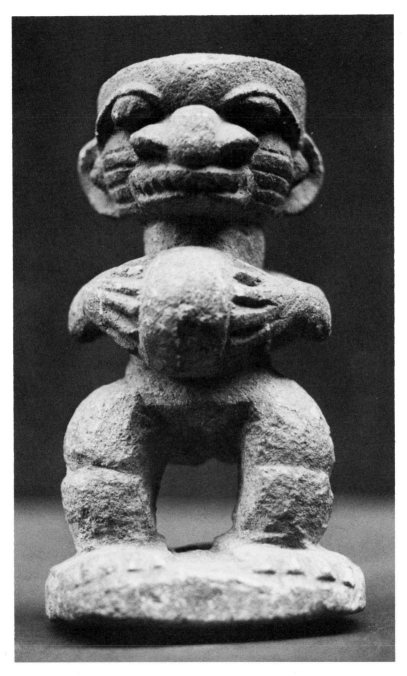

79. *Nomoli*. Mende country. Sierra Leone. Soapstone. Height 14 cm (5.5 ins). Museum of Mankind, London, 1906.5-25.2. Photo: Arno Hammacher, in A. Tagliaferri and A. Hammacher, *Fabulous Ancestors*, New York, 1974.

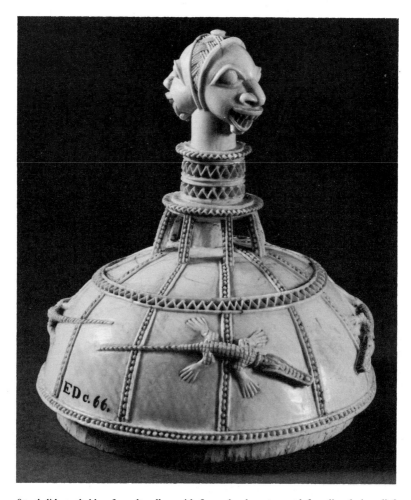

80. A lid, probably of a salt cellar, with Janus head on top and four lizards in relief. Sherbro-Portuguese ivory. From Sierra Leone. Height 15 cm (5.9 ins). National Museum of Denmark, EDc 66, first registered in the Royal Kunstkammer in Copenhagen in 1743. Photo: courtesy National Museum of Denmark.

discoveries on Sherbro Island. This has recently led to the determination of Sherbro origin for a substantial part of 'Afro-Portuguese' ivories [80].[6,7] These show the same prognathous features and treatment of eyes, ears and beard as do most *nomoli*.

Portuguese account books of the Casa da Guiné[8] contain references to imports of carved ivory spoons and salt cellars. Although the ships containing these cargoes had called at Gold Coast ports, they had also loaded rice, which came only from the stretch of coast between Sherbro Island and what used to be Portuguese Guinea. Reference is made to this

fact by a contemporary Portuguese chronicler, who also wrote that the Bulom 'make ivory spoons of better design and workmanship than in any other part . . .'[9] This corroborates a Sherbro origin for a large number of Afro-Portuguese ivories, and the age of the *nomoli*.[10] As these stone figures were found in widely separated areas of Sierra Leone, they were probably made by the Sherbro people before they were driven to Sherbro Island by invaders in the fourteenth century.

A number of life-size stone sculptures were found in Mende and Kono areas [81]. The Mende called these *mahen yafe* (spirit of the chief), and they have a distinct style, though there is some resemblance to certain *nomoli*. The heads are set almost horizontally on sturdy conical necks, and

81. *Mahen yafe*. From Sierra Leone. Stone. 26 cm (10.25 ins). Metropolitan Museum of Art, New York. Photo: André Held.

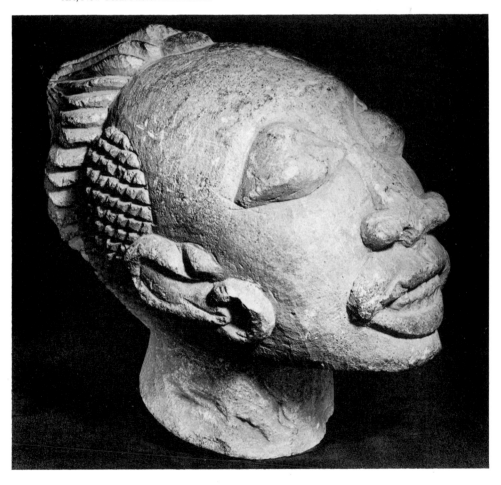

many have hair, beards and topknots indicated by cross-hatching. The *mahen yafe* are much larger than any other stone carvings in the area, and some are made of stone harder and darker than steatite. One head in the British Museum is atypical in spite of cross-hatched hair, topknot, and similarity of ear treatment. It has a great naturalistic beauty and serenity which, Allison states, 'is seen nowhere in Africa, except at Ife'.[11]

It is assumed that all stone figures from Guinea, Sierra Leone and Liberia were carved with metal tools, and this is borne out by metal strips and rings often found together with stone sculptures. Recent archaeological research in Sierra Leone confirms that a metal-using culture existed in the area at least as far back as the fifteenth century. The stone figures found can thus be assumed to have been produced some 400–500 years ago,[12] and some may be considerably older, as they could have been carved by the Kissi or the Sherbro before the great waves of invasions. Woodcarvings of the nineteenth and twentieth centuries by the Mende, Toma, and Vai of the area do not show any stylistic affinity with the art of the ancient inhabitants who carved the *nomoli, pomtan* and *mahen yafe*.

Kanem-Borno and the 'Sao' Culture

The Western Sudan produced yet another important kingdom, that of Kanem-Borno, which developed simultaneously with ancient Ghana. It was founded by Chief Sefuwa, who in the ninth century established a dynasty centred in Kanem, in the area of Lake Chad. Its strength – like Ghana's – was based on trade, and though Kanem had apparently no access to gold, the salt and copper of the north, presumably the tin of the Jos plateau, the ivory, ostrich feathers and fine textiles [82] of the forest people in the south, were the basis of its exchanges with northern Africa via the Sahara. Entrepot trade extended to the east as far as Egypt on the Mediterranean coastal road and to Nubia by the caravan routes leading through Darfur.

The political system of Kanem-Borno was the most stable developed by any African state. In spite of temporary subjugation by Mali in the fourteenth century, it outlived Mali and Songhai and survived a serious rebellion in the fifteenth century, when the seat of government moved from Kanem to Borno in the west. In 1571 the greatest ruler of the

7. Kanem-Borno and Ancient Ghana.

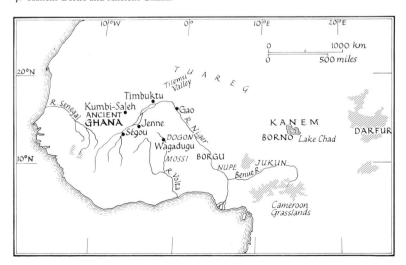

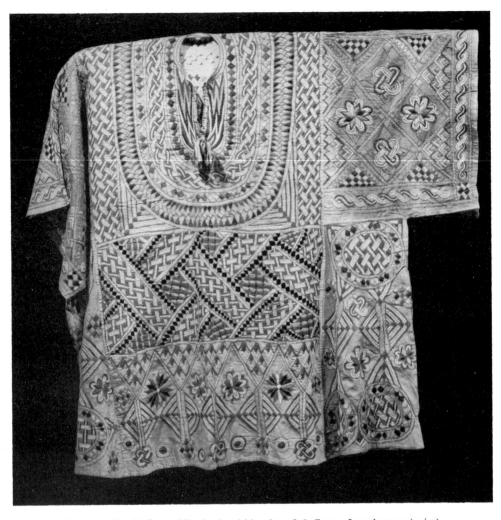

82. Dress, female. Borno. Nigeria. Acquisition date 1876. Cotton. Length 99 cm (39 ins). Museum für Völkerkunde, Berlin. Photo: André Held.

Sefuwa, Idris Alaoma,[1] came to power and united large areas, extending from Darfur to the border of Hausaland. The last member of the Sefuwa dynasty died in 1846.

In the area of this kingdom, a culture developed which is known today by the collective name of 'Sao'. This is an offensive name which was used by Moslem converts for a group of people living near Lake Chad and to the south-west of it. Whatever the ethnic origin of these people, they produced excellent artists in metal and terracotta [83], in styles and with iconography unrelated to any other African art known to us thus far.

The 'Sao' apparently lived on friendly terms with the regime of
Kanem-Borno for quite some time. But conflicts developed between them
early in the fourteenth century, and the 'Sao' were finally defeated. They
were islamized in the eighteenth century and disappeared as a separate
people. Several tribes, such as the 'Fali' on the Jos plateau and the Kotoko

83. Wine or water jar. 'Sao.' From Damazoué, Chad. Terracotta. 21 cm (8.27 ins). Photo:
Dominique Darbois, in Jean-Paul and Annie Lebeuf, *Les Arts des Sao*, Paris, 1977.

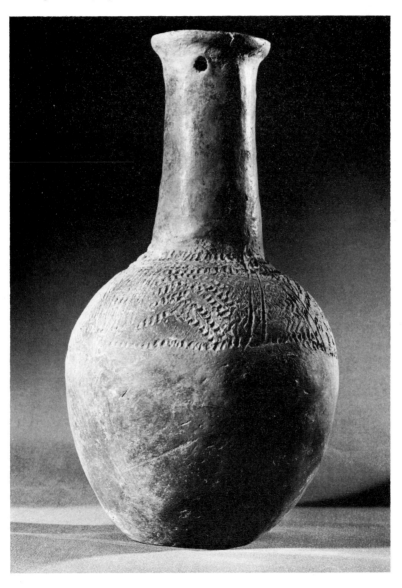

of northern Cameroon, may be their successors. The 'Fali', in fact, produced terracotta figures probably between A.D. 1600 and 1900 which have a certain similarity to 'Sao' ones, though the 'Fali' objects are much cruder. However, both peoples buried their dead in a seated position in huge pottery urns, which is a possible link between the two cultures. As the Kotoko, a Chadic-speaking people, lived in proximity with the 'Sao' from the twelfth to the fourteenth century, they may be the real successors of the 'Sao', or may even have been one of the tribes that made up the group of people named 'Sao'.

The 'Sao' art objects were mostly found in tombs during the extensive excavations and research expeditions of Jean-Paul and Annie Lebeuf.[2] These covered 680 sites believed to have been settled by the 'Sao', and unearthed almost 20,000 objects, mainly of terracotta and copper alloys.

Early terracottas were always well fired and ranged from thick-walled to very fine. Many were decorated and coloured red or pink. Finds from later periods were of mediocre quality, including vessels for burial and household use made by women potters, though figures representing humans or animals may have been fashioned by men.[3] Many ceramic toys were found, mostly in zoomorphic form, all of which are believed to have been made by children.

Iron tools made by the 'Sao' as well as some ferrous jewellery, all in a state of great deterioration, were unearthed. The very large number of objects made of copper alloys (containing mainly zinc or tin, but some alloyed with lead) date from the twelfth and thirteenth centuries onwards. A fine silver equestrian figure, 6 centimetres high, of Kotoko origin, is in the Musée de l'Homme in Paris. The items discovered were mostly jewellery [84, 85] with a preponderance of bracelets, some with fine anthropomorphic sculpture. Many show a high degree of mastery of casting by the lost wax technique.

Very little is known about the origin of the various techniques used by the 'Sao' in making and fashioning metals; nor is there reliable information on the source of the minerals. Tin is said to have been transported by Hausa traders from the Jos plateau, while copper and iron are thought to have originated in Waza, Madagali and Mora, and brought to the area via Makari.

South of Lake Chad, on the Nigerian side of the border, extensive excavations and research were carried out by Connah from 1961 to 1971 and for three months in 1978.[4] It was predominantly a study of early man and his world, and accordingly was of great help and importance in reconstructing the history of the area. (A report by Lebeuf on excavations north of Lake Chad is of similar value.) We learn that fishermen, hunters and gatherers of food were attracted to the country around the lake in prehistoric times. Geological and climatic conditions long in a state of flux finally stabilized some 3,000 years ago,

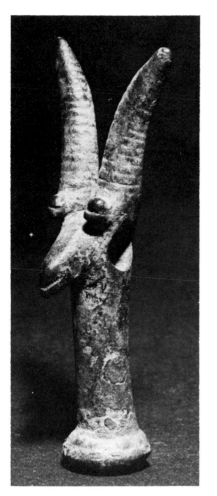

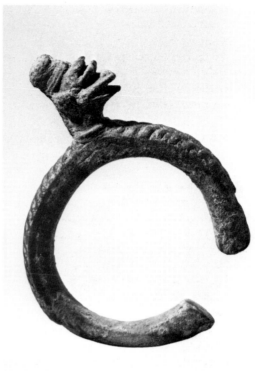

84 (*left*). Pendant, head of a gazelle. 'Sao.' From Azeguène, Chad. Bronze. 5 cm (1.97 ins). Musée de l'Homme, Paris. Photo: Dominique Darbois, in Jean-Paul and Annie Lebeuf, *Les Arts des Sao*, Paris, 1977.

85. Bracelet with anthropomorphic head. 'Sao.' From Gawi, Chad. Bronze. External diameter 7.7 cm (3 ins). Photo: Dominique Darbois, in Jean-Paul and Annie Lebeuf, *Les Arts des Sao*, Paris, 1977.

and this led to the development of sedentary agricultural communities.

Giant 'So' terracotta pots, some over 1.2 metres high, were found in a number of sites, mainly around Ndufu. They have simple decorations, and, partly sunk into the ground, were principally used for burial, as well as for grain storage from ancient times onwards. At Daima a wealth of domestic pottery with more sophisticated decorations was found. By

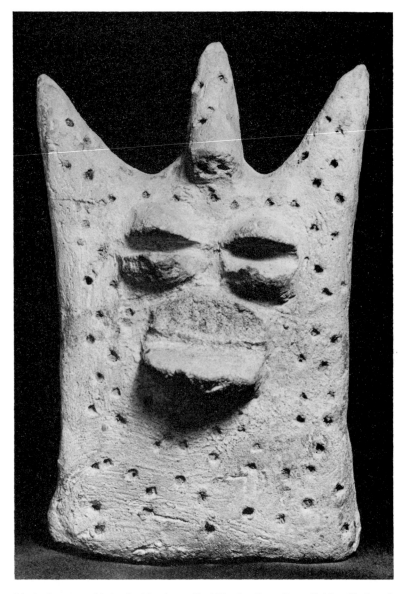

86. Anthropomorphic head with tricorn. 'Sao'-Kotoko. From Bonta Kabira, Chad. 17th century (?). Terracotta. 16 cm (6.3 ins). Chad National Museum, N'djamena. Photo: André Held.

87 (*right*). Dancer with bovine mask. 'Sao.' From Tago, Chad. Terracotta. 34 cm (13.39 ins). Photo: Dominique Darbois, in Jean-Paul and Annie Lebeuf, *Les Arts des Sao*, Paris, 1977.

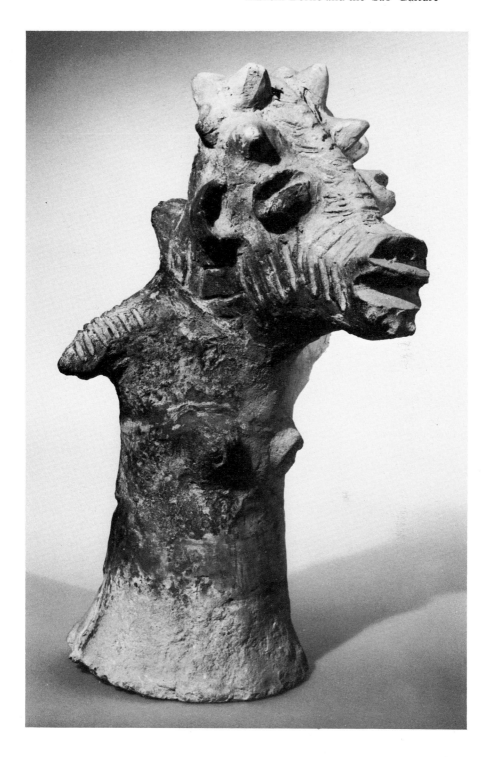

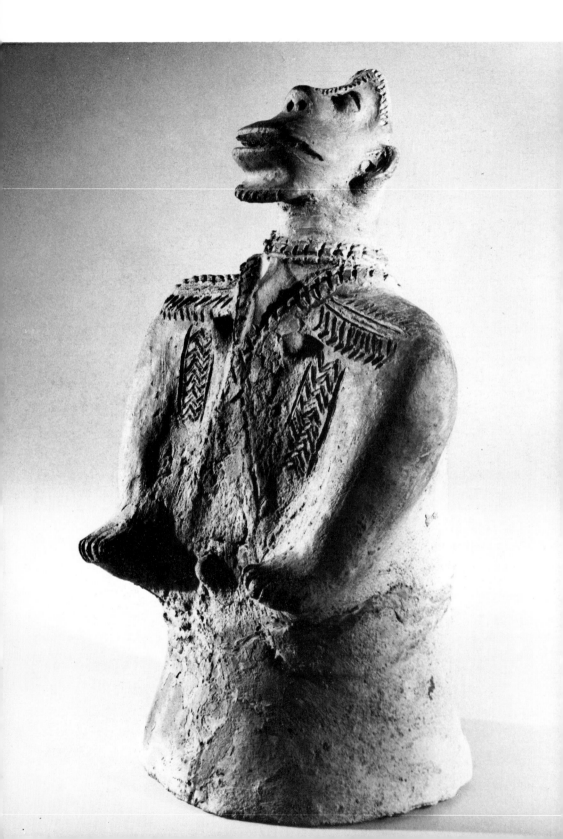

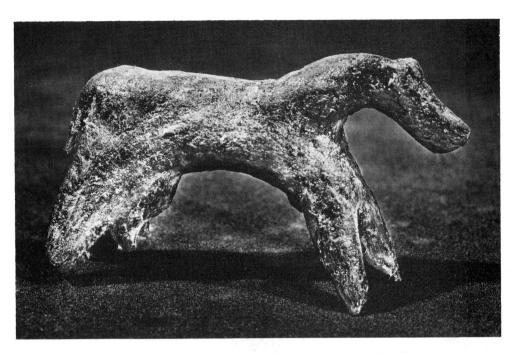

88 (*left*). Statue of an ancestor (?). 'Sao.' Central figure in shrine at Tago, Chad. Terracotta. 36 cm (14.17 ins). Photo: Dominique Darbois, in Jean-Paul and Annie Lebeuf, *Les Arts des Sao*, Paris, 1977.

89 (*above*). Sculpture of a sheep (or goat). From Daima, Nigeria. 6th-11th century A.D. Terracotta. Length 8 cm (3.15 ins). National Museum, Lagos, SF 17714, ex-University of Ibadan. Courtesy National Commission for Museums and Monuments, Lagos. Photo: André Held.

about A.D. 1000, figurines of fired clay representing cows, humped oxen, antelopes and humans were being made. The terracotta figure of a goat shown here [89] is one of the finest of the earliest zoomorphic sculptures from Daima. There were also finds of jewellery in iron and brass, and beads of cornelian, glass and clear quartz. Some bronze jewellery and figurines were cast by the lost wax process.

A pottery head of a man, the only artefact resembling the 'Sao' style, was unearthed during the Connah excavations at Amja and is probably from the beginning of the second millennium A.D.[5]

Just as Nubia is the corridor to Africa, the Chad region is its crossroads, for trade and migrations moving east to west, north to south, and vice versa. Many answers to our questions about the history of Africa's art may well be buried in that area; but the results of excavations in Chad, Cameroon and Nigeria, however promising and exciting, have revealed few of such answers, and the quest for more archaeological evidence from the past must continue.

'Kororofa' – the Jukun and Related Peoples

The peoples of the Benue River Valley seem to have been impervious to the influence of Kanem-Borno and other kingdoms to the north. They were mainly acephalous tribal units; and those having linguistic links with the Jukun came under the tutelage of that 'divine kingdom'. The people of the valley occupied an area stretching roughly from Gombe and Jalingo in the north-east to Katsina Ala and Lafia in the south-west. They shared this region with groups of different ethnic and linguistic origin, including the Fulani, who had brought Islam to the area in the nineteenth century, and the Hausa. Jukun culture was centred on the institution of divine kingship, to which much of their art is related.

According to Arab chronicles, a great state, Kororofa (also spelled Kwararafa), is reputed to have flourished from the thirteenth century until A.D. 1750, extending from Kano and Borno in the north to the Cross River in the south. Several authorities have considered the Jukun to be the 'descendants of the royal line of Kororofa'.[1]

The Jukun left Biepi, also called 'Kororofa', for Puje in the seventeenth century; and then, in the nineteenth century, moved to Wukari, their present capital. As 'Kororofa' seems to have vanished in the mid seventeenth century, it is likely that the Jukun moves were caused by a power vacuum.[2]

The 'divine king' of the Jukun was chosen by a small group of chiefs and courtiers, and was responsible for the nation's well-being and the fertility of the crops. Tradition ordained that after a rule of seven years – or earlier, if he fell ill or failed in his duty to protect the people against drought or epidemics – he was subject to death by strangulation. But there is only one known case of regicide, from which it appears that the idea of the failure of the king's divinity was invoked only as a means of resolving the political conflicts surrounding his person. The recurring story of compulsory ceremonial strangulation of kings may be based on periodical rites of their symbolic death and the subsequent renewal of their reign for a further span of time. The ceremonials of election, coronation, life and death, the customs and religion as depicted by Meek[3] and others, resemble the stories told about many other African 'divine kingdoms'.

The Great God of the Jukun is described by Meek as the Sun-God[4]

Chido who, in the role of earth mother, takes on the nature of a female, called Ama. Ancestor cult is central to Jukun religion.[5]

Rubin divides the Jukun lands into two art-producing sectors: the north-eastern, termed 'figure-using', and the south-eastern, called by him 'mask-using'. The major Jukun mask group is centred around the main male mask, *aku maga*, performing with one or two masks, *aku wa'unu* and *aku wa'uua*, representing females; though, like all masks, they are worn only by men. The *aku maga* and the *aku wa'unu* are thought to be abstractions of human heads, and the *wa'uua* is a helmet mask with carved features surmounted by a crest.[6]

Among the people who claim descent from the Jukun or historical links with Kororofa are the Igala, Idoma and Geomai. The Mongop masks of the latter are clearly related to the Jukun *aku maga* mask,[7, 8] and there is also a 'demonstrable tie' with the Afo stool found in Wukari (erroneously labelled Jukun in von Sydow's book).[9] During certain festivals, in particular during the celebrations of the king's coronation, two images [90] and a number of masks were brought out from secret shrines and kept overnight in the palace, to revalidate and regenerate the chief's powers; sacrifices were made to the images and new clothes were supplied to them before their return to the shrine. Similar customs were observed among the Wurbu and the Chamba (and the Keaka and Mambila in the Cameroon highlands, now Adamawa province of Nigeria). Other figures are thought to be incarnations of founding ancestors and chiefs,[10] or wives and attendants connected with sacrifices to succour the chief in his afterlife.[11] Carved figures generally appear in pairs of male and female images.

The Chamba and the Wurkun of the Benue River Valley used wooden figures on iron rods or with a tapered base [93]. They were stuck into the ground and served as guardians of crops, to ensure the well-being of the owners.

Other peoples claiming links with the Jukun are the Nupe, Waja, Karim and Koro,[12] and there are, in fact, clear stylistic and iconographic similarities.

In field research conducted by Rubin[13] on the role of Jukun-speaking peoples in the history of northern Nigeria, objects mainly of bronze were found in the area of Wukari.[14] They were symbols of leadership – ceremonial weapons, ornaments, regalia, bracelets and objects connected with religious observances [94, 95]. On stylistic, formal and iconographic traits, Rubin mentions three main sub-groups: those that are akin to bronzes found in Adamawa, especially from the Vere around Yola; those that incorporate motifs known from the Lower Niger and southern Nigeria; and a third that does not relate to any tradition outside the area.

Most of the bronzes found have openwork surfaces with non-figurative decoration and small clapperless bells or crotals suspended from loops. No age is mentioned by Rubin, but though some of the objects may be of

90. Three Jukun figures. From Benue River Valley, northern Nigeria. Eroded wood, nails.
Left (female) 56.5 cm (22.25 ins). *Centre* (male) 76 cm (29.9 ins). *Right* (male) 72 cm
(28.3 ins). Collection Ulrich von Schroeder, Zürich.

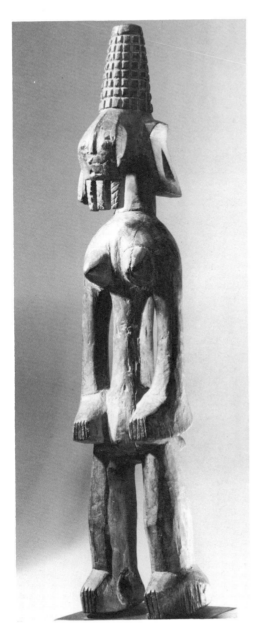
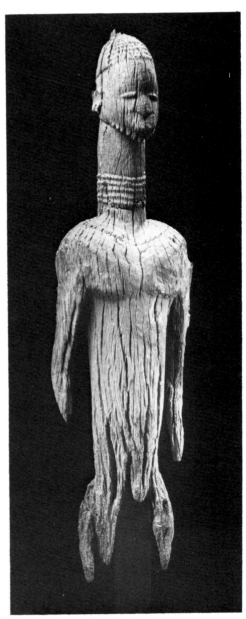

91 (*left*). Female figure. Identified by Arnold Rubin as Wurbu, sub-group of Jukun, who live on Tarba and mid-Benue River, between Jibu and Bakunde; probably used in 'possession' or Mam cult. Wood. 69 cm (27¼ ins). Private collection. Photo: Werner Forman.

92. Monumental male figure. Mboye. Benue River area, north-eastern Nigeria. Probably 18th/19th century. Eroded wood. 110 cm (43.3 ins). Collection Baudouin de Grunne. Photo: Roger Asselberghs.

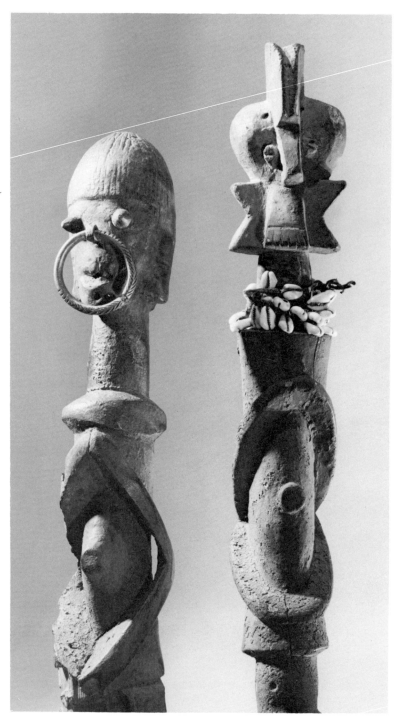

93. Two guardian figures. Wurkun, a Chadic-speaking people. Benue River area, north-eastern Nigeria. *Left:* wood, encrustation, metal eyes and nose ring, iron spike. 38.75 cm (15.25 ins). *Right:* wood, encrustation, fibre, cowrie shells, iron spike. 45.75 cm (18 ins). Tara Collection. Photo: Werner Forman.

recent manufacture, their style appears to be traditional. Priestesses connected with a healing cult carried ceremonial axes [96] with an iron haft on which a bronze head was fixed with an iron blade issuing from the mouth. These are well made and finely ornamented and may also have been used by the Tiv and Chamba in ancient times. No such implements appear to be produced in the area now.[15]

A great variety of pottery was made by Jukun women, and ceramic ware of similar types can be found among the neighbouring Mumuye, Wurkun and Tiv.

Prestige textiles woven with traditional motifs were made on men's horizontal looms.

94. Anklet with hinged gates. Jukun, Wukari area. Part of the regalia of the Kukuma of Wukari, a chief of the royal household. Bronze. 10.9 cm (4.29 ins). Nigerian Museum, 54.L.1. Courtesy National Commission for Museums and Monuments, Lagos. Photo: Arnold Rubin.

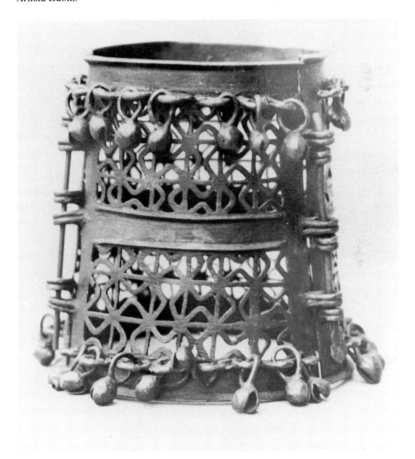

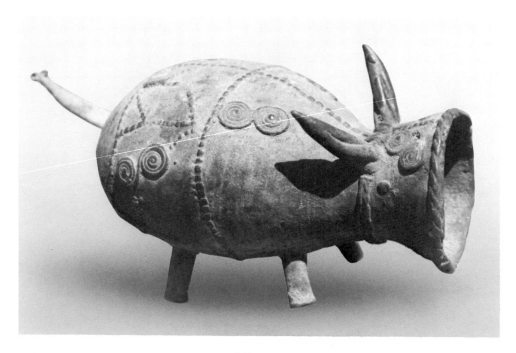

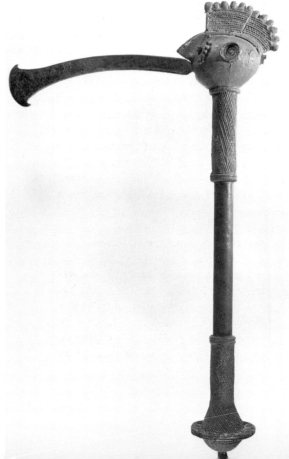

95. Mythical animal, possibly representing a hippopotamus. Found near the Wukari-Bantaji Road. From the regalia of the Aku of Wukari; 'rope' and spiral decorations. Bronze. Length (including tail) 13.7 cm (5.4 ins). Nigerian Museum, 65.L.3. Courtesy National Commission for Museums and Monuments, Lagos. Photo: Arnold Rubin.

96. Ceremonial axe. Abakwariga or Tiv, Nigeria. From the regalia of the Chamba chief of Kashimbila; used in possession cult by priestesses of the Jukun *jonkpa* or healing cult. Iron blade, issuing from mouth of anthropomorphic cast bronze head; cast bronze bottom terminal. 42 cm (17 ins). Collection Arnold Rubin. Photo: Peter J. Harris, in A. Rubin, 'Bronzes of Northeastern Nigeria', in *The Art of Metal in Africa*, New York, 1982.

The Art of the Akan

Land and History

The majority of the Akan-speaking people live in central and southern
Ghana (the Gold Coast of colonial times) and in the south-eastern Ivory
Coast. Their country is in part tropical rain forest mixed with savanna
reaching towards Burkina Faso in the north, bordered by Togo in the east,
by the Gulf of Guinea to the south, and to the west by the Ivory Coast,
where the Akan-related Baule, Anyi and Atye live. In the north of Ghana
are indigenous Gur-speaking people, intermingled with Mande-Dyula
and Hausa who came to that region in the fourteenth to sixteenth centuries
as traders or invaders. The Asante, the dominant nation of the Akan
group, are centred on Kumasi, with the Fante in the coastal area, the
Aowin, Adansi and Akwamu, among others, in the central forest zone,
and the Bron (also Brong or Bono) in the north-west. The mighty Volta
with its many tributaries is the central highway. A multitude of other
rivers cross the country to flow into the ocean in the south.

Until the end of the nineteenth century, or perhaps even later, virtually
all Akan people, even those converted to Islam or to Christianity, were
deeply involved in indigenous animist cults. All believed in the supreme
God and creator Nyame, in spirits of rivers and bush, in witchcraft and
in the power of protective charms, which for chiefs often took the form of
a golden or leather talisman bearing Koranic writings, worn as a pendant
or sewn on to garments. But while some art may be described as 'spirit
orientated', with roots in these ancient beliefs, most Akan art serves the
needs of the state, the court and chiefs, personal prestige and trade or
domestic requirements. In many visual arts, including architecture, Is-
lamic influences outweigh those of the indigenous cults.

In 1957, when the country became independent, the name 'Ghana' was
chosen because it embodied the traditional belief of the inhabitants that
their forefathers had come from the medieval Sudanic kingdom of that
name. This origin is now doubted by all scholars,[1] although there are
historical[2, 3] and pre-historical considerations which make migrations
'from the north', at least in small waves, feasible. These migrations may

8. The Black Volta and Akan goldfields.

have contributed to the cultural development of the Akan, who have probably lived in their forest region since the first millennium B.C.

The great development of the arts of the Akan took place in much more recent times and is closely linked with the trade based on the rich gold deposits of the country. Some time in the fourteenth century, the trading town of Begho became the centre for the exchange of gold, kola nuts and slaves for the salt, textiles, beads and metalwork that the Hausa and Mande-Dyula traders brought in from Jenne and the Maghrib.[4] These same contacts led to the spread of metal-working, weaving, and other technologies to the Akan. The city was destroyed in 1750, and excavations at its site showed that brassware, pottery, narrow-loom cloths and pottery weights, believed to have been based on Islamic systems, were traded there.[5]

Begho was in the territory of the Bron, who learned many technologies, including probably metal-casting, from people in the Niger bend, many hundred miles to the north.[6] Their first state, Bono Mansu, was founded about A.D. 1400 in the approximate area of today's Bron. The founding of Bono Mansu was followed by the emergence in the forest zone of the kingdoms of Akwamu, Adansi, Twifo, Denkyira and many others. The northern merchants who traded with all these Akan states brought with them fresh concepts and 'the ideology of Islam' in addition to new technologies. All this must have had a profound and lasting effect on Akan arts.

The growing trade in gold also involved the Portuguese, who landed in the 1470s and 1480s and were followed by the Dutch and French. Then came the British, who ruled the Gold Coast as a colony from the mid nineteenth century until independence. The Europeans, like their Moslem predecessors, traded brass vessels and trinkets, beads, cloth and salt, but also sold muskets and became very active in the growing coastal slave trade. This involvement and the introduction of firearms into the area led to strife and warfare among the Akan states and to domination by the Asante empire, founded by Osei Tutu early in the seventeenth century, with Kumasi as the capital. The power of the Asante kingdom, which lasted until the nineteenth century, was based on the unifying symbol of the Golden Stool: brought down, according to Asante legend, from the sky by the priest Anokye, to land gently in Osei Tutu's lap. The chiefly stools of other Akan rulers were buried, and henceforth the Golden Stool represented the power and spirit of the entire nation, who deeply believed that their well-being depended on the safety of the Stool.[7]

Of Gods, Life and Death

A limited number of Akan art objects were made specifically for use in shrines or for other cult purposes. The centrepiece of religious shrines, whether private or communal, was the 'god's bowl'. There were also carved figures, each representing one of a great number of minor deities (messengers or the sons and daughters of gods), though in most cases their functions were probably more like those of statues of Christian saints.[8] Other objects found in shrines were brass vessels, oil lamps, bells, stools and ceremonial swords, some of which show strong Islamic traits.

Very few wooden carvings were made by Akan sculptors. The most significant are *akua 'ba* figures, the style of which varies according to age and area of origin. The best-known type, usually associated with the Asante, has a flat discoid (or oval) head (said to represent the people's ideal of beauty), set on a neck with rings depicting fat rolls, symbols of prosperity as well as beauty. The torso is most often a cylinder, straight or conical, with breasts and navel indicated, and with horizontal rudimentary arms,

or occasionally armless. This ends in a base, and those *akua 'ba* which have naturalistic legs and arms are believed to be of a later date. The tradition of the *akua 'ba* is, however, old, and implied references to this most distinctively Akan sculpture are contained in writings by Barbot, Churchill and Dupuis.[9] The Fante version of the *akua 'ba* usually depicts the head as rectangular, and a variety of *akua 'ba* figures in Cole and Ross show styles attributed to Bron.[10]

Akua 'ba are female, for this is a matrilineal society. They are used as fertility figures in shrines or worn by women either to induce conception or, during pregnancy, to assure the birth of a beautiful child, preferably a daughter. Other Akan wood carvings used in cults, most probably long before the nineteenth century, are mother and child figures, seated on a stool or a royal *asipim* chair. The woman holds the baby on her knee and sometimes at her breast. As in other African cultures, the mother looks straight ahead, never at the child; symbolizing fertility and motherhood rather than portraying an individual mother-child relationship. There are also carvings of women seated alone, or standing with or without an infant; and here again styles vary with the areas of origin.[11]

The Baule are a sub-group of the Akan and according to oral tradition their kingdom was founded at the beginning of the eighteenth century by an Asante princess, who fled her country together with a large number of followers. In her new environment she became Queen Aura Poku, and her people merged with the original population. The Baule originated in an area where gold and brass castings were made [97], but which probably had little tradition of wood carving. It is believed that this art developed under the influence of the Guro and Senufo, both with considerable carving talents. The newcomers brought with them the traditions of a well-organized court as constituted in the Asante kingdom, together with a rich mythology, and so the demand for ceremonial royal and religious ritual symbols developed. The result is the calm and dignified Baule art, by professional carvers who at times reached great heights of creativity. Baule figures and masks are of serene beauty, with an attractive dark, almost metallic, patina.

Masks called *go* had naturalistic yet stylized human faces, and perhaps the greatest of these is in the Charles Ratton Collection.[12] Other masks were zoomorphic, the best-known type being the *guli*, with discoid face, powerful round eyes set in heart-shaped sockets, rectangular mouth and the disc surmounted by horns. Another *guli* mask is a helmet with two discs, an animal mouth and horns. *Guli* masks are abstractions of the buffalo and are said to represent the sun and to be in the service of the sky-god Nyame.

The Baule carved both standing and seated figures, and though they have an ancestor cult they did not carve ancestor statues. The male and female images made by them are either figures to accommodate the

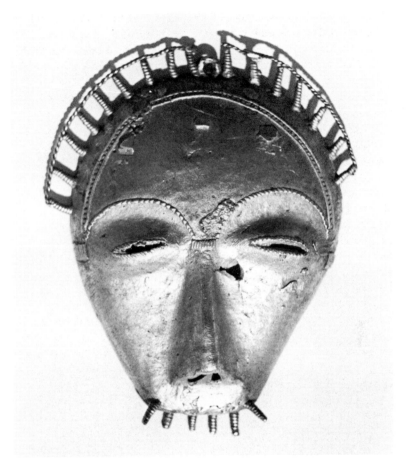

97. Pendant mask. Baule. Ivory Coast. Gold. 9.8 cm (4 ins). Collection Lance and Roberta Entwistle, London.

dangerous spirits of nature or they are spirit-lovers.[13] These are carved on the advice of a diviner to provide a home either for the nature-spirit or for the pre-natal lover. The jealousy of the spirit-lover and the dangerous activities of nature-spirits may be assuaged by these carvings. When first produced, there is no difference in the images to distinguish nature-spirit from spirit-lover. But as the latter is fed from a bowl, and is always cleaned and fondled, its patina will be smooth and shiny. The sacrificial offerings made to the nature-spirit image are simply thrown over it, so that the figure becomes encrusted and dirty. Details are always well carved, the hair is carefully incised and precisely detailed, and faces and bodies have raised cicatrice marks. Baule figures usually have small mouths, finely modelled eyes with delicately carved lids, and eyebrows

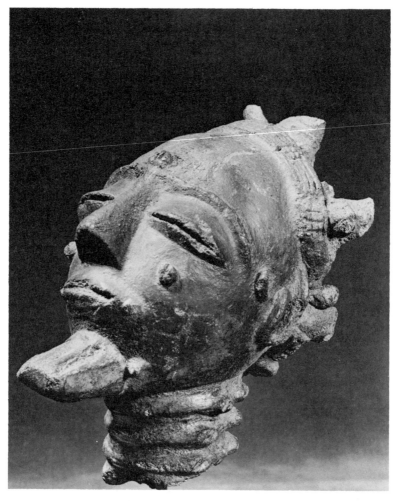

98. Head. Part of figure. Krinjabo. Ivory Coast. Terracotta. 18 cm (7 ins). Collection André Held, Ecublens, Lausanne. Photo: André Held.

99 (*right*). Head. Akan. Ghana. 18th/19th century. Terracotta. 29.2 cm (11½ ins). Private collection. Photo: Horst Kolo.

continuing into the line of a straight nose. Very different in style is the *egbekre* or ape spirit, the guardian, often placed at the village gate, bowl in hand. He is also the patron of the farmers, who sacrifice to him to ensure fertility in the field and protection from evil spirits.

There is good documentation on the use by the Akan of pottery vessels and funerary heads, and it appears that customs and ceremonial use of these objects have not changed since they were first mentioned by European travellers.[14] The first report is by de Marees,[15] who describes the

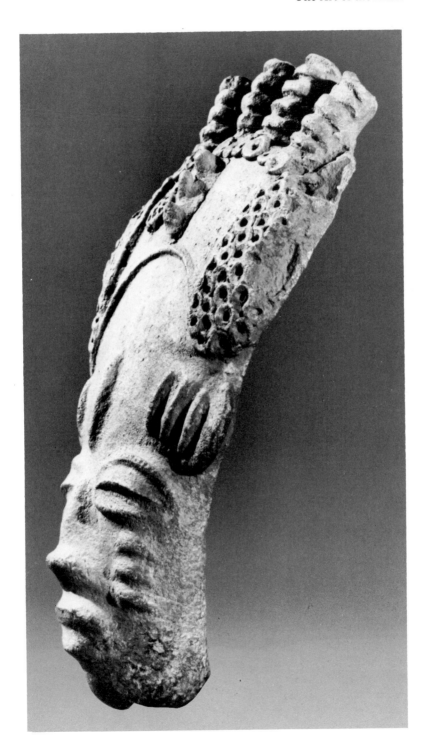

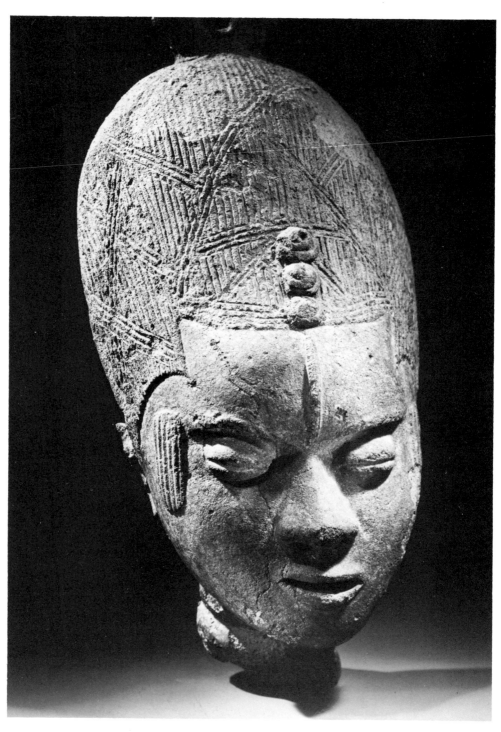

100. Head. Part of figure. Akan. Ghana. Terracotta. 33 cm (13 ins). Private collection. Photo: Horst Kolo, courtesy Entwistle, London.

use of vessels for the provision of food and drink on the tomb of a Fante king. He also tells of terracotta portraits of all those who served the king in life, 'placed orderly round about his grave'. Barbot in 1680 and Bosman in 1705 refer to similar use of pottery objects at Axim; and two photographs taken by members of the Basel Mission in the nineteenth century, in other areas of Akan country, confirm the survival of the ancient funerary use of terracotta vessels and heads. In fact a description of a royal funeral in the late 1930s shows that the customs continued well into the twentieth century.[16] The pottery was made by Akan women artisans and both ordinary domestic vessels and extensively decorated *abusua kuruwa*[17] were used for the same purpose.

Those with figures on lids or overall decorations with iconographical symbols, like snakes, frogs, 'ladders of death' - often referring to proverbs well known to all Akan people - were made for wealthy families. The heads, meant to be portraits of the deceased, were apparently used for chiefly and royal descendants only.[18] Both vessels and heads were placed in or near the cemetery during a funeral ceremony which took place some time - often many weeks - after the actual interment. In cases where the dead were buried under the floor of the house they had lived in, the vessels and heads were kept in the room above the entombed person. Some vessels and *abusua kuruwa* were reportedly placed in stool rooms or shrines, but in most cases they remained at or near the place of burial.

Use of the terracotta heads was very widespread and has been documented all along the coast of Ghana, into the Ivory Coast, and as far as Techiman in Bron country [98, 99, 100]. Archaeological data[19] from sites at Ahinsan and Hemang are given for various objects, dating them to the seventeenth and eighteenth centuries. Terracotta fragments collected by Calvocoressi at Hani near Bron, now at the Department of Archaeology, University of Ghana, were tentatively dated first millennium B.C., but such an age for figurative pottery must be very questionable until there are further finds reliably dated to that period. Excavations were made by James Bellis[20] of three sites at Hemang, revealing some fine terracotta fragments, mostly heads broken off funerary vessels dated about 1650 to 1700. Many other terracotta heads of varying styles, collected during field work in widely separate areas, are reported and analysed by Sieber.[21] Attribution by scholars to specific areas has not proved to be entirely reliable, given the considerable migrations before and after the emergence of the Asante federation of states. Sieber states that there is no clear pattern of geographical or ethnic origin. He recommends further research, centred on what he considers the more promising areas: the old kingdoms of Akwamu, Adansi, Bono, and possibly Denkyira. He thinks that the possibility should not be excluded of an origin for the tradition outside the countries of today's Akan settlements.[22] Some differences are undoubtedly due to local variations and the personal style of the potters.

The art of the Akan potter is much older than the reports of chroniclers led us to believe,[23] and its beauty and sophistication put it in the top rank of West African terracotta sculpture. The suggestion by Cole and Ross[24] of a possible historical link with Ife appears to be rather far-fetched.

The Regalia of State and Leadership

The pomp and splendour with which divine rulers of ancient African kingdoms impressed their neighbours and intimidated their subjects was greatest in those countries where gold was mined. Since the eighth century, Arab travellers have described the splendour at the courts of the West Sudanic kingdoms and the lavish use of gold, silver and ivory for the adornments of the ruler, his retinue, servants, horses and palaces. The manifestation of wealth and power expressed in the regalia of kings, chiefs and courtiers in early Akan states, culminating in the Asante confederation, probably outshone most other West African courts.

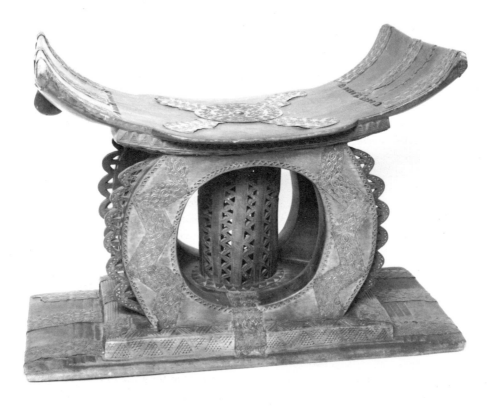

101. Stool. Akan. Ghana. Wood with hammered silver strip. 28 cm (11 ins). Museum of Mankind, London. Photo: courtesy Trustees of the British Museum.

The throne, the chair and the stool are symbols of power in most organized societies in the world. In Akan kingdoms the role of the stool was central, but with the ascendancy of the Asante it became paramount[101]. The Golden Stool became the incarnation of the soul of the nation, whose physical well-being, even survival, was inseparably linked to it. It is, therefore, not only the most important item of the Asantehene's regalia, but a cult object of the entire people. The original stool, 'sent from the sky', was desecrated by thieves when it was hidden from British governors from 1896 until after the return of the Asantehene, exiled by the British when they annexed the Gold Coast in 1901. When it was discovered that pieces of the stool and golden bells had been stolen, the whole nation went into a period of mourning. A new Golden Stool was made, incorporating parts of the old one, and possibly shaped like the original which differed from the typical Akan stool. The latter is carved from a single wood block, typically with a rectangular bottom and a concave seat on a central openwork and four solid outer columns. There are many variations, mainly in the supports – which may be in the form of animals or human figures – but the overall shape remains constant and can be easily recognized.

The Golden Stool differs greatly from this pattern. It has a round base, and the seat, though curved, is made up of three sections of a circle instead of being rectangular in shape. It is supported by a circular openwork column and two tubular braces and hung with bells and golden effigies of slain enemies. One such effigy was said to have been a portrait of the slain king Adinkra of Gyaman who had copied the Golden Stool. The Asante went to war, captured and executed him, and his counterfeit stool was melted down to make the effigy, a trophy head.[25] In the view of some scholars, the golden Asante mask in the Wallace Collection[102] may have been a trophy once attached to the Golden Stool. There is a ring under the chin of that mask by which it could have been hung head down, which makes the connection with the holy Asante stool credible. Alternatively, it may have been an ornament on the Asantehene's sword. The stool, the great symbol of power and divinity of the Asantehene, must never be sat on or touch the ground and is displayed on its own chair.[26]

Each Asantehene has his own ceremonial stool made for him on his accession. Ceremonial stools of chiefs, often covered with silver or gold sheet, will usually pass from incumbents to successors. Every man's and woman's personal stool is intimately linked to him or her throughout life. The stools of those who were office-holders in life (and provided that death was not caused by leprosy, avenging spirits, suicide and many other factors[27]) will be blackened with soot and placed in the stool-room. This is, in fact, the ancestor shrine in which the black stool takes the place of the statues in other African nations with an ancestor cult. Through

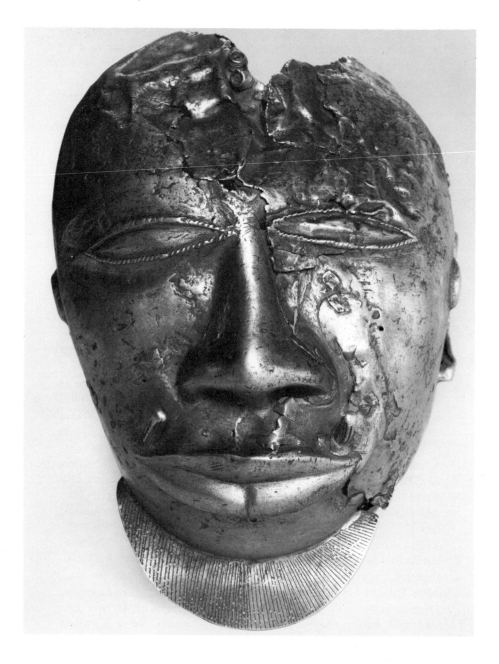

102. Mask. Asante. Ghana. Trophy from the treasury of King Kofi Kakari. Gold. 18 cm
(7 ins). Wallace Collection, London. Photo: by kind permission of the Trustees, The Wallace
Collection, London.

contacts with Europeans, the Akan became acquainted with chairs, and the three major types which they developed are all variations of seventeenth-century European designs. Their use is a royal or chiefly prerogative, but in general they have no religious connotations.

Ceremonial state swords are part of the Asantehene's regalia, carried by swordbearers when the Golden Stool is paraded and on many other occasions. Swords are used in ceremonies of accession of chiefs and a variety of state and religious functions. They are symbols of royal messengers and ambassadors or are handed to generals on appointment as their emblem of office. The state sword is usually about 75–80 centimetres in total length, with a curved wrought-iron blade resembling Islamic weapons, a wooden hilt with round or bell-shaped carving at the ends of the grip, and with a surface of gold leaf. The sheath may be covered with skin, preferably that of ray. Ornaments attached to state swords were traditionally masks or trophy heads, cast in gold or brass. Subsequently such ornaments took on bizarre forms such as birds with cannons, cartridge belts or even teapots, demonstrating the inventiveness of the artists influenced by acculturation. Many of the traditional motifs are linked to proverbs or metaphors.[28]

The use of the state sword, *afena*, in its traditional form, similar to that shown [103], is older than the Asante confederation. The example shown was already in the Danish Kunstkammer in 1674 (described in the catalogue as 'an East Indian Scimitar'). A painting by A. Eckhout executed in Brazil in 1641, and given by the Dutch Prince Moritz of Nassau to the King of Denmark in 1654, represents a man from the Gold Coast carrying the identical type of sword.

A very different category of ceremonial sword is the *afenatene*, which is much longer, with openwork blade (or sometimes with multiple blades and hilts). The elaborate hilts and blunt blades make them useless as weapons and underline their function as symbolic substitutes in the absence of the actual sword of state.[29] We must also mention the beautiful ornate hats worn by richly costumed swordbearers.[30, 31]

Ornaments made in disc form of cast or repoussé gold are called 'soul-washers' badges' or *akrafokonmu*. They were originally worn only by men appointed to perform the ceremony of purifying the chief's soul, but were later also used by swordbearers, other court-appointed officials, and chiefs. Furthermore, discs with radiating rosette-like patterns were attached to many ceremonial stools, swords and other objects for ritual or state purposes. A gold pectoral from a fourteenth-century cemetery in Senegal is similar to typical soul-washers' discs,[32] and so are decorations on Islamic leather and silver work regarded as protection against the 'evil eye'.[33] The motif was probably copied from objects bought from Muslim traders and used as charms. The disc with a simple cruciform design shown here [104] may precede the more ornate Islamic-inspired badges.

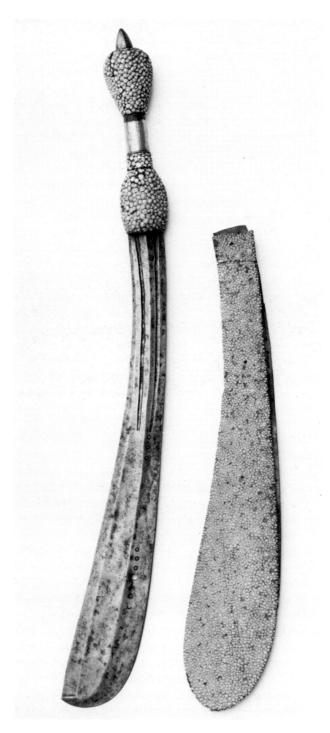

103. Ceremonial sword and sheath. Akan. Wrought iron, wood, ray skin, gold leaf. 79 cm
(31 ins). National Museum of Denmark, Copenhagen, ECb. 8. Recorded A.D. 1674. Photo:
courtesy National Museum of Denmark.

104. Soul-washer's badge. Asante. Ghana. Taken from King Kofi Kakari's bedroom by Lt Annesley in 1874. Gold. 8.8 cm (3.46 ins). Collection Lance and Roberta Entwistle, London. Photo: Horst Kolo.

It is also of special historical interest as it was taken from the Treasury of Kofi Kakari, the ruling Asantehene, in 1874, when Kumasi was sacked by British forces. (The gold mask in the Wallace Collection was found in the same treasury.)

The description of staffs of office as 'linguists' staffs' is misleading and results from an inaccurate translation of the Akan name *okyeame*. Officials wearing such staffs ranked very highly at the courts of the Asantehene and chiefs in the nineteenth century, and were described by Wilks as counsellors, judicial advocates, military attachés, ambassadors, prime ministers and envoys engaged in legal work.[34] Their symbol of office is probably more accurately described as 'counsellor's staff'. These very ornate staffs, covered with gold leaf and topped with various fancy gold-covered finials representing lions, birds, elephants, couples playing the *oware* game, or a hen and cock, are most probably all from the twentieth century. Their origin is thought to be the European walking-

stick or possibly clubs used by chiefs in northern Ghana as symbols of authority.[35] Early staffs were single canes with gold or silver handles, and the custom dates back to the seventeenth century in the coastal areas.[36]

State umbrellas used by kings and chiefs for ceremonial purposes were said to have been made of imported silks and velvet cloths; later, brightly coloured home-woven fabrics were used. They were, like the counsellors' staffs, topped with golden or silver finials, but fewer motifs were used [105]. Most frequently the umbrella tops represent *babadua*, a bamboo-like cane, and images of other plants, all illustrating popular proverbs.[37] Umbrellas, though without finials, were first illustrated by Müller in 1673.[38] The state umbrella is, of course, a feature in many West African countries. They were commented on by Arab chroniclers who observed them in ancient Mali, and their use might well have spread there from Mameluk Egypt.[39, 40] The side-blown trumpets carved with Akan motifs – stools, state swords, or crocodiles[41] – may also be of northern inspiration. Parts of two carved ivory side-blown trumpets were found at Begho; such instruments are reported to have been used at medieval Western Sudanic courts.[42]

Dress was a symbol of rank and status from early days in the hierarchical societies of Akan kingdoms. The splendour of the voluminous robes worn by kings and chiefs probably reached its height in the nineteenth century under Asante rule, when Bowdich wrote[43] that 'the chiefs, as did their superior captains and attendants, wore Ashantee cloths of extravagant price. They were of incredible size and weight, and thrown over the shoulder exactly like a Roman toga.' That traditional type of garment can be traced back to the early seventeenth century, when Samuel Braun reported in 1614 that 'Akan traders ... have a cloth over their shoulders as a cloak which is very stately in style'.[44] These chronicles are of pre-Asante time, and the cloth used for the cloaks described by Braun may have been imported. The first definite mention of local production comes from a Danish source[45] of 1760, in which the spinning and weaving of cotton into narrow strips of various colours is recorded. Also described is the purchase by Akan weavers of silk and wool cloth, which they unravelled to obtain thread for interweaving in their strip.

This art may be very ancient and predate European contacts. Cotton was used in Benin at least as early as the thirteenth century,[46] and the use of narrow looms for the production of strip fabrics in the area of the Niger Bend goes back to the eleventh century or even earlier.[47] Parallel with the earliest production of woven fabrics (or possibly predating it), cloth was made locally out of beaten bark. It was the cheapest material available and was worn by the poor, but had its use right into the twentieth century for hunters whose garments were easily soiled or torn in the forests. The narrow West African horizontal frame treadle loom (unknown in the Congo) was used only by men. They produced cloaks, blankets and

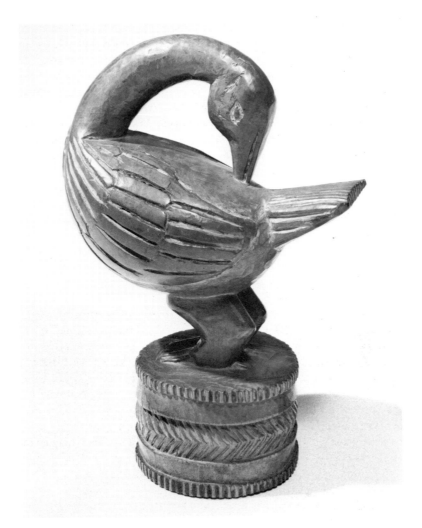

105. Umbrella finial. Akan. Ghana. Wood. 20 cm (7.87 ins). Museum of Mankind, London. Photo: courtesy Trustees of the British Museum.

tailored garments by sewing the strip along the edges. Women worked a wider vertical treadleless loom on which fabrics for family use only were woven.

There were basically three types of fabrics produced by Akan craftsmen. The earliest was made of strips with woven designs, called *kente*, resulting in very beautiful multicoloured cloths and made into splendid garments for kings and chiefs. The finest were woven of silk. The second category was *adinkra* cloth [114], traditionally made of single dyed strips sewn together and hand-stamped with great varieties of patterns, or decorated with linear designs drawn on the cloth. There is usually a verbal

interpretation for each pattern. Later, multicoloured strips were used, and some were ornamented with embroidery. The third type consists of appliquéd or embroidered fabrics, called *akunitan*, or 'cloths of the great' [106]. These are usually made of imported damask or felt and the appliqué technique may well have been influenced by Dahomey, while the embroidered gowns probably have an earlier Islamic origin.[48]

War shirts called *batakari*, hung with amulets and charms, are certainly of northern origin and may have been used by the Akan as early as 1602, when de Marees made an oblique reference to the people's belief in the protection of charms. But the first actual description of a *batakari* was made by Bowdich in 1819.[49] The shirt illustrated [107] is a specially fine specimen. War hats, some richly decorated with silver and gold, and incorporating charms, complete the warrior's protective outfit.

The most beautiful of the Akan heddle pulleys, veritable works of art, were the products of Baule carvers. Several outstanding specimens by Ghanaian artists are illustrated in Cole and Ross.[50]

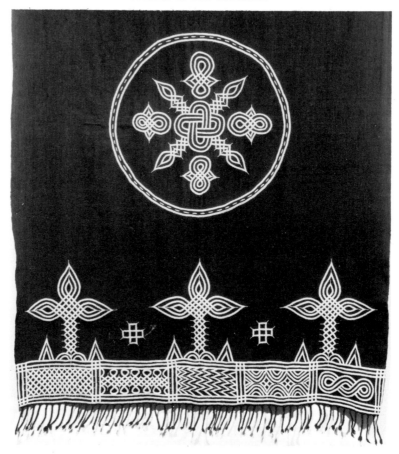

106. Embroidered cotton cloth. Baule. Ivory Coast. Width 112 cm (44 ins). Musée d'Ethnographie, Geneva. Photo: André Held.

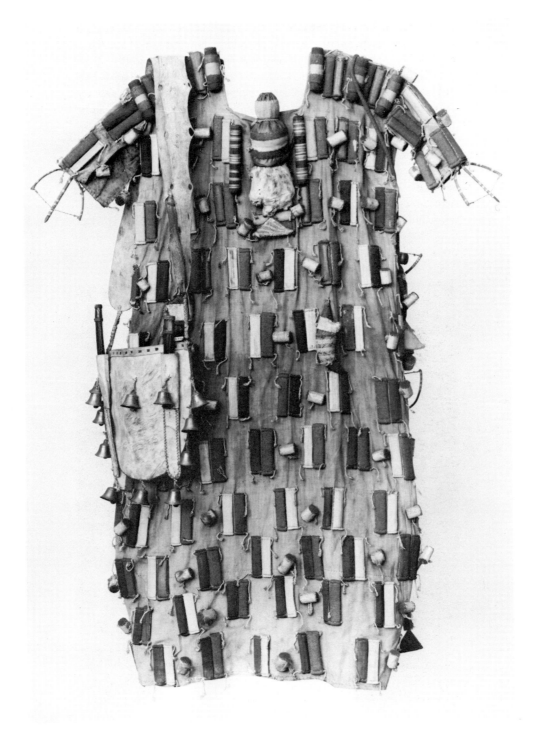

107. War shirt, (*batakari*) and shoulder bag. Asante. Ghana. Cloth, leather, bells and miscellaneous decorations. 109 cm (43 ins). National Museum of Denmark, collected by a governor of the Danish possessions on the Gold Coast, accessioned by museum 1850. Photo: courtesy National Museum of Denmark.

The use of jewellery, starting with stone and pottery beads, is as ancient as African art itself, and the earliest specimen connected with the cultures included in this book is a stone armband of about 2200-2000 B.C. from the Nubian C-group.[51] The Akan used stone, shell, and glass beads, ivory, silver and, above all, gold for their jewellery. Most of it was for personal adornment, but spiritual connotations or use as amulets must be assumed for many objects in this category of art. The forms of jewellery in Akan and other parts of sub-Saharan Africa influenced by Islam are derived from northern Africa, the Mediterranean area and the Near East. There are notable similarities in both form and technique between jewellery made in those regions and the products of Akan artists.[52] Illustrated here [108] are two examples from the bewildering variety of rings, necklaces, bracelets, pendants and miniature masks in the possession of Akan kings and chiefs, or in museums and private collections the world over.[53, 54]

Body and facial scarification have now all but disappeared among the Akan, but are well documented in writings of the mid sixteenth and early

108. Talisman, worn by chiefs around upper arm, and bracelet. Asante. Ghana. Leather pouches of talisman covered with gold foil; bracelet gold. Talisman 8.5 cm (3.35 ins). Collection Asantehene, Kumasi. Photo: Werner Forman.

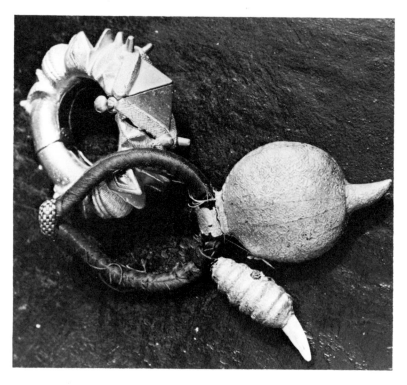

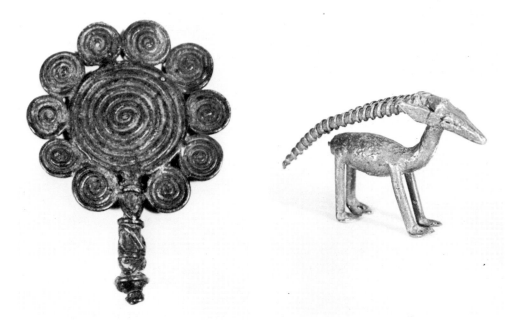

109 (*left*). Goldweight in shape of a fan. Akan. Brass. 4.6 cm (1.8 ins). Museum für Völkerkunde, Leipzig, MAF 1951. Photo: courtesy Museum für Völkerkunde.

110. Goldweight, antelope. Akan. First quarter of 19th century. Brass. Length 5.7 cm (2.25 ins). Illustrating a proverb: 'At the end we always say: If I had only known' (said the antelope caught in a trap). Museum für Völkerkunde, Leipzig, MAF 29850. Photo: courtesy Museum für Völkerkunde.

seventeenth centuries.[55, 56] Coiffure was significant as an identification of status and role; and though this is now of diminished importance, many fancy hairstyles are still very popular with Akan women.

As gold played a leading role in Akan trading, at least as far back as the early fifteenth century, implements for weighing nuggets and gold dust became a necessity for the conduct of internal and external commerce. Before that trade developed, the currency used by the Akan consisted of iron discs. When gold dust became the means of exchange, scales became part of everybody's kit, along with weights, touchstones, spoons and a metal box to contain the gold dust. The first foreign trading partners, the Mande, introduced weights and weighing systems. In the beginning, *abrus precatorius* and carob seeds were used. The carob is called *kirat* in North Africa, and from this the word 'carat' is derived. Pottery and stone weights were also in circulation, and a variety were found in the area of Begho;[57] these, too, were common in Sudanic and North African regions.

In the field of cast-metal weights, the Akan became the undisputed

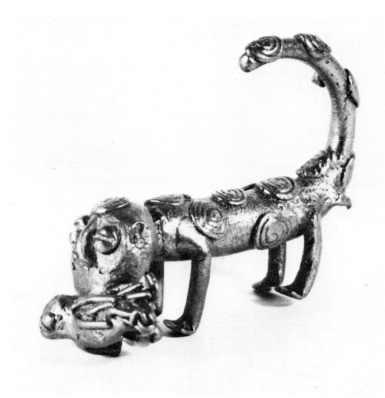

111. Goldweight, leopard attacking porcupine. Akan, Asante. Brass. Length 4.8 cm (1.89 ins). Illustrating two proverbs, the first alluding to the leopard as a symbol of royalty: 'Who else would attack the porcupine protected by all his quills?' and the second praising the courage of their warriors: 'Asanti warriors are like the quills of a porcupine – thousands grow again (when thousands fall).' Museum für Völkerkunde, Leipzig. Photo: courtesy Museum für Völkerkunde.

masters, and the enormous number produced during some 500 years are among the most enchanting African art objects [109, 110, 111]. The figurative weights are not known in other areas and were an original creation of the Akan long before Asante times.[58] Some of them were cast by 'direct' methods – using seeds, nuts, fruit, beetles, snails or fish as models[59] – but most were produced by the lost wax casting method, introduced from North Africa via the West Sudanic traders. Both geometric and figurative weights were used from the beginning (assumed to be c. A.D. 1400), and the geometric category had its origins in Western Sudan, though prototypes have also been found in Egyptian and Roman excavations.[60] The great mass of gold weights may be divided into classes of early (1400–1700) and late (1700–1900) geometrical and figurative weights.[61]

The weighing systems were first based on Islamic weights - the *mithkal*, the *okiya* and the *rotl* and later the Portuguese and the troy ounce were incorporated to create the Akan weight standards. Garrard arrives at sixty Akan metal weights, ranging from 1.4 to 1866 grams,[62] and he has also produced a table to show the weight tolerances, which are 1.3-1.55 for the 1.4 standard and 1525-1594 for the 1584 gram weight, or 16 per cent and 5 per cent respectively. But these seem to be unacceptable tolerances for weights in the gold trade. Islamic weights as used in North Africa and the Near East differ so greatly from country to country and from town to town that precise standards for Akan weights can hardly be based on comparisons with *mithkal* or *okiya*.[63] The method used by the British

112. *Forowa*. Embossed brass sheeting. Height 11.8 cm (4.65 ins). Museum of Mankind, London. Photo: courtesy Trustees of the British Museum.

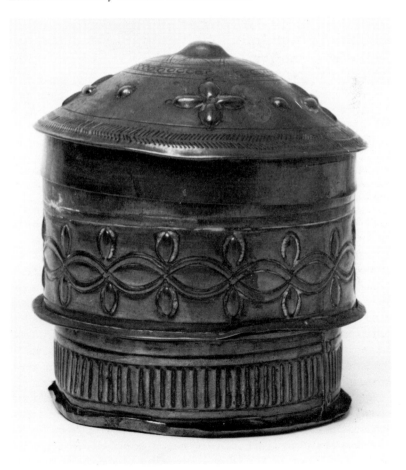

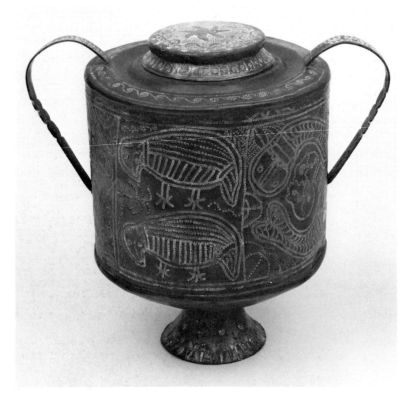

113. Pedestal vase with handles and cover; engraved designs. From Attabubu, north of Kumasi in Bron country. Bronze. Height 20.3 cm (8 ins). Museum of Mankind, London, 1936 10-22.7. Photo: courtesy Trustees of the British Museum.

Museum Research Laboratory[64] appears to be more reliable, as it is based on the actual Akan weights without regard to the external origin of the system.[65]

Many, though certainly not all, figurative gold weights represent proverbs, which are an important aspect of Akan life and culture. While some were made to illustrate well-known proverbs, others induced the coining of new ones. Proverbs are not universal for all sections of the Akan but differ from group to group.[66, 67] Garrard[68] quotes a number of proverbs, recorded or explained by scholars, applying to various categories of figurative weights: human figures, birds, animals, reptiles, fish, seeds, fruit and sundry artefacts including drums, stools, shields and knots.

A very large proportion of Akan gold was spent on the import of brass vessels and manillas of brass and copper.[69] The larger vessels were often used in stool rooms and other shrines, but very many were beaten flat and served as raw material for locally fashioned containers, especially the *forowa* [112], a lidded box on an openwork base which was used for

114. Ewer and *kuduo* (background *adinkra* cloth). (The shape of this type of *kuduo* may have been based on the design of the old English ewer of the time of Richard II, which was taken from the palace of Kumasi in 1896 as booty and is now in the Department of Medieval and Later Antiquities, British Museum.) Museum of Mankind, London. Photo: courtesy Trustees of the British Museum.

115. *Kuduo.* Asante. Found at Aseju in 1895. Brass. On the lid is a casting of a leopard seizing an antelope; body with typical decorations; bottom open work. 35.5 cm (14 ins). Museum of Mankind, London, 1903-17.1. Photo: courtesy Trustees of the British Museum.

shea butter, a body ointment. The box was also used as a receptacle for funeral offerings. The other Akan metal vessel is the *kuduo* [114, 115], cast by the lost wax method; and though, like the *forowa*, it is used to hold valuables, it serves many ritual purposes. It is believed to have been used in soul-washing, female puberty rites[70, 71] and other ceremonies.

Forowa are mainly based on European forms, but some of the decorations show Islamic influence, which is also the origin for the shape and ornaments of most *kuduo* vessels. Those with flared concave sides are usually open; and the globular pots with a domed lid,[72] some on three short legs, are said to be the earliest style. Those with decorations in the form of birds, bush animals, crocodiles or human figures – single, in couples or even large groups – belong mostly to the nineteenth and twentieth centuries.

In dealing with the art history of the Akan we have the advantage of considering a civilization still very much alive. We have no such benefit when exploring the history of artefacts of unknown origin, such as those from Igbo-Ukwu in the next chapter.

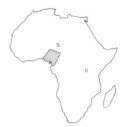

Igbo-Ukwu, the Niger Delta and the Cross River

The excavations in Nubia were targeted on sites known to have been places of worship, cemeteries, palaces or other centres of the ancient civilization being explored. But this was the exception in archaeological work in Africa, which is almost always a consequence of accidental finds, as in the case of the Nok culture.

In the Lower Niger region of Nigeria, another fortuitous find led to the discovery of an African civilization almost as enigmatic as Nok, and to the unearthing of the oldest copper alloy artefacts known so far in West Africa.

During building operations in 1938, at his yard in the village of Igbo-Ukwu (about 40 kilometres south-east of Onitsha), a man called Isaiah Anozie found some bronze objects which he sold to the administrative officer of the area; and when the Federal Department of Antiquities came into being, the officer donated the bronzes to the Nigerian Museum.[1,2] It was only well after the Second World War, in 1959/60, that Thurstan Shaw started excavations in the compound of Isaiah Anozie and the neighbouring properties of Richard and (in 1964) of Jonah Anozie: the sites referred to in Shaw's reports[3] as Igbo Isaiah, Igbo Richard and Igbo Jonah respectively.

The digging of a cistern by Richard Anozie led to the discovery of an amazing burial chamber, made for someone who is now presumed to have been a great religious leader of the Igbo about 1,000 years ago. In a relatively shallow depth of one to two metres, the decayed bones of at least five people, together with some beads and two copper wristlets, were found. These may well be the remains of slaves buried with their master, himself interred about a metre further down. His remains, a skull and parts of the skeleton, all very decayed, were surrounded by many items of regalia and adornment, among them a stafftop with a bronze leopard's skull on a copper rod [116] and a bronze handle surmounted by an equestrian figure. This is, one guesses, the hilt of a flywhisk finely decorated in the Igbo-Ukwu manner. The horse, with square columns for legs and the head and neck proportionally large, appears crude by itself. With the rider, however, larger than the mount and his head about a third of the body, the whole is a composition typical of much western

African art. The face is scarified all over with heavy raised weals radiating from the nose. An Ife terracotta head from Inwinrin Grove[4] has similar weals [141], running down in parallel lines from the top to the chin; but it is possible that the raised weals in the small castings of Igbo-Ukwu are a convention for incised scarifications identifying rank and title [117]. They resemble forehead markings (*ichi*) which have persisted into this century and which occur frequently on Igbo masks.

Numerous other objects of copper, including a crown, altar stands, vessels, anklets, armlets and a fan holder, over 100,000 glass beads (two armlets with nearly 1,000 blue beads each), and items made of bone, ivory (including three whole tusks), iron, pottery and beads of cornelian were discovered. From the finds and their location, it was assumed that the body of this important person had been buried in a seated position; a reconstruction painting of the burial chamber as it may have been at the time of the funeral was published by Thurstan Shaw.[5]

Meanwhile, the excavations at Igbo Isaiah produced a wealth of bronzes, pottery and other objects. These had been assembled in what appeared to be a repository of regalia or ceremonial utensils, housed in a

116. Bronze skull of a leopard on a copper rod. From Igbo Richard. 24.2 cm (9.53 ins). National Museum, Lagos. Courtesy National Commission for Museums and Monuments, Lagos. Photo: André Held.

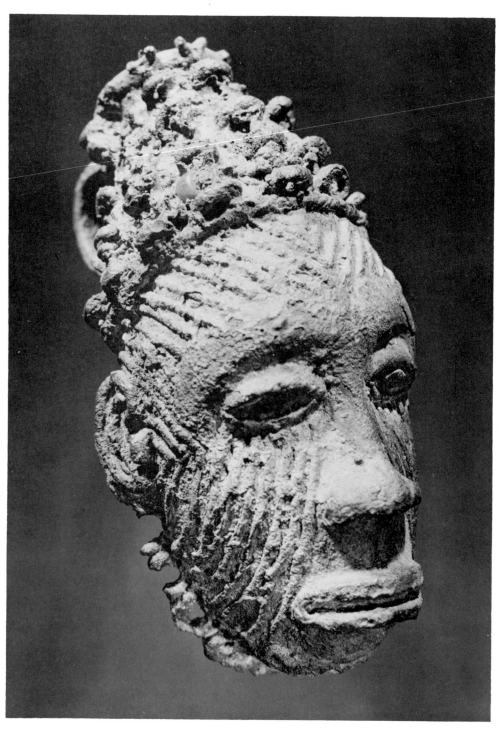

117. Miniature pendant representing a human face with striations, similar to some Ife facial markings. Probably from Igbo Isaiah. Bronze. 7.6 cm (3 ins). National Museum, Lagos. Courtesy National Commission for Museums and Monuments, Lagos. Photo: André Held.

building which may have collapsed many centuries ago, burying the treasure. The most outstanding object was the leaded tin bronze vessel which consists of a cast receptacle in the form of a waterpot, set on a finely designed base and surrounded by a cage of copper ropework [118]. There have only been guesses about the use for which this vessel was made. Armstrong[6] saw, in the orchestra of an age-group society, an instrument made up of a nearly globular pot, entirely ringed with a net of coral beads, tied to a circular base of braided rope. The musician would strike the pot sharply across the mouth with a flat implement made of cowhide, and the rope-nesting caused the pot to vibrate. This produced a sound of single pitch, which provided the bass rhythm of the orchestra. Examples are quoted for the use of suspended idiophones in the Lower Niger and Cross River areas, while there are roped pots, and pot decorations simulating ropes, at the Odinani Museum in Nri – only fifteen miles from Igbo-Ukwu. Extensive research at the British Museum has revealed that the Igbo-Ukwu bronze vessel was built up from several parts. The rim section, the lower part of the stand, and the ropework were each cast separately. The way that the ropework was fitted over the vessel and stand is not completely understood, but it was presumably slipped over the pot and the base. The lower knots of the rope were bent inwards, while the metal was still hot, to bring it close to the stand, and fresh metal was then poured in to join the heated pieces.

However, it is not clear how artists using the relatively simple lost wax process could have achieved the fine invisible joints. Certainly it would be difficult to find, anywhere in the world of metal-working, an equal to the anonymous master who made this roped vessel.

At Igbo Jonah, during excavations about four years later, a large number of copper alloy and iron objects, with a considerable quantity of potsherds and some complete terracotta vessels, were uncovered. The largest of the vessels[7] is a splendid example of fine Igbo-Ukwu pottery, adorned with deeply channelled geometric patterns, snakes, a ram's head, a chameleon, and other objects. We cannot guess why these fine ceremonial vessels and utensils had been dumped into the pit where they were found by Shaw.

The dating by radiocarbon of one object and of charcoal from the levels where the others were found resulted in four dates from the ninth century A.D. and one from the fifteenth century. In spite of a controversy which developed over these results,[8, 9, 10, 11, 12, 13] the four dates must be accepted as proof. One explanation for the 'odd date' of the fifteenth century is possible contamination of the area from which the samples were taken. This could have happened through a crack between the pits mentioned by Shaw,[14] and this possibility is examined in great detail by M. A. and B. O. Onwuejeogwu.[15] There are still unanswered questions. What type of society created these wonderful artefacts? Where did the

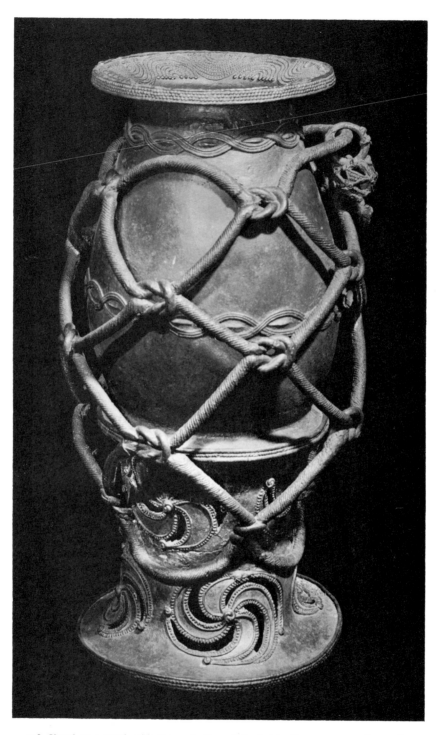

118. Vessel on a stand, with ropework. From Igbo Isaiah. Bronze. 32.3 cm (12.7 ins).
National Museum, Lagos. Courtesy National Commission for Museums and Monuments,
Lagos. Photo: André Held.

raw materials - mainly copper, tin, zinc (or ready-made alloys) and beads - originate; and how were they paid for?

The metals, beads, etc., may have been imported from the north by trans-Saharan caravan traders, or metals and ores might have been brought from mines at Azelik and Marandet in Niger. In the controversy over the dating, it has been argued that there is no evidence of trade with the Islamic north earlier than the eleventh century, and hence the dating of the Igbo-Ukwu finds must be erroneous. But trans-Saharan trade between the southern forest nations and North Africa predates the arrival of the Arabs there in the eighth century.[16] Shaw maintains that, by the 'Early Contact Period' (400 B.C.-A.D. 700), 'negroid people were in contact with Berbers of the desert who were by that time equipped with camels and ferried West African gold (from ancient Ghana) across the desert'. By these means, they could well have reached the borders of the southern forests with Mauretanian copper.[17] But copper supplies from the mines at Azelik in Niger, much nearer to Igbo-Ukwu, are the most likely source of raw material, since these mines were in operation as early as the first half of the first millennium B.C.[18, 19, 20]

The occupation of the area by Igbo- and Ijo-speaking peoples is thought to have started much earlier than 1,200 years ago.[21, 22] Ivory and slaves were the most likely export commodities available in abundance at the time. There was a demand for ivory in parts of the Mediterranean and in India, and the trade was well established on the North African coast in Roman and Byzantine times. It may have been interrupted by the invading Arabs but was soon revived by them. Cola nuts were perhaps also exported from Igbo country.[23]

The Igbo in this area are - and apparently were, at least as far back as oral history traces - an acephalous society which, nevertheless, had a spiritual or religious leader, called the Eze Nri. The burial site, the regalia and ceremonial objects found may, therefore, have been connected with the Eze Nri; though the elaborate burial may have been that of the bearer of a non-hereditary title, bestowed for personal achievements. Whatever the structure of the society at the time that the artefacts were made, it apparently came to a sudden end, possibly through hostile actions. The religious leadership was later revived, and the position of the Eze Nri is still strong today.

The most important aspects of all the art objects discovered at Igbo-Ukwu are their style and iconography, totally unlike those of the sculpture and artefacts found at Ife or Benin. The delicate, filigree-like work of the castings made in the lost wax technique by masters of their trade [119, 120], and the use of insects as part of the decoration of vessels in the shape of sea-shells, are atypical of African art. Yet, as both archaeological and ethnographical research progresses, tentative comparisons are being made with styles of the Yoruba and the Igala to the west; with Ikom and

Bamileke to the east; and with the 'Sao' region to the north.[24] The 'Sao' certainly used spiral or plaited rope motifs comparable with Igbo-Ukwu decorations.

The Igbo-Ukwu style may well have been a strictly local phenomenon, though possible influences by artists of immediate or more remote neighbours should not be excluded. The fact that no traces of a metal-casting industry that could have produced the bronzes of Igbo-Ukwu have been found in the immediate vicinity of this site must also turn our search for information to adjacent territories.

119. Shell of a snail, possibly ceremonial cup, surmounted by a spotted animal (? leopard); the fine decorations are typical of Igbo-Ukwu work. Probably from Igbo Isaiah. Bronze. 20.10 cm (7.9 ins). National Museum, Lagos. Courtesy National Commission for Museums and Monuments, Lagos. Photo: Werner Forman.

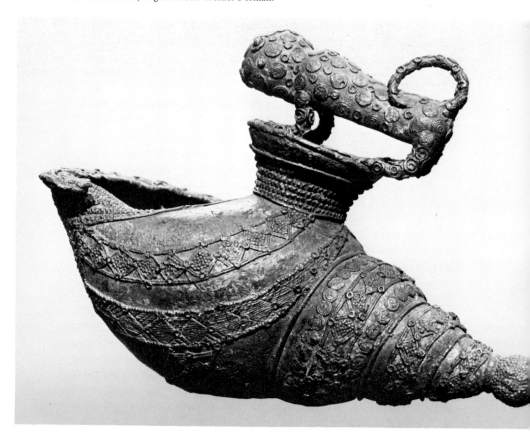

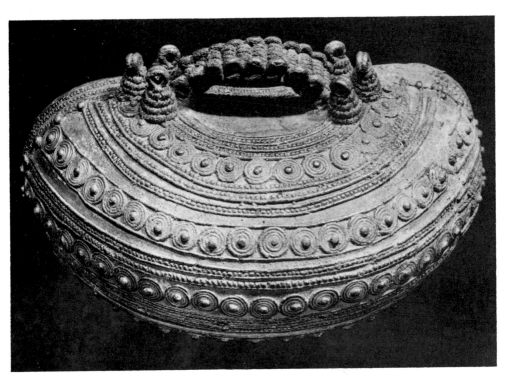

120. Bowl in shape of a calabash with handle and delicate spiral and rope decorations. Probably from Igbo Isaiah. Bronze. Length 13.9 cm (5.47 ins). Width 9.4 cm (3.78 ins). National Museum, Lagos. Courtesy National Commission for Museums and Monuments, Lagos. Photo: André Held.

Art of the Niger Delta and Cross River Areas

Widespread finds of copper alloy castings made over recent years in parts of the Niger Delta and Cross River areas have shown stylistic and iconographic affinities with objects from the Igbo-Ukwu excavations, and it is now widely believed that some of these castings were produced by itinerant Igbo smiths from Nkwerre, Awka and Abiriba.[25] The finds were made over wide areas, from the Forcados River in the western delta to the Andoni creeks[26] in the east, in Kalabari villages and some even far up the Benue River.[27] But the travelling smiths are only part of the developing story. The discovery by Nicklin[28] of what apparently was a major brass-casting (and iron-smelting) site on the western bank of the Cross River, and Peek's suggestion, based on recent fieldwork[29] in the Delta, that Isoko as well as Awka smiths produced copper-alloy castings in a number of places, leads to the conclusion that a number of 'Delta and Cross River

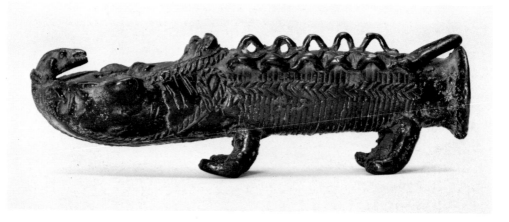

121. Mythical animal with zoo-anthropomorphic face on short legs. Ibo charm, *Ofo*. Believed to originate in the Western Niger Delta area. Bronze. 20.25 cm (8 ins). Formerly George Ortiz collection. Photo: courtesy Sotheby Parke Bernet.

Bronze Industries' did exist, and should in future be treated separately from the concept of a 'Lower Niger Bronze Industry'. Igbo-Ukwu may well have been part of the Delta and Cross River group.[30]

The art works discovered consist mainly of castings by lost wax, a technique no longer practised in the region of the Lower Niger Delta and the Cross River. Represented are human and animal figures or heads, some in the form of anthropomorphic bells [123]. Several sculptures are realistic; in others, human and animal figures are stylized to such an extent that the representation of spirits or supernatural beings must have been intended [121, 122]. Other bronzes found in quantities were calabash-type vessels, animal skulls [124] and cylindrical objects, possibly bells, flared at top and bottom, with fine overall filigree-type decorations. These, like the skulls, have a stylistic character comparable with the Igbo-Ukwu material, with which many Delta and Cross River objects share also single and reversed spiral as well as cordage motifs. In fact this comparison and common iconography must be extended to the Middle Benue,[31] and to the area of Lake Chad with its 'Sao' culture.[32] As many objects were actually discovered in shrines,[33] their use for religious cults cannot be doubted. Some were associated with the sacred chiefdoms of the Ibibio, the Bokyi and the Ejagham (or Ekoi). Other castings, twisted manillas and extruded, hammered or chased artefacts, were prestige items forming leg and arm jewellery. Bells, many without clappers, outnumber all other copper alloy castings in the region and were surveyed and classified by Neaher.[34] She makes reference to Benin-influenced castings,

122. Human figure with bells, spiral and rope decorations. From Lower or Middle Cross River. The style resembles three figures collected by Murray in 1946 (National Museum, Lagos, 46.16. 25-7) at Ikot near Itu in the Enyong Ibibio area of the Lower Cross River; the style and decorations are also seen in some Igbo-Ukwu bronzes. Bronze. 25.5 cm (10 ins). Musée Barbier Müller, Geneva, 1015-23. Photo: courtesy Musée Barbier-Müller.

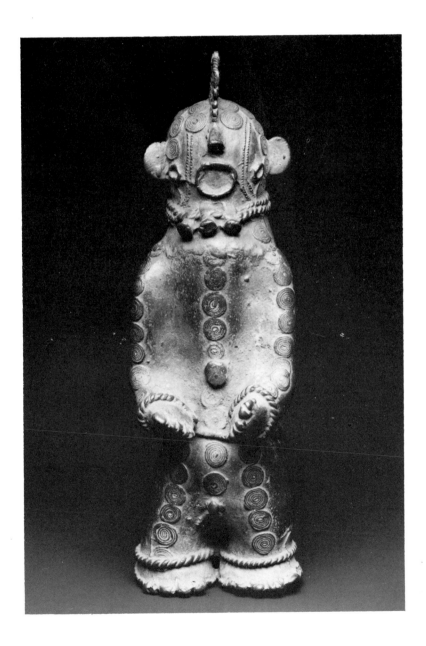

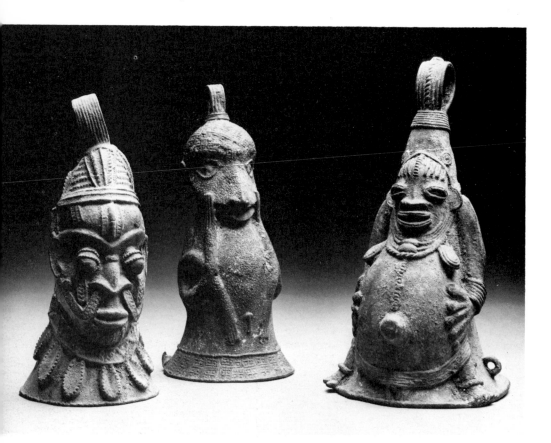

123. Three bells. From Forcados River area, Niger Delta. Bronze. *Left:* 15.5 cm (6.1 ins).
Snakes issuing from nostrils. *Middle:* 15.5 cm (6.1 ins). *Right:* 17 cm (6.7 ins). Collection
Baudouin de Grunne. Photo: Roger Asselberghs.

to the Igbo-Ukwu corpus of brasses in south-eastern Nigeria, and to a
possible relationship of the region's bronze industry with those of the
Cameroon grasslands, Adamawa and the 'Sao' culture of Chad.

Although the area as a whole has been settled for a very long time,[35, 36]
few brass sculptures have as yet been dated. Uncorroborated statements
that some objects are 'at least 500 years old' have been made, but the
earliest recorded dating is of the mid seventeenth century, for the casting
of a stylized carnivore skull from a burial site at Oron.[37] The traditional
style and use in shrines continued until quite recent times, and two objects
in actual ritual use in an *asunaja* shrine in the Middle Cross River area
were recently dated by thermoluminescence showing A.D. 1855 ± 12 and
A.D. 1827 ± 14 respectively.[38] However, if the association of the copper-
alloy industries in the region with the Igbo-Ukwu culture is taken to its

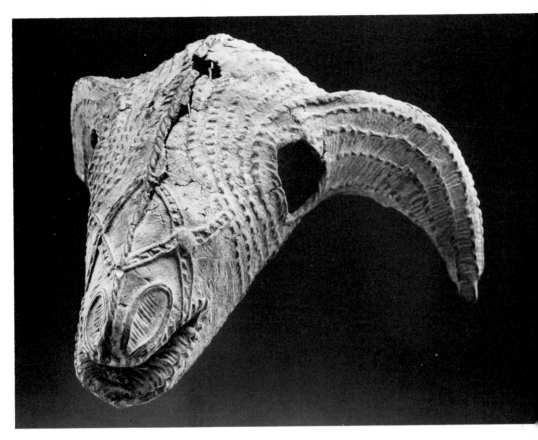

124. Horned head of an animal (ram). Probably from the Niger Delta or the Cross River area, judging by style and decoration which is comparable with [119] and [120] from Igbo-Ukwu. Bronze. 16 cm (6.3 ins). Collection Baudouin de Grunne. Photo: Roger Asselberghs.

logical conclusion, the origins of Delta and Cross River metal-casting must go back to about A.D. 1000. The pottery figures are generally older than the metal sculptures, which may have been modelled on clay images. Masks fashioned in terracotta and unearthed at Ke in the Niger Delta have been dated as early as the tenth century A.D.[39]

Wood carving is probably as old as pottery in most parts of Africa, but discoveries of early sculptures are very rare indeed. It is therefore of particular importance that several hundred wooden ancestor figures, many of great artistic excellence, were found in and around the area of the Oron, a sub-tribe of the Ibibio people, on the Cross River estuary [126]. Made of hardwoods, reasonably resistant to climate and termites, and well looked after by adherents of the ancestral cult *ekpu*, some of them are estimated to be up to 300 years old. They are in a style which has no

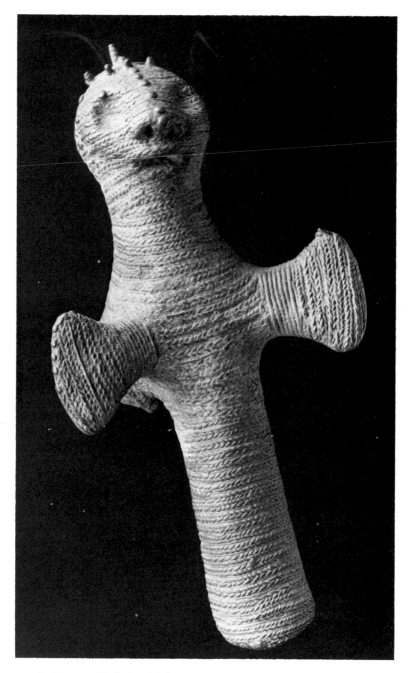

125. Anthropomorphic figure with short arms and cylindrical body, neckrest (?); with fine skeuomorphic decorations. From Middle Cross River (or possibly Tiv, Benue River). Bronze. 31 cm (12.2 ins). Collection Baudouin de Grunne. Photo: Roger Asselberghs.

126. Ancestor (*ekpu*) figure with long beard, holding two staffs; crocodile and spiral decorations, conical hat; legs are missing. Oron. Cross River area. 19th century. Wood. 109 cm (42.9 ins). Courtesy National Commission for Museums and Monuments, Lagos. Photo: André Held.

obvious relation with that of other people in the area, except perhaps with the *Akwanshi* stone figures [128].[40] But the Oron style has affinities to that of Eket[41,42] and both are examples of an 'archaic' Ibibio style.[43] These skilfully carved figures are recognizable by their construction from elemental geometrical shapes. Their faces, however, are of individual character, representing the male ancestor *ekpu* in whose memory they were carved. Though their style is idiosyncratic, a certain number have spiral decorations, linking them to many other cultures in the area and beyond. They were first observed by Murray in 1938 when he saw them in *ekpu* shrines, some of which were already in a state of neglect owing to the decline of the cult. But 666 figures were collected and assembled in the Rest House at Oron and in 1959 were transferred to the new Oron Museum. The Biafran war broke out in 1966; and in the course of this tragic chapter in modern Nigerian history, over 500 *ekpu* statues disappeared. Some are believed to have been stolen and subsequently sold overseas, many to have been used as firewood by soldiers and refugees. When the rebuilt museum was opened in 1976, only 116 figures could be traced, and some of these are now on exhibition at Oron, Lagos, Jos and Kaduna.

Although old wood carvings are rare in sub-Saharan Africa, there is yet another example of ancient wooden sculptures in Cross River country. These were made by a small tribe, the M'bembe, neighbours of the Ibo and the Ejagham. But the individual style of the M'bembe is quite different. They carved huge slit drums, measuring three to four metres, whose powerful call was heard over long distances when the people were summoned to attend ceremonies or to prepare for war. The drums are also reputed to have been used as altars on which human sacrifices were made. Very few complete drums were ever taken to Europe, but statues representing ancestors[44] were detached and appear in some collections [127].[45] These drums and sculptures seem to be of considerable age; and one in the Berlin Museum für Völkerkunde, collected in 1907, may well have been 100–200 years old at that time. The report of the collector, von Stefenelli, that 'the drum, according to the evidence of local chiefs, is about 400 to 500 years old'[46] is now believed to be exaggerated. The drums, as well as separate ancestor figures, were made of the very hard wood of *Afzelia africana*, and the drum-related sculptures were carved against the grain of the timber. This gives the powerful figures the appearance of eroded sandstone and lends them additional grandeur and monumentality.

The Ejagham – or Ekoi – inhabit the area between the bend of the Cross River and the south-eastern boundary of Nigeria, spilling over into Cameroon, still further east. They speak a Bantu language, and the area is of special importance as the probable centre of the 'nuclear Bantu' from where the eastward migration started. In a section of Ejagham land are five small communities, speaking different dialects of the same language.

127. Commemorative figure of chief, which once formed part of a giant drum. M'bembe. Cross River area. 19th century. Wood. 82 cm (32.15 ins). Private collection.

128. Three *Akwanshi* monoliths representing sacred chiefs. Stone carvings, two standing and one fallen, in phallic form with protruding navels; the centre monolith has spiral decorations. Height of nearest 122 cm (48 ins). Photo: courtesy Philip Allison (taken in the field).

They were hostile to each other and frequently involved in internecine wars, though each group consisted of no more than a few thousand people. It is now considered that these people are ethnically and linguistically unrelated to the Ejagham.[47] In this restricted area – less than 400 square miles – many stone sculptures were found [128], called *Akwanshi* by the Nta and Nselle, two of the five communities, and this name means literally 'dead person in the ground'.[48] Some were first seen in 1905 and thought to be of Ekoi origin. A survey by Philip Allison for the Nigerian government in 1961/2 showed that there were twenty-nine separate groups, mostly arranged in circles, with eleven single sculptures – a total of 295

carved stones. These carvings of natural boulders are of basalt, limestone and sandstone, often apparently phallic, and they all represent men, many of them bearded and with protruding navels. Present inhabitants of the area state that they 'grew out of the earth'. It is thought that they were carved over a period of 300 years ending at the turn of the century.[49] The *Akwanshi* vary from 30 centimetres to 2 metres in height, and the tallest could weigh half a ton. Many carvings have naturalistic heads and are apparently a development from a purely phallic column. Some have facial features resembling the Oron wooden *ekpu* figures. Decorations and scarifications vary enormously, and some may be related to Ejagham and Tiv body ornamentations. Spirals and concentric circles, which may point to older associations and traditions, are also frequently used.[50]

129. Skin-covered wooden headdress; *ekarum*, horned animal head, used in ceremonies of hunters' society. From Akparabong, Ikom. 19th century. Length 60 cm (23.62 ins). National Museum, Lagos. Courtesy National Commission for Museums and Monuments, Lagos. Photo: André Held.

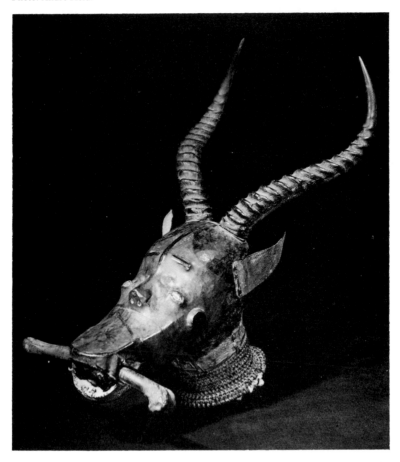

The Ejagham are believed to be the originators of the skin-covered masks which are unknown in any other part of Africa or, indeed, anywhere else in the world. This type of artefact has spread from the Ejagham to the Ibo and Ibibio to the west and north-west; to the Keaka, Anyang, Widekum, Bamileke and other grasslands groups in Cameroon, and to a few other communities to the east and north-east.[51] The use of these masks is believed to have originated in the custom of victorious warriors dancing with the severed head of a slain enemy.[52, 53] Some of the older masks may have been covered with human skin, but antelope skin has been used on wooden masks now in collections. However, some museums are said to describe pieces in their catalogue as being covered with human skin.[54] These masks represent both human and animal heads, some beautifully naturalistic, others rather brutal. Most of those in museum collections are not older than the nineteenth century, and the age of the tradition is unknown. In recent times their use was restricted to funeral and initiation ceremonies, and they were owned by warrior and huntsmen societies or age-set groups, but they may have been used in ancient times by associations whose activities are reported to have been connected with human sacrifices and head-hunting.[55]

To the west of the territory of the peoples whose art has been surveyed in this chapter live many other nations of the Federation of Nigeria. The largest among these are the Yoruba, the subject of the next chapter.

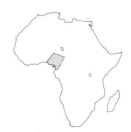

The Yoruba and
Their Neighbours

The Yoruba people, numbering some 12 million, are the largest nation in Africa with an art-producing tradition. Most of them live in south-west Nigeria, with considerable communities further west in the Republic of Benin (Dahomey) and in Togo. It appears from the evidence of linguists that the Yoruba have been established in the area for several thousand years. As to their origin, we have only the popular legend that 'they came from the east'.

They may have received 'new infusions of blood'[1] from waves of immigrants or itinerant artists bringing with them new technologies. Contacts with art centres along the Upper Niger, in the Benue Valley and further away could have influenced certain stylistic characteristics in Yoruba art. This would explain similarities between Nok, Ife and modern Yoruba sculpture. A common ancestry with Nok cannot be excluded, but no proof of such a relationship has as yet been found. Whatever the outside influences may have been, Yoruba culture grew out of their own socio-political and religious organization; developing over the millennia from dispersed groups of chiefdoms to the rule of divine kings supported and controlled by powerful hierarchies.

The Yoruba have been city dwellers since very early times, and founded urban centres of great importance and power, possibly as long as 1,000 years ago. Some of their towns became centres of art with the spiritual capital at Ile-Ife, founded according to legend by the ancestral Odudua who was sent by Olorun, 'God of the Sky', to create the world. This Yoruba myth of creation made Ife the heart of Yoruba kingship and the seat of the Oni, who was the religious head of all Yoruba people. His powers derived from his direct descent from Odudua. Although many other Yoruba city states claim to have been founded by a son of Odudua, none achieved the eminence of Ile-Ife.

The Yoruba are still prolific carvers and produced outstanding art until quite recent times. We thus have a situation, unique in West Africa, of a nation which created the ancient art of Ife and Owo (and whose present style has unmistakable similarities with Nok sculpture created 2,500 years ago) still carving and observing the customs of their forefathers. The study of these customs, with the possibility of comparing the work of

contemporary carvers and the connection of their work with the institutions, religious beliefs and social structure of the Yoruba today, allows a rare insight into the history of an important segment of African art.

The Art of Ife

The greatest artistic manifestations of the Yoruba – and, in fact, of black sub-Saharan western Africa – are the bronzes and terracottas of Ife. The art discovered in and around the city has been dated from the twelfth to the sixteenth century A.D.; but as no undisputed primary excavation has yet been carried out, the artefacts buried and re-buried for safety might well have been made in an even earlier period. It has been established by radiocarbon testing that the city was occupied from the sixth century A.D., but Willett warns that such dating may require adjustments.[2] A similar view, based on several theories, is also expressed by Wai Audah, who maintains that 'there is a real possibility that Ife dates back to at least the sixth century of our era'.[3]

The question is whether these dates of occupation can in any way be related to the people who produced the small number of bronze and terracotta objects, all of the highest artistic quality. In spite of the proven great antiquity of the present site of Ile-Ife, the city was first mentioned in European documents in the mid nineteenth century, although Benin was already described by the Portuguese in A.D. 1485.[4] Furthermore, the splendid artefacts found have all been masterpieces, and no traces of early beginnings by less accomplished artists have been discovered. No signs of a bronze-casting industry have been found in the area of Ile-Ife, nor are there any surviving guilds of casters or sculptors of pottery, which would point to an ancient tradition in these arts. The recent Onis of Ife do not appear to have attached any great importance to these works. They were placed in shrines, sometimes of nineteenth-century origin, divorced from the ancient myths or the true significance of the objects.[5] Fagg quotes an example of this confusion:[6] 'At Igbo Idio in the centre of Ife, the most important of all shrines of Odudua, and the very spot where earth was first created from the primeval ocean, the priests preserve one famous relic of the god, "Odudua's drum".' This is in fact a large crucible for the production of bead glass, and it was obviously attributed to Odudua long after bead-making had disappeared and the function of the crucible had been forgotten.

The people of Ife were forced to leave the town and surrounding area on two occasions during the nineteenth century, and it is possible that similar events occurred in the more distant past. Ryder quotes an early scholar of Yoruba history, who maintained that 'the present town of Ile-Ife should not be taken as the original Ile-Ife ... the old Ile-Ife was much farther in the interior'.[7]

9. The Burkina Faso, Akan (Ghana), Bight of Benin, Niger Delta and Cross River area.

The site of today's Ile-Ife was once a key position, controlling the trade routes northward from the forests. This was the power base for the development of the city state with the Oni as its king. When Ife lost this key role, it nevertheless retained its significance as the origin of kingship in the area; the Yoruba states, whose allegiance to Ife as their religious centre prevailed, continued to pay tributes. This position and the Odudua myth sanctioned the role of the Oni as ruler over the many Yoruba kings and, above all, the establishment of an Ife dynasty to govern the city of Benin. Ife was also engaged in foreign trade with the neighbouring countries and with northern Africa. It is possible that the export of slaves was the main source of revenue. But this, says Shaw,[8] does not detract from the art, since 'the institution of slavery underlay the artistic production of ancient Greece – and we do not think worse of them for that'.

The first sight that Europeans had of Ife art was through a gift by the Oni to Sir Gilbert Carter (then Governor of Lagos) of three quartz stools. One of these was given by Sir Gilbert to the British Museum in 1896,[9] and the other two are now in Lagos. The one in the British Museum is the only complete example of such a stool, and is universally admired for the remarkable technique employed. Quartz is a very hard but brittle stone, and only the greatest skill could have achieved this intricate carving. These stools are believed to be reproductions of wooden box-stools known from Ife, Benin and several other places in the Guinea Coast area.[10] They may have served as thrones for the 'divine' Oni, whose feet were not allowed to touch the ground. Similar stools were also made of granite and soapstone and copied in terracotta and bronze.

In 1908, Europeans discovered the stone carvings at the Ore grove of Ife. These were two male figures worked in granite, hands clasped over stomachs, dressed in garments reaching almost to the ankles, with decorative tassels on the side; and wearing carved necklaces and bracelets of heavy beads.

The taller figure – called the Idena – is over one metre high, naturalistic and in proportions nearer to life than most other Ife sculptures. The features are negroid, and the hair is indicated by iron nails driven into the stone. The other figure, usually called Ore, is almost 90 centimetres tall, and its proportions resemble those of Yoruba wood carvings, with the head constituting about a quarter of the total height.

The first classical Ife work known to the outside world is a terracotta head in the Guennol Collection, New York, of which a plaster cast has been in the British Museum since 1900.[11] The most exciting discovery occurred, however, in 1910, when the German Africanist and ethnographer, Leo Frobenius, acquired a number of pottery sculptures and one nearly life-size bronze head in a naturalistic style atypical of West African art. All these objects were of great classical beauty; and Frobenius believed that what he had discovered were the works of Greeks from the lost colony

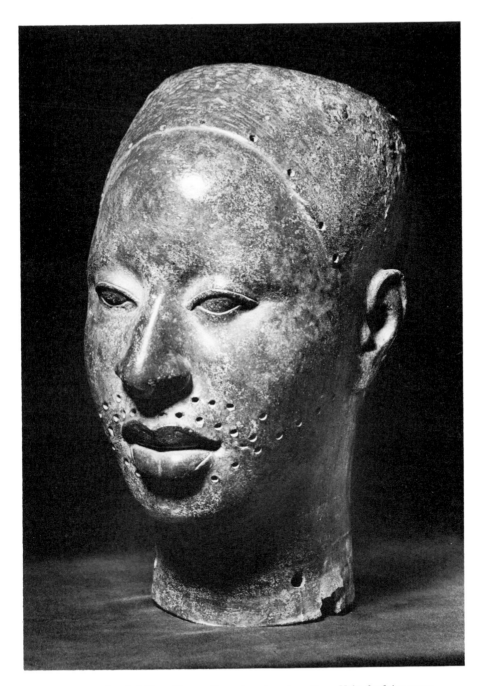

130. Head of an Oni. From Wunmonije. 12th-15th century. Brass. Holes for fixing crown or hair and beard or veil, and nailholes in neck. 29.5 cm (11.6 ins). Museum of Ife Antiquities. Courtesy National Commission for Museums and Monuments, Lagos. Photo: André Held.

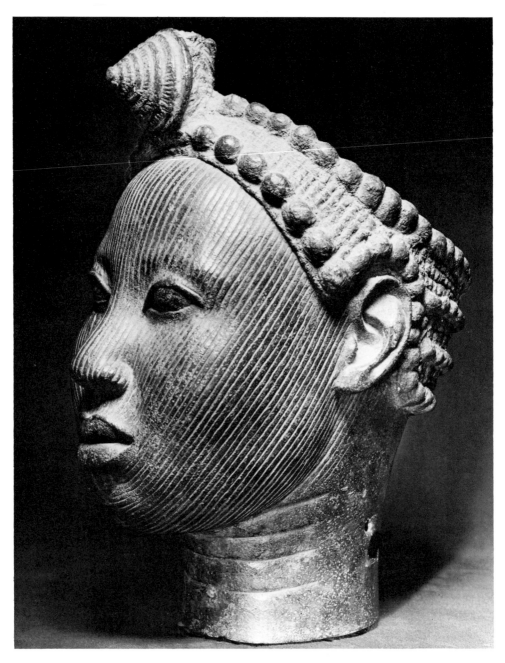

131. Head of an Oni with crown and facial striations. From Wunmonije. 12th-15th century. Brass. Nailholes. The rings around the neck (on this and other heads) are still considered attributes of beauty by today's Yoruba. 24 cm (9.45 ins). Museum of Ife Antiquities. Courtesy National Commission for Museums and Monuments, Lagos. Photo: André Held.

of Atlantis who, he thought, had come to the forests of Ife from North Africa in the thirteenth century B.C. The bronze head was found in the grove of Olokun, the Yoruba goddess of the sea, and Frobenius was convinced that Olokun was, in fact, Poseidon.[12] Others also concluded, like Frobenius, that these beautiful objects could not be African but must be the work of Greeks, Romans or even Dynastic Egyptians.

In the course of time it was established that the objects were the creations of African masters. Conclusive evidence was provided at Ita Yemoo, where figures with classically beautiful heads but in typical African proportions of head and body were unearthed. They are now considered to be among the greatest works of art in the world. Frobenius took seven terracotta pieces to Berlin but was forced to leave the 'Olokun' head behind. That head was supposed to have been safely deposited in the Oni's palace together with all the later finds of Ife art. But during a visit to the city in 1945, the British sculptor Leon Underwood had his suspicions aroused by the casting; and when, three years afterwards, all the bronze heads were sent to the British Museum for treatment, he and Fagg became convinced that this Olokun head was a copy of the original.[13] It is now generally accepted by experts that the head presently in the Ife Museum is a modern sand cast. The fate of the genuine Olokun head, which would have been made by the traditional lost wax technique, remains unknown.

During building works in the Wunmonije compound adjacent to the palace, a magnificent discovery of thirteen life-size 'bronze' heads – five actually cast of pure copper – was made in 1938. In the following year, four more such heads and the upper part of a full-length figure, apparently representing an Oni, were dug up in the same compound [130, 131]. The half figure of the Oni[14] in splendid regalia was called 'Lafogido' after a king buried near the Wunmonije site. In about 1937 the Oni disclosed that he had in his possession a mask made of copper, as classically beautiful as the heads. According to him, this mask is the likeness of Obalufon, the third Oni, who is reputed to have started metal-casting. He also stated that this mask had always been kept in the palace; but this has never been corroborated. It is now referred to as the 'Obalufon mask' and has been transferred to the Nigerian Museum [132].

The treasure-trove found by workmen in 1957 at Ita Yemoo included a complete figure of an Oni, 47 centimetres high, apparently in coronation robes [133], and a linked pair of what is thought to be an Oni and his queen, 29.6 and 26.8 centimetres high respectively [134]. The face of the Oni was unfortunately shattered by a workman's pickaxe, and as the metal was as brittle as glass, no traces of broken bronze were found. The couple are wearing their crowns, ankle-length robes, and many beads and other adornments. The Oni's left leg is twisted round the right leg of his queen (in an anatomically impossible fashion), and their arms

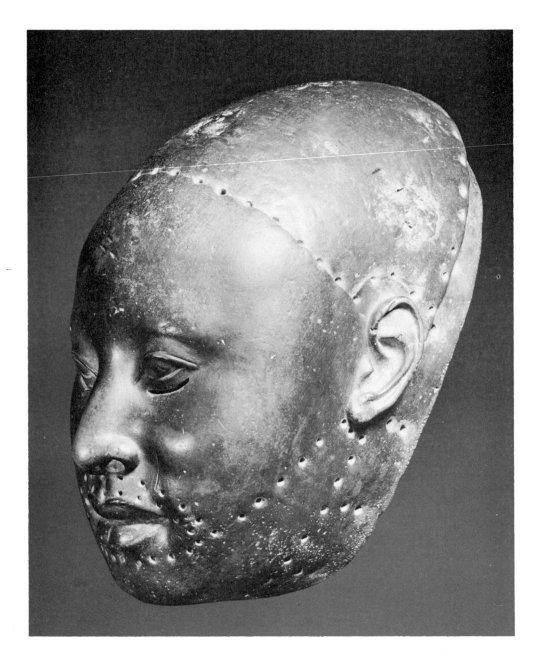

132. Mask. Said to represent Oni Obalufon. From Oni's Palace, Ife. Copper. Holes on hairline and for beard or veil attachment. 29.5 cm (11.6 ins). Museum of Ife Antiquities. Courtesy National Commission for Museums and Monuments, Lagos. Photo: André Held.

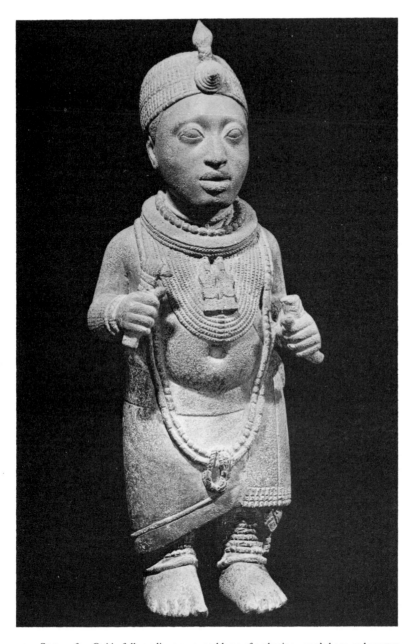

133. Statue of an Oni in full regalia: crown, emblems of authority – ram's horn and sceptre in hands and double bow on chest; heavy beaded collar and rows of beaded necklaces; long ropelike string of cylindrical beads; rows of anklets; wrap from hip down, tucked between legs. From Ita Yemoo. Early 14th–early 15th century. Brass. 47.1 cm (18.54 ins). Museum of Ife Antiquities. Courtesy National Commission for Museums and Monuments, Lagos. Photo: André Held.

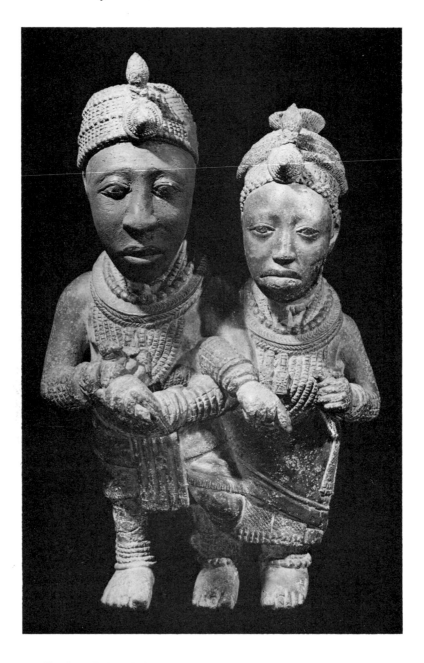

134. Royal couple, both in full regalia. The Oni's face has been restored. His left leg is wound around his queen's right. Regalia, decorations and dress are similar to [133], but the queen's dress reaches to the armpits. From Ita Yemoo. 12th–15th century. Brass. 28.57 cm (11.25 ins). Museum of Ife Antiquities. Courtesy National Commission for Museums and Monuments, Lagos. Photo: André Held.

are interlocked. The man's wrap is tucked between his legs, and the couple are sculpted in traditional African proportions. This is technically perhaps the most extraordinary casting among all the Ife bronzes.[15] Further finds at Ita Yemoo included a curious small figure, 12 centimetres high, of a queen curled around a bowl atop a round stool of typical Ife cotton-reel shape with a tubular loop connecting the support column with the seat, and the loop supported by a small four-legged stool. The queen holds a sceptre in her hand with a human head on top: two similar bronze maces, one with a gag in the mouth, were found in the same excavation [135].[16] These staffs, like other small castings, are among the finest and most artistically modelled of Ife castings, with expressive faces, furrowed brows and delicately indicated bone structure, quite unlike the impassive larger heads. One of the staffs, a Janus figure, depicts an old man; although in Ife and most other African art, people are usually shown in their prime, with idealized features. This kind of realism can also be observed in two terracotta heads, one from the Okesokun compound, the other from an unknown site.[17]

A 'bronze' figure, one of the greatest Ife sculptures [136], was discovered about 200 kilometres north of the city of Ife. It was seated in a Nupe village called Tada, one of a group of nine bronze figures, of which seven were at Tada and two at Jebba (one of the latter was stolen in the 1970s from the island); the remaining eight are now all in the museum at Lagos. They are collectively called the Tsoede Bronzes, having – according to legend – been brought from Idah, the capital of the Igala people, by Tsoede, a prince reputed to have founded the Nupe Empire. While the actual origin for eight of these sculptures has not yet been determined, the seated figure from Tada was clearly made by an Ife artist. It is the most naturalistic of all the known works of that origin; the only one in which the body proportions are true to life. The posture differs greatly from the usual rigidity and frontality of much African sculpture. A loincloth is tucked between the legs, also unusual in African art, though the male in the linked couple of the Oni and queen, and the Oni depicted [133], show the same feature. The arms and part of the right leg are missing – probably due to excessive ritual cleaning with gravel over the centuries – and the right leg would, when the figure was complete, have extended beyond the present base. The figure may, therefore, have been seated on a stool or throne.

Like the Obalufon mask and some heads, this Tada figure was cast of pure copper, a metal which is most difficult to work unless alloyed with tin, zinc or lead. While the Obalufon mask is an absolutely perfect casting, the artist who created the seated figure apparently experienced considerable difficulties, as it was patched in a number of places. This is not surprising, as the modelling and casting of such a large and intricate sculpture, especially in non-alloyed copper, is technically a most difficult enterprise.

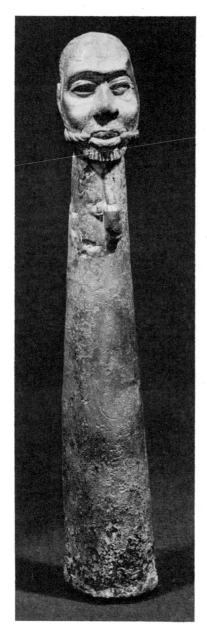
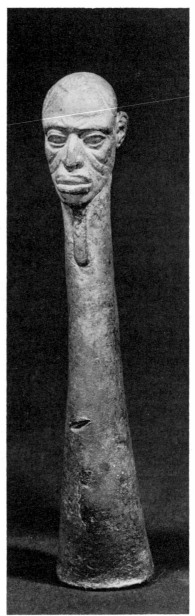

135. Two staffs surmounted by human heads (one with gag). From Ita Yemoo. 12th–15th century. Brass. *Left:* 23.5 cm (9.25 ins). *Right:* 25.5 cm (10 ins). Museum of Ife Antiquities. Courtesy National Commission for Museums and Monuments, Lagos. Photo: André Held.

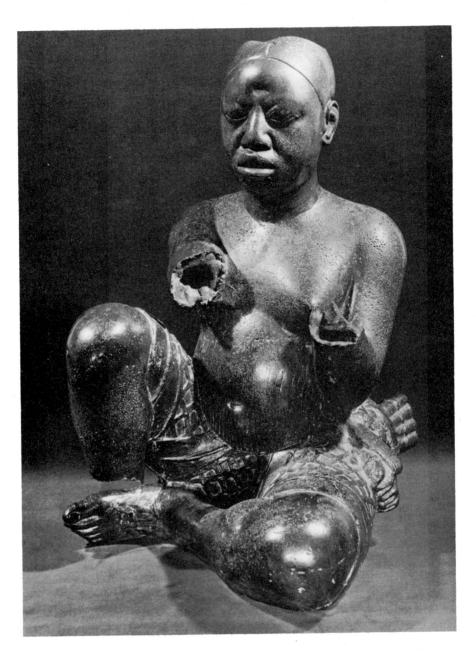

136. Seated male figure. In naturalistic Ife style. Wrap tucked between legs; arms and part of right leg missing; pitted surface caused by ceremonial scouring with gravel. From Tada. Late 13th–14th century. Copper. 53.7 cm (21.14 ins). National Museum, Lagos. Courtesy National Commission for Museums and Monuments, Lagos. Photo: André Held.

These 'bronzes' (the term is used collectively in this book for bronze, brass and copper castings) are undoubtedly masterpieces. But they number less than thirty (though more may still be buried under the town's buildings or elsewhere), and it has been suggested (by K. C. Murray) that they could be the work of one generation or even of a single artist.[18] Others, like Willett, reject that theory.[19] But whoever created them was working in the tradition of the Ife terracottas: much older than the bronzes and much more numerous and varied in style.

The terracottas are naturalistic and 'expressionistic' in style and some are abstract images. A terracotta head in the classical style [137] is called the Lajuwa head, after a usurper executed by the order of an Oni who ruled many generations ago. It was said to have been kept in the palace ever since it had been made, but no one has explained why a usurper should have a memorial in the palace; and besides, as traces of earth were found on the head, it is more likely to have been buried at one time and dug up recently. It was not part of a complete figure but was conceived as a head.

There are not as yet sufficient data available from archaeology or from a methodical analysis of styles to classify the various types of Ife terracottas. It was at one time believed that the geometrical or abstract heads were of an early date, followed by classical and post-classical periods. Bernard Fagg discovered, during excavations at Abiri, that naturalistic and abstract heads [138] were placed on the same altar. This fact was corroborated by the discovery at Obalara's Land of a ritual vessel[20] with the relief of a 'classical' head along with two abstract figures. However, this does not actually prove contemporary use, as the abstract heads may have been found and 'adopted' as holy figures, to be used in rituals alongside other images found at that time.

Inwinrin Grove, excavated by Kenneth Murray in collaboration with Bernard and William Fagg in 1953, and digs by Oliver Myers made at Igbo Obameri and at Odudua College, all produced artefacts, mostly terracotta sculpture and potsherds. The sites did not contain 'primary' material, i.e. material found in archaeological context. Ekpo Eyo, in his report on excavations at Odo Ogbe Street and Lafogido,[21] maintains that he found primary material there. But this claim, though credible for a potsherd pavement, is unsubstantiated. Similar tentative suggestions made by Willett regarding finds at Ita Yemoo,[22] which yielded some of the most beautiful ceramic sculpture of Ife [139], and by Myers on discoveries at Igbo Obameri, also remain uncorroborated.

Eyo recovered a lovely classical head at Odo Ogbe, and at Lafogido unearthed a potsherd pavement into which several pots, covered with beautifully modelled animal head 'lids', were sunk [140]. This was most probably the area of a religious shrine.

Excavations made by Garlake in 1971 and 1972 at Obalara's Land and

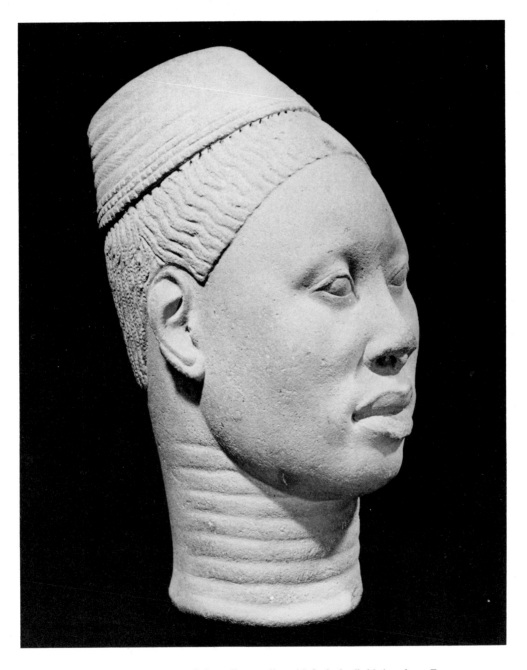

137. Head said to represent Lajuwa. Freestanding with finely detailed hair and cap. From Oni's Palace, Ife. 12th–15th century. Terracotta. 32.8 cm (12.9 ins). Museum of Ife Antiquities. Courtesy National Commission for Museums and Monuments, Lagos. Photo: André Held.

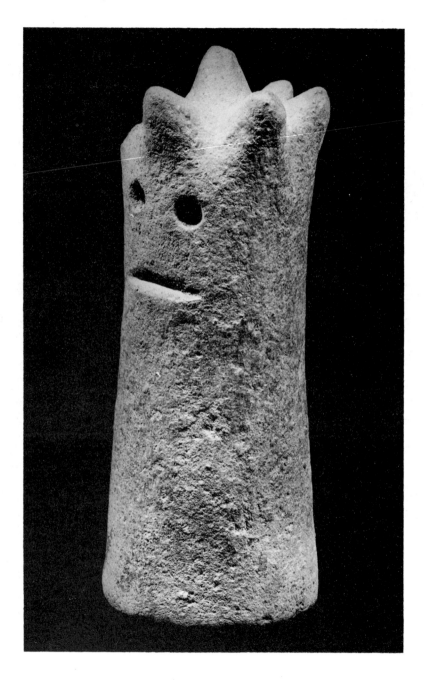

138. Abstract representation of human head, cylindrical. From Abiri. 12th-15th century. Terracotta. 16 cm (6.3 ins). Museum of Ife Antiquities. Courtesy National Commission for Museums and Monuments, Lagos. Photo: André Held.

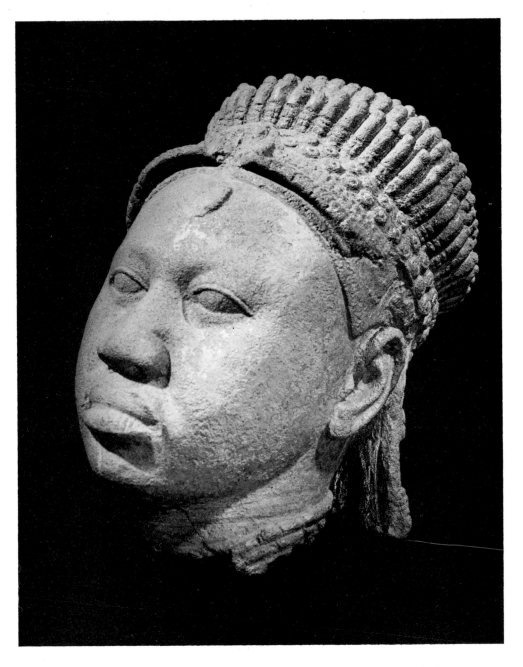

139. Head of a queen (broken off from a figure), wearing a crown of five tiers; a crest broken off has left a disc-like mark (compare with [47], Nok). From Ita Yemoo. 12th-13th century. Terracotta. 25 cm (9.84 ins). Museum of Ife Antiquities. Courtesy National Commission for Museums and Monuments, Lagos. Photo: André Held.

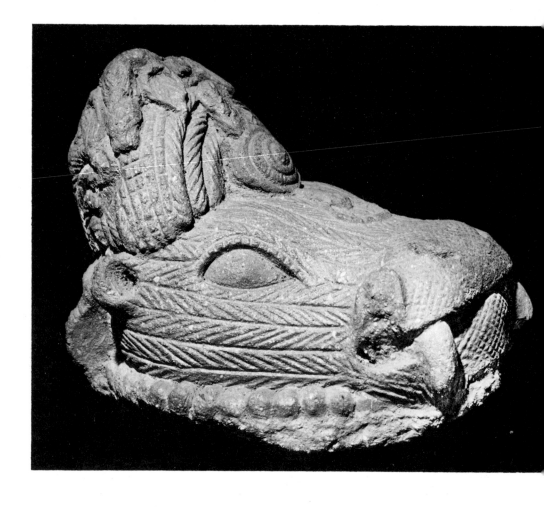

140. Head of mythical animal with royal crest. The decoration on top of the head is said to represent *akoko* leaves, as used by modern Yoruba in ceremonies installing a chief. Potlid from Lafogido. 12th–15th century. Terracotta. 12.5 cm (4.92 ins). Museum of Ife Antiquities. Courtesy National Commission for Museums and Monuments, Lagos. Photo: André Held.

at Woye Asiri deserve special mention because of the importance of the terracotta sculpture and potsherd pavements of shrines discovered.

The ritual vessel from Obalara's Land, already discussed, shows in relief a classical head with a snake descending on it, two abstract heads and other symbolic features. On the altar were two grotesque 'expressionistic' heads; several classical heads, with both striated and smooth surfaces; conical heads; and two terracotta male figures, standing on a plinth and both about 39 centimetres high.

At Woye Asiri, situated near the Ife–Ibadan road and in close proximity to Obalara's Land,[23] Garlake had the opportunity of excavating one of the last seemingly undisturbed plots of land of old Ife. It, too, was already scheduled for building operations.[24] He found there pottery of various shapes, including some with extraordinary decorations. The dating, very similar to Obalara's Land, at A.D. 1190 ± 85 to 1470 ± 95, showed that the area was occupied from the twelfth to the fifteenth centuries. The well-preserved pavement, made of potsherds set on edge in the ground in herringbone patterns, had semicircular niches for altars and a pot buried in the centre, apparently meant for libations. Such pavements, made of broken potsherds, have been found on prehistoric sites from Chad to Togo,[25, 26] and are also a feature in Benin. Pavements with potsherds set on edge were particularly numerous in Ife, but the method was also used in some of the other sites mentioned.[27]

While a great deal is known on the use of all types of art from the city of Benin, the purpose for which Ife bronzes and terracottas were created is largely hypothetical. In Garlake's reconstruction of a shrine at Woye Asiri,[28] it is convincingly assumed that terracotta figures were placed on altars, but it is not known whether they represented ancestors or deities.

As the heads – and other objects found in context – were from 'secondary' excavations or accidental finds, their primary purpose is certainly not apparent. The bronze heads are few, and it is unlikely that they represented individual Onis. Some of the Ife bronze heads were cast with a crown, while others – of larger size – have holes provided which may have served for the attachment of real crowns [130].[29] All heads have holes in their necks – in some of these nails were found – and it is therefore possible that they were meant to be nailed to wooden effigies for second burials.

Such ceremonies are not uncommon in Africa, where the dead are usually buried quickly because of the climate, and a ceremonial burial may take place after a considerable period of time. This would allow for the arrival of mourners from distant places and the collection of enough money to organize a funeral with the dignity and pageantry due to the status of the departed. The head would thus represent the royal or noble office and status rather than being a portrait of the dead person. Such customs were also observed for royal funerals in medieval England and

France; and in Owo, the use of a wooden effigy with a head closely resembling the deceased was reported to have been used in a 'second burial' ceremony – called *ako* – as recently as 1944.[30, 31]

The figures of Onis and the linked figures of a royal couple may be commemorative statues of specific kings or of their coronation. Alternatively, these sculptures may have been used in a royal ancestor cult. The mace heads and the staffs with gagged figures are possibly connected with ceremonies in which human sacrifices were made.[32]

There is no satisfactory explanation for the fact that there are striations on some of the heads, faces and bodies of Ife sculpture, while others are without such marks. Nor is there any viable theory on the differences in the types of striations, from fine lines to heavy raised weals [141]. Regarding the latter, Willett was told by Sir Adesoji Aderemi, the Oni of Ife, that it used to be the custom of the royal family to paint their faces with an extract of blister beetles (*cantharidae*) for certain festivals.[33] On the subject of the fine striations, Fagg has offered a new hypothesis to the author:[34] 'The following explanation occurs to me for the fact that only about half of the Ife bronzes (and presumably royal terracottas) are striated. Suppose that the royal lineage was already divided into two (or four) families for the purpose of succession, the families alternating to provide the Oni. It is not then too great a leap – though we are unlikely ever to learn the explanation of it – to suppose that one of the two families (or two of four) chose to practise scarification while the others did not. This provides a simple solution of what has always seemed an intractable problem. Moreover – though the argument is circular – it also provides us with the first major fact of social organization about ancient Ife, and one derived from material culture.'

The half figure from Wunmonije also has striations on the body. Some lips are smooth and others are striated. These may be tribal marks no longer used in the area of Ife; or, as Fagg and Willett suggested in an earlier attempt at an explanation,[35] they may represent the royal veil or fringe of beads hanging from the crown. But the figure of an Oni from Ita Yemoo has a smooth face, and not all the striated terracotta heads may depict royalty.

The raised weals, more widely spaced on the faces than incised striations, are rarer. Such raised lines were also used to mark human faces in some Owo terracottas and on Igbo Ukwu bronzes. While Owo customs are obviously closely related to those of Ife, we have no justification for linking either of them with Igbo Ukwu traditions. Facial scarifications could be tribal markings, but those on the Ife sculptures do not resemble known Yoruba markings. The 'cat's whiskers' [142] on Ife heads may indicate foreigners, possibly of Nupe origin.

Beads have been used by Africans since very early times, as is evident from sculpture going back 2,500 years in the case of Nok, and to very

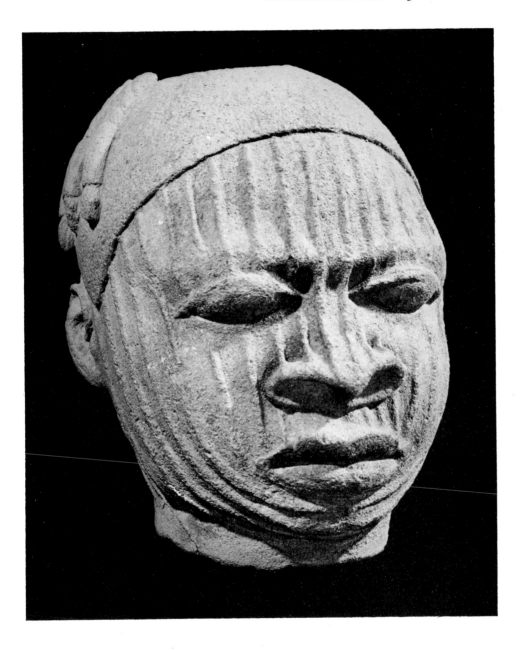

141. Head of man with raised weals. From Inwinrin Grove. 12th–15th century. Terracotta. 18.5 cm (7.28 ins). Museum of Ife Antiquities. Courtesy National Commission for Museums and Monuments, Lagos. Photo: André Held.

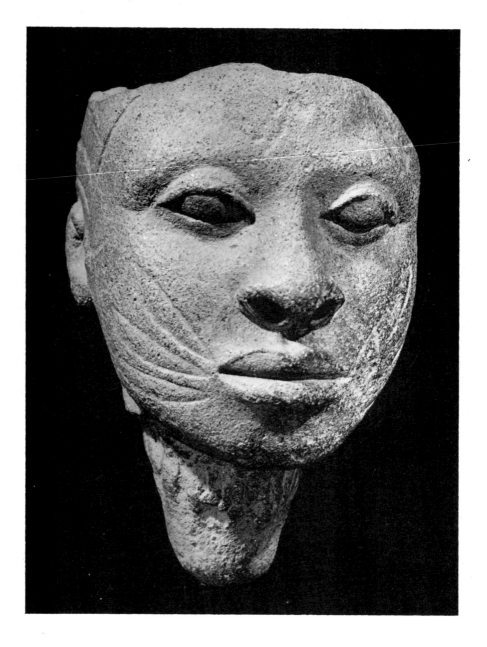

142. Fragment of head of man with 'cat's whiskers'. Broken off a figure. From Grove of Olokun Walode. 12th–15th century. Terracotta. 12.5 cm (4.9 ins). National Museum, Lagos. Courtesy National Commission for Museums and Monuments, Lagos. Photo: André Held.

ancient periods in Nubia. The beads made of glass or the glass for local production in western Africa were imported from Europe or from medieval Islamic sources.[36, 37] In Ife, solid evidence of a glass-working industry was first found by Frobenius in 1910, in the form of crucibles coated with glass in many colours and large quantities of beads in the Olokun grove.[38] Willett found glass beads from both sources during his excavations, and these, dated by radiocarbon, showed results varying from the ninth to the twelfth centuries.[39] In Garlake's excavation at Woye Asiri, fragments of glass-working crucibles were found and dated to the thirteenth or fourteenth centuries.[40] The source of beads used at dates earlier than that – as, for instance, those found in Igbo-Ukwu – remains unknown.

Between the old walls of Ife and the modern town is the sacred Ore grove in which two granite figures, the Idena and the Ore, stand.[41] In another clearing, surrounded by tall peregun trees, stands a carved granite column over 5 metres high called Opa Oranmiyan – the staff of Oranmiyan, the legendary founder of Oyo. It was first found lying on the ground in fragments, and was restored by Bernard Fagg, who ascribes a phallic significance to it. The 'staff' is decorated with iron pegs driven into one side in the shape of a trident. Another column 1.80 metres high stands in the market place of Ife and is called Opa Ogun, the staff of Ogun, god of iron and war. If reconstructed including the pieces found lying on the ground, the total height would be 6 metres. At a distance of about 75 kilometres to the north-east of Ife, in Ekiti country, there is a group of stone carvings seemingly related to Ife; some of them resemble the Idena figure,[42] yet they are much more stylized than the naturalistic figures in Ife proper.

Several conclusions can be drawn from this survey of information on the art of Ife and its relationship with that of other peoples. Large areas in the forest zone and in the savanna were occupied by organized art-producing nations at the beginning of the Christian era and, in some cases, earlier. Technical and stylistic similarities between Ife and Nok have been described; and pottery finds at Yelwa and other places in the vicinity of the Kainji Dam, as well as at Daima to the east of Nok, also show a relationship in style.[43, 44] It is very possible that artists and traders passed through the region of Nok and Yelwa on their way to Jebba and further south, diffusing technologies and styles.

The 'classical' period of Ife is thought to have lasted from the eleventh to the fifteenth centuries A.D., though terracotta sculpture is probably much older and may have started in the seventh century, within or outside the present city limits. When the technology of the lost wax process came to Ife from the north, the highly developed art of sculpting in clay was translated into copper alloy casting. Though the technique was introduced from the outside, the art itself was pure Ife.

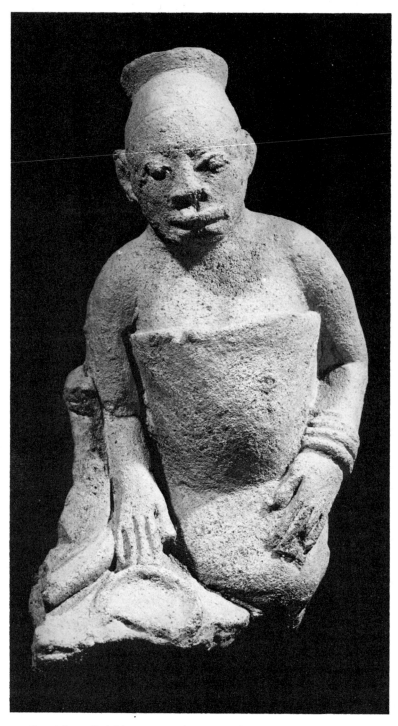

143. Seated figure. Probably once part of a group. 12th–15th century. Terracotta. 12 cm (4.72 ins). National Museum, Kaduna. Courtesy National Commission for Museums and Monuments, Lagos. Photo: André Held.

The end came in the sixteenth or seventeenth century and it was sudden. The cause was political, for the religious role of the Oni continued. Hostile forces and Mande merchants appeared on the approaches to the forests, imperilling the trade with the north. The centre of trade and the strongpoint for defence shifted to the fortified town of Oyo-Ile, which had become a military power, using cavalry against marauders.[45] As well as Oyo-Ile, the city states of Benin and Ijebu grew in importance and contributed to the decline of Ife in political and economic terms.

Owo, the 'Tsoede' and 'Lower Niger' Bronzes

Owo, another important Yoruba town, lies about half-way between Ife and Benin city. According to folklore and the town's historian, Chief M. B. Ashara,[46] the city state of Owo was founded by Ojugbela, youngest son of the mythical Odudua, in about A.D. 1200. Because of the impenetrable forests and swamps in the area, the route that connects Ife with Benin must go through Owo. This geographical factor and the

10. Nigeria: the Yoruba and their neighbours.

144. Ram's head. Placed on chief's ancestral altar. Owo. Wood. 40.5 cm (15.9 ins). National Museum, Lagos. Courtesy National Commission for Museums and Monuments, Lagos. Photo: André Held.

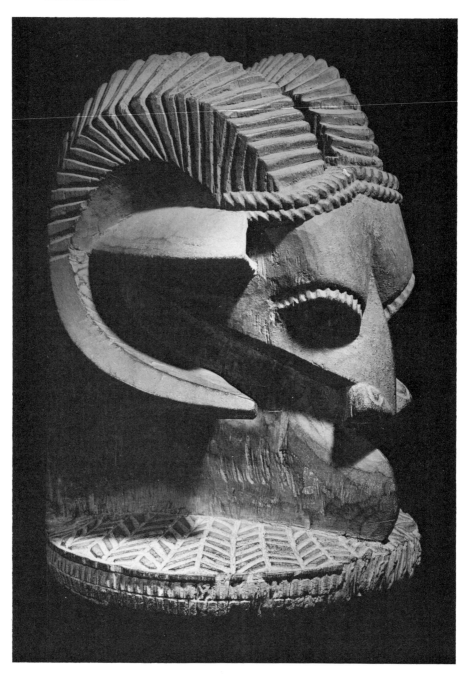

spiritual suzerainty of the Oni of Ife over the Yoruba kingdoms meant that Owo's art, now recognized as having a genius of its own, was influenced by both neighbours.

Wood carvings of rams' heads [144] or of human heads with rams' horns, used by Owo chiefs in their ancestor shrines, are similar to those used on Edo altars in and outside the city of Benin.[47] This would strongly suggest that contacts had existed between the cities for a long time.

Owo objects which were taken from Benin in 1897 (and some that had been known before or were discovered later) were attributed to Benin by

145. Fragment of small statue of (?) dwarf with weal striations. Probably broken off a tableau. Owo. From Igbo 'Laja. Early 15th century. Terracotta. 9.2 cm (3.6 ins). National Museum, Lagos. Courtesy National Commission for Museums and Monuments, Lagos. Photo: André Held.

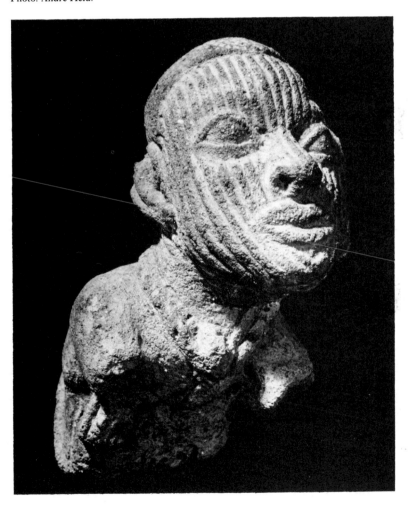

von Luschan and many others. The first time that Owo art was considered on its own merits was during the exhibition organized by the Royal Anthropological Institute in 1949,[48, 49] and the larger exhibition, 'Traditional Art from the Colonies', in 1951 in London. From these exhibits it became clear that here was a strong independent art style, though showing both Edo and Yoruba characteristics. The influences go beyond sculpture and are evident in architecture and the royal regalia.

In 1971 Ekpo Eyo carried out excavations at the site known as Igbo 'Laja, at the foot of the hill on which, according to tradition, the Owo

146. Fragment of figure with large necklace of beads and tassels. Owo. From Igbo 'Laja. 15th century. Terracotta. 25 cm (9.8 ins). National Museum, Lagos. Courtesy National Commission for Museums and Monuments, Lagos. Photo: André Held.

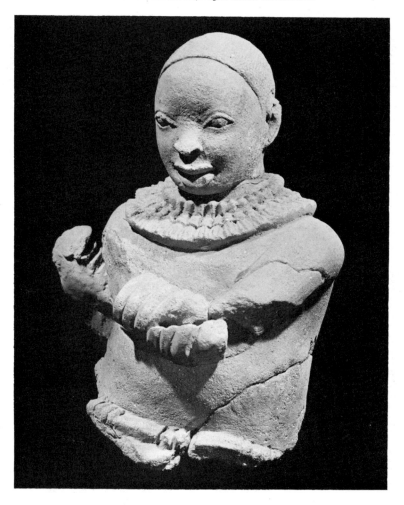

first settled, and near the Olowo's (king's) palace. A number of important terracotta sculptures were discovered in what had probably been a shrine [145, 146, 147, 148]. Some had been found by later generations and re-used long after the making of such pottery figures had ceased.

These sculptures, too, demonstrate the stylistic (and some iconograph-ical) relationship with both Ife and Benin, but they are also proof of Owo's individual character, since they are more vital and vigorous than the art from either.

147. Fragment from ritual pot. The snakes issuing from the mouth are one of the motifs linking Owo with Ife, Benin, 'Tsoede' bronzes and other West African cultures. Owo. From Igbo 'Laja. 15th century. Terracotta. 10.8 cm (4.25 ins). National Museum, Lagos. Courtesy National Commission for Museums and Monuments, Lagos. Photo: André Held.

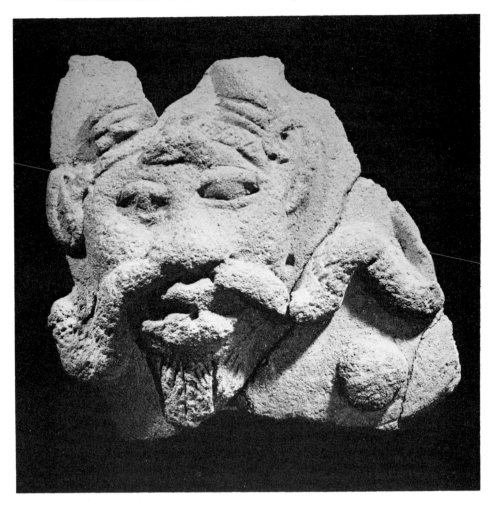

The radiocarbon dating of these excavations was A.D. 1435 ± 65, which implies that Ife, Benin and Owo produced art in the same time slot, although a date prior to A.D. 1500 for Benin remains uncertain.

Since the 1951 exhibition, scores of ivories, originally classified as Benin or Yoruba, are now attributed to Owo. Among them are two ivory armlets, which have been in the National Museum at Copenhagen since 1689, and which were first catalogued as of East Indian origin [150].[50] Symbols used on many of these ivories have been one factor leading to the recognition of Owo as a culture on its own, of considerable importance

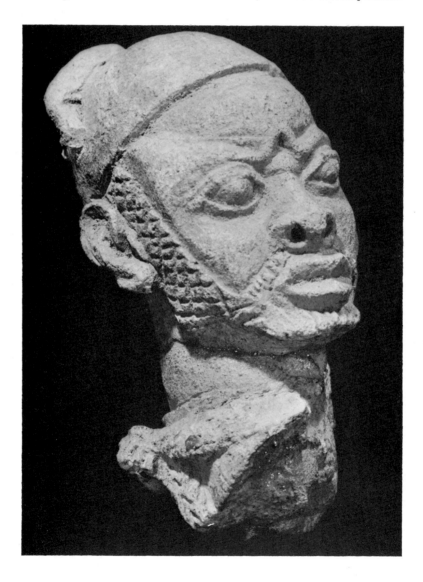

148 (*left*). Head and part of torso. Broken off a figure (and once part of tableau ?); frowning brow and sideburns, beard in hatched pattern. Owo. From Igbo 'Laja. 15th century. Terracotta. 11 cm (4.33 ins). National Museum, Lagos. Courtesy National Commission for Museums and Monuments, Lagos. Photo: André Held.

149. Ovoid bowl and cover, each with four panels intricately carved in relief. The panel shown depicts (*top*) a human-headed spread-eagled bird with two snakes emanating from the back, representing wings; (*bottom*) an elephant head, looking upwards, and four trunks grasping *akoko* branches. The other panels (not shown) are equally beautiful and well carved. Two other bowls of similar quality are in the Berlin Museum and the Museum of Mankind respectively. Owo. Ivory with ebony and coconut shell inlay. Height 21 cm (8.27 ins). Photo: courtesy Christie's, London.

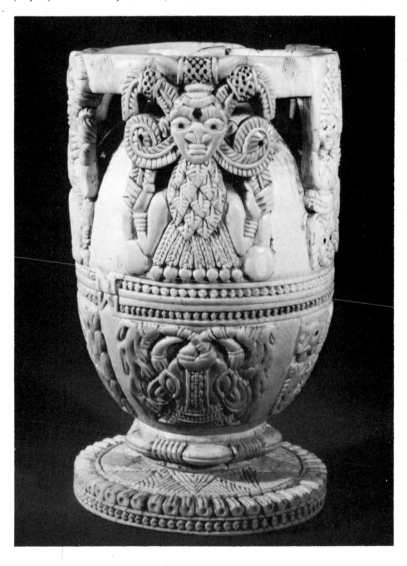

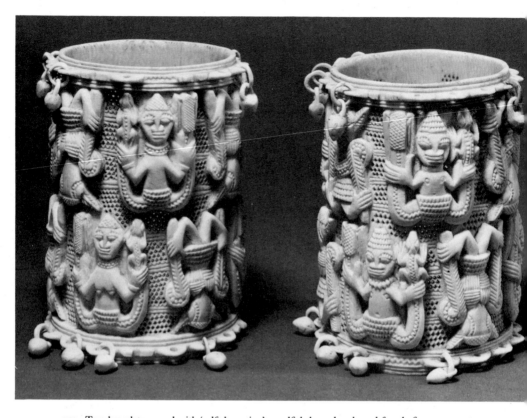

150. Two bracelets carved with 'self-dompting', mudfish-legged male and female figures, crotals attached to lower rims. Owo (described in Royal Danish Kunstkammer records first as East Indian, later as 'Benin-Yoruba', but William Fagg confirmed on 18 July 1982 that they are Owo). Ivory. Both 12 cm (4.72 ins). First record of acquisition A.D. 1689. National Museum of Denmark, Copenhagen EDC 26, 27. Photo: courtesy National Museum of Denmark.

in the emerging history of African art. Another is the great stylistic freedom also evident in the terracotta figures.

The most singular symbol of Owo iconography is a mysterious snake-wing bird [149]. These birds together with human figures, the legs represented by mudfish, appear on the Copenhagen armlets and on several Benin ivory bells, one of them in the British Museum.[51] Such objects may have been made in Owo for the court of Benin or used for local ceremonies.

Fraser[52] states that the snake-wing bird has sinuous *upper* limbs, which – sometimes in Owo, but never in Benin – are grasped by the naturalistic *lower* limbs [150]. He then refers to the mudfish-legged figure and states that it 'has sinuous *lower* limbs (which in Yoruba are often grasped by the naturalistic *upper* limbs, i.e. the hands)'. This feat of grasping one's own

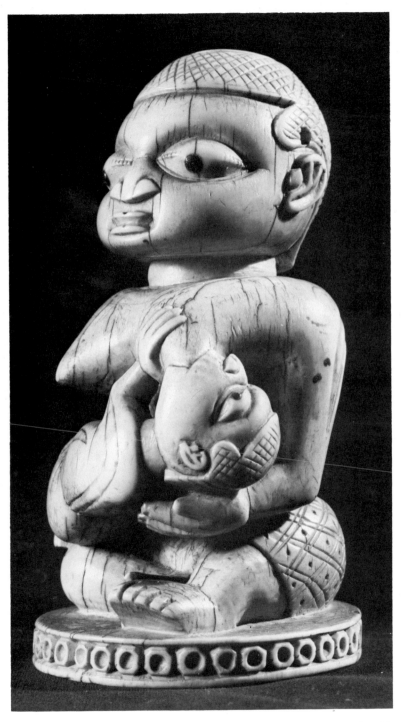

151. Seated mother feeding her child. One of the greatest sculptures of Owo origin. 16th century. Ivory. 15 cm (5.9 ins). Collection William J. Moore, Los Angeles. Photo: courtesy W.J. Moore.

limbs (self-dompting) is known in Africa only in Yoruba art. The snake-wing bird motif also appears on a magnificent ivory bowl, but in this case with 'a human-headed bird and snakes issuing from the back instead of wings'.[53] The particular greatness of the Owo style is illustrated here by the maternity carving [151] and some beautiful figures with Benin scarification on the forehead. The latter may well have been made for Benin and – more specifically – for their Ifa, or divination cult.[54] Another outstanding example is a ritual ivory sword.[55] An almost identical one was given to a British collector early this century by the then Olowo of Owo.

The specific style and iconography in the art of that town have also led to the re-attribution to Owo of bronzes once thought to be Benin. Thus a bronze stool in the University of Ife has the snake-wing bird motif. On yet another bronze stool, in the Berlin Museum,[56] a 'grinning ape-like face', resembling simian faces known only on ivory carvings from Owo, means that the attribution of both stools to that origin is a logical conclusion.

The study of Owo art has also led to some rethinking on the Tsoede and the 'Lower Niger Bronze Industry' castings. The objects grouped by William Fagg under that name, originally listed with Benin (where some had been collected), were subsequently recognized as being stylistically or iconographically of different origins.

Of the enigmatic Tsoede bronzes, only the seated Tada[57] figure is now firmly recognized as belonging to a definite culture, that of Ife. Several scholars have, in recent times, attempted to link the others with various art styles. Thompson[58] claims that they may have come from Oyo-Ile; although excavations in and near the city, destroyed by the Nupe in the sixteenth century (Oyo-Ile was rebuilt and finally sacked by the Fulani in the nineteenth century), have not yielded any supporting evidence. However, as the digging was carried out in a small area only, it cannot be taken as disproving these theories. Thompson links the removal of the objects with the Islamic *jihad* at the beginning of the nineteenth century and guesses that the Gara figure, 'found at Tada in southern Nupe on the Niger, was perhaps looted from the nearby imperial capital of Oyo-Ile'.[59]

He appeals for 'the acceptance of the importance of Oyo-Ile as a primary source for the development of the arts of the Yoruba, from the end of the classic period of Ile-Ife in the twelfth century, to the appearance of Benin in the fifteenth, and continuously until the final destruction of the site in 1839'.[60] He quotes mainly folklore and tradition on the 'richness of the palace with rows of brass columns, red silk hangings, silver doors, and carved verandah posts', but in support he also quotes Willett's finds of the remains of a furnace and the conclusion that brass could have been cast at Oyo-Ile. While all this is not sufficient proof of Thompson's theory, his approach – like all others – should be pursued, in the interest

152. Detail of the Gara figure of a divine king or a warrior. Elaborate headdress with large plaque depicting horned head, Benin scarifications on forehead, snakes issuing from nostrils, 'chainmail' cloak with snake-wing birds and pectoral with ram's head. Probably Owo. From Tada. Early 14th–15th century. Bronze. 115.5 cm (45.47 ins). National Museum, Lagos. Courtesy National Commission for Museums and Monuments, Lagos. Photo: André Held.

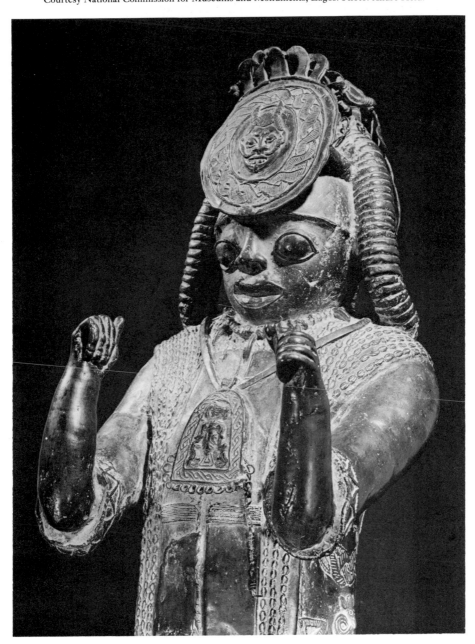

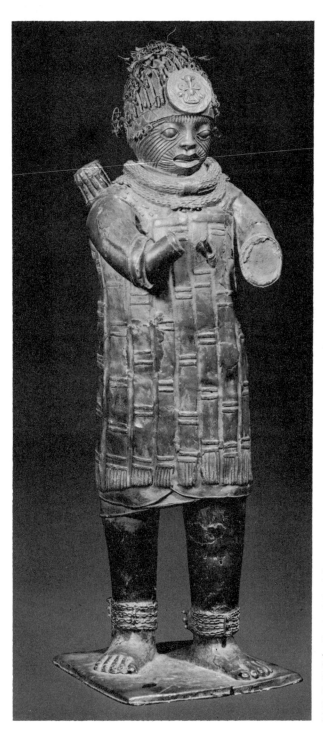

153. Bowman, clad in slatted armour. Plaque with snake-wing bird. Facial scarifications (similar to some Esie figures and Igbo-Ukwu pendant [117]). Quiver on back, elaborate anklets, and heavy necklace. Probably Owo. From Jebba Island. Early 14th-15th century. Bronze. 92 cm (36.22 ins). National Museum, Lagos. Courtesy National Commission for Museums and Monuments, Lagos. Photo: André Held.

of a reliable reconstruction of Nigeria's art history. Shaw, following a new line of thought, also suggests that the bronzes found at Tada and Jebba may have been connected with Oyo-Ile. He does not claim that they were produced there, but suggests that they were originally placed in the heart of the trade zone between Yorubaland and North Africa, 'marking perhaps important toll or control points of that trade'. Quoting Lawal,[61] he conjectures that when the Nupe conquered the town they removed the bronzes to the places where they were subsequently found. The seated Tada figure and a small figure with pigtail are of pure copper, like several Ife castings; but the others are of unleaded tin bronze, 'a composition very rare in Nigeria'.[62] Willett expounds the idea of Idah origin by diffusion from other centres, if not by local manufacture, for all but the seated Tada figure,[63] basing himself on the folklore story of the fleeing Tsoede.

Some art historians have recently linked several of the Tsoede bronzes with the great artists of Owo. The Gara figure of Tada [152] has a number of snake-wing birds on his cloak. He also wears an arch-shaped pectoral with a ram's head and birds; and this, because of its shape, has been likened to a pectoral in the British Museum – classified as Lower Niger Bronze – depicting two female figures with mudfish legs. The head of the Gara has a crown topped by birds and a large forehead disc on which a horned head with Benin marks and snakes issuing from the nostrils appear. For stylistic reasons, Benin origin is excluded, but the 'snakes from nostrils' motif could be a link with several cultures, including Owo.[64]

The bowman of Jebba [153], with facial striations, wears a forehead medallion with a snake-wing bird fixed to a crown. These two figures are among the largest bronze casts in Africa, and Idah – which had for long been the supposed origin – cannot be considered for the production of works of such size, since no evidence of any brass industry has ever been found there. The stool at the University of Ife has now been attributed to Owo, and as Benin and Ile-Ife are ruled out for the Gara figure and the Jebba bowman, these also could now be classified as of Owo origin. Fraser includes in the Gara group the Gara figure itself, the female nude (114 centimetres high, now stolen) and the Jebba bowman; to conclude, 'in the present state of our knowledge, the place of origin for the Gara group of the Tsoede bronzes can only be Owo'.[65]

Fagg now goes even further. He considers two half-crescent bronze reliefs [154][66] as almost certainly of Owo origin, and states that there is a growing likelihood that the figures classified as 'Hunter-style' [155] – the 'Hunter', the bronze head, several other objects in the British Museum, and the 'Kneeling Woman with Pumpkin'[67]– are all of Owo origin. Basing himself on iconography and style,[68] he adds that the Tsoede bronzes were not created in Idah but 'in an early period in Owo'. Presumably he would now include the bronze figures found at Bida[69] and

154. Crescent-shaped pendant surmounted by warrior with shield, sword and bell. Probably Owo. 15th century. Bronze. 21 cm (8.27 ins). National Museum, Lagos. Courtesy National Commission for Museums and Monuments, Lagos. Photo: André Held.

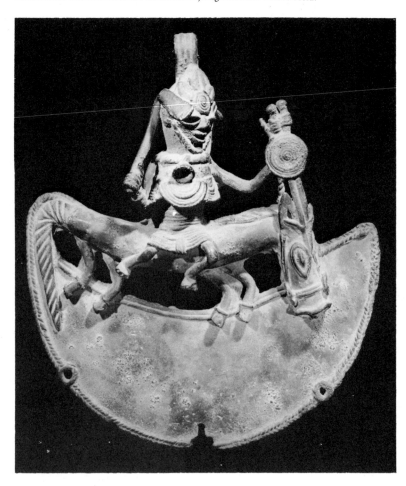

Giragi[70] in addition to the eight castings – excluding the seated male – at Tada and Jebba. Ryder suggests that the 'Tsoede' bronzes 'may prove to be relics' of Nupe art prior to islamization in the early nineteenth century. He adds that bronze figures played an important role in the 'ritual of kingship' among the Nupe and the Igala.[71] This attribution is yet one more hypothesis of the origin of the beautiful and mysterious bronze sculptures of Tada and Jebba.

155. A royal attendant with shield and armour. Probably Owo. Mid 16th century. Bronze. 33 cm (13 ins). Metropolitan Museum of Art, New York. Photo: courtesy Lance and Roberta Entwistle.

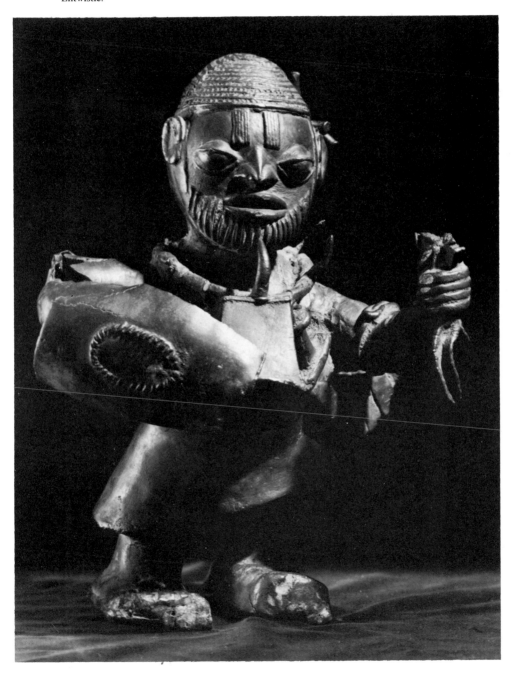

A bronze amulet with snake-wing bird motif, once thought to be from Benin, had been reassigned by Sieber[72] to the 'Lower Niger Bronze Industry'. It should now be ascribed to Owo.

The evidence suggests that Ife, Benin and Owo (and probably also Ijebu-Ode) developed their bronze industries and technologies independently – and perhaps contemporaneously. But it must be pointed out that no archaeological, or even accidental, finds have produced corroboration of the existence of a bronze industry at Owo. Excavations over a wide area around the site of that city may eventually provide such proof. Yet Owo emerges as an ancient art centre of equal importance with those of the other cities, with a style which may be described as falling between Yoruba and Benin.

The Art of Dahomey

At the beginning of the seventeenth century, the area which is now known as the Republic of Benin was the home of the Fon, Egun (or Popo) and Ewe, collectively called the Aja group of peoples, who were related to the Yoruba by religion, by political and social systems and also to some extent by language.[73] Two Aja states, Whydah and Allada, dominated the coastal region at that time, and local tradition says that the Aja came to the area from Ile-Ife after first settling further west in Togoland. Two princes struggled for succession in Allada, and in 1625 the defeated prince retreated north-west to the Abomey plateau and there founded a new kingdom, Danhomey, later Dahomey. He and his successors created an absolute monarchy with a stratified society in which merit, loyalty and unquestioning service to the king rather than birth and kinship were the conditions for advancement. There were no secret societies in the highly centralized kingdom. The Dahomeans shared many deities with the Yoruba, whose Eshu (or Elegba) was the Dahomean Legba, while Ogun became Gũn. The Lisa of Dahomey described by Burton as the sun god was represented by a chameleon[74] and was derived from the Yoruba *orisha*, but the snake cult originated in Whydah and became specifically Dahomean. The creator god himself made Aido-Hwedo, the serpent who lies coiled up in the sea supporting the earth and is fed with iron bars by the red monkeys of the ocean. If ever the supply of iron is exhausted, the serpent will collapse; and that, the legend says, will be the end of the world. However, there seem to be two Aido-Hwedo: one lives in the sea, and the other is the rainbow, who sends the thunderbolts of the gods. Aido-Hwedo is concerned with the whole universe and is followed in importance by Da, the snake which deals with the problems of the individual and the dynamics of life: movement, flexibility and fortune.[75]

Dahomey, sensing the first weaknesses in the kingdoms of Whydah and Allada, started its expansion southward. The enmity between these two

coastal nations grew with the increasing involvement of the Europeans in the slave trade, then handled by the Dutch and the French, who no doubt stirred up conflict between the Aja kingdoms. While Dahomey was still building up its power, the first Oyo invasions into the area of the kingdom of Dahomey and of Allada introduced a new force in the growing conflict over shares in the lucrative slave trade. The Dahomeans blocked the slave raids of the Aja kingdoms, until they were forced to negotiate and agree to pay tribute. In 1708 Agadja became king and built up Dahomean strength even further by the creation of a military training school, a band of skilled spies, and the famed corps of women soldiers whom the Europeans called 'Amazons'. Dahomey then conquered Allada and Whydah. In spite of continuous wars with Oyo and Abeokuta, Dahomey continued to prosper under its rulers Tegbesu, Gezo, Glele and Gbehanzin, until it became a French colony in 1894.

In this monarchy the king was omnipotent. Slavery was a royal monopoly, while ancestor worship and human sacrifices were part of the ritual. Art was a fundamental element in the process of state-building and military power. It was of basic importance in the aggrandizement of the king and the prestige of those he had elevated to high office. The display of rich splendour was linked with verbal imagery which combined to impress the people with the power of the king and the élite; it climaxed at the annual celebrations, called the 'customs', at which victories were celebrated, court cases were heard and death sentences were executed.[76, 77] Art was the mortar that cemented the carefully built structure of monarchy, hierarchy of governors and chiefs, army and religion and the entire highly stratified society. It had its roots in the earlier tribal culture of the Fon, and developed from the birth of the nation and through the 300 years of its tempestuous existence.

Graphic art included decorating calabashes with incised designs and painting on temples and the walls of important buildings. For the production of appliqué cloth Dahomey became especially famous [156]. The artists who made the appliqués were retainers of the king (as were the brass workers).[78] They were organized in family guilds which held the monopoly for the making of these cloths, and only men were allowed to sew the patterns on them.[79, 80] These fabrics, mostly imported, but some of locally made cotton, with their colourful decorations designed to tell stories of many kinds, were used for a variety of purposes. There were wall hangings on gold or black ground to commemorate victories or hunting scenes; banners made of appliqué cloth were carried at funerals; pillows were decorated with royal emblems or with religious or political motifs. Society banners for religious associations or military units were made of appliqué cloth and given symbols connected with the use for which they were intended.

The umbrella was a mark of rank, as in other African states. But in

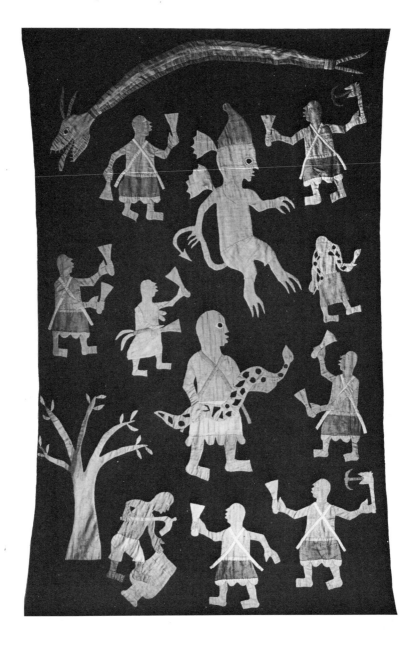

156. Appliqué cloth in vivid colours. Said to depict scenes from ceremonies of fight against evil spirits. Dahomey. Cotton. Musée des Arts Africains et Océaniens, Paris. Photo: André Held.

Dahomey the tops were decorated with appliqué designs. The royal umbrellas were made of silk or velvet, fabrics not permitted to any other user. The symbols were lions, harps and other royal emblems. Newly commissioned officers were given plain white umbrellas, to be decorated with images of their achievements in battle.[81] The royal umbrellas were sometimes designed by the king himself and the patterns sewn on cloth dyed in a variety of colours. Skertchly described one such royal sunshade as of 'dark green velvet bordered with yellow and scarlet'.[82] Caps and ceremonial clothing were also embellished with colourful appliqué designs.

Incised calabashes are an art form which – like the appliqué cloth – goes back to the earliest days of the Dahomey kingdom. The carved geometrical and animal designs – no human figures are ever depicted[83] – are descriptive of a great number of proverbs understood by all Dahomeans, a kind of pictograph.[84] Though sometimes used in the ancestor cult of certain highly placed families, they were mainly containers for presents sent as love-tokens by men to the women of their choice. The proverbs depicted on the calabash expressed the suitor's feelings and offer of marriage.

Dahomean plastic art includes objects made of brass, silver, wrought iron, wood - plain, painted or clad with silver or brass sheeting - and clay moulded in bas-reliefs. As in most regions of Africa, the most frequently used medium was wood. There were *bochie:*[85] some, anthropomorphic carvings worn as talismans on journeys; others, pairs of male and female guards placed inside the house, flanking its door. *Bochie* were also used in courtyards and on verandahs to protect the home. These were regularly fed with kola nuts or bean stews, which were poured into openings provided in the head and the navel, and sacrifices were made to them, with the blood of poultry poured into the same orifices. The blood of ducks was used for black magic, when injury to an enemy was intended. Statues of Legba and the legendary wives of gods were other objects for wood carvings. They were naturalistic - mainly nude - made for personal or family religious use, and generally of little artistic distinction. Some *Fa* cups and wands used by diviners, similar to Yoruba *agere-ifa* bowls and divination tappers, are, however, exceptionally well designed and carved.[86]

Wood carvings made for royal prestige, such as the polychrome statue of King Glele, depicted with a lion's head, and that of King Gbehanzin, shown as a shark from the waist up, are impressive monumental works of art.[87] Typical for Dahomey is the art of cladding wooden carvings with metal sheeting hammered closely on to the wood. A fine example is the figure of a lion, the hard wood covered with thin silver sheets fixed with silver nails [157].[88]

Sceptres or wands are further examples of fine royal art. The wand in the shape of a ceremonial axe shown here [158] is made of wood, brass and ivory; a lion, representing King Glele, exemplifies his pronouncement

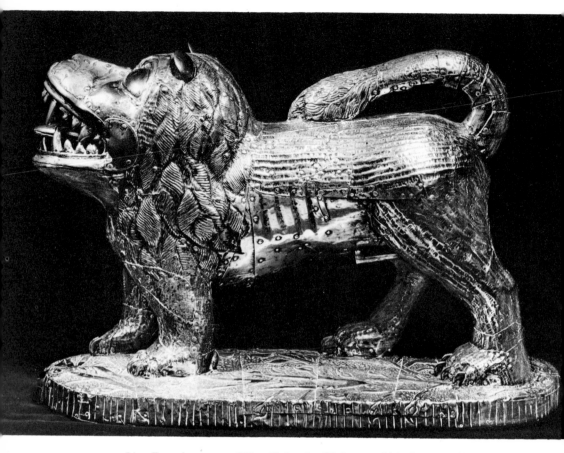

157. Lion. From the treasure of King Gbehanzin of Dahomey. 18th/19th century. Wood with silver sheet cladding. Length 45 cm (17.72 ins). Collection Charles Ratton, Paris. Photo: André Held.

after a victory: 'I am the lion cub who spreads terror showing his first teeth.' Other ceremonial axes are connected with the cult of the thunder god.[89]

The art and technology of casting metals in lost wax is part of West African culture. But in adopting it, the Dahomeans developed their own distinctive style. The brass workers, who also fashioned iron and silver, were organized in family guilds whose members lived and worked in special quarters near the palace. Brass rods were imported in ancient times from Europe in exchange for slaves.[90] The castings in silver (and later in brass) are in elegant stylized forms: human images with slender elongated limbs, and animals with long tails and legs. The casts were highly polished; and hair, clothing, or animal pelts were fashioned by tooling, for which each artist used his own special dies.[91]

Two remarkable sculptures of Gũ, the god of war and iron, are well known. One - in the Musée de l'Homme in Paris - is a crowned figure entirely made of iron sheets of European origin; 165 centimetres high and riveted to an iron base plate,[92] it resembles a modern sculpture made of found objects. The other image of Gũ, made of riveted copper sheet [159], is in the collection of Charles Ratton in Paris; holding a ceremonial sword in each hand, it is in a naturalistic vein in complete contrast with the first.

Brass and silver objects were used on tombs to commemorate certain events or as prestige ornaments for the palace or persons of rank. Brass genre figures depicting great varieties of subjects - wrestlers, drummers, men hoeing, women pounding mortars, and very explicit pornographic scenes[93] - are mostly of recent manufacture for a flourishing tourist market, though their roots are in traditional Dahomean art.

158. Royal sceptre. Dahomey. Wooden haft with silver plaques and ring; blade ivory with royal lion. 53 cm (20.87 ins). Musée de l'Homme, Paris. Photo: André Held.

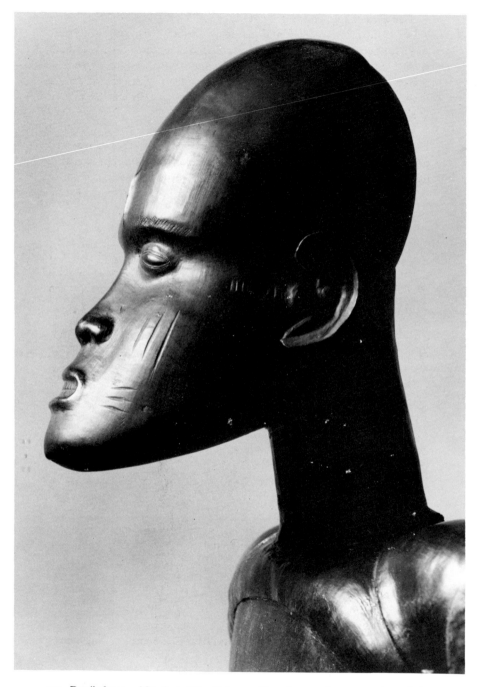

159. Detail of statue of Gŭ, God of War. Dahomey. Riveted copper sheet. 102 cm (40.15 ins).
Collection Charles Ratton, Paris. Photo: Eliot Elisofon.

Asen are beautifully designed altarpieces forged in iron or sculpted in brass, fixed to an iron staff and placed in shrines devoted to ancestors. They are decorated with birds, animals and geometrical designs, and are related to the Yoruba iron staffs of the Osanyin cult, also called *asen*.

The royal palaces were finely built. Many had walls decorated with bas-reliefs made of clay, depicting battles, royal emblems and symbolic or allegorical scenes, all painted in vivid colours.

The court art of Dahomey, strongly influenced by the Yoruba and succeeding the vigorous tribal art of the Fon, as shown by some *bochie*, produced an eclectic art of notably Dahomean character and imagination like the Gū and king figures.

The Esie Stone Images and Nupe Art

The people of the town of Esie in the Ilorin province of Nigeria are part of the Igbomina sub-group of the Yoruba and are believed to have settled in their present place of habitation in the mid sixteenth century, when they came from Oyo-Ile (Old Oyo) in a wave of migrations. In 1911 Frobenius, again first in the field, found three stone heads at Offa.[94] Twenty-two years later, a group of about 800 similar soapstone figures, broken and dismembered, came to the notice of the Nigerian authorities. They were found outside the town of Esie, covered by shrubs and undergrowth in a grove of peregun trees; the largest find ever of stone figures in Africa. They were later arranged by K. C. Murray on shelves in an octagonal hut in the grove, where they continued to be the focus of a cult by the 'children of the images', who held an annual festival in the grove, invoking the help of the images for the general well-being and fertility of the people and their land. The last of these festivities was held in 1965, after which the stone sculptures were transferred to a museum building, the House of Images, with the figure of an Oba and his attendants displayed on an altar.[95]

The figures vary in size from 20 to 120 centimetres, and a few of the heads are about life-size. Most are seated on stools, the top connected with the circular base by a central pillar, resembling stools common among the Igbirra. The seated images are draped from the waist to the knees with skirt-like garments tied with sashes. Many have facial marks, consisting of three horizontal lines between eyes and ears; some are depicted with facial striations[96] resembling those of the bowman at Jebba; and most are adorned with necklaces and bracelets [160, 161]. Some kneeling figures are nude and may represent servants. There are armed figures among both male and female images: the men carrying swords and quivers of arrows for hunting, the women, cutlasses which might have been used in farmwork and not for the hunt or for military purposes.[97] All figures

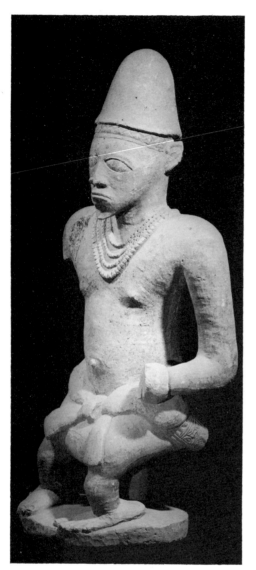
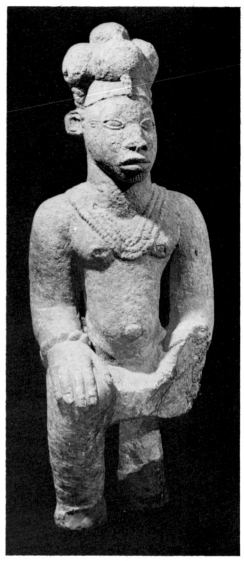

160 (*left*). Seated male figure with bead necklaces. Esie. Steatite. 60 cm (23.62 ins). Esie Museum, Esie, Nigeria. Courtesy National Commission for Museums and Monuments, Lagos. Photo: André Held.

161. Seated figure with bead necklaces. Esie. Steatite. 73.6 cm (28.98 ins). Esie Museum, Esie, Nigeria. Courtesy National Commission for Museums and Monuments, Lagos. Photo: André Held.

show certain similarities in dress, decoration and posture, but the faces are carved with distinctive characteristics and are obviously the work of a number of different artists. Several similar carvings were discovered near Esie in the villages of Ofaro and Ijara, the latter somewhat different in style.[98]

Local accounts of the origin of the stone figures differ. Some state that they were found abandoned in the bush at the end of the eighteenth century by the then inhabitants of Esie, who had come from Old Oyo. Another tradition has it that strangers from Ife came to the outskirts of the town and threatened to harm the Elesie (ruler) and the people. By the intervention of Olorun, the supreme god, the hostile intruders were turned into stone; but even the petrified figures were still blamed for damage to crops and other misfortunes, so that the men of Esie went into the bush and destroyed them. There are several other theories attempting to explain why almost all the images are broken, including the destruction by iconoclastic Muslims or Christian missionaries.

Willett speaks of 'echoes of Nok and Ife'. He compares the structure of neck and head in some Esie images with that in Nok figures, and he believes the round stools resemble those of Ife. The form of the ears is compared with modern Yoruba wood carvings.[99] Nok or Ife similarities are also noteworthy in the elaborate hairstyles, the use of incision for decoration, and in the representation of calabashes. Fragments of terracotta found in the same grove were dated by thermoluminescence in 1974, and though the reading of about A.D. 1100 was considered inconclusive, Shaw believes that an assumption for the age of the images corresponding with the date for the pottery is 'reasonable'.[100] The most important of these terracottas was a human head, stolen some time after 1965. Fagg also inclined to an Ife connection, as that town is the 'only other known centre of stone sculpture for some hundreds of miles around'. In particular, a head of unusually large size and differing stylistically from other Esie heads has been singled out for comparison with Ife's late classical period.[101] Another link with Ife is implied in a story that Chief Ikole took a large number of images with him when he left Ife for Ekiti, south-east of Esie.

Apart from the hypothesis of an Ife origin, there are conjectures of Benin and Dahomean connections. Benin is favoured by some because of similarities of dress, jewellery and 'cotton reel' stools – all arguments also used to prove descent from Ife. Those who believe in a Dahomean provenance point to the female images carrying cutlasses or swords, which are similar to the 'Amazons' of Dahomey. This theory lacks conviction, since no women soldiers were used in that state prior to 1727,[102] while the Esie images were probably made not later than the sixteenth century;[103] and, furthermore, King Agaja's female warriors were armed with muskets like male soldiers.[104] No firearms are depicted on any of the Esie

images. The Oyo/Yoruba institution of Iyalode gave women great power and influence and the right to carry arms, so this could have been the inspiration for the armed females among the Esie carvings.

Supporters of a Dahomean origin have pointed to images believed to represent royal servants of the 'Ilari' type. This refers to king's messengers and court delegates who served as liaison with the Europeans on the coast and kept an eye on the chiefs. This 'Ilari' group was introduced by King Tegbesu. He succeeded to the throne in 1740 after ten years in Oyo captivity, where he had learned much about Oyo institutions, including 'Ilari'. The members of the corps had one side of their heads shaved, as their mark of office.[105] Stevens believes that 'the trail will eventually lead to Old Oyo' and that geology and archaeology will supply the proof.[106] The source of the talc schist used for the stone carvings is likely to be found somewhere from the Upper Ogun River Valley, west of Esie, to the land of Borgou, to its north-west.[107] In Sierra Leone and Guinea, steatite carvings (nomoli) were found carved out of rock in the quarry itself. The reason is that the soft steatite hardens after quarrying and storing, and carving is easier in situ.[108] A discovery of unfinished carvings in the rock of quarries in the area would be a key to the origin of the images. As to their age, there is another pointer, if Oyo-Ile is the presumed origin. The strength of that great city state was the development of its cavalry, which was decisive in the wars with Dahomey; yet no horses or equestrian riders are included among the stone carvings, which may imply that they were carved before the introduction of the horse in that area, some time in the sixteenth century. Oyo-Ile was situated at a strategic crossroads, a meeting place of many cultures, from north and south of the Niger, which used the city as a trading centre. Its art would, therefore, not have been of a uniform character, but would have reflected influences from Benin, Ife, Nupe and Borgou. The city state, which was founded between the tenth and fourteenth centuries,[109] was attacked by the Nupe in the sixteenth century; and Stevens's hypothesis is that one of the waves of emigrants who left Oyo-Ile at that time may have taken the images with them to Esie, about 185 kilometres to the south-east. The figures are thought to have been linked with the well-being of the home city of the migrants. They had to be saved from the Nupe attackers and were, therefore, brought to a new place, where they could be preserved. This theory is based on Stevens's thorough research but lacks corroboration.

In this search for the origin of the Esie figures, the Nupe must also be considered as a possibility.[110] They once lived in the area, and some are still settled nearer to Esie than to Oyo-Ile. Very little is known about their art since they were forcibly converted to Islam in about 1830. Tribal customs survived only in a few places, although masked dances were observed by Frobenius during his visit to Mokwa in 1910. He collected about six masks, now in museums in Berlin,[111, 112] Hamburg and Basle;

and one very fine example, probably also from that collection, is in the British Museum. Wood carving survived in the fine 'bookcovers', probably also used as mirror cases or containers for amulets. Their intricate designs were once believed to have been influenced by Coptic, Nubian or Egyptian art.[113] A scholarly analysis has been made by Göbel,[114] who considers the carvings to have come from Nupe artists, influenced by Islamic designs.

Although figurative art virtually disappeared, the Nupe continued to be outstanding craftsmen in pottery,[115, 116] glass-making [162] and metalwork. Most of this art was concentrated for centuries at Bida, just north of the Niger, and artists there are still organized in guilds. The glass-makers were believed to have come 'from the east' – Byzantium, Persia, Nubia,[117] or Egypt[118, 119] – to settle near Bida, where they found suitable raw material. It is possible that the industry was started by craftsmen from the Nile valley, as no similar glass-production is known anywhere else in western Africa; they are believed to have arrived at Bida in the second half of the sixteenth century A.D.[120, 121]

162. Bracelet. Bida, Nupe. Nigeria. Glass, black with wide irregular decoration in white and red spots. Max. diameter 10 cm (3.94 ins). Museum für Völkerkunde, Leipzig. Photo: Karin Wieckhorst.

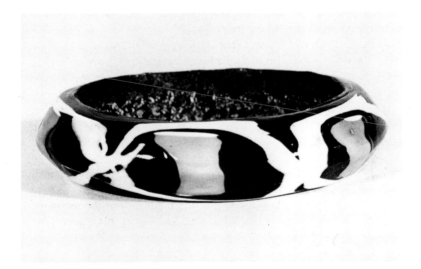

The embossed and chased brass objects of the Nupe coppersmiths of Bida [163] have been known and admired for a long time. The Leipzig Museum has a fine collection, assembled by Frobenius in two expeditions. Of the first collection of fourteen pieces, Frobenius wrote to the museum that these 'old hammered "bronze" vessels were buried in the fifteenth century and were later stolen by the Fulani'. He paid seventy guineas in

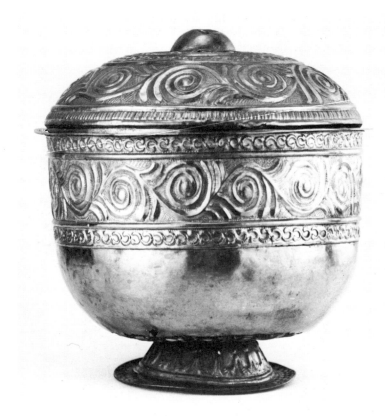

163. Lidded vessel on base. Chased brass sheeting. Height 25 cm (9.84 ins). Diameter 24.5 cm (9.65 ins). Museum für Völkerkunde, Leipzig. Photo: Karin Wieckhorst.

gold to the Emir of Kano, whose family can, according to Frobenius, be traced back to the great days of the old Nupe kingdom.[122] Apart from the hammered and chased brass sheet objects, artefacts were also cast in the lost wax process, as was the hilt shown here [164, 165].[123] There are no records of Nupe stone carvings; but an important art centre like that of Bida may well have included artists who worked in steatite and produced human images, until Islamic strictures prevented them.

Yoruba Art in the Nineteenth and Twentieth Centuries

There are many Yoruba city states which, like Oyo-Ile, claim Ife origin. They elected their Obas (or kings), and in today's Nigeria there are still a number of such kingdoms linked by tradition to the Oni of Ife. Their political power is now very limited. But their importance in matters of religion and culture, through their legendary ancestral links back to

164, 165. Dagger with cruciform bronze hilt and cross-shaped opening in it, and flat blade; sheath and guard of hammered brass sheeting. Bida, Nupe. Nigeria. Overall length 44.5 cm (17.52 ins). Museum für Völkerkunde, Leipzig. Photo: Karin Wieckhorst.

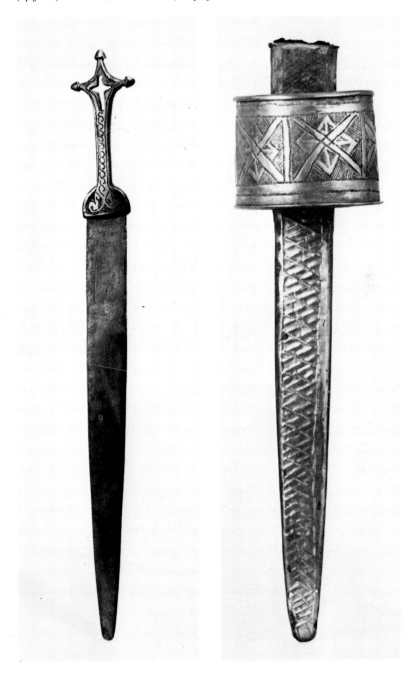

creation, is of great historical significance and has a bearing on the survival of Yoruba sculpture and the closely related masquerades and dances, as well as textiles, beadwork and body adornment.

Men's and women's dress, hairstyles, jewellery, painting and scarification of face and body have played an important role in Yoruba art, from early periods in their history to the present. Nok art may have influenced Ife, and similarities in the field of personal adornment and dress are discernible [166]. The use of beads, bracelets, anklets and pendants on Nok figures is frequent, as are elaborate hairstyles. No textile garments are depicted; but in one case at least,[124] clothing, possibly representing fibre cords and bark cloth and leather, is gracefully arranged and can be described as ornate dress. Massive strings of beads covering most of the Bwari figure [52] constitute another example.

The history of Yoruba dress begins around A.D. 1000. Statues from Ife show women wearing a covering from the waist to the knee or ankle and men with a similar garment tucked between the legs [136]. The full figure of an Oni [133] and the small figure in Ife style found in Benin [180] both show the abundant use of beads and other ornaments, and early fashions from which Yoruba dress developed. Oyo-Ile, and subsequently Iseyin, south-west of the Oyo kingdom, became the principal centres of narrow-strip weaving. Later, the advent of Islam and the

166. Bracelet, depicting a ram's head with serpents (or mudfish?) issuing from nostrils, a clenched fist and two bearded heads, all in raised relief. Yoruba, Ogboni Society. From Ijebu area. Bronze. Diameter 8.38 cm (3.3 ins). Photo: courtesy Pace Gallery, New York.

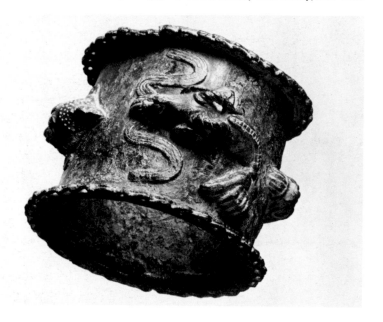

167. Loincloth. Yoruba, Abeokuta. Tie-dyed, imported cloth. Detail shown 115 × 80 cm (45.27 × 31.5 ins). Museum für Völkerkunde, Basle. Photo: André Held.

168. Cloak made of beads (including seed beads) in traditional style. Yoruba. Part of wardrobe of Oba Abimbolu II of Ode Irema, Ijebu. Height 133 cm (52.36 ins). National Museum, Lagos. Courtesy National Commission for Museums and Monuments, Lagos. Photo: André Held.

169. Twin figures (*ere ibeji*). Yoruba, probably early style of Oshogbo area. 19th century. Two male figures, wood, each dressed in beaded cape. 27 cm (10.63 ins). Collection G. and K. Anschel, London. Photo: Horst Kolo.

Europeans inspired new designs and colours. This mingling produced the splendid garments and headscarves of the women. Men overshadowed even this magnificence with their togalike wraps called *agbada*.[125] The cloths used were strips about 10 centimetres wide, woven on men's vertical looms. These are similar to Hausa fabrics, which are basically white and indigo stripes, but the Yoruba used a greater variety of colours. Other fabrics traditionally used for dress were tie-dyed and resist-dyed *adire* cloths [167], and English and Dutch traders bought large quantities of this merchandise in the mid seventeenth century.[126] The use of beads as ornaments dates back to antiquity in Africa and other continents. The availability of European 'seed beads' in a vast selection of colours and in uniform sizes gave impetus to the emergence in the nineteenth century of an entirely novel Yoruba art of beadwork [168] based on their ancient traditions. This colourful beaded material was used for garments of *ere ibeji* (twin statues) [169], sheaths for *orisha-oko* staffs, diviners' bags, and many other cult and secular objects.[127]

We know little about the history of Yoruba architecture, since the building materials used were mainly mud, thatch and timber, none of which withstood the ravages of time and climate. The splendid house and verandah posts of towns and villages, the wood frieze from Owo (Benin influenced) in the British Museum,[128] and the carved doors in the nineteenth and twentieth centuries were all probably modelled in the traditions of more remote times.

The overall style of Yoruba wood carving, though varying from area to area, and from artist to artist, can be described as quasi-naturalistic, although body and head are in the usual African proportions. Faces have heavy-lidded, bulging, globular eyes, and sensuous mouths with flat parallel lips that do not meet at the corners, sometimes displaying a fixed smile. Under the finely detailed hairdress is a large forehead. The Yoruba female carvings are opulent in character, with prominent breasts and rounded limbs. The finish may be polished wood, paint or a mixture of both.

In order to understand the art objects, it is helpful to look at the complicated picture of the Yoruba pantheon and at some of the most important societies and their patron *orisha* (spirits) for whom art is produced in one form or another. Olorun is the supreme god, a remote being too important to be directly involved in matters concerning mortal humans. No images are made of him and he is not worshipped except through an *orisha*, especially Eshu, to whom sacrifices for Olorun are made by proxy. There are hundreds of such spirits, as each family and clan could have had their own, and every phase of life, birth, sickness and death was related to an *orisha*. Altars and shrines are dedicated to the *orisha*, and a great number of carvings or castings are used in connection with sacrifices or when appealing for the help of the spirits.

Eshu (or Elegba) is represented in human form, and other spirits have masks, figures or symbols relating to them. Eshu, Olorun's messenger, recognized usually by his long cap - sometimes in the shape of a hook - and attributes such as flutes and knives, is the trickster; he represents uncertainty, change, chance, malice and conflict in life.

The counterpart of Eshu is Ifa, standing for fate, cosmic order and wisdom. With him are connected the divination tray, usually with a head of Eshu carved on it,[129] divination bowls (*agere-ifa*) and tappers; in short, all the implements to predict and influence fate, as well as counteract Eshu's malice by restoring man's confidence.

The *Ogboni* society devoted to the cult of the earth spirits was, and occasionally still is, powerful [170]. It keeps priests and secular rulers under control, uniting them in a common organization. The ritual implements of the *Ogboni* are kept and used in great secrecy, except for the *edan* staff, one of the implements, which is usually made of two figures, a male and female, joined by a chain [171].

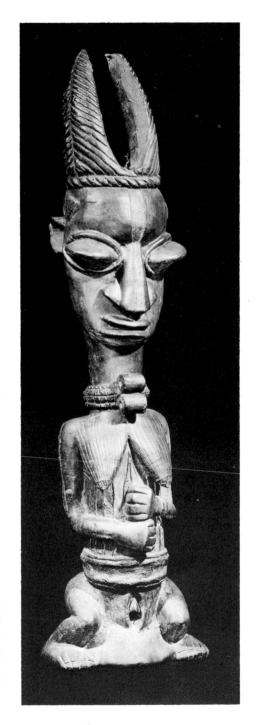

170. Female figure representing Onile, spirit of the earth in *Ogboni* cult. Yoruba. From Iperu. Probably 18th century. Brass. 106 cm (41.75 ins). National Museum, Lagos. Courtesy National Commission for Museums and Monuments, Lagos. Photo: André Held.

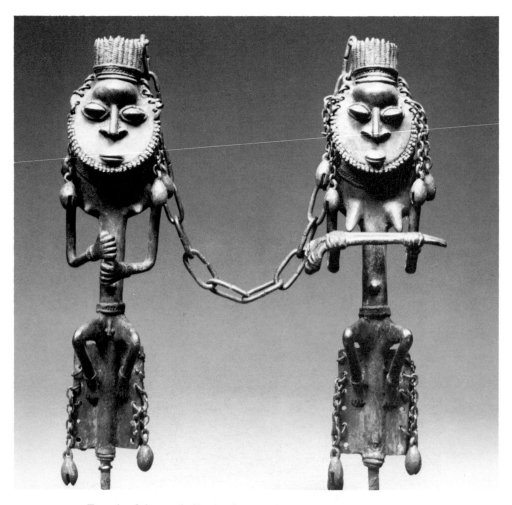

171. Two *edan Ogboni* staffs. Yoruba. Oyo area. Bronze. 28 cm (11 ins). Photo: courtesy Pace Gallery, New York.

Shango – the spirit of thunder and lightning – is represented by the neolithic axeheads which are dug up all over Yorubaland (and elsewhere in Africa) and regarded as 'thunderbolts'. They symbolize power and are depicted in the double-axe-shaped baton associated with the *shango* cult.

Of great importance is the *ibeji* or twin cult. The high incidence of twins among the Yoruba and the rate of child mortality in a society which did not have modern hygienic and medical help combined in the development of this cult. If a twin dies, a figure is carved for the dead child, then clothed and fed alongside its live twin [169]. A resting place for the spirit of the dead twin is thus provided; for otherwise its vengeance will for ever

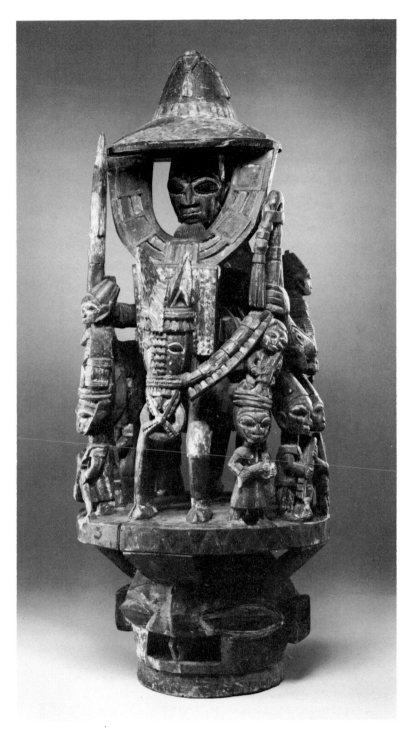

172. *Epa* headdress. Superstructure representing a warrior on horseback with numerous retinue. By the master carver Bamgboye (died 1978). Yoruba. Ekiti, Odo–Owa. Wood. 127 cm (50 ins). Detroit Institute of Arts. Photo: courtesy Pace Gallery, New York.

threaten the parents. If both children die, two figures will have to be provided. The *ere ibeji* figures are among the best-known Yoruba carvings. The Yoruba are one of the few peoples in West Africa to have such a cult, though twin births and twin lore are widespread.

The *gelede* society and cult are devoted to the problems and control of witchcraft. All women are potential witches, because witchcraft is the negative, malevolent aspect of womanhood, just as motherhood is its positive, benevolent side. Men who dance in *gelede* rituals often impersonate females. The cult fights the dangers to fertility, the perils of the sea, and epidemics brought about by the action of witches. *Gelede* masks are worn on top of the head, and some have elaborate superstructures.

173. Face mask for *Egungun* festival. Yoruba. Iseyin. Wood. 18.4 cm (7.25 ins). Photo: courtesy Pace Gallery, New York.

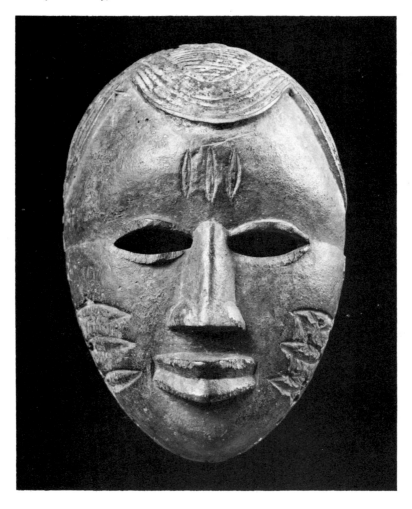

A second type of Yoruba mask, prominent mostly in north-eastern Yorubaland around Ekiti (but also made and used for fertility rites in Efon Alaye and other centres), is commonly called *epa*. It consists of a pot-shaped mask on top of which are large complex carvings, painted in strong colours [172]. Some are as high as 2 metres and they can weigh up to 50 kilos.

174 (*left*). Cephalomorphic bell. Yoruba. Ijebu area. Bronze. 25.4 cm (10 ins). Photo: courtesy Pace Gallery, New York.

175. Armlet consisting of two separate cylinders. Yoruba, Ijebu area (confirmed by W. Fagg, 28 July 1982; previously attributed to Benin). 16th century. Ivory. 15.7 cm (6.18 ins). National Museum, Lagos. Courtesy National Commission for Museums and Monuments, Lagos. Photo: André Held.

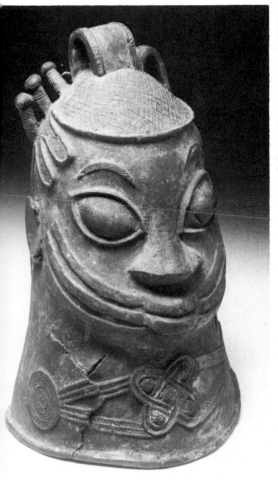
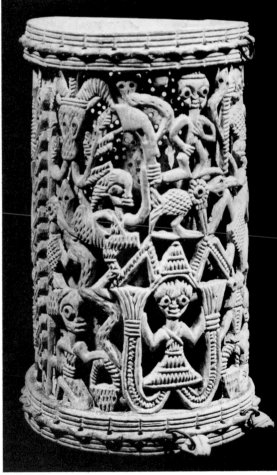

176. Lidded bowl. Intricately carved by the great master Areogun. Yoruba. Osi, Ekiti area. Wood. 56 cm (22 ins). Milton Ratner family collection. Photo: courtesy Pace Gallery, New York.

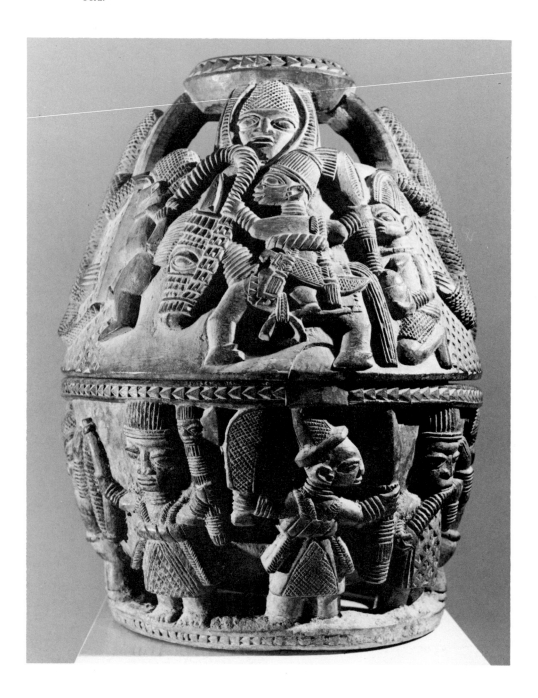

Egungun rites are connected with ancestors and other forces affecting the lives of the people. The carved masks for the masquerade, which is a widespread festival in Yorubaland, vary considerably from area to area. Those from the Oyo area are of dignified simplicity [173]. Those from Abeokuta may feature hares' ears and teeth, and a drum above the forehead, and are usually associated with hunters. The cult is said to have its origin in the city state of Oyo-Ile.

The god of iron and war, Ogun, has as his devotees all those who work or use iron, most especially blacksmiths, warriors, hunters and wood-carvers. As Ogun is still regarded as a powerful force, his worshippers today include cyclists and the drivers of motor vehicles. Some masks and implements are specially made for Ogun rituals, though anything made of iron may be used as a symbol. In Ekiti, north-eastern Yorubaland, the festival of Ogun is a special occasion at yam harvest time.

Ancestors are worshipped in family shrines, as are the numerous *orisha* protecting individuals and groups against any and all dangers, from sudden death to stomach-ache.

The style of Yoruba ironwork differs from that of the wood carvers because of the difference in material. Several types of wrought-iron staffs are of importance. Among them are the *orisha-oko* staffs, made for female initiates of that cult. These staffs are beautifully designed, about one and a half metres high, and often covered with a beaded sheath. Then there is the staff for Osanyin, the *orisha* of medicine, with birds mounted on a ring crowning the staff. These are used by diviners and doctor-priests in curing afflictions of all kinds. Bronze casting has remained a traditional form of art and includes bells [174], pairs of *edan ogboni*, bronze heads and figures on iron staffs. Some of these may date back to the eighteenth century, others are contemporary. Many of the ivory carvings [175] evoke the quality of the great art of ancient Benin, and some of the finest Yoruba wood sculptures have been carved by masters of the late nineteenth and early twentieth century [176].

Benin – the Art of the Edo City State

In the great jigsaw puzzle of African art history, more is known about the art of the city of Benin than about any other aspect of West African plastic art. Most of this knowledge derives from the study of the many art objects which were taken from the palace of Benin in 1897, following a British punitive naval expedition. These are now in museums and private collections, and provide much material for research, as do European travellers' reports from the fifteenth century onwards.

The home of the Bini is tropical forest country, bordered in the west by the Ovia and in the east by Ibo territory, reaching southwards towards the Niger Delta. The hot and humid climate, the poor soil, the dense woods and the remoteness from river and other communications were hardly conducive to the pursuit of agriculture or trade. The early successes of the Bini were based on the fighting quality of their warriors, and expansion through wars led to the establishment of the divine kingdom and the city state.

The Bini belong to the Edo-speaking group which, like Yoruba, is part of the Kwa family of languages. Edo is the actual name of the people for themselves, for their language and for the kingdom and city of Benin, now the capital of Bendel State in the Federation of Nigeria. They had their own tribal sculpture [178] and social organization, in which the government of the village was in the hands of the local elders. In contrast, the Yoruba had a system which can best be described as a constitutional monarchy. The area has certainly been inhabited by man for at least 3,000 years, and the people of Benin are probably descendants of the earliest inhabitants. They had (indeed, still have) an ancestor cult. Shrines housed altars on which wooden animal heads, usually rams, and rattle staffs (*ukhure*), representing ancestors, served as memorials.

Oral tradition speaks of an old 'dynasty', that of the Ogiso – Kings of the Sky[1] – whose rule over the city of Benin is said by Chief Egharevba to have begun about A.D. 900.[2] But in the early part of the twelfth century, the tradition maintains, a rebellion put an end to the Ogiso rule, and the elders of Benin called on Odudua, the Oni of Ile-Ife – a Yoruba city state – to send them a king. He did so, obligingly nominating his youngest son Oranmiyan, who is said to have reached the vicinity of

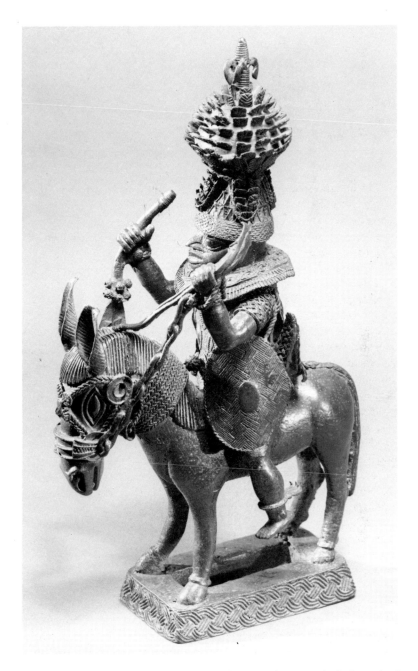

177. Equestrian figure. The headdress resembles those worn by present-day bodyguards of Fulani emirs; said to have represented visitors from the north to ancient Benin. A.D. 1525–75; collected before 1897. Bronze. 46.5 cm (18.25 ins). Merseyside County Museum, Liverpool. Photo: courtesy Christie's, London.

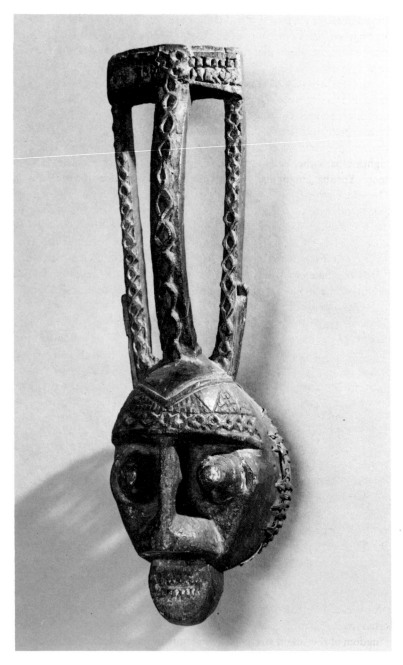

178. Bini mask called *ighodo* for the Igbile cult at Ughoton, port of Benin. Carved by a Bini artist. The style originated with the Ijo of the Niger Delta. Collected 1897. Wood with black surface, traces of red pigment. 61 cm (24 ins). Indiana University Art Museum. Photo: Ken Strothman and Harvey Osterhoudt.

Benin in about 1170 but did not enter the city to become its Oba. Instead, he lingered outside, to marry the daughter of a local family, of the Ogiso clan; and it was their offspring, Eweka, who became the first ruler of the new dynasty.

As Odudua was, according to tradition, the first man on earth, sent from heaven to create the world with Ife as its centre, the story was certainly invented to serve as a legal basis and justification for the assumption of power by the Yoruba dynasty over the Edo city of Benin. The dynasty persisted, and Eredia-Uwa was enthroned in 1979 as its thirty-eighth Oba. Other sons of Odudua were said to have been sent to form more Yoruba kingdoms. Oranmiyan himself was also the founder of Oyo-Ile, so the dynasties of Benin and Oyo-Ile had a common ancestry. But Ryder asserts that the strong relationship which now exists between Ife and Benin began only in the nineteenth century. He bases this on the absence of any mention of such a connection in the records of Europeans who had contacts with Benin over a period of four centuries. He points to symbols, iconography and certain historical records in concluding that Ife origin for the Benin dynasty and art is, at the very least, doubtful.[3]

Ryder notes that many Benin bronze figures depict 'Maltese' or 'Greek' crosses, originating from the 'interior kingdom of the Ogane', which may have been in Nupe-Igala country. They were worn around the neck, and all figures thus adorned have 'cat's whisker' markings at the corners of the mouth [179]. These are not Yoruba or Benin markings but are identified in Benin as of Nupe and Igala origin.[4] The crosses are not known in Ife iconography, but one of the standing bronze figures from Tada, Ryder asserts, has a 'Maltese' cross hanging from its waist similar to a standing Benin figure of an Oba.[5] This, however, is apparently a mistake; there is no cross of any kind visible on that figure. There are several Ife heads, one of them in the National Museum at Lagos, with 'cat's whiskers' [142]. Muslim traders in the early nineteenth century placed Benin in southern Nupe country, apparently referring to the Beni confederacy, from which the Nupe kingdom developed.[6, 7] Although this might be a confusion of names, Ryder considers it another possible indication that the Nupe played an important role, which has since been forgotten, in the history of Benin. Analysing Nupe and Benin oral traditions, though warning of their doubtful reliability, Ryder concludes that the various clues cited point to the area of the Niger-Benue confluence, which the Nupe once dominated, as the key to the reconstruction of Benin dynastic relations and its influence on material culture. The power of the divine kingdom of the Jukun stretched at one time into the same region. Quoting the tradition of a Nupe princess's connection with Oyo-Ile, Ryder conjectures that a relationship between Benin, Nupe, Oyo, Igala and Jukun may have existed, though neither its nature nor its chronology is known at the present time.[8]

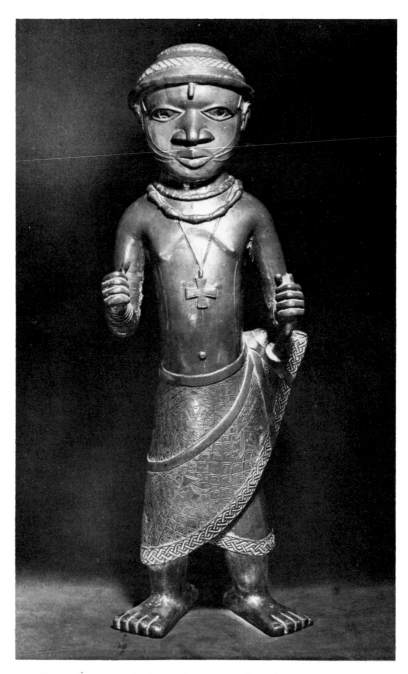

179. Figure of messenger with 'Maltese' cross and cat's whisker marks. Benin City court art. 16th century. Bronze. 63.5 cm (25 ins). Museum of Mankind, London. Photo: André Held.

Documentation is scant on all these subjects, and we must, therefore, keep an open mind on most theories until a well-based reconstruction of the history of Benin and the entire area involved has been achieved.

Bradbury, basing himself on de Barros's report written in 1552, states that the death of the Oba of Benin was communicated to Ife, and the successor was sent a brass cross, cap and staff by the 'Awgenni' (i.e. the Oghene of Uhe or Oni of Ife) approving his succession. This led Bradbury to conclude: '. . . that this dynasty (founded by the legendary Oranmiyan) was derived from Ife is beyond reasonable doubt.'[9]

The Ogiso are reputed to have initiated domestic crafts, wood and ivory carvings; the ceremonial sword *ada* dates back to them.[10] The great development of the arts, however, is connected with the Eweka dynasty,[11] founder of the craft guilds, of which there were at one time between forty and fifty in the palace compound. The artists and craftsmen of the villages outside the city gates continued to work for the needs of the population, the local religious leaders and the secular chiefs.

Until the end of the nineteenth century, the heads (or at any rate 'symbolic parts') of the kings of Benin were sent to Ife for burial. In the tradition of the Benin–Ife relationship, the Oni of Ife, as spiritual 'father' of the kings of Benin, sent back in return to the new ruler a bronze memorial head for the altar of the deceased. Oguola, the fifth Oba,[12] however, requested the Oni to send him a master of metal casting, so that in future memorial heads could be produced in Benin itself. The ruler of Ife once again complied, and one, Iguegha, came to Benin as the first master of Iguneromwon, the guild of the bronzesmiths. He is still venerated by that guild. A small bronze figure in Ife style in the Benin Museum, representing an Oni in full regalia [180], was excavated in Benin and was identified by Egharevba as having been brought or made there by Iguegha.

The sculptural arts of the Edo – using terracotta, ivory, and wood[13] – had probably been in existence for a considerable time before the establishment of the new dynasty. When the Edo craftsmen had mastered the art of casting metal by lost wax, they started to make bronze castings in their own style [181, 182]. In both Ife and Benin, sculptors of heads and figures apparently did not attempt to depict individual features. They represented the marks of rank, dignity and often tribal affiliations by adornments, clothing and scarifications. But the styles of Ife and Benin sculpture are very different in character.

Ife heads are more naturalistic than in most other known West African art and were, therefore, initially – and mistakenly – thought to be of Greek or Egyptian origin. The Benin heads commonly believed to be the earliest are finely modelled, in a somewhat stylized naturalism. For that reason they were thought to be derived from Ife. But, in fact, Ife stylization of ears, the setting and shape of eyes, the striations of faces and bodies, holes in the heads for attachment of crowns, hair or veils, and holes in the neck,

180 (*below*). Small figure of an Oni of Ife in full regalia. Feet missing. Found in Benin.
? 15th century. Bronze. 12.19 cm (4.8 ins). National Museum, Benin City. Courtesy
National Commission for Museums and Monuments, Lagos. Photo: André Held.

181 (*above right*). Stool. Seat in form of intertwined mudfish on round base. Benin City
court art. 16th-17th century. Bronze. Height 34 cm (13.38 ins). National Museum, Lagos.
Courtesy National Commission for Museums and Monuments, Lagos. Photo: André Held.

182. Vessel with drummer, snail and tortoise on both sides and handles in form of snakes
with humans in mouths. Benin City court art. 16th-17th century. Bronze. 22.5 cm (8.85 ins).
National Museum, Lagos. Courtesy National Commission for Museums and Monuments,
Lagos. Photo: André Held.

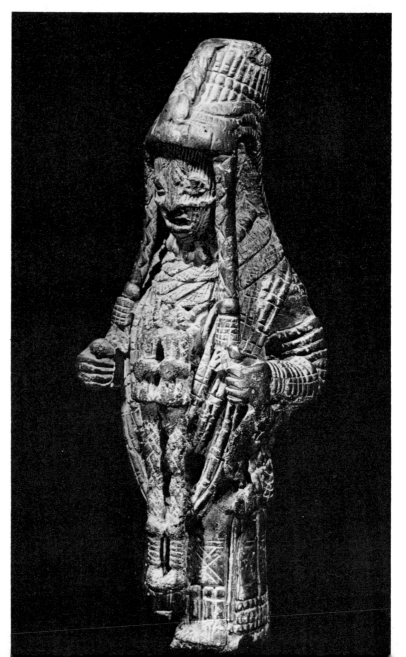

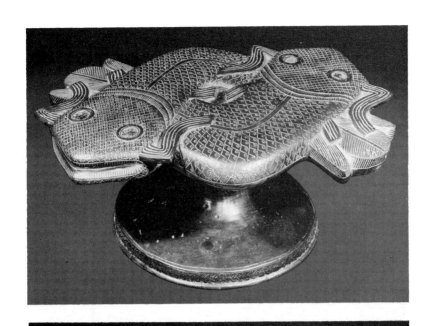

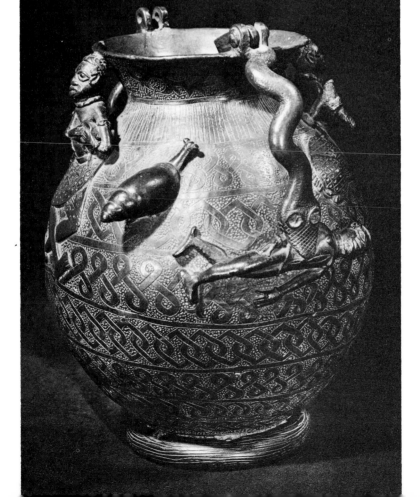

probably for fixing to wooden poles, are all unknown in Benin art. Benin artists may or may not have learned the lost wax casting technique from Ife, but they certainly developed an individual style.[14] There are also technological differences quoted as arguments against a close Benin-Ife relationship. Most Benin castings are of leaded brass,[15] as are those from Ife, but the proportions of trace elements vary, which may point to different European sources of the material used.[16, 17] There were undoubtedly trading contacts between the city states, and these could have led to the exchange of raw material for casting or of brass objects for melting down.

Werner and Willett suggest that old Ife castings in Benin were used to augment local supplies, and Willett expresses the opinion that both Ife and Benin imported metal from Europe.[18] The practice of mining and smelting of copper in western Africa is very old: mines at Azelik in Niger were producing in the sixth century B.C., and Mauretanian mines are believed to have been exploited as early as the first half of the first millennium B.C. The copper produced at Azelik and Marandet could presumably have reached not only Igbo Ukwu but also Ife and Benin.[19, 20]

There are differences in the techniques of lost wax casting between Ife and Benin craftsmen.[21] Iconographical symbols on sculpture from both can also be observed in other cultures; snakes issuing from the mouths or nostrils of human figures, for example, are common to Owo, and to 'Tsoede' bronzes.

A chronology of Benin court art of the Eweka dynasty was first attempted by von Luschan and Struck. The basis for a classification and time sequence proposed by Fagg[22] and interpreted by Dark,[23] though recently queried, remains the soundest, for critics have so far failed to offer a more acceptable method. Fagg bases himself partly on reports published by Dapper in 1686, mentioning bronze plaques on pillars in the palace, but Nyendael in his account (recorded by Bosman in 1705) makes no mention of them. This, and the fact that Portuguese figures are depicted on the plaques in mid sixteenth-century dress [183], caused Fagg to conclude that they were made only during the period from about A.D. 1550 to 1650. The 'Early Period' in his theory lasted from the fifteenth century or before until the mid sixteenth century; the 'Middle Period' ended with the mid seventeenth century; and the 'Late Period' ended with the fall of the city in 1897. In this chronology, the most naturalistic and least decorated heads are allocated to the 'Early Period' [184]. However, early forms and styles were copied in later periods, and Willett cites a late eighteenth-century head in the style of the 'Early' bronzes. But the face resembles those of much later types, and it is heavier than the earlier heads. Ben-Amos refers to this particular casting and to another in Willett's article.[24] She points out that both are effigies of enemies of Benin taken in battle or killed

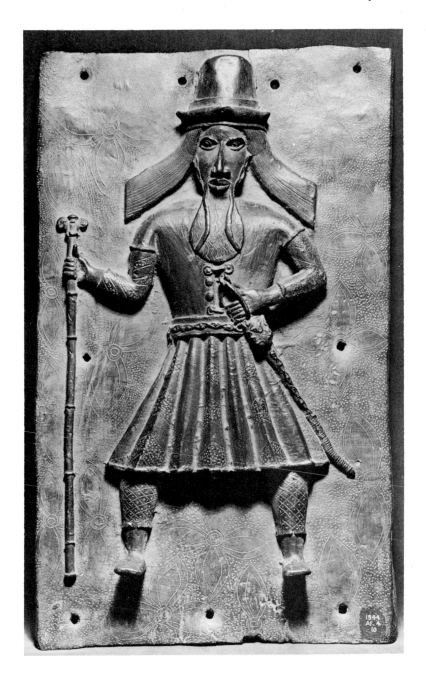

183. Plaque depicting Portuguese emissary. Benin City court art. 16th century. Bronze. 49.9 cm (19.65 ins). Museum of Mankind, London. Photo: André Held.

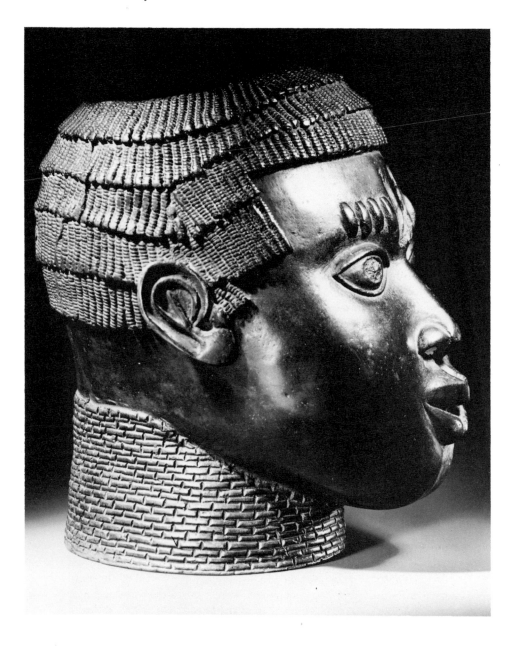

184. Head, for the altar of a deceased Oba. Benin City court art. Early period. This head believed to date from 1475-1525 (W. Fagg, 23 February 1980). Bronze. 21 cm (8.27 ins). For similar terracotta head from *c.* 15th century in Rietberg Museum, see Paula Ben-Amos, *The Art of Benin*, London, 1980, fig. 12. Formerly Louis Carré Collection. Photo: Horst Kolo.

leading a rebellion, and concludes that these are 'trophy' heads and not, as usually classified, ancestral commemorative heads. In support of this she also quotes oral traditions.[25, 26, 27] The possibility thus arises that certain Benin bronze heads were used for several purposes, and early styles may have been repeated in later periods.

Whether or not the theory of 'trophy heads' is corroborated by future evidence, the largest number of Benin bronze heads were ancestral memorial heads placed on the altar of a deceased Oba by his successor. The earliest castings were thin-walled, a sign of technical excellence and perhaps also of the scarcity of the raw material. Apart from these commemorative heads, there are also spirit cult heads for Osun [185], embodying the power of medicine, adorned with their respective attributes and symbols. The corpus of bronze castings also includes headdress masks for the annual Odudua masquerade [186], and hip masks [187]. The four magnificent queen-mother heads in Lagos, London, Liverpool and Berlin are probably from the early period. As the special position of the Queen Mother in the Benin hierarchy is said to have been created by Oba Esigie, who came to power at the beginning of the sixteenth century, these famous heads and other representations of the Queen Mother cannot be from an earlier date.

The sixteenth century saw a sudden development of trade with the Portuguese and subsequently with other European nations, resulting in a more abundant supply of raw material for the castings. From 1550 onwards the heads became heavier in weight; and later, higher collars and additional decoration replaced the early purity of form. The greater weight, however, was required to make the heads standing on altars more suitable as bases for the large carved ivory tusks inserted into or placed upon them. The plentiful supply of bronze also facilitated the production of plaques [188, 189]. These are a rather uncommon feature in African art and may have been inspired by illustrated European books. Certainly, they are one of the best sources for reconstructing the history of Benin art. Some depict traders with their staffs and the brass manillas used as money. Rosettes and fish decorate corners of the plaques. Also used for decoration are heads of Europeans, the half moon, and many types of floral and geometrical designs. It is possible that some of the most frequently used engraved decorations were inspired by similar patterns on handguns and armour bought from the Portuguese. A flower design with four petals, almost identical with that widely found on Benin plaques, is also used by the Akan; but as the Akan design is always compass drawn, it may be an Arab-influenced motif.

Plaques were made in both low and high relief, some having only one figure on a background of engraved design, while on others every inch is filled in typical Benin style. Although many of these castings are uninspired, some do stand out as masterpieces, classified according to decor-

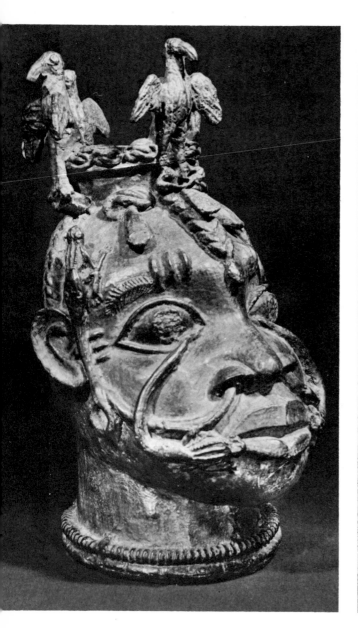

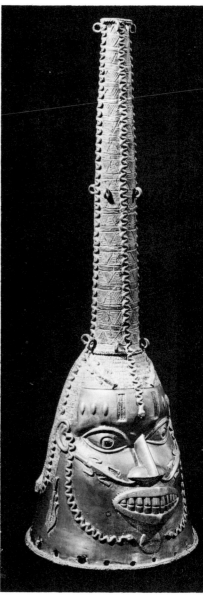

185 (*left*). Head for Osun cult. Birds of prophecy; snakes issuing from mouth and corners of eyes, and devouring frogs; 'thunderbolts' (stone celts). Benin City court art. Early 18th century. Bronze. 27 cm (10.7 ins). Museum of Mankind, London. Photo: André Held.

186. Odudua mask surmounted by tall cone for Osun cult; lizards issuing from nostrils. Benin City court art. Late 18th century. Bronze. 56 cm (22 ins). National Museum, Lagos. Courtesy National Commission for Museums and Monuments, Lagos. Photo: André Held.

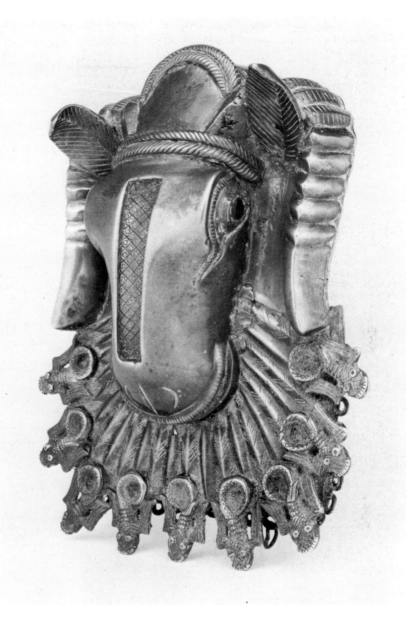

187. Hip mask in the form of a ram's head. Benin style, possibly by Owo artist. c. A.D. 1650.
Bronze. Eyes inset with iron nails; nose has copper inlay engraved with stippled circlets;
double spiral copper bands on forehead; beard bordered by nine mudfish. 20 cm (8 ins).
Photo: courtesy Christie's, London.

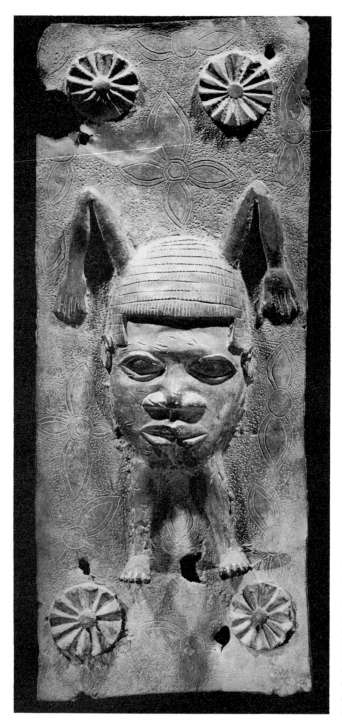

188. Plaque. Stylized human figure, limbs attached to head; said to represent the 'messenger of death'. Benin City court art. 16th century. Bronze. Height 47 cm (18.5 ins). National Museum, Benin City. Courtesy National Commission for Museums and Monuments, Lagos. Photo: André Held.

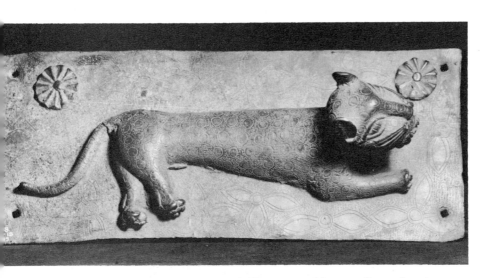

189. Plaque depicting a leopard. Benin City court art. 16th century. Bronze. Length 45.5 cm (17.9 ins). Museum of Mankind, London. Photo: André Held.

ation or design as from the 'Master of the Circled Cross', and the 'Master of the Leopard Hunt'. These works are in low relief, extremely well modelled and composed. Only seven plaques have been attributed to the Master of the Leopard Hunt. Some of the high-relief plaques give the impression of being cast separately in the round, a demonstration of very great skill in both modelling and casting.

Few, if any, *figures* can be attributed to the 'Early Period'. The two dwarfs in the Vienna Museum[28] could be from that period; but their vitality and strong naturalism make them atypical of Benin art, and they may belong to a different culture. Some figures attributed to the 'Middle Period' may well have been made in the middle of the sixteenth century. These include several sculptures representing hornblowers; a variety of bells; bronze aquamaniles [190] depicting rams or leopards, the royal animal; casts of bronze cocks for the altar of the Queen Mother [191]; figures of royal messengers; and shrines of the hand. Such shrines or altars[29] of the hand are called *Ikegobo* and, cast in bronze, are for the king's use only. But one bronze altar was made for Oba Akenzua I's general. The scenes depicted on it are based on the oral tradition of one family, that of the Ezomo or the Oba's commanding general, and so the object becomes an important historical document. It shows something about the relationship of the Oba and the Ezomo; the use of ritual devices in war; the dependence of the Bini on 'medicine' to achieve victory; the types of weapons, dress and ornament of the times. Although the altar shows Akenzua I, who reigned in the early eighteenth century, the

263

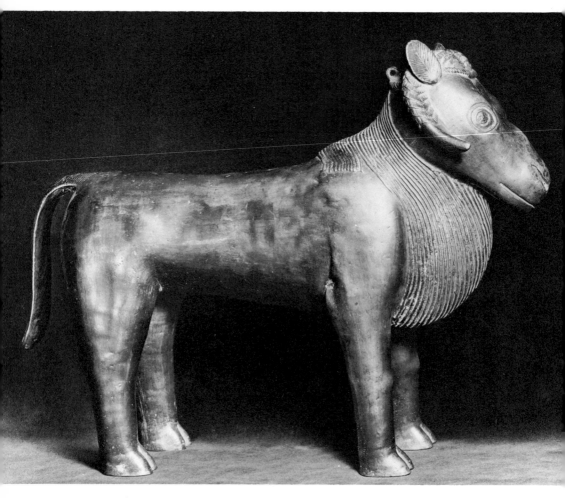

190. Aquamanile in form of a ram. Benin City court art. Mid 16th century. Bronze. Length 44 cm (17.3 ins). Museum of Mankind, London. Photo: André Held.

casting itself may be of more recent origin. A comparison with the cult and the altars of the hand used by the Ishan, Urhobo, Ibo, Igala and Ijo shows many similarities between these neighbours and Benin. Another important cult is devoted to the head, the 'symbol of life and behaviour', and it was more widespread than the cult of the hand.

Whatever vigour the 'court' art of Benin showed in the 'Early' and 'Middle' periods (and it could rarely compare with the fervour and vitality of 'tribal' sculpture), the later the piece, the greater the stylistic degeneration. While the objects made in the 'Middle Period' still show great qualities of design and execution, those of the 'Late Period' seem to lose these attributes progressively, until in the end they become heavy with

191. Figure of a cock (*okpa*) on stand, perhaps for Queen Mother's shrine at Uselu. Benin City court art. Mid 16th century. Bronze. 55.5 cm (21.85 ins). National Museum, Benin City. Courtesy National Commission for Museums and Monuments, Lagos. Photo: André Held.

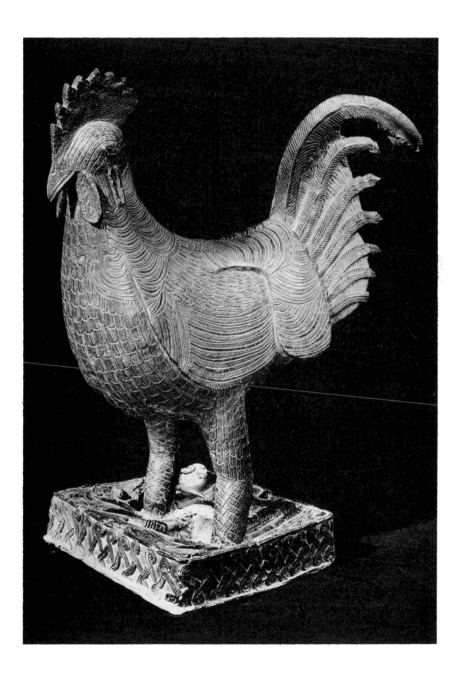

excess ornamentation and suggest a dying art in a moribund kingdom. The 'winged' heads of that period[30] are said to have been introduced in the first half of the nineteenth century under Oba Osemwede (but more likely by his predecessor), and they still had a certain strength of style; but from then on, the road led downwards to a vulgar, sterile realization of the Oba's orders.

192. Bell in shape of a Janus head with snakes issuing from nostrils. Atypical of Benin style, originally in possession of the Onogie of Avbiama; provenance remains undetermined. Probably 18th century. Bronze. 24.9 cm (9.8 ins). National Museum, Benin City. Courtesy National Commission for Museums and Monuments, Lagos. Photo: André Held.

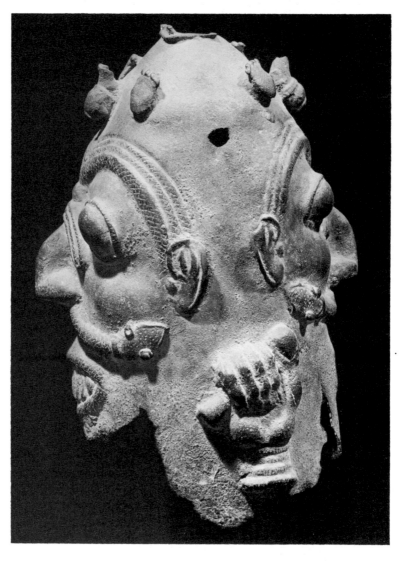

Many bronze and ivory objects found in Benin or elsewhere and originally attributed to the art of its guilds were excluded from that corpus when Fagg formulated his theory on Benin chronology. This applies also to a number of heads, mostly found in the city, but too strong and vital to be of its court art, though derived from it [193]. They are now believed to have been made in the neighbouring town of Udo.

193. Head. Found in Udo Village, 37 kilometres from Benin City. 16th century. Bronze. 23 cm (9 ins). Museum für Völkerkunde, Leipzig. Photo: Karin Wieckhorst.

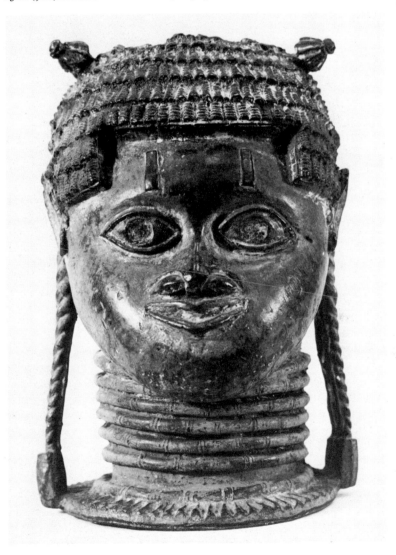

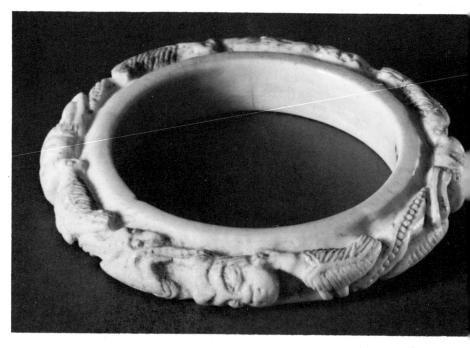

194. Bracelet showing birds picking at decapitated heads. Benin City court art. ? 16th century, registered in Royal Kunstkammer in Copenhagen in 1689. Ivory. Diameter 10 cm (3.94 ins). National Museum of Denmark. Photo: courtesy National Museum of Denmark, Department of Ethnography.

In contrast to the decline from the early greatness of the bronzes made by the craftsmen of the Iguneromwon guild, the members of the Igbesamwan, responsible for wood and ivory carving, maintained an extremely high artistic and technical standard right to the end. For that half of the ivory reserved for the Oba's orders, there were rigidly dictated designs to demonstrate his power and status of royal divinity. Some of the most outstanding ivory sculptures are the intricately carved tusks that were placed on the memorial heads; hip masks; ivory sceptres of the sixteenth to eighteenth centuries; side-blown horns, figures, armlets, and double bells [194, 195]. The other half of the ivory was available for the demands of a number of patrons, including the Portuguese; and the carvers accordingly enjoyed a greater freedom of design.

Heads, similar to the bronze commemorative heads, were also made in terracotta. These are thought to have been placed on the altars of ancestors of the chiefs of the bronze-workers' guild. Some fifty such terracotta heads are now in museums. It has been asserted by Ben-Amos, basing herself on Ihama, present chief of the bronze-workers' guild, that these types of head were used by Ogiso kings.[31] Wooden heads are now used

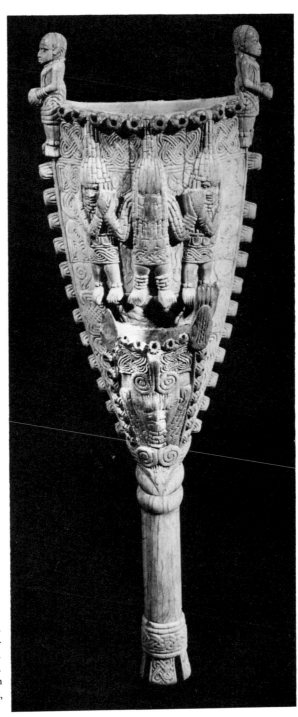

195. Ceremonial double bell.
Benin City court art. 16th cen-
tury. Ivory. 36.5 cm (14.37 ins).
National Museum, Lagos.
Courtesy National Commission
for Museums and Monuments,
Lagos. Photo: André Held.

by chiefs for their family altars, a custom introduced under Osemwede. Egharevba believed that the use of these heads, too, dates back to the Ogiso dynasty, but there is no corroboration for this.[32]

The study of chronology and other matters concerning Benin art is made the more difficult because hardly any of the known objects were discovered in controlled excavations, except for those undertaken by Connah.[33] Radiocarbon datings of smithed and chased copper alloy artefacts and a wide range of other objects average A.D. 1255.[34] It is widely believed – as is asserted at the beginning of this chapter – that 'relatively more is known about the art of the city of Benin than about any other aspects of West African plastic art'. Yet, as has been demonstrated, scholars are still at variance, and the answers to many tantalizing questions are yet to be found.

The Art of the Southern Savanna

The Art of the Kingdom of Mani Kongo

The Kongo people and the ethnically related Yombe, Woyo, Boma, Vili, Solongo and Sundi, with the Bembe and Bwende, inhabited an area, some of which is dense tropical forest, bounded by the Atlantic coast and the rivers Zaïre (Congo), Kwango and Dande, and by the Stanley Pool, and their common language was Kikongo. In the thirteenth and fourteenth centuries the Kongo founded a state with the Mani Kongo as its head and with Mbanza Kongo (later to be named São Salvador) as its capital. The other groups were linked to the kingdom as allies or tribute-paying neighbours.

When the first Portuguese under Captain Diego Cão landed in 1482 in the Zaïre estuary, they reported to Lisbon that they had found a well-organized and civilized – even though pagan – nation. The cultural evolution of the Kongo people, their religious hierarchy, their social organization based on clans and matrilineal succession, and possibly their art, may have had their beginnings in much earlier times.[1, 2]

The Portuguese very soon established correct and cordial relations with the Mani Kongo and his kingdom, exchanged ambassadors between Mbanza Kongo and Lisbon, followed later by an exchange with Rio de Janeiro, and, at least during the first few years, abstained from interfering in the internal affairs of the African kingdom. In 1490 missionaries arrived, and within a year the Mani Kongo, his family and many chiefs had been converted to Christianity. The king was baptized as Alfonso I and remained, despite all the tensions and troubles that followed, faithful to his new religion until his death in 1543. He protested first to Lisbon and subsequently to the Pope against the increasing slave trade and its ferocious raids, but all in vain.

Paolo Dias, abandoning his original role as representative of an allied nation, became the 'conquistador', and from his base at Loanda started his fight against the Mbundu kingdom of Ndongo (in what is now northern Angola) and their king or Ngola. The Ndongo were defeated, and Dias used some of the Kongo vassals and the ferocious Jaga[3] (marauding 'pilferers' of mixed ethnic origin) to harass the Kongo. The conflict escalated into full-scale war in 1660, and the Portuguese inflicted on the

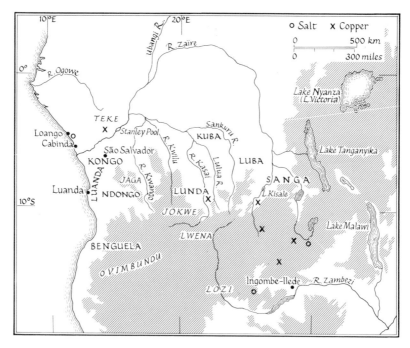

11. The southern savanna.

kingdom of Kongo a crushing defeat from which it never recovered. By the end of the eighteenth century the kingdom had lost its power; and Christianity was all but dead in the entire region.

Historical and art-historical data for the Kongo are unusually plentiful and detailed from the arrival of the Portuguese onwards. There is even a mention of purchases of African figurines by Duke Charles the Bold in about 1470,[4] i.e. some twelve years before Diego Cão landed. On his second voyage home, Cão is said to have taken coloured mats of woven palm fibres and ivory carvings as presents for the King of Portugal. These ivories may have been traditional carved side-blown trumpets, as in Pigafetta's description based on the writings of the Portuguese Duarte Lopez.[5] In this early chronicle there are also descriptions of cloth made from palm fibres, beautifully coloured; caps ornamented with fibres; belts of exquisite workmanship hung with bells; and glass beads used as money.

Two raffia baskets, originally in a collection in Worms, were registered in the inventory of the Royal Danish Kunstkammer in 1653; the acquisition date in Worms is unfortunately not known, and they were originally described as 'Indian baskets or hats'. However, on a canvas painted by Albert Eckhout in Brazil in 1641,[6] a similar object, being used as a basket, is depicted in an African background. Many objects woven, knotted or plaited from palm fibres, in particular raffia mats [196], tablecloths and

cushion covers, appear in European collections, many registered in the seventeenth and eighteenth century. Twenty such objects in the Pigorini Museum, Rome, recorded in 1881, were acquired from the Bircher collection, which had been formed in about 1650. A great number are in the National Museum of Denmark, Copenhagen, and others can be found in the Wieckmann Collection in Ulm.

A splendid ivory carving, believed to be a knife case, is in the Detroit Institute of Art. It is supported by small caryatides and four human figures and carved in relief on the sides of the case, which is decorated with geometric patterns derived from basketry and textile designs. It is most probably of sixteenth-century Kongo origin.[7] Carved figures on top of chiefs' staffs are other examples of the mastery of Kongo ivory sculpting [197].

Much of the documentation on the origin and whereabouts of all these Kongo artefacts has been painstakingly researched by Bassani in recent years.[8]

196. Raffia fibre mat. Kongo. Registered in the Royal Kunstkammer, Copenhagen, in 1737. Length 57 cm (22.4 ins). National Museum of Denmark, EDC 108. Photo: courtesy National Museum of Denmark, Department of Ethnography.

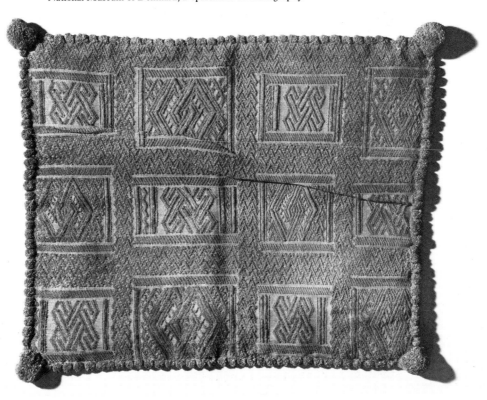

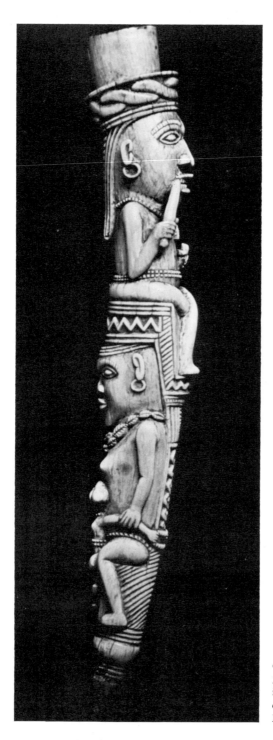

197. Two figures on top of chief's staff. Kongo. Ivory. 31 cm (12.2 ins). Musée Barbier-Müller, Geneva. Photo: courtesy Musée Barbier-Müller.

An important form of art of the Kongo and related people are the funerary sculptures carved of steatite [198, 199]. Called *ntadi* (plural: *mintadi*), which Thompson now names *tumba/bitumba*,[9] although both terms are applicable to all grave monuments, these sculptures were collected from various locations; direct dating has, therefore, not been possible. The earliest estimates of the age of *bitumba* were made by Verly, who placed them in the sixteenth or seventeenth century.[10] His conclusions were based rather vaguely on an appeal by Alfonso I in 1514 against the worship of stone idols, and on four *bitumba* in the Museo Nazionale Preistorico Etnografico 'L.Pigorini' in Rome, which were said to have been collected in about 1695 and had come from the Kircher Collection in the Roman Jesuit College. The catalogue entries, with related documents of the Kircher collection and the Italian state museums including the Pigorini, were examined by Bassani,[11] and he established that the earliest accession date for *bitumba* in the Pigorini was the year 1887. On Bassani's evidence, the seventeenth-century attribution may have to be revised. This conclusion leaves us without any reliable age for the *bitumba*, since the accession date has, of course, no bearing on the actual dating of the objects, though Vansina maintains that the cult goes back at least to the mid seventeenth century.[12] They were made for kings, chiefs and noblemen, often in their lifetime, and kept until death, when they were placed on the tombs as memorial figures. They were not intended as likenesses of the deceased, but rather as showing the roles and characteristics for which they had become known. Rulers were depicted as well-built, handsome and sitting tailor-fashion in asymmetric attitudes on a pedestal or kneeling; hands in a variety of gestures, with some carrying symbols of power; and all wearing a distinctive cap, the badge of their authority.

The results of Volavka's research into the background and meaning of the caps in their various shapes led to discoveries of historical and art-historical importance.[13] Following previous trails and reports on 'royal insignia',[14] and information from elders of the old Ngoyo kingdom, between Cabinda port and Muanda, she was unable to trace the insignia or the shrine in Cabinda in which they were said to have been kept. In 1976 she discovered the insignia in the Musée de l'Homme in Paris. The most important object among the sixteen items was the large dome-shaped copper crown, the model for caps still worn by chiefs. It is also depicted in many stone or wood sculptures as headgear adorned with leopards' claws and teeth. The king of Kongo was invested by the priestly chief with the copper crown conferring divine power. Divine kingship in Kongo was thus not an inherited authority but derived from election by the chiefs, which may have been a device of checks and balances. The social and royal structure of Kongo and the role of the insignia in carvings is very old, and according to oral tradition predates the arrival of the Portuguese. Seemingly, Kongo customs and art forms are as ancient as

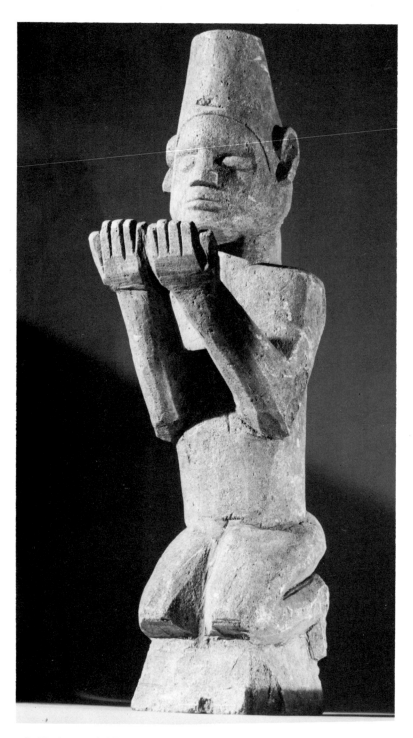

198. *Tumba* or *ntadi*. Mboma region, Kongo. Steatite. 43.5 cm (17.12 ins). Musée Royal de l'Afrique Centrale, Tervuren. Photo: Werner Forman.

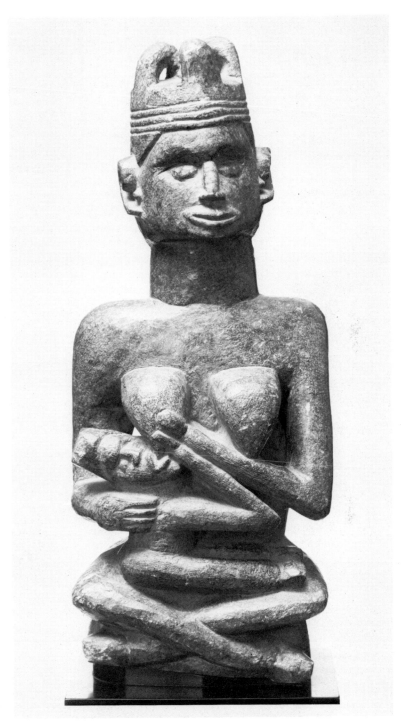

199. *Tumba* or *ntadi*. Maternity figure. Mboma region, Kongo. Steatite. 35.6 cm (14 ins).
Tishman Collection, New York. Photo: courtesy Pace Gallery, New York.

the 'insignia of divine authority'. Volavka believes it fully justified to consider the thirteenth or fourteenth century as the date for the origin of the regalia.[15]

Van Geluwe points out that the Woyo inhabit the coastal area of Cabinda and Zaïre from where the regalia are said to have come. However, only very few stone carvings originated in that part of Kongo, and she believes that the link of the 'crown' with the cap widely worn in Kongo seems 'hazardous'.[16] Yet the argument in Volavka's hypothesis cannot be ignored.

Not all *mintadi* depict chiefs, and the images include hunters, drummers, healers and executioners. An important image is that of a mother, seated tailor-fashion, nursing her child [199]. Some of these carvings show the probably symbolic 'mother', wearing the chief's cap with the emblematic four leopards' claws. Others are shown with different types of headgear representing various grades of authority, derived from appointment rather than election. Some *mintadi* are not anthropomorphic but objects representing the deceased's wealth, prestige and occupation: a gun for a hunter or, in very recent times, a sewing machine for a tailor. Other prestige objects placed on graves are Toby jugs and old Dutch gin bottles which are then also called *bitumba*. There are some tombstones in the form of stone slabs, the work of the Solongo,[17] on which figures are carved in low relief. The great majority of the known *mintadi* originated in Mboma and Solongo territory in southern Zaïre and in northern Angola, where archaeological research may one day give the answers to many remaining questions on Kongo stone monuments. Thompson is inclined to credit a number of different Mboma workshops to explain the great variety of style, treatment of surface and detailing of features.[18]

Other Kongo tomb markers, less well known than the *mintadi*, are hollow terracotta columns, averaging 40 centimetres in diameter and varying from 80 to 140 centimetres in height. The first comprehensive description, with illustrations of numerous examples, was published in 1981,[19] showing the pottery artefacts called *maboondo* (singular: *diboondo*) in a variety of shapes, with geometrical or anthropomorphic decorations or iconography. Most are barrel-shaped and some have covers surmounted by figures; others are made with open tops; none apparently are closed at the base. They were seen in cemeteries in many parts of Kongo country from Yombe to Boma [200]. As to the age of these extraordinary objects of Lower Congo art, Thompson quotes a reference by Carli (made in his report 'Voyage to Congo' in the years 1666–7)[20] of 'figures made of clay like our mortars' which he had seen on graves. Decorative designs on the *maboondo* resemble those of ancient Kongo pottery.[21] No direct dating is available, but here again the art and the customs for which these unique objects were produced seem to be ancient.

The deep respect for the dead and the importance of funeral ceremonies

200. Funerary column, *diboondo*, from cemetery at Lunga Vaza. Boma, Kongo. Terracotta, hollow. Height 44.5 cm (17.5 ins). Diameter 29.5 cm (11.6 ins). Institut des Musées Nationaux du Zaïre. Photo: Horst Kolo.

among the peoples of the Kongo kingdom brought about the creation of yet another type of sculpture among the Bwende and Bembe of the Stanley Pool area. These are huge cloth mummy cases in which the smoke-dried body of an important person is wrapped for funeral. These large 'mummy' type figures, more than life-size, are used by the Bwende and called *niombo*. The smaller cloth 'mannequins' of the Bwende are not intended for burial, but are made to honour an important person about a

year after his actual death. The *muzidi* or *kimbi* (plural: *bimbi*) of the Bembe are also mannequins made of red cloth like the *niombo*, but they are reliquaries containing the bones of the ancestor, exhumed after decomposition of the body. The *niombo* of the Bwende were tattooed on the chest with what Thompson called 'cosmic ideography'[22] and carried well-designed heads with scarification marks and filed teeth. Travellers' records[23, 24] are confirmation of the antiquity of this custom. The *niombo* is always shown with right hand up and left hand down, which is believed to symbolize crossroads: the deceased is on his way from this world to the next. This gesture is said to be demonstrated by the Sword of Authority, one of the important items in the regalia of the kingdom, and the sword itself is believed to have been made in the sixteenth century.[25]

201. Upper part of seated male fetish figure. Bembe. Stanley Pool, Republic of Congo. Wood, glass beads, eyes with porcelain inlay. 20 cm (8 ins). Indiana University Art Museum, Bloomington. Photo: Werner Forman.

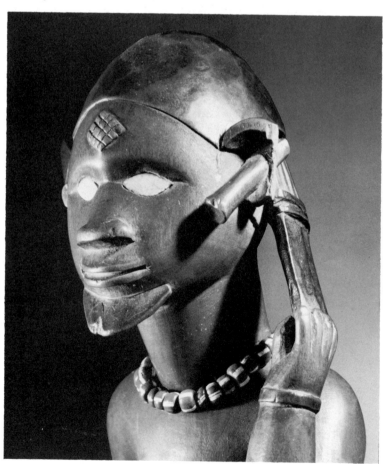

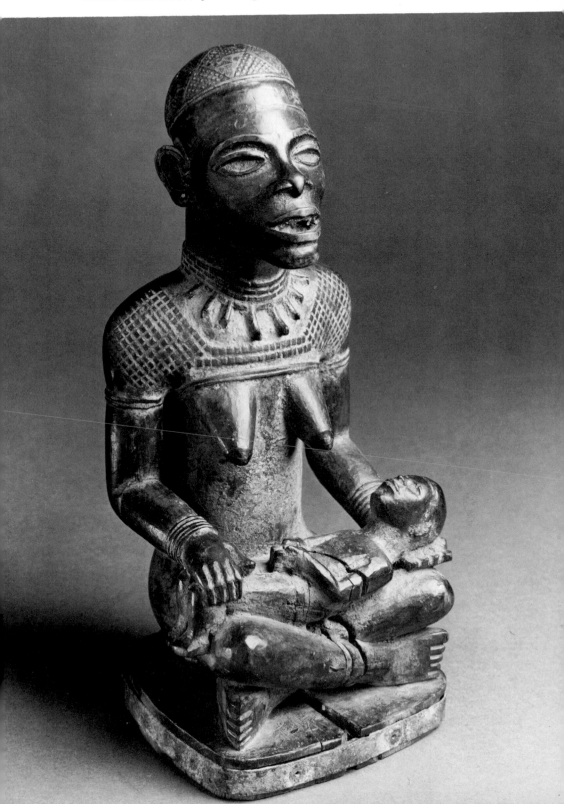

The Yombe, who live in forest country between the Zaïre and Kwilu rivers in the northern part of the old kingdom, produced some of the finest sculpture in all Africa. The objects, mainly of wood and ivory, were collected in the twentieth or at the end of the nineteenth century, and their iconography and the context in which they were used link them with the history and traditions of the kingdom.

The remarkable maternity figures, mainly of Yombe origin [202], are carved of wood in a realistic style, rare in Africa, and are said to have been used in divination ceremonies or to be associated with fertility rites.[26]

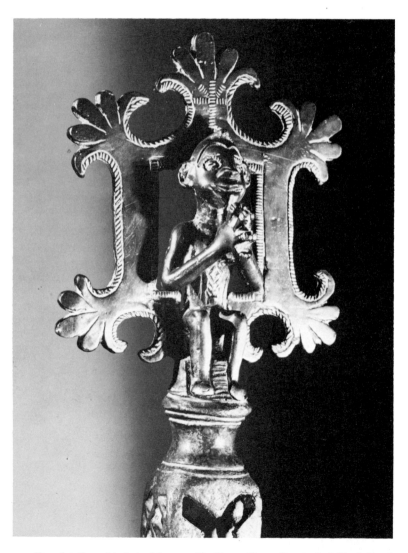

203. Top of staff, possibly derived from crucifix. Kongo. Brass. 28 cm (11 ins). Musée Royal de l'Afrique Centrale, Tervuren. Photo: courtesy Musée Royal de l'Afrique Centrale.

The symbolic mother, as in the stone figures, is usually depicted seated tailor-fashion – one exception is the standing figure in the Deletaille collection – looking straight ahead and never at the infant. The figure becomes thereby, as elsewhere in Africa, a symbol of fertility rather than a picture of the mother and child relationship. The headgear is either the cap of an elected chief or of a royal appointee, and high rank is also indicated by a necklace of leopard claws or teeth. The intense realism and the mother and child theme give rise to speculation of Christian derivations. The subject is, of course, universal; but the large number of Yombe maternity sculptures and the very close relationship of the Kongo kingdom with the Portuguese and other European nations – leading to temporary conversion – does make the idea of Christian stylistic influence plausible. In an attempt to establish the identities of sculptors or schools of carvers, Bassani examined a large number of wooden Kongo maternity statues. He selected two groups of sculptures, each with common stylistic denominators, and called them the works of the 'Master of the Roselli-Lorenzini maternity' and the 'Master of the de Briey maternity', after the name of the first collector of each type. Both groups of figures are believed to have been by carvers of the late nineteenth or early twentieth century.[27]

Metal crucifixes also appeared [203], but these became more and more africanized and were absorbed into the indigenous culture, a process known from other African contacts with Christian, Islamic or outside influences. While Christian missionaries fought what they considered the misuse of Christian icons for 'pagan' use, Islam was more tolerant and acquiesced in syncretism.

Maternity figures and kneeling or seated women are found on staffs, flywhisks, bells and ivory side-blown trumpets. There are also a number of male and female figures carved in wood, seated or kneeling, which are believed to have served in Kongo ancestor cults. They were receptacles for the spirit of the primordial or the immediate ancestor himself, who remained a part of the family even after his death and was relied on for aid.

Nail and mirror fetishes are a unique and important phenomenon of Kongo sculpture [204], while figures with magical substances embedded in various parts of the body are also used by other African nations. In the Kongo, all these fetishes are called *nkisi*. The *nkisi*, properly endowed with magic substances and additions by the Nganga or doctor, had the power to act in a number of ways. According to Maes, there are four main types of *nkisi*, used for different purposes.[28] *Nkondi* are fetishes of ill omen, usually brandishing a spear or a knife, while *npezo* are just as evil, but less menacing in attitude. *Na moganga* are benevolent figures which protect against sickness and dangerous spirits. They help the hunter and the warrior; while *mbula* protect against witchcraft.

Several Africanists have come to the conclusion that all *nkisi* can be

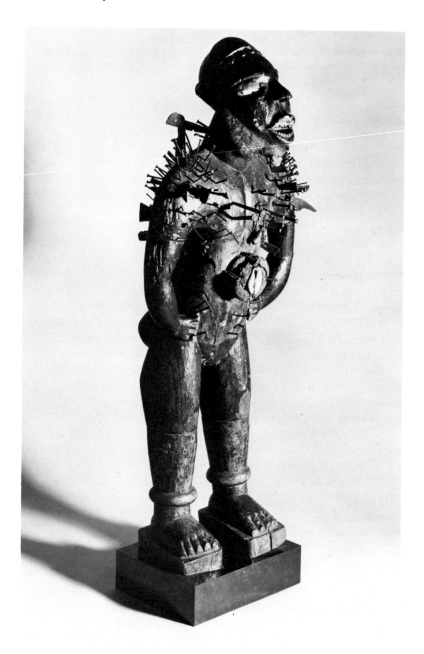

204. Nail fetish, *nkisi*. Yombe, Kongo. Wood, nails, cowrie, resin, eyes inlaid with porcelain. Both legs restored below the knee (probably while still in Africa). 118 cm (46.45 ins). Private collection.

used for a variety of purposes and that their meaning is ambivalent.[29, 30] The reports of an Englishman, Andrew Battel, who visited Loango at the beginning of the seventeenth century, and a book by Weeks[31] show that one and the same *nkisi*, whatever its form, was used to destroy or to protect, to cause an illness or to cure one.

The *nkisi* are made in stages, and more than one person is involved in their creation. The *nganga* orders from the carver a wooden figure in which the elements of its function as a *nkisi* are already incorporated. Some *nkisi* have very sensitive heads and well sculpted bodies; others may have a fine head, while the body is poorly carved. The figure is not yet a *nkisi*, but the *nganga* will now attach a box made of resin filled with medicine - or fetish material - sometimes covered with a mirror. He may add a headdress in which medicine is embedded, and hang horns, chains, snake heads, carved figures, beads and vials around the neck and on the arms of the figure, according to the purpose for which the fetish is being prepared. After the necessary rituals have been performed, the *nkisi* is endowed with its power and kept by the *nganga*. A further transformation is then begun with those *nkisi* into which the diviner will drive nails, blades, etc., for malevolent or benevolent purposes. This co-operation of carver and diviner creates the ultimate figure, and its aesthetic appeal to the European eye lies in the overall effect of the wooden statue and the added attributes. But a *nkisi*, however impressive to non-Africans, will be discarded by the *nganga* if it appears to have lost its power.

The importance of the report by the English trader Battel[32] is not only in its description of the manifold functions of a *nkisi* but in its historical implication. He was in Loango from about 1607 to 1610, and during a visit to the Yombe area saw there a 'large image called a Maramba fetish'. We can thus assume with reasonable certainty that the *nkisi* cult and the use of a carving for that purpose were established in Yombe country at that date and possibly earlier. There is no mention of the use of nails in Battel's report; a feature recorded for the first time in 1818.[33] The driving of blades and nails into anthropomorphic figures is also thought to have been derived from the Kongo people's exposure to Christian icons depicting the martyrdom of the saints and the crucifixion.

The relationship of the Teke with the Kongo in the fifteenth and sixteenth centuries varied from military cooperation to ferocious wars. Though some details of their history are known, their art history is obscure, except for the apparent influence of the Mboma and other Kongo tribes on their sculptural forms. Their fine brass work, anthropomorphic figures, and especially the heavy chiefs' collars, intricately decorated with geometric designs, could have had their inspiration in the ancient connection with Kongo.

The Kwilu-Kwango Area

The history and art of the peoples inhabiting the areas between the rivers Kwilu and Kwango was dominated by two powerful political organizations: to the west, the kingdom of Kongo; and to the south-east, the Lunda kingdom, which emerged in Angola in the seventeenth century. Both kingdoms had ties with the Holo, Suku [205], Yaka and - indirectly - with the Pende. Further east the Lunda, not an art-producing people themselves, became the catalyst in the development of the Luba and Jokwe cultures.

The art of the Pende, like that of the other tribes and nations in the Kwilu-Kwango region, is known to us through objects collected since the beginning of this century [206, 207]. Our knowledge of the more ancient arts, for which the Pende are praised in the oral history of other African nations, is therefore indirect and circumstantial. The Kuba are reputed to have learned the art of making pottery [209] (now mostly imported) as well as the weaving of textiles and the crafts of the smith from their Pende neighbours. In fact, Shyaam aMbul aNgoong (generally known as Shamba Bolongongo), founder of the Kuba dynasty,[34] is said to have himself been taught the making of cloth from palm fibres and embroidery work by the Pende, during his visit to them in the Kasai (or it may have been introduced through a Pende wife).[35] The same praise for their art and credit for passing on their knowledge comes from other tribes that migrated from Angola to the upper Kwango where the Pende once lived.[36] Similar credit was given to them by Jokwe blacksmiths, who told Bastin that they learnt their art from the Pende through the intermediary of the Lunda.[37] This is high praise indeed, coming from two nations, the Kuba and the Jokwe, considered to be among the best producers of plastic art in Africa. Yet no traces of ancient pottery, textiles (except for some red raffia pile cloth in simple geometrical patterns which is still in use) or ironwork,[38] nor even the memory of their old glory, remain with the Pende people. The reason for this can perhaps be found in the social structure and history of the Pende, compared with those of the Kuba and Jokwe. The high level of art attained by the Kuba and the Jokwe was largely due to the patronage provided by the courts of kings and chiefs, and - in the case of the Kuba - to an affluent population, established centuries ago in the region. Compared with them the Pende, once leaders in many arts, became impoverished people who, at the time of the Lunda and Jokwe expansion, had to leave their original home in Angola to settle between the Kwango and the Kwilu, only to move again, following renewed Jokwe pressure.

The movements of people from Angola into areas of Zaïre influenced art styles in the Kwilu-Kwango region and beyond. Wood carving is arguably as old in the eastern parts of Central Africa as in the west, where that art is so well known and documented. On existing evidence, the

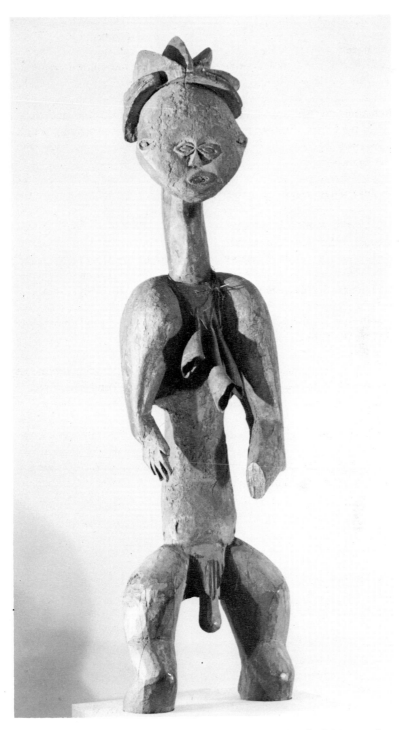

205. Large male statue. Suku. Kwango region, Zaïre. Wood, animal horns. 93.6 cm (36.85 ins). Musée Royal de l'Afrique Centrale, Tervuren. Photo: Werner Forman.

206. Gitenga mask. West Pende. Kwango region, Zaïre. Wood, raffia, palm-fibre, kaolin, pigments. 39.4 cm (15.5 ins). Musée Royal de l'Afrique Centrale, Tervuren. Photo: Werner Forman.

oldest African sculpture in wood originated in Angola [3].[39] Two wooden sculptures originating in Angola, or possibly in the Kwango area, are among the earliest collected by Europeans. (Compare Ifa tray in the Wiekman Collection in Ulm.[40]) The two figures, in the Museo Nazionale Preistorico Etnografico 'L. Pigorini' in Rome, were probably acquired in Lisbon between 1692 and 1695 by a Papal envoy, and are thought to have been carved during the first half of the seventeenth century.[41] Bassani concludes that the statuettes were made in the Kwango area, influenced in part by the style of artists who had come to the region from Angola in migrations dating back to the twelfth century. Bontinck, referring to the curious labels on the base of the figures, 'Idolo de la China detto Mocorri' and 'Idolo de la China detto Bamba Engo', believes that they originate from the region of Kina in the Kwango area.[42] The head and coiffure of the figures have a strong affinity with the style of the Ovimbundu of Angola, but the treatment of the shoulders and the arms with hands on the chest resemble carvings by Suku,

207 (*left*). Door. Pende. Zaïre. Wood, kaolin, pigments. 99 cm (39 ins). Acquired 1902 from Leo Frobenius. Museum für Völkerkunde, Hamburg. Photo: courtesy Museum für Völkerkunde.

208. Male cult figure with horns. Hungana. Kwilu River Valley, Zaïre. Wood, iron neckrings. 43.5 cm (17.12 ins). Musée Royal de l'Afrique Centrale, Tervuren. Photo: Werner Forman.

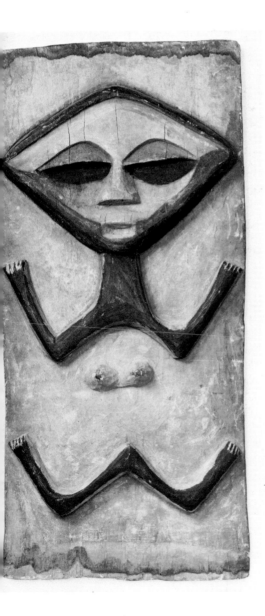

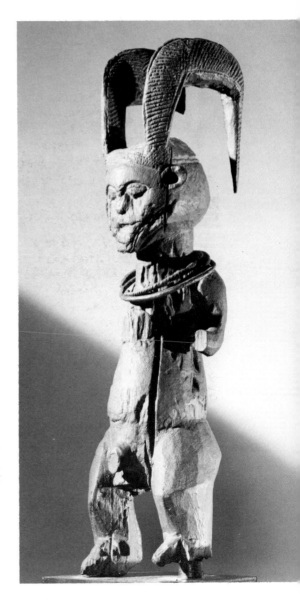

Hungana [208] and other Kwango tribal artists. The most likely origin of the Pigorini figures appears, therefore, to be the Kwango region, demonstrating once more the influence of migrations on indigenous art.

The Luba, Lunda and Jokwe Complex

Between the western shores of Lake Tanganyika and the Kasai river are centres for some of the most significant art-producing peoples of Zaïre – and of all sub-Saharan Africa. In this and adjacent areas, archaeological finds have led to the formation of theories on the ethnographical and art-historical background of the tribes and nations in the region.

Towards the end of the first millennium B.C. and in the early period of the Christian era, a rapid expansion of Bantu-speaking Negroid Iron Age people occurred. They spread from the forest areas in southern Central Africa to the region of the Great Lakes, and were instrumental in the development of pastoral and agricultural economies in which possession of iron tools played an important role. Finds of Early Iron Age pottery were made along the shores of Lake Nyanza (Victoria) and at some fifty sites in Kenya, Uganda, Rwanda, the Kivu province of eastern Zaïre and – possibly – in Tshikapa on the Upper Kasai [209].[43, 44, 45, 46] A 'dimple-based' type of pottery, usually referred to as 'Urewe ware' after the locality at which the first ceramics of this type were found, has been dated to between the third and fifth centuries A.D. Similar though not identical ware stems from the Wele region, from Ennedi and Darfur.

The Bantu-speakers then turned southwards in an eastern and a western stream, and their arrival on the upper Lualaba is most probably related to the so-called Sanga culture, unearthed in a necropolis at Sanga, an area rich in copper. Important finds were made of fine pottery with bevelled rims and horizontal groovings, together with iron tools, bracelets of ivory and copper wire, necklaces of copper beads and ivory [210]. Large numbers of cruciform copper castings, possibly used as monetary units, were also discovered. Decorations in the form of crosses – used long before the coming of the Christian era – were also found on some pottery vessels in Sanga graves. It is not known if there is any connection between this symbolism and the shape of the copper castings. Among the pottery vessels found at Sanga is one with an anthropomorphic decoration, and an engraved stone pendant. On the basis of excavations by Nenquin and Hiernaux in 1957–8, the Sanga (and near-by Katongo) cultures were dated to the eighth to ninth century A.D. New dates obtained in the 1970s resulted in a revision of the age of the cultures, and readings vary from A.D. 710 ± 120 to A.D. 1760 ± 65.[47, 48]

Drawn wire and the use of welding point to advanced technologies at that early period, when there had not yet been any external influences from Europeans. It is from this area of Sanga, not far from Luba country,

209 (*above*). Vessel. From Mushenge, Kasai, Zaïre. According to the Nyim (king) of Kuba this vessel is of Pende (Tshikapa area) origin. Terracotta. Height 15.9 cm (6.25 ins). Diameter 22.4 cm (8.82 ins). Musée Royal de l'Afrique Centrale, Tervuren. Photo: courtesy Musée Royal de l'Afrique Centrale.

210. Vessel. Sanga. Shaba-Bukama area. About A.D. 1200. Terracotta. Height 8.7 cm (3.42 ins). Diameter 20 cm (7.87 ins). Musée Royal de l'Afrique Centrale, Tervuren. Photo: courtesy Musée Royal de l'Afrique Centrale.

that the Bantu moved further south and spread their culture to Leopard's Kopje in Zimbabwe and beyond. No clues have been found at Sanga or at Katongo regarding the people buried in the cemeteries there. But as the area appears to be the cradle of the great Luba culture, it is possible that the Sanga people may have been the ancient ancestors of the Luba, though it must be stressed that there is as yet no proof for such a theory. As the Sanga culture may go back to A.D. 1000 or earlier, and the first Luba empire is believed to have been founded about A.D. 1500, there is a large time gap to be bridged by further excavations and research.

From the many chiefdoms in the Kasai region, two strong empires were formed at the end of the fifteenth century: the Lunda and the first Luba empire. Their emergence had a most important influence on the arts, which developed into a Luba-Lunda culture over an enormous area – from the Kasai in the north, to Angola in the south, and to the shores of Lake Tanganyika and across its waters in the east. The spread of this culture, in which the Lunda were the administrative and political genius and the Luba the artistic influence, affected numerous nations in the region.

The legendary founder of the first Luba empire was Kongolo-Mukulu, who was murdered by his nephew Kalala Ilunga, the first 'divine' ruler of the kingdom labelled 'the second empire',[49] which appears to have differed little from the first. The third empire, dominated by the Kaniok, is believed to have been created about A.D. 1700, and the great expansion of Luba power and influence started roughly at about that time. This inspired the art of the Kaniok [211], Luluwa, Songye, Hemba, Kusu, Boyo, Bembe, Tabwa, Holo Holo [212], and many others.

The Luba greatly revered and admired their smiths and sculptors. Their outstanding artistic achievements, along with those of related nations, date back to early times and continued into the twentieth century. Their naturalistic, well-rounded, beautifully carved figures with shining patina, and their fine realization of the female form – of great importance in this mostly matrilineal society – have also a special appeal to western aesthetics. They are traditional carvings for ancestor and spirit cults, for initiation, medical and divination purposes: seated females with bowls (*mboko*), chiefs' staffs, bow and arrow stands and neckrests, of which those attributed to the Shankadi are the most delicate and touching works of Luba art. Another important category of Luba carvings are the caryatid chieftain's seats, and among these, the stools attributed to the workshops of the Hemba master (or masters) of Buli are outstanding [213]. Few masks were used, but those known are among the greatest in all Africa. The variety of Hemba styles is linked to the migrations of the tribes that created this fascinating culture.[50] They spread northwards from Shaba province to the Luama, and their art, mainly ancestor statues, is indeed impressive.

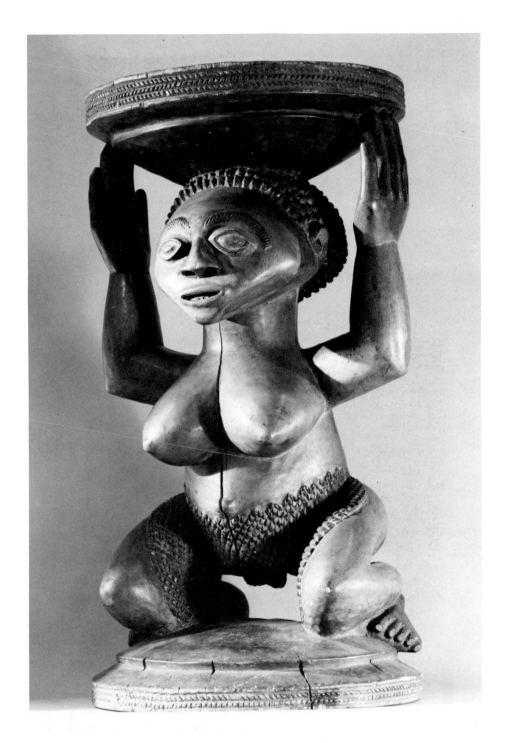

211. Stool supported by kneeling female. Kaniok. Zaïre. Wood. 52 cm (20.5 ins). Musée Royal de l'Afrique Centrale, Tervuren. Photo: Werner Forman.

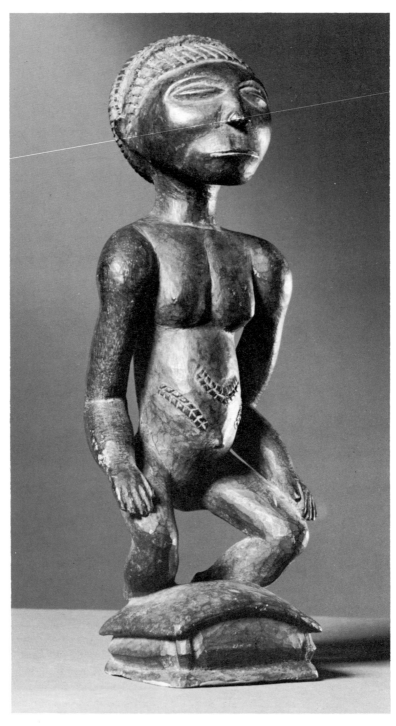

212. Standing male figure. Holo Holo. Collected on eastern shore of Lake Tanganyika, Tanzania. Wood. 26 cm (10.25 ins). Museum für Völkerkunde, Berlin. Photo: Werner Forman.

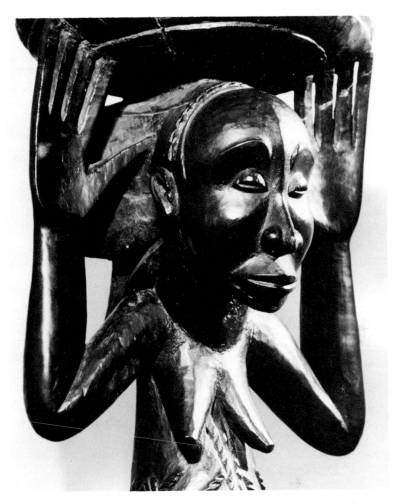

213. Part of a chief's stool supported by a caryatid. Hemba. Zaïre. Master(s) of Buli. Wood. Overall height 55.25 cm (21.75 ins). Private collection.

The Lunda live in southern Zaïre, Angola and Zambia, and are believed to have been in the northern part of those territories 'since remote times'.[51] A number of clans and chiefdoms were formed into a divine kingdom, with a strong centrally controlled political hierarchy. This was based on a bi-lineal system of succession (both patrilineal and matrilineal). Chiefs were related by blood to the king and to each other, exacted tribute, and ruled subjugated tribes in Angola and central and southern Zaïre. This process was started by the legendary Chibinda Ilunga, a Luba prince who left that kingdom in about A.D. 1600 and, by marrying the Lunda queen Rweej, became the founder of the Lunda empire, the *mwata yamvo*.

His leadership and the revolutionary pattern of government developed by the Lunda led to an expansion into Angola, where he was adopted by the Jokwe as their hero and leader. The Lunda, in spite of their close association with some of the greatest art-producing peoples of Africa, were never known to have had a carving tradition of their own, and their chiefs' seats, sceptres, other regalia and sculpture required for their socio-religious needs were acquired from Luba, Jokwe and other carvers.

The *ndongo* and *kimbundu* speaking peoples of Angola settled on the Luanda plateau in the early Iron Age.[52] To their north was the Kongo state, with which the *ndongo* were so closely involved; to the south were the Ovimbundu; and to the east, the peoples of the Jokwe-Lwena complex. In the north-east at that time were the Pende, renowned as rain-makers, and the power of their weather god, vested in their wooden *malunga* figures, was greatly respected by their neighbours.

The *ndongo* had their own ritual symbol called *ngola*, the root word from which the name of Angola was later derived. Their images were made of iron - a sign, perhaps, of the increasing use and importance of the metal - introduced in about the fourteenth century from the north by the Samba, a tribe related to the Suku. The origin of the Jokwe is unknown, but according to oral tradition they had lived in the centre of Angola since the sixteenth century A.D.[53] Jokwe culture emerged, how-ever, after the Lunda conquest in the seventeenth century A.D., when a system of chiefdoms and ideas of divine kingship were introduced by Chibinda Ilunga. The greatest works of wooden sculpture date back to the time when the Jokwe were settled in Angola, and although most known carvings in the 'style of the country of origin' (Bastin) stem from the nineteenth century, they are considered as the culmination of the Jokwe culture. Representations of the 'héros civilisateur Chibinda Ilunga'[54] and of chiefs are among the most powerful Jokwe art [214, 215].

Jokwe expansion to lands between the Kwilu and the Kasai and areas in Zambia started in about 1850 and was caused by economic factors, mainly the search for ivory and rubber. By the end of the nineteenth century, they had overrun the territories of the *Mwata Yamvo*, the Lunda empire. The changed style of the works produced after 1850 in their new habitats in Zaïre is named by Bastin the 'style of the expansion'. The uniqueness and individuality of Jokwe art is evident, yet they absorbed many influences from their neighbours and later on from Europeans. They learnt the process of iron-making in blast furnaces from the Pende, and refined their pottery by adopting Lwena methods. The Kuba and the Jokwe, who traded widely with each other, used designs which appear similar, though both developed their symbols and decorative patterns independently of each other, while Kuba culture was partly Kongo derived. Chiefs' chairs, which replaced stools, designs of combs and pipes, and the use of metal decorations are a result of Jokwe contacts with the

214. Statue of Chibinda Ilunga carrying musket and staff for his *mukata* (hunting charm). Jokwe. Style country of origin. Angola. Probably 19th century. Wood. 39 cm (15.35 ins). Museu de Antropologia, Luanda, Angola. Photo: courtesy Marie-Louise Bastin.

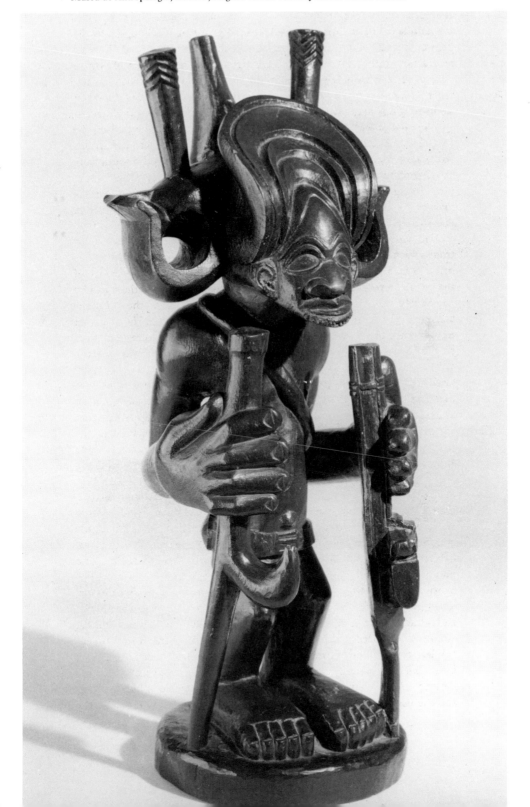

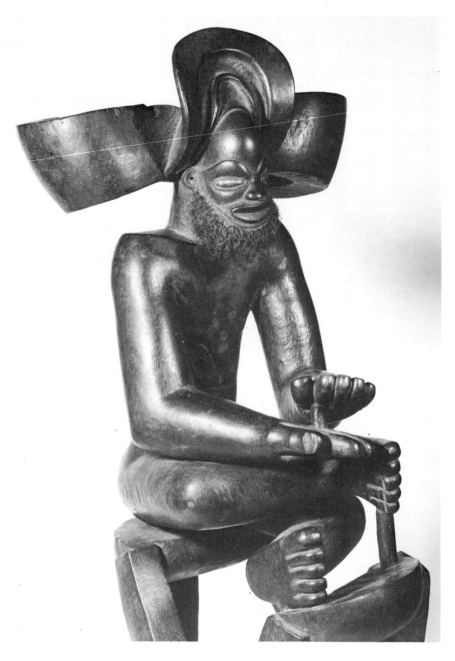

215. Seated chief. Carved in three separate parts: upper part, lower part of body and rear support. Jokwe. Moxico, Angola. Style country of origin. Collected 1904-6. Wood. Eyes with brass inlay; beard of inset hair. 49 cm (19.25 ins). Museu de Antropologia da Universidade, Porto. Photo: courtesy Marie-Louise Bastin.

Portuguese. Conversely, Jokwe stylistic and iconographical characteristics can be observed in the arts of the Pende, Mbagani, Kete and Kaniok.[55]

The cultures and, for that matter, the art styles among the neighbours of the Jokwe, in particular those of the Lwena, Songo and Ovimbundu, are closely related. The Ovimbundu were conquered by Lunda elements, who invaded the Benguela plateau late in the seventeenth century, and they then absorbed the Lunda by inter-marriage and acculturation. They still live on the plateau, though many are now settled further east, along the tributaries of the Upper Zambesi.[56] The Songo, who still occupy an area near the original Jokwe homeland, are known for their fine ceremonial stools, sceptres often surmounted by figures of mounted chiefs, and most of all for their sculptures called *nzambi*, which depict men riding on oxen. The inspiration for these idiosyncratic figures seems to have come from white traders and from explorers like von Wissmann and Livingstone, who gave preference to the ox over the horse because of its greater resistance to the tsetse fly and because it was more suitable for travel in the bush. The Songo attribute magic powers to the *nzambi*, which became the object of a cult connected with initiation ceremonies.

The interaction of Lunda rule and the artistic creativity of the Jokwe and related peoples resulted in a remarkable culture which still remains largely unexplored, owing to the almost total absence of archaeological research in Angola to date.

Art in the Kuba Region

In Kasai province, north of the Lunda–Jokwe complex and crossed by the Sankuru, Lulua and Kasai rivers, is the region of the Kuba and related people, united in one kingdom since about 1600, with the Bushoong as the dominant chiefdom. The origin of most of the tribes constituting that state is most probably Mongo country north of the Sankuru, and the southward migration that started 300 to 400 years ago is said to have been continuous until well into the 1950s.[57] The Luba-speaking Kete and some pygmies [216] are believed to have been the only inhabitants before the migrations started. This is a territory of equatorial forest and rich savanna, intersected by a number of rivers that provide good fishing, and with great natural resources adding to the area's potential wealth.

Our knowledge of the history of the Kuba is based on a mixture of oral tradition, myths, the writings of missionaries, the report by Emil Torday on his ethnographic research early this century, and subsequent work by African and western historians. The Kuba are fascinated by history, the keeping of which is entrusted to the king, his eldest son the *bulaam*, and others who must also learn the dynasty's genealogy.[58] There are several myths of creation, and in the one most often cited the world and man

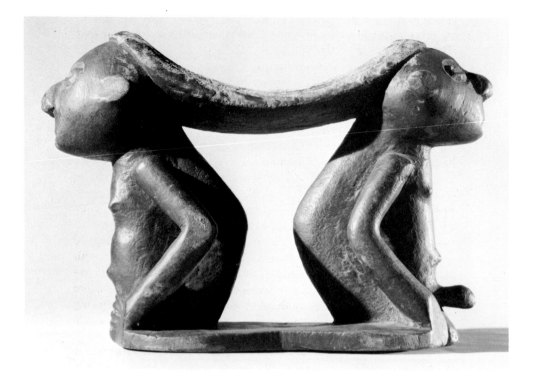

216. Neckrest supported by male and female half figures. Twa (pygmies integrated with the Kuba). Bushobbe Village, Kasai, Zaïre. Wood. Length 27 cm (10.5 ins). Musée Royal de l'Afrique Centrale, Tervuren. Photo: Werner Forman.

were created by the great god Mboom. The first man in the tradition of the five peoples that Vansina calls the 'Central Kuba' is Woot, and he is 'a culture hero', central to many myths and ceremonies and figuring prominently in the boys' initiation rituals. Next to the gods, and possibly to a greater degree, the Kuba revere nature spirits, *mgesh*, probably taken over from the indigenous Kete, from whom their masks also derive.

Though oral tradition is of vital importance to the Kuba, it is, of course, not factual and must be corroborated before being accepted by the historian, and such corroboration was provided for the history and genealogy of the dynasty. When Torday made his journey through Zaïre, he visited among others the Tetela, Songye, Pende and in 1904 the Kuba, with whom he stayed for some time. His report on the Kuba is one of the most comprehensive on any sub-Saharan nation compiled at such an early date.[59] The elders told him the history of their long line of kings and in their recital referred to an eclipse of the sun and the

appearance of a comet. These events were checked with British astronomical records and were confirmed as having occurred in 1680 and 1835 (Halley's comet) respectively.

With this corroboration, Torday was able to establish the approximate dates of the Kuba kings, starting with Shyaam aMbul aNgoong, otherwise known as Shamba Bolongongo. His reign is now believed to have begun in the first quarter of the seventeenth century. In Kuba tradition he was the creator of their nation, as Woot, the first man, was the creator of their culture in general. Shyaam was a foreigner, the son of a female slave, and he became king of Kuba by 'stealth and gamble'. He ruled as a divine monarch, supported and at the same time controlled by a hierarchy of chiefs and notables. He was credited with many agricultural innovations; with the introduction of raffia 'pile' cloth-making (in which his Pende wives were reputedly involved); and with other techniques which, oral tradition maintains, he learned from the Pende during his extensive travels before and after his accession. Shyaam was also credited with many artistic developments which augmented his prestige, although excellent work appears to have been produced in the Kuba area even before his accession.[60] Torday's story that he abolished the use of the throwing knife because of his horror of war is contradicted by one of Vansina's informants.[61]

Europeans first visited Kuba at the end of the nineteenth century and the beginning of the twentieth. William Sheppard, a black American missionary, Frobenius and Emil Torday after him were most impressed by the sophisticated civilization of this small country with only some 150,000 inhabitants: its court resplendent with pomp and ceremony; its political structure; its legal system unique in Africa; and, above all, its art, which they rightly recognized as being an essential part of the people's life. Not only the objects made for use in religious cults or the regalia of king and court, but everyday possessions were well designed and richly decorated to satisfy their great sense of beauty. The crafts of the sculptors and smiths were highly regarded by the people and the court. Several kings had the reputation of being master smiths themselves, and one of them, Bope Pelenge, adopted an anvil as his personal symbol.

While there are fairly good data available for the history of the Kuba and related people, art-historical study is still in its early stages. Knowledge is based on the three great collections, those of Sheppard in 1892, Frobenius in 1905 and Torday in 1908. Some of the art objects collected by Sheppard are now at Hampton, Virginia. The Frobenius collection is in the Berlin Museum für Völkerkunde and in other German museums. The objects brought home by Torday are in the Museum of Mankind, London. As to the age of the objects collected, very little information is available. While some of the art may precede the Age of Kings, the majority of the wooden specimens in the collections are of quite recent

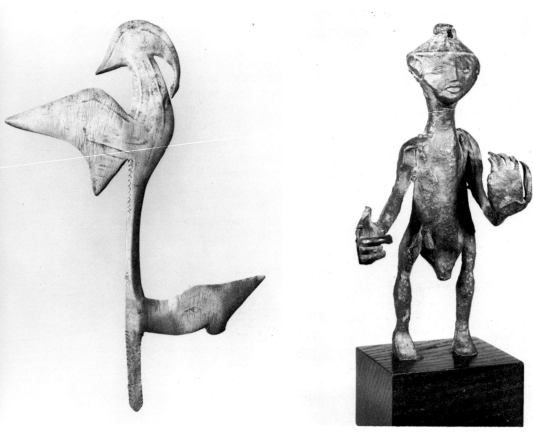

217 (*left*). Throwing knife. (?) Kuba. Zaïre. Iron. 45 cm (17.7 ins). Registered in Royal Kunstkammer, Copenhagen, 1775. National Museum of Denmark. Photo: courtesy National Museum of Denmark.

218. One of two wrought-iron figures. Kuba. Zaïre. (?) 16th century. 19.5 cm (7.68 ins). Etnografisch Museum, Antwerp. Photo: courtesy Etnografisch Museum.

date. Though apparently adhering to traditional forms, artists used a great deal of individual initiative.

An Iron Age statue was excavated by Desmond Clark on the Kwango River and is probably from the first millennium A.D. and of Kete or Pende origin.[62] An iron throwing knife [217], registered in the Royal Kunstkammer in Copenhagen in 1775 as 'from Central Africa', was probably collected in the first half of the eighteenth century. There is a Kuba iron figure of a dog in the Verwilghen Collection (Belgium),[63] and two wrought-iron human figures [218] are in the Etnografisch Museum in Antwerp. Torday believed that these and several other iron figures,

representing both animals and humans, mentioned to him, were made about A.D. 1515 – i.e. before the Age of Kings.[64, 65, 66] If this is so, an attribution to the legendary Myceel, an ironsmith of the royal family, would be incorrect. But whether they were made in the sixteenth century or the seventeenth, they may be attributed to the Kuba or the Kete, since these figures have the typical hairline defining the triangular face common to both nations.

219 (*left*). Anthropomorphic cup. Kuba. Zaïre. Wood. 25.8 cm (10.15 ins). Musée Royal de l'Afrique Centrale, Tervuren. Photo: courtesy Musée Royal de l'Afrique Centrale.

220. Royal sceptre (or handle of flywhisk). Kuba. Zaïre. 16th–18th century. Ivory. 39.8 cm (15.67 ins). Formerly Ortiz Collection. Photo: courtesy Sotheby Parke Bernet & Co.

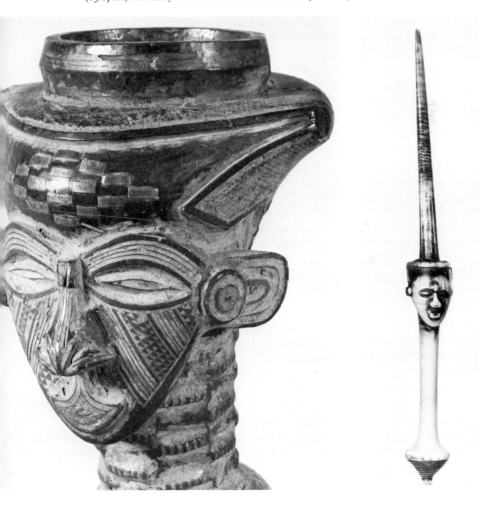

There is a close relationship between basket making, the textile industry and sculpture. Many sculptural shapes are derived from the former, while some of the hundreds of intricate patterns decorating wood carvings may well have their origin in textile designs. Kuba raffia fabrics, especially the cut pile embroidered cloth, acquired a great reputation.[67] The technique may have come to Kuba from the Kwilu-Kwango area through the Pende, and similar cloth, though made on a loom and not embroidered, was exported to Europe from the kingdom of Kongo [196], where it was first mentioned in 1508, before the arrival of the Europeans.[68]

The many types of carved objects include ornamented boxes for jewels, razor blades, and *tukula* (red wood powder). Their forms vary: half moon, rectangular, semicircular, basket shape, or the image of a human face. Cups, goblets and pots may be skeumorphic, cephalomorphic or anthropomorphic [219]; and among the many other objects are drinking horns, knife handles, neckrests, doorposts and drums. Prestige objects were widely owned by chiefs, courtiers and wealthy people, as symbols of rank. Frobenius, when writing of his visit in 1906, stated that in the villages in the Upper Kasai–Sankuru regions, the streets were lined with four rows of palm trees, and every hut was decorated with beautifully designed latticing. Men wore ceremonial knives of chiselled iron, or copper blades in snake-skin sheaths, and there was an abundance of velvet cloth, carved goblets, pipes, flywhisks and other works of art [220].

The Kuba use masks for dances in religious ceremonies, initiation, burials and for many other rituals, based on their rich traditions. About ten styles have been classified, of which three relate to the myth of Kuba origin. The masking customs date back to ancient times, and it is believed that certain masks were adopted from the Kete who lived in the area before the formation of the Kuba kingdom. The helmet masks *mwash a mbooy* [221], representing the son of Woot, and *bwoom* could be among early ones. *The mwash a mbooy* is constructed with the stalks of palm leaves forming the base of a head made of cowrie shells, skin and cloth, often richly embroidered. The masks, coloured blue, white, red, black and ochre, have a long tubular extension representing the trunk of an elephant, a symbol of royal power. The *bwoom* is made of wood covered with copper sheeting, cowries, beads and skin [222]. A large, bulging forehead is its distinctive feature. Both the *mwash a mbooy* (or *mosh' ambooy mu*) and the *bwoom* are royal masks, *mbey a nyim*.[69] The third royal mask, inspired – according to folklore – by Woot's sister, is the *ngady a mwash*.[70] This represents the king's wife/sister and is made of raffia and painted wood, ornamented with beads and cowries. Divining instruments, usually in zoomorphic form, are other ritual woodcarvings. They are activated by rubbing a wooden pad on the smooth back of the animal and were used by the diviner in combating sorcery and witchcraft, powerful

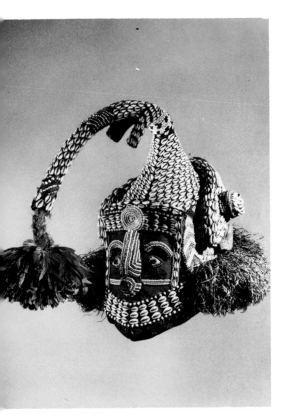 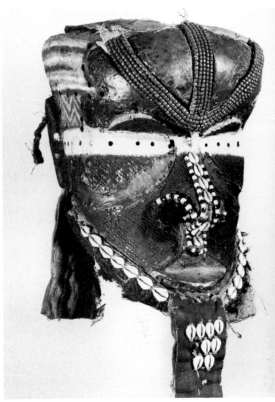

221 (*left*). *Mwash a mbooy* mask. Kuba. Zaïre. Cloth, cowries, beads, feathers, fibre. 40 cm (15.75 ins). Musée Royal de l'Afrique Centrale, Tervuren. Photo: courtesy Musée Royal de l'Afrique Centrale.

222. *Bwoom* mask. Kuba. Zaïre. Wood, copper sheeting, beads, cowries, cloth, paint. 40.1 cm (15.78 ins). Musée Royal de l'Afrique Centrale, Tervuren. Photo: courtesy Musée Royal de l'Afrique Centrale.

forces in Kuba society. This rubbing oracle is of Kete origin and must, therefore, have been in use before Shyaam.[71]

Related nations like the Ndengese and Kete or neighbours like the Bene Lulua and Mbagani [225] are well known for their beautiful carved statues. The Kuba themselves are rightly famous for their royal figures, the *ndop*. Few other Kuba figurative statues [224] are known, though many cups and pipes are in anthropomorphic form. This underlines the position of the *nyim* as the keystone of the entire socio-political and religious system, which evolved from the time when the Bushoong primacy over the other chiefdoms led to the creation of the Kuba kingdom.[72] The *ndop* represent kings (or *nyim*), and are carved of hardwood (*Crossop-*

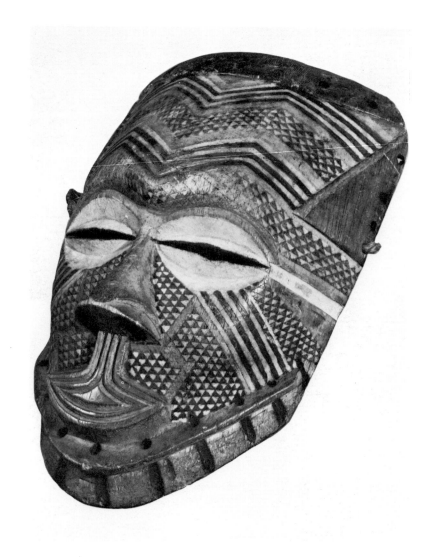

223 (*above*). Mask. Kuba. Zaïre. Painted wood. 26.9 cm (10.6 ins). Musée Royal de l'Afrique Centrale, Tervuren. Photo: courtesy Musée Royal de l'Afrique Centrale.

224 (*opposite left*). Standing female figure. Kuba. Zaïre. Wood. 29 cm (11.5 ins). Musée Royal de l'Afrique Centrale, Tervuren. Photo: Werner Forman.

225. Standing male figure. Mbagani. Kasai, Zaïre. Wood, metal. 25 cm (9.84 ins). Musée Royal de l'Afrique Centrale, Tervuren. Photo: Werner Forman.

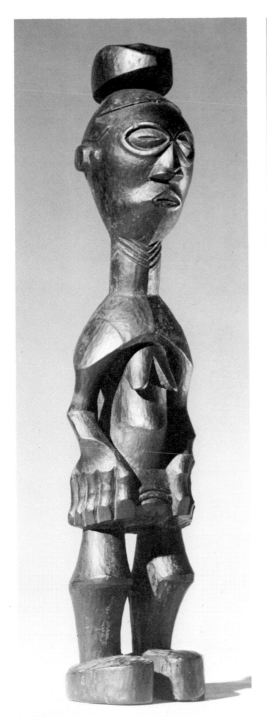

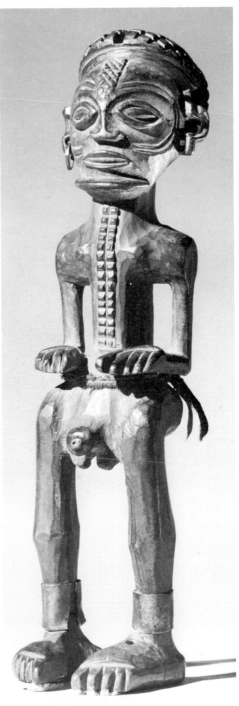

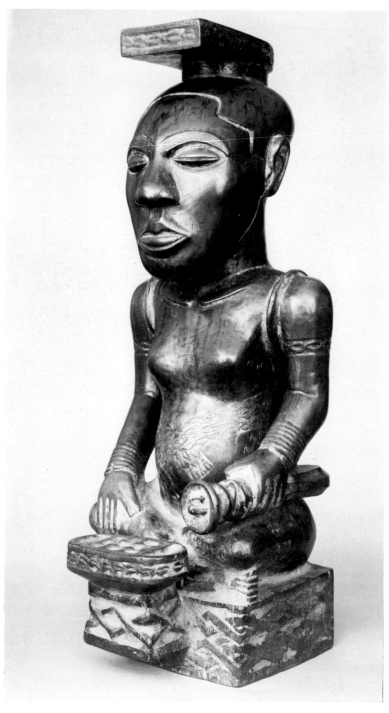

226. Statue, *ndop* of King Shyaam aMbul aNgoong. Kuba. Zaïre. *c.* 1600–1620. Wood. 55 cm (21.65 ins). Museum of Mankind, London. Photo: courtesy Trustees of the British Museum.

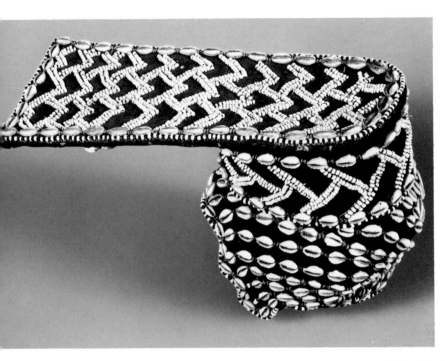

227. Royal headdress (shape as on *ndop*), *shioody*. Kuba. Kasai, Zaïre. Before 1894. Beads and cowries on cloth. Height 23 cm (9.05 ins). Length 33 cm (13 ins). Musée Royal de l'Afrique Centrale, Tervuren. Photo: courtesy Musée Royal de l'Afrique Centrale.

228 (*right*). Royal ceremonial knife. Kuba. Kasai, Zaïre. Brass, iron. 80 cm (31.5 ins). Musée Royal de l'Afrique Centrale, Tervuren. Photo: courtesy Musée Royal de l' Afrique Centrale.

terix febrifuga). The figure is seated on a decorated cube-shaped pedestal, and holds a ceremonial knife in his left hand [228], the right holding his personal symbol or resting on his knee.[73] His arms, hips and belly are ornamented with cowries. He wears the distinctive royal head-dress [227], uniform for all statues, and displays his individual *ibol*, which is usually carved on the front of his seat. The personal emblems or *ibol* could be a *lyeel* game-board, an anvil, a drum, a cockerel or a human head, and would have been chosen either by the king, as a symbol for the proposed policy of his reign, or by his successor, as an image of his achievements. Belepe believes that the game-board of Shyaam expresses the 'gamble' of this son of a slave in taking up the fight for the throne.[74] Oral tradition simply states that he invented the game [226]. A drum signifies that the king's reign was peaceful, as he brought music and dance to his people instead of problems and warfare. A human head does not indicate a slave but symbolizes the king's right over life and death.[75]

The introduction of the royal *ndop* is traditionally attributed to Shyaam aMbul aNgoong, the first of the Matoon dynasty; the twenty-second king has ruled the kingdom since 1969. Theoretically there should be as many *ndop* figures as the number of kings since Shyaam, but this does not appear to be so. Vansina lists twenty-two kings;[76] Belepe has a list of only nineteen, but mentions four others whom he excluded because of their short reign.[77] Some figures have not yet been attributed to a particular monarch, and for some ten kings no *ndop* has as yet been discovered. Torday was given three *ndop* statues, though he saw four, during his visit; and a fifth was given to a Belgian minister. In theory they would have been made in the seventeenth and eighteenth centuries, but this is now generally discounted. Vansina[78] supports the conclusions of Jean Rosenwald[79] that the first ten *ndop* from Shyaam to Kata Mbula were all carved during the latter's rule in the late eighteenth century by a single artist. The remaining three statues – and by implication all the others – were carved in the twentieth century, possibly also by one hand.

Like the *ndop*, a drum called *pel ambish* was made for each king. They were all kept in the capital until at least 1969, and the drums seen there by Vansina included two from the end of the eighteenth century.[80]

The Kuba created a highly individual art style, and their prolific production of beautiful objects in many media reflected a well-organized and stratified society. Their contacts with neighbours through travel and trade influenced their style and techniques, while they in turn affected the art of many nations around them.

FOURTEEN

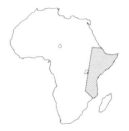

Eastern Africa

The interior of Africa was largely isolated from the rest of the world until the Portuguese arrived on the Atlantic coast and began a process of colonization by slow penetration. But the lands bordering on the Mediterranean and those on the shores of the Red Sea and the Indian Ocean had attracted traders, migrants and invaders from very ancient times. The character of these populations and of their art differed substantially from that of the hinterland. On the east coast, monsoon winds, changing direction twice a year, facilitated navigation for trade with areas in the Persian Gulf, India, Indonesia and even faraway China. The nearer regions on the eastern shores of the Red Sea played a great part in these contacts, although there the prevailing winds were less favourable. The full extent of this trade and the great number of commodities involved are well described in *The Periplus of the Erythraean Sea*, the log book said to have been written in the first century A.D. (more probably in the second or third) by an anonymous Greek captain[1] from Alexandria.

The major African exports were ivory, rhinoceros horn, myrrh and frankincense, gold and slaves. The imports from Arabia and the Far East were metals, cloth and clothing, wheat, rice and a great variety of other merchandise all mentioned in the *Periplus*.

Aksum and Christian Ethiopia

The ancient state of Aksum, with its capital city of the same name, was situated in the north-east of the territory now known as Ethiopia. The area was populated by pastoralists as early as the second or third millennium B.C. They were mainly of Cushitic origin, speaking languages ancestral to Beja and Agaw. Monuments and inscriptions found in the course of archaeological work show a strong cultural influence emanating from the South Arabian kingdom of Saba during the fifth and sixth centuries B.C.[2] People from that kingdom, today's Yemen, had been emigrating[3] over a long period to the highlands of Tigre and were well established there by that date. They spoke Sabaean, a semitic language used in the inscriptions [229, 230].

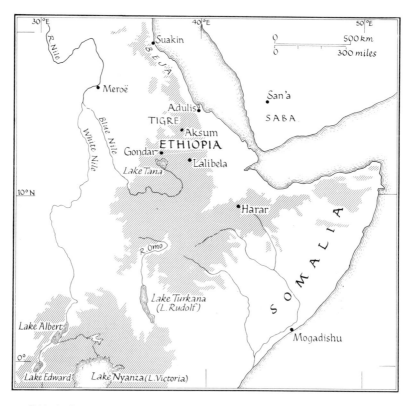

12. Ethiopia, Somalia and the Upper Nile Valley.

Lunar, solar and other cults have been identified in the many finds and texts [231]; the autochthons were apparently quickly assimilated and embraced the new religions. Towards the end of the first millennium B.C., language and images changed (the language turning from Sabaean to Ge'ez, the forerunner of Amharic), and a new culture was born out of the merging of the immigrants and the indigenous population. The best-known monument of the pre-Aksumite era is a temple at Yeha, near Adua, a two-storey building constructed of smooth-dressed stone blocks. In context with this and other 'pre-Aksumite' monuments, objects made of bronze and iron tools were found. It thus appears that metals and metal technology were also introduced to the Aksum region by immigrants from Saba.[4]

There are many fine examples of Aksumite buildings all over north-east Ethiopia, most of them now in ruins. These were temples, crypts, palaces and family dwellings built of dressed stone, timber and masonry.

Typical architectural features were walls built of layers of roughly hewn boulders interspersed with dressed beams, and a uniform type of square or rectangular layout. One of the finest examples of this architecture is at Dongur, north of the Gondar road; it was probably the villa of a nobleman.[5] With the emergence of Aksum as an empire came a tendency to gigantic architecture and monuments. Examples of this tendency are the

229. Lion god with Sabaean inscriptions. From Aksum, Ethiopia. *c.* 1500 B.C. Stone. National Museum of Ethiopia, Addis Ababa. Photo: Werner Forman.

huge monolithic stelae. Many of the smaller ones are just large trimmed stones which served as tomb markers, while the larger ones, of which most are now no longer erect, were carved to represent multi-storeyed buildings. The tallest of these – also no longer standing – was 33 metres high and depicts on one side nine storeys, complete with fake windows, doors and butt-ends of beams. The largest example still erect is 20 metres high [232].

During excavations in 1973-4, forty-one granite stelae were recorded, in addition to the seventy-eight previously mapped by the Deutsche-Aksum Expedition in the main area of Mai Hejja field. A further hundred were located in the Gudit area. When standing, they all faced south/south-east.[6] There are no radiocarbon dates as yet, but the approximate date for the stelae is now believed to be the fourth century A.D. Catacombs were located in the area of Aksum stelae, reinforcing the belief that they were funerary figures. A large underground burial ground, styled

230. Statue of a priest king or god, on a plinth with a Sabaean inscription believed to be a prayer for fertility. It is uncertain whether the plinth was originally associated with the statue. From Hawila-Assaraw, near Aksum, Ethiopia. 5th-4th century B.C. Limestone. Statue 47 cm (18.5 ins). Archaeological Museum, Addis Ababa. Photo: Werner Forman.

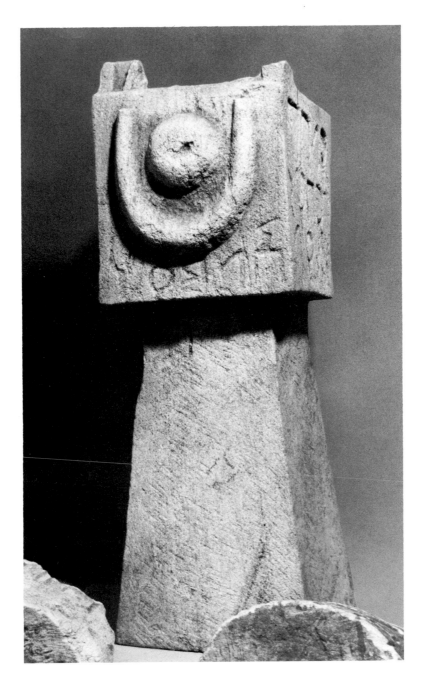

231. Altar with Sabaean inscription, in the service of the moon god Almaqah. From Melazo, near Aksum, Ethiopia. *c.* 5th century B.C. Stone. Archaeological Museum, Addis Ababa. Photo: Werner Forman.

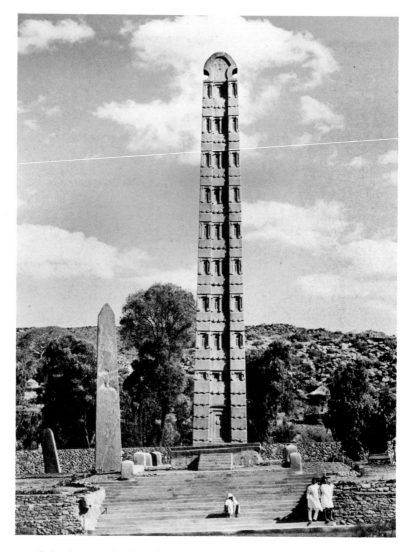

232. Stelae; in centre the tallest of those still erect, at Aksum, Ethiopia. About 20 m (66 ft). Photo: Werner Forman.

'the mausoleum', was found at the site of the fallen giant stela.[7] The storeyed stelae are believed to be symbolic houses, and those with representations of timber beams are probably of a later date.

One monument, called the 'Tomb of the False Door', located near the main stelae group at the Mai Hejja field and also considered to be a symbolic house, is believed to predate the stelae, however, and to have been the mausoleum of a person of royal blood.[8] The tombs contained burial gifts, pointing to a pre-Christian date, although it appears that

'pagan' interment customs did not vanish with the advent of Christianity.[9] Finds of the 1973–4 excavations were pottery and metal objects, beads and stone bowls turned on lathes.[10]

The enormous stone monoliths, stone platforms, altars and other large-scale monuments are believed by some scholars to have been influenced by Syrian, Arabian and Indian architecture and art.[11] Other artefacts of the Aksumite period are pottery, plain or decorated either with

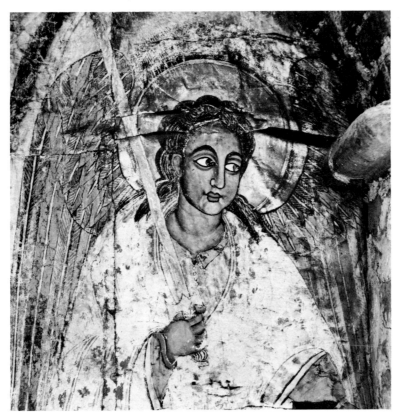

233. Icon covering a door in the church of Debra Berhan at Gondar, Ethiopia, built by Yasu the Great (1682–1706). Photo: Werner Forman.

geometric patterns or with plants, birds and snakes in black and red terracotta. There are also clay figures of animals and female figures resembling Near Eastern fertility statues. Many thousands of coins, mostly minted in bronze, were found, and these were instrumental in establishing the names of eighteen Aksumite kings.

The merger appears to have been beneficial and led to the rise of Aksum in the first century A.D. as an important African trading nation, using the Red Sea port of Adulis near modern Massawa. That trade,

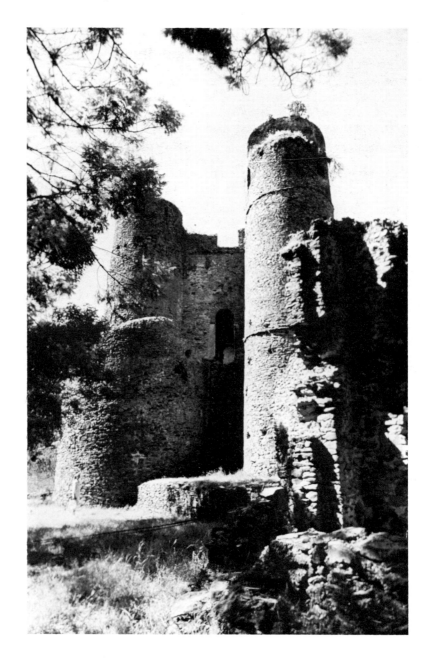

234. Palaces at Gondar, Ethiopia. 17th–18th century. Photo: D.W. Phillipson.

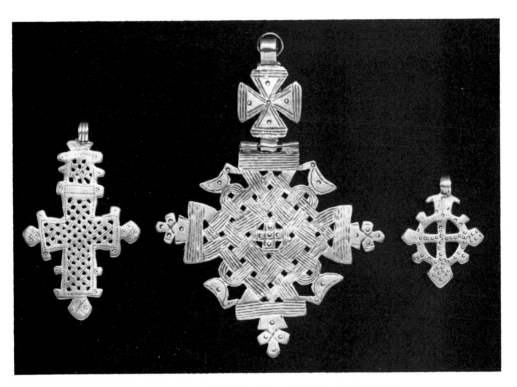

235. Three ancient Coptic crosses. Ethiopia. Silver. *Left:* 8.6 cm (3.38 ins). *Centre:* 14 cm (5.5 ins). *Right:* 5 cm (1.97 ins). Collection G. and K. Anschel, London. Photo: Horst Kolo.

mainly through Greek merchants, was documented in the *Periplus* and Aksum's role corroborated by coins with the names of kings inscribed in Greek – though, alas, without dates. The power of Aksum began with the reign of King Ezana, who embraced Christianity at about the time of the destruction of Meroë. Surmounting several rebellions and defeating the onslaught of Islam in the sixteenth century, the Christian state of Ethiopia developed and survived until the overthrow of Emperor Haile Selassie in 1974. The orthodox Coptic Church became the official state religion, although many tribes in the hinterland were converted to Islam. Ethiopia was the first Christian state in Africa and the only one not to be colonized, except for the short period of Italian rule from 1936 to 1941.

Many fine churches were built, often on the sites of Aksumite or pre-Aksumite temples. Of these, the monastery and church at Debre-Damo are outstanding examples. In the twelfth century, churches were carved out of solid rock, and these are still admired for their architectural excellence. One of the best known is the Church of Abba Libanos at Lalibela.

In the seventeenth century churches, palaces and castles were built in Gondar in a style resembling that of medieval Europe, and many still stand [234]. The art of Christian Ethiopia excelled also in ceremonial crosses [235] of many different decorative styles, including large processional crosses, made of wood, bronze or silver.[12] Much excellent jewellery, mostly worked in silver,[13] and dating from ancient to recent times, is part of the Ethiopian artistic heritage.[14]

The pre-Aksumite, Aksumite and Ethiopian eras all produced important art, reflecting their different cultural backgrounds, and in all three periods, they were almost totally isolated from most parts of Africa. Apart from the finds of two bronze bowls and two faience figures, all of Meroitic origin, and of a few Aksumite objects excavated in Meroë, there is no evidence of a cultural relationship between Meroë and its Aksumite neighbours, though contacts must have existed. External contacts were predominantly with Greece, Egypt, Arabia and the Far East. Christian Ethiopia developed relations with Alexandria and Constantinople, and all the cultural influences resulting from this intercourse were absorbed and assimilated by the people of Ethiopia who, both along the coast and in the hinterland, were deeply rooted in Africa.

The Hinterland of Eastern Africa

The impact of the contacts with the Arabian peninsula and the Far East, experienced in the lowlands all along the East African coast from Ethiopia to Mozambique, hardly affected the hinterland. The reasons were geographical, ethnological and economic. The land between the coast and the Great Lakes becomes increasingly barren until it reaches the mountains, which extend nearly all the way from the highlands of Ethiopia to Lake Nyasa. The people who have inhabited the area for 2,000 years – Khoi, Cushitic, Nilotic and Bantu-speaking – were hunter-gatherers, pastoralists and nomadic cattle herders, whose main long-distance trade was for salt, metals, Indian Ocean shells and beads. This may account for the paucity of sculptural art compared with the abundance in Africa west of the lakes, where the tribes and nations with a tradition of wood carving were settled agriculturists.

It must be remembered that in the west too, there are many areas where no figures or masks were produced. But there, as well as east of the Lakes, the African artistic genius was expressed by music and dance and such easily moveable items of visual art as basketry, pottery, calabash work, jewellery, ornamental weapons, decorated furniture and household objects. Decorating the body with paint and scarifications was another manifestation of the peoples' desire for artistic expression.

The traditions on which the forms, decorations and use of materials were based reach back to neolithic times or earlier.[15] The oldest example

of an elaborately embellished wooden vessel [236] was excavated in the Njoro River Cave near Nakuru in southern Kenya and dated about 1000 B.C.[16] The vessel is comparable with those used by today's pastoralists in northern Kenya as containers for milk. The Njoro River Cave was a burial site, and there is evidence that stone bowls, pestles and mortars were left in the tomb together with pottery, stone beads and pendants.[17]

13. Eastern Africa.

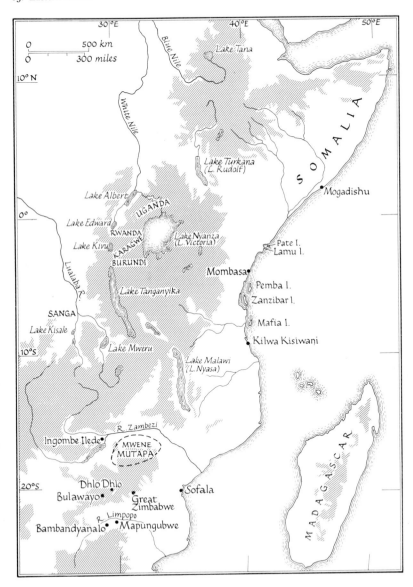

236. Vessel resembling milk urns now in use in Kenya. Excavated in 1950 by M.D. and
L.S.B. Leakey at Njoro River Cave, near Nakuru, Kenya. *c.* 1000 B.C. (single radiocarbon
date). Wooden, elaborately decorated. Reproduced with kind permission of Mary D. Leakey.
Photo: courtesy Roy Sieber.

Dating and grouping pottery into categories gives us a reliable guide to
the migration of peoples and the spreading of their cultures. Signalling
the beginning of the Early Iron Age in the region (about 300 B.C.), Urewe
ware – or, as it was initially called, 'dimple-based ware' [Fig. 2] – was first
discovered around the shores of Lake Victoria (now Lake Nyanza), and
subsequent finds were made south of Lakes Mweru and Tanganyika.
Recent data on the earliest production of Urewe ware south and south-
west of Lake Nyanza show it to date back to the last centuries of the first
millennium B.C., and its association with an Early Iron Age culture now

appears likely.[18] Other pottery types, like the Kwale ware originating in about 200–100 B.C. far to the east of Lake Nyanza, spread southwards; they can be traced to Tanzania, Mozambique and the Transvaal; but although there is a 'definite connection' between these regions, 'there are also important differences'.[19, 20, 21] Urewe ware was also found in Rwanda and Burundi and is attributed to the Bantu people who expanded from the forests into the interlacustrine areas. During excavations on Luzira Hill near Port Bell on Lake Nyanza, Uganda, a remarkable terra-cotta head and fragments of torsos were discovered [237]. They appear to be of considerable age, but no dating was possible. The style is not comparable with any other art object found in eastern Africa. But unless

0 2 4 6 8 10 cm

Fig. 2. Urewe ware. South-west Kenya. After Leakey, Owen and Leakey, 'Dimple-based pottery from central Kavirondo', *Occasional Papers of the Corydon Museum*, 2, Nairobi, 1948.

this was the unique product of a particular artist – which is doubtful – it is possible that the Luzira head may form part of a yet unknown culture in this region of Africa.

In Kenya, functional artefacts and personal adornments were widely made. Sculpture in wood was restricted mainly to stoppers of medicine bottles, ceremonial staffs and a very few masks like those carved by the Duruma for their ritual use.[22, 23] Some ceremonial masks were made of leather, and these are also found in the lake areas to the west and among the Maasai and other Nilotic and Kushitic peoples. The Maasai warriors

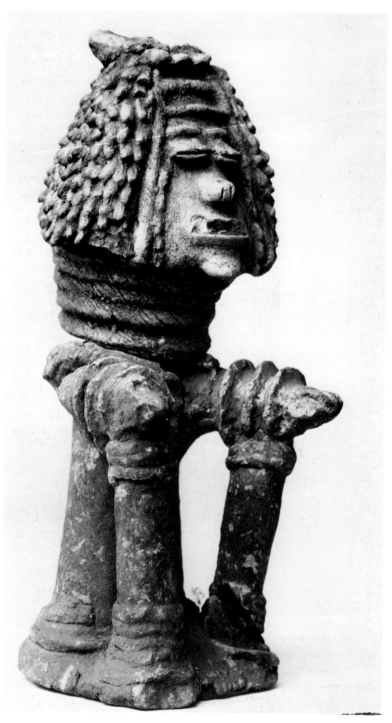

237. Pottery head, probably representing a woman, set on fragments of body and limbs,
possibly not belonging to head. From Luzira Hill, near Bell, Uganda. 20.3 cm (8 ins).
Museum of Mankind, London. Photo: courtesy Trustees of the British Museum.

238 (*left*). *Vigango* memorial posts. Mijikenda. Kenya coast. ? 19th century. Wood. *Left figure:* 207 cm (82 ins). *Right figure:* 178 cm (70 ins). Private collection.

239. Memorial post. Madagascar. Wood. 183 cm (72 ins). Photo: courtesy Pace Gallery, New York.

are especially renowned for the beauty of their dress, headgear, spears, swords and shields.[24]

Over a narrow stretch, just inland from the coast of Kenya and extending south into Tanzania, are the Mijikenda with their largest sub-group, the Giriama. Their carvings of wooden memorial posts in anthropomorphic forms are called *vigango* (singular: *kigango*) and are the most significant of Kenya's sculptural art [238]. Generally they are not placed on tombs but are erected in small huts, or in fields or palm groves together with undecorated memorial sticks. *Vigango* are the memorials of deceased members of the *Gohu* society of wealthy and influential men. They are commonly two-dimensional carvings, the body part decorated with triangular and snake-like designs, rosettes or other geometrical ornaments. The head, set in the form of a disc on a rectangular neck, may also be decorated with abstract motifs or have indications of eyes, nose and mouth carved on it. Some sub-groups, especially the Kambe and southern Mijikenda, carve the heads of their *vigango* naturalistically. Little was known of these people and their history until recently, mainly because early European reports deal with coastal nations and events and not with those of the interior. The Mijikenda may, however, have been in their present area by the seventeenth century, as some related groups are mentioned in Portuguese documents of that period.[25, 26]

Nothing is known about the origin of the *vigango*. Though they may be an old tradition, it was only in 1873 that they were first recorded by a missionary. But the fact that memorial posts of a similar nature are known in several other areas of eastern Africa makes it more likely that this type of sculpture has ancient roots in the east of the continent. The Gato and Konso of southern Ethiopia also have wooden commemorative figures and so have the Bongo who live along the Upper Nile. The Zaramo, a Bantu people of north-eastern Tanzania, use sculpted figurative posts as memorials to their dead, and these were first noticed by Burton in 1860. Similarities also exist with certain Malagasy funerary posts [239].[27] But in the case of these, and all other groups mentioned, stylistic differences are great, and as no records exist of contacts between them and the Mijikenda, it may be assumed that the resemblance of decorative designs between the *vigango* and the Malagasy posts could be due to the Swahili influence on these nations, unrelated and living far apart. The chip-carving technique used by the Mijikenda, and Malagasy decorations on the memorials and on Swahili architectural elements,[28] prompted Sieber to suggest, 'however tentatively, that the type and its use are related to the burial practices and memorial posts of widely dispersed, so-called megalithic tomb-producing groups, with a decorative overlay originating in the Near East'.[29]

The few kingdoms of eastern Africa which emerged in about the fifteenth century – Bunyoro and Buganda followed by Karagwe, Rwanda

and Burundi – were based on pastoralist and agriculturist societies. Their courts had little of the wealth and splendour of Kuba, Asante or Benin. Buildings, clothing and regalia were simple, and few figurative carvings are known from these kingdoms. There are, however, a few isolated examples of sculpture, some of which are unique specimens, like the splendid figure in Berlin[30] collected in 1897. It is from the Ukerewe Island in Lake Nyanza, and is believed to be an effigy of an ancestor of a chief of the Kerewe carved on the island by a 'Nyamwese' sculptor. There are other cases of unique masterpieces which make the subject of figurative art in East Africa even more of an enigma.

240. Female figure. Nyamwese. Central Tanzania. Collected 1900. Wood. 74.5 cm (29.33 ins). Private collection, London. Photo: courtesy Sotheby, Parke Bernet & Co.

241. Stool, supported by human figures. Makonde. Mozambique. Wood, paint. Height 39 cm (15.5 ins). Depth 44.5 cm (17.5 ins). Private collection, London. Photo: Werner Forman.

Was there an old carving tradition which has vanished; and were the objects destroyed by climate and termites? Or are these few exceptions the work of visiting artists or perhaps imports from across the Lakes? The iron sculptures of Karagwe depicting animals, which Stanley discovered in 1876 in the palace of Rumanika, the ruler of Karagwe, provide another example. These sculptures are fine stylized figures of cattle and were certainly made by a very gifted artist. The ruler's treasury contained many other items: figures of copper, ceremonial weapons, textiles, splendid ceramics and a copper throne, which are now in a museum in Karagwe. Twenty objects, including three iron sculptures, are in the Linden Museum in Stuttgart.[31] The German army officers who collected the material and gave them to the Linden Museum believed that they were the work of Rumanika's predecessor. Nothing similar is known from eastern or western Africa, and the origin of these iron figures remains obscure. A few outstanding wood carvings were collected from the

Nyamwese, including the splendid female figure shown here [240]. These and a chair attributed to the Hehe pose the same question: are they the works of itinerant carvers or the relics of a vanished art?[32, 33]

The only nations of eastern Africa which produced sufficient carvings and developed a recognizable style on which to base a typology of their art are the Zaramo and the Makonde [241]. Others like the Tabwa and the Jiji are so obviously influenced by Luba art that origin west of the Lakes or the work of visiting Luba carvers may be assumed.

242 (left). Ishakani pillar tomb. Swahili. Kenya coast, south of Somalia border. 15th–16th century (?). Photo: courtesy D.W. Phillipson.

243. Composite drum. Swahili. Collected 1895 by Admiral Sir Harry Rawson at Mwell, 30 kilometres south-west of Mombasa, Kenya. Wood with small four-legged base, hide membrane, carved decoration and four iron rings for carrying. 109.73 cm (43.2 ins). Museum of Mankind, London. Photo: courtesy Trustees of the British Museum.

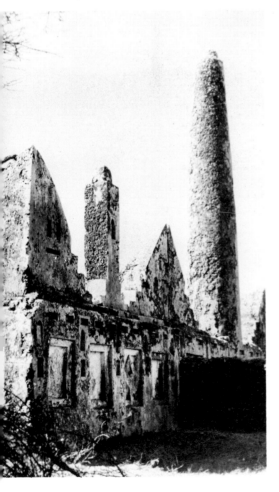

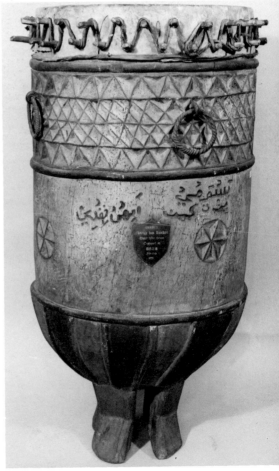

The Swahili Coast

While the main influences in the interior of eastern Africa were the Bantu arriving from the west or Nilotes and Kushites advancing from the north, the coastal areas of the Indian Ocean were exposed to trading and cultural contacts with people from Yemen, the Persian Gulf and the Far East. The coastal traffic also facilitated contacts among the inhabitants of the land stretching from the Horn of Africa to Mozambique, including many islands along the coast. Islamization of that population, from around A.D. 800 on the islands and from A.D. 1100 to 1200 on the mainland, contributed decisively to the creation of a homogeneous culture and a unifying language, Swahili – predominantly Bantu in vocabulary and grammar, but containing a large number of Arabic words and expressions. Although there are some variations in the styles of Lamu, Mombasa, Zanzibar and Dar-es-Salaam, like the Swahili language their arts are African, with external influences absorbed over long periods of time. To label the culture 'Arab' is incorrect.

244 (*left*). Carved door. Swahili. Lamu, Kenya. 19th century. Wood. Photo: courtesy D.W. Phillipson.

245. Mihrab of mosque. Swahili. Gedi, Kenya. (?) 16th century. Height of herringbone moulding 152 cm (60 ins). Photo: courtesy D.W. Phillipson.

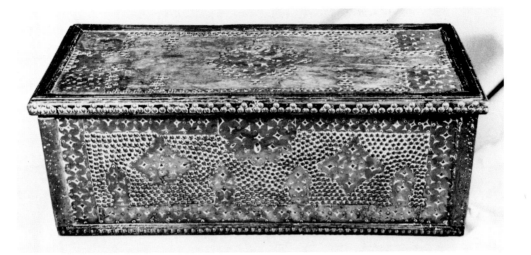

246. Chest. Swahili, Zanzibar. 19th/20th century. Wood, metal. Length 74 cm (29 ins).
Height 27 cm (10.6 ins). Collection Udo Horstmann.

Some of the oldest inhabited islands were Pate, Manda and Lamu,
north of the mouth of the Tana river, which were probably settled some
2,000 years ago. Of these Lamu, the city on the island bearing that name,
is still standing, though the buildings date mainly from the fifteenth to
the seventeenth centuries. Yet Lamu serves as a fine example of Swahili
art and customs, not only of medieval but also of more ancient times.[34]
The old buildings were constructed of coral rock brought up from the
bottom of the sea or gathered from the shore, along with some rock
quarried on the mainland. Blocks were estimated to weigh up to one ton,
larger than any building material used south of the Sahara before the
arrival of the Europeans. Local timber was also used in the architecture
and building for the mosques, palaces and dwelling houses in Lamu [244,
245] and the rest of the coastland.

Styles were influenced by the Turks, who controlled some coastal areas
for a period from the seventeenth century.[35] All along the east coast,
decorations have special features: geometrical and floral plaster designs
are to be found in mosques and on the front galleries of private houses;
the beautiful carved doors and chests [246], for which the artisans of the
island of Zanzibar became especially famous; decorated household appli-
ances made of wood or metal and jewellery; and musical instruments like
the *siwa*, made of brass, ivory or carved cowhorn.[36]

Some ceramics and textiles were imported from other African countries
or from across the seas. But local production of pottery was an ancient
tradition, continued well into the Islamic period; and the weaving of

cloth – presumably cotton – can be traced back to the twelfth century in areas ruled by the Shirazy dynasty. Later printed cotton fabrics are known to have been produced in Kenya and Zanzibar.

The island cities of Pemba and Kilwa of ancient fame, now in ruins, are both believed to have been settled by Persians in the tenth century A.D. and by Arab immigrants in the thirteenth to fourteenth centuries. The ruins of Kilwa, all of the Arab period, comprise a large fortress called the Gereza, a vast fortified walled area with a two-storeyed building almost certainly the palace of the Kilwa Sultan, several mosques, and two forts guarding the harbour of Kilwa.[37]

The large island of Madagascar, now the Malagasy Republic, off the coast of Mozambique, is a separate case and is peripheral to the Swahili complex. It is geographically a part of Africa and ethnically a mixture of Indonesians, Arabs and Bantu from the mainland, but the predominant artistic and cultural influence on the island is clearly Indonesian. Archaeological research has established that Indonesian penetration began in the

247. Male and female memorial posts. Sakalava, Madagascar. Wood. *Male:* 57 cm (22.44 ins). *Female:* 45 cm (17.72 ins). Collection Baudouin de Grunne. Photo: Roger Asselberghs.

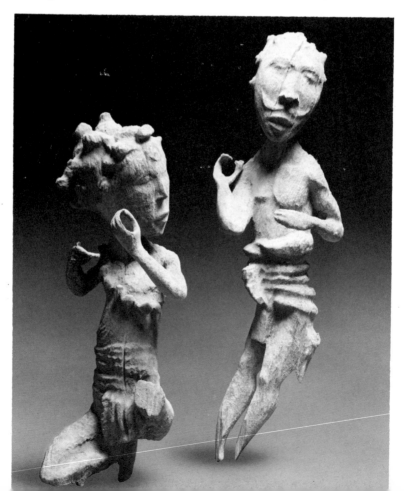

second half of the first millennium A.D.[38] During that period iron was introduced into the island, and pottery found in context differs from mainland ceramics of the Early Iron Age.[39] The language spoken in Madagascar is said to be linked to ancient Bornean dialects,[40] and Arabic script for writing Malagasy was adopted at a time as yet undetermined.[41]

Memorial posts made of wood are the best-known examples of Malagasy art [247, 248]. The two-dimensional posts have been mentioned in connection with the *vigango* of the Mijikenda, and ornamental similarities in geometrical patterns could, as stated, be due to common Swahili influences. The very naturalistic memorial statues of Madagascar are, however, purely Indonesian in style. A limited number of other wooden carvings, mainly from the Sakalava people who had absorbed some Bantu immigrants, are known. The Bara may have come from the mainland in or after the sixteenth century, and connections with Zimbabwe have been mooted.

Silver, brass or wooden sculpture and jewellery of Malagasy origin can be seen in many European museums.

248. Detail of *Aloala* memorial post. Madagascar. Eroded wood. 76.5 cm (30.12 ins). Collection Ulrich von Schroeder, Zurich.

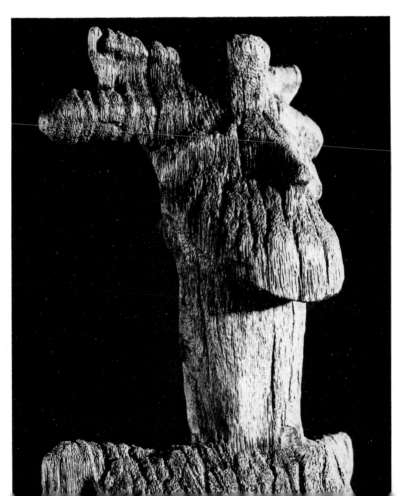

Arts of Southern Africa

The most ancient art of southern Africa, the paintings and engravings on the walls of rock shelters and caves, has been discussed in Chapter 2. Their age is still largely undetermined but many certainly predate the Early and Late Iron Age cultures by centuries or possibly millennia. Their originators, the San, never became truly part of the Iron Age. They remained the hunters and gatherers of a Stone Age civilization; and although the remnants surviving in the Kalahari desert have no rock surfaces to paint on, they still decorate ostrich eggs and domestic implements in their traditional style.

Over large areas of the South African Republic, from the Transvaal to the Cape Province, stone-walled settlements built by food-producing and metal-working people have been dated to about A.D. 1000 to 1500. Skeletons found in the course of archaeological research in areas related to these settlements were of negroid people.[1, 2, 3]

Khoisan potters produced ceramic ware found in the southern Cape. This was fine, well-fired pottery, reinforced with internal lugs, easily recognized by its pointed base. It was apparently made there from the beginning of the Christian era.[4] Pottery found at Transvaal sites resembles ceramics still produced by the Venda people, a major Bantu group. The early inhabitants are known to have mined and smelted iron in several areas, and remains of the smelting activities at Melville Kopje on the Witwatersrand were dated A.D. 1050 ± 50.[5] Early Iron Age datings south of the Zambesi, usually related to pottery, produced readings from the first century to A.D. 800. In the Phalaborwa district of the Transvaal, datings showed that probably from the eighth century A.D. Early Iron Age people inhabited the area. It has been established that the present inhabitants are still producing pottery that closely resembles ceramic ware excavated and positively dated to the eleventh century A.D. In fact, so close is the similarity between excavated early pottery and that made by the BaPhalaborwa, a Sotho group, in the nineteenth century that 'it is possible to "lose" individual potsherds from, say, the eleventh century in a collection of nineteenth-century material'.[6]

An important discovery of Early Iron Age figurative art was made near Lydenburg in the north-east Transvaal.[7] In 1956 Dr K.L. von Bezing,

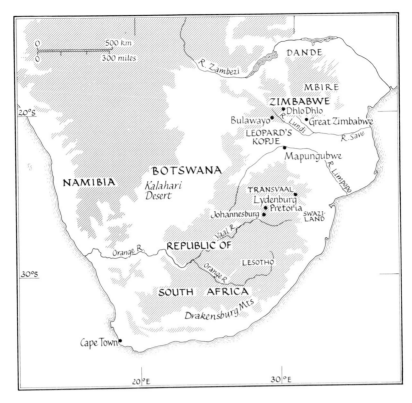

14. Southern Africa.

then a boy, noticed some pottery sherds. Some five years later, he returned to examine the same site and collected potsherds, bone plaques, beads of shell, items made of iron and copper, and fragments of an ivory bracelet. Further examination at Cape Town University, where von Bezing took his finds, showed that the potsherds were what appeared to be seven terracotta heads broken into numerous pieces. One large head was very incomplete, but five small ones were restored at the university; the pieces of the other large head were sent to the British Museum and reconstructed in the conservation department. A comprehensive report on the heads and associated finds was published in 1975, and T.M. Evers then undertook excavations at the site and in adjacent areas.[8] The first radiocarbon dating of charcoal possibly associated with the heads was published in 1971[9] and showed a reading of A.D. 490 ± 50. In a subsequent report by Evers and Vogel in May 1980, further datings of material from Lydenburg and White River in eastern Transvaal were recorded. The second test of material from the site of the heads resulted in a dating of A.D. 540, so that a date of about A.D. 520 is reasonable for the site and for the heads.[10]

The heads are now on exhibition at the South African Museum in Cape Town [249, 250, 251, 252]. They have motifs in common with South African domestic pottery of the Early Iron Age culture: herringbone patterns, hatching in bands, panels and triangles, oblique and cross-hatching. The fired clay is coarse and gritty and resembles in fabric and colour the domestic ceramic ware. X-ray examinations of sherds from heads and vessels did not show any difference in texture. The heads seem to have started out as elongated inverted pots. The human features – lips, ears, eyes – and some decorations were then incised, or added by the application of clay. In spite of this partly 'additive' method of construction, some of the features give the impression that the artists were familiar with the methods of carving in wood.

Of the seven heads, two are about 380 millimetres high and the others vary from 108 to 115 millimetres. The size of No. 2 is given as 'large', based on the diameter of the rim at the neck opening, but the sherds for this head were insufficient to establish the height. Nos. 1–6 represent human heads, but No. 7 is atypical, having an animal snout [251].

The two large heads are topped by animal figures, possibly representing lions. Patterns of decoration vary, but all have a ridge along the forehead or at the ears, running downwards or sideways. They also have notched raised lines starting on the side of the forehead, running downwards to end between the eyes. In the case of the animal snouted head, the line runs down to the nose. Other raised lines form horizontal ridges across the faces. It could be assumed that some of these ridges and notched lines represent scarifications, always characteristic features in Africa, but this must remain speculative.

The purpose for which these heads were made remains an enigma. The two large ones might have been used as helmet masks, though the position of mouth and eye openings as well as the fragility of the material makes this unlikely. The other heads would, in any case, be too small for such a purpose. These small heads each have two holes of about 5 millimetres diametrically opposed near the bottom rim, and these might have served for the attachment of the head to a wooden post or effigy, possibly for 'second burial' ceremonies. They could have been used in connection with initiation ceremonies, as were the pottery figures made for such rites in various parts of eastern and southern Africa.

In a subsequent report on the Lydenburg heads published in 1981,[11] several other South African sites that yielded Early Iron Age sculpture, both hollow and solid, are mentioned. The sites are in the Tugela Basin of Natal where fragments of solid figures, both anthropomorphic and zoomorphic, were found and dated about A.D. 600. Another site in the area, Ndondondwana, dated A.D. 750, yielded both solid and hollow terracotta sculpture in fragments. The hollow figures, when complete, would have been the size of the large Lydenburg heads. Many recent

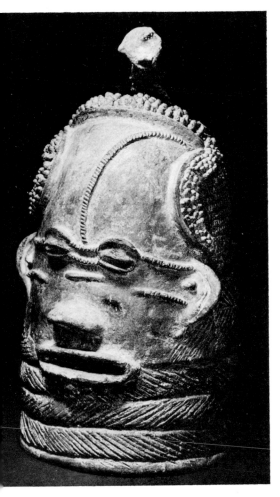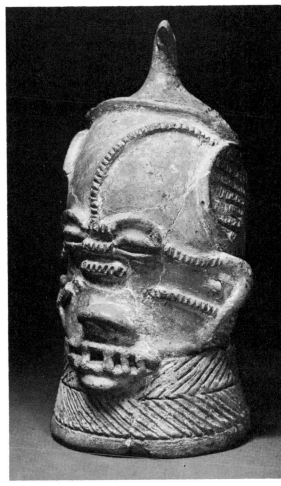

249. Head surmounted by an animal (? lion). 'Lydenburg head' No. 1. *c.* 500 A.D. Terracotta. 38 cm (14.96 ins). Photo: courtesy South African Museum and University of Cape Town.

250. 'Lydenburg head' No. 3. *c.* 500 A.D. Terracotta. 21 cm (8.27 ins). Photo: courtesy South African Museum and University of Cape Town.

finds of solid ceramic figures, dated from the ninth century A.D., were made in and north of the Limpopo Valley. Generally speaking, hollow terracotta sculpture is much rarer than solid in those areas of Early Iron Age cultures, across southern and eastern Africa, which share technologies of iron production and styles of pottery.

The exact time at which the Bantu reached their southernmost penetration into southern Africa has not yet been determined. The presence of Nguni people, including the Swazi and the Zulu, was reported by ship-

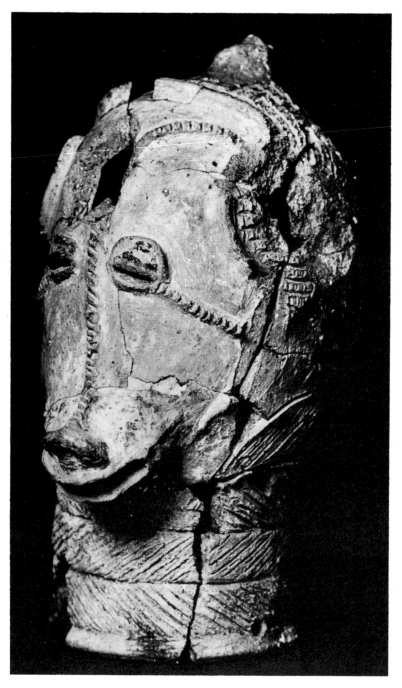

251. Head with animal snout. 'Lydenburg head' No. 7. Terracotta. 24 cm (9.45 ins). Photo: courtesy South African Museum and University of Cape Town.

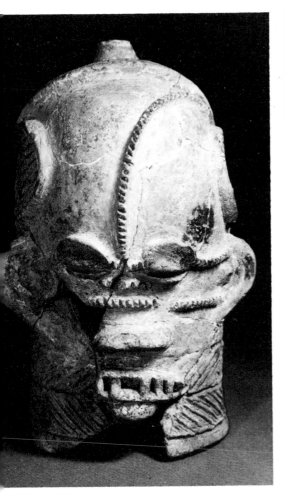

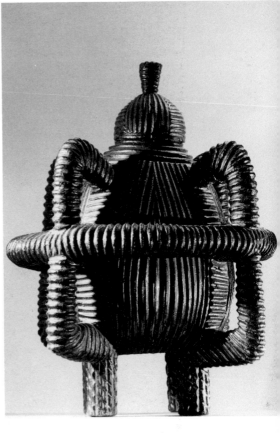

252. 'Lydenburg head' No. 4. *c.* 500 A.D. Terracotta. 20 cm (7.87 ins). Photo: courtesy South African Museum and University of Cape Town.

253. Milkpot. Swazi. South-east Africa. Wood. Height 48 cm (19 ins). Diameter 38 cm (15 ins). Private collection, London. Photo: Werner Forman.

wrecked Portuguese at the end of the fifteenth century. But they had actually reached Mozambique and northern Natal by A.D. 300–400 and southern Natal by A.D. 500–600.[12] They displaced the indigenous people, mostly San and Khoi, but they also intermarried with them and elements of Khoisan were incorporated in the Zulu language. At the beginning of the nineteenth century Shaka, a Nguni chief, organized an army and founded a Zulu state based on territorial rather than kinship principles. He became an absolute ruler and his army, in which unmarried men were

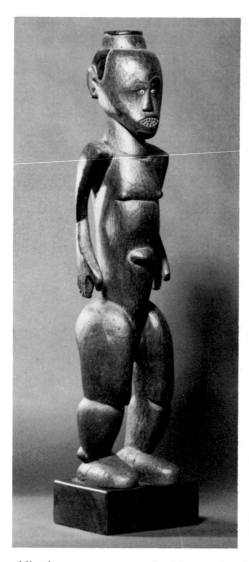

254. Figure of a standing male. Zulu, with typical headring. Collected in South Africa during the second half of the 19th century by Thomas Bailey, and in England since 1870; a rare example of the greatness of Zulu sculpture before the Zulu wars. Wood, bead eyes. 65 cm (25.5 ins). Private collection, London.

255. View of the Conical Tower at Great Zimbabwe. Photo: Peter Chéze-Brown, in Peter Garlake, *Great Zimbabwe*, London, 1973.

obliged to serve, was organized into well-trained regiments. These were, at a much later date, to prove formidable foes to Boers and British alike.

There is as yet no archaeological evidence of early art produced by the Nguni, and we can only assume that the arts and crafts of the nineteenth and early twentieth centuries are a continuation of an ancient culture of the people of the area. Among those artefacts are wooden sculptures [253, 254], often pairs of males and females, beadwork,[13] jewellery, arms, decorated wooden household implements and domestic pottery.

Further north, in the area between the Zambesi and the Limpopo, events of considerable art-historical interest took place between the eighth

340

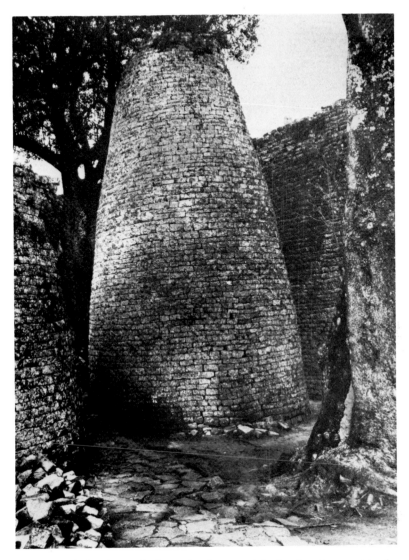

century and the sixteenth, brought about mainly by the east coast trade in gold with the Arabs.

In this region are the ruins of Great Zimbabwe and of some 100 other sites. Along with the ruins of monumental stone buildings in Nubia, Angola, south-west Kenya and the Transvaal, these bear witness to an ancient African architecture unknown in the rest of sub-Saharan Africa. According to archaeological data, the area of Great Zimbabwe was first occupied in the fourth century A.D. and was abandoned by Early Iron Age people at an unknown date. The entire region was resettled by Iron Age people coming probably from the west, presumably the Shona. They

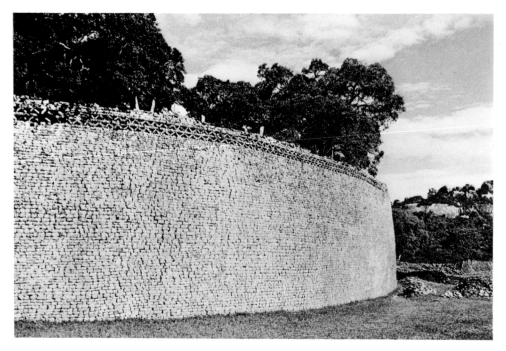

256. View of the outer wall of the Elliptical Building at Great Zimbabwe. Photo: Peter Chéze-Brown, in Peter Garlake, *Great Zimbabwe*, London, 1973.

engaged in basic agriculture, cultivated cereals, bred domestic animals, hunted and fished. They introduced cattle, which for them were not only a source of food but objects of trade, prestige and even cult. Clay figurines of bovines have been dug up throughout the region.

The centres of the developments that followed the arrival of the new-comers were located at Leopard's Kopje, south of Bulawayo, and Great Zimbabwe, east of the Lundi River. Gold mining was started in the area possibly by A.D. 1000, at which time trading with Sofala on the Indian Ocean began to develop, with far-reaching benefits for the economy of people to the east and south of Leopard's Kopje, and for Great Zimbabwe in particular. In excavations at the two centres, pottery was brought to light, similar in shapes and decoration. There were beautiful deep bowls and shallow vessels, the earlier ones matt and progressing to highly burnished exteriors. Great Zimbabwe produced, in the final stages, gra-phited ceramics surpassing Leopard's Kopje pottery.

The skills of the people of Great Zimbabwe in mining and building, a more diversified economy, and expansion of trade led to a greater concen-tration of population and a stratified society. These factors had a consider-able influence on the development of Great Zimbabwe and its rise to power from the thirteenth century A.D., when building in stone replaced

solid daga construction in many areas. Primitive beginnings gave way to high skills, and resulted in the advanced art of building walls of well-faced granite blocks. This culminated in the amazing edifices of the 'acropolis', the Conical Tower [255], the Elliptical Building, and a 'magnificent surrounding wall, approximately 240 metres in circumference and much of it more than 9 metres in height' [256].[14] The siting and construction of these buildings prove that they were not meant for defence. They were the seat and centre of religious and temporal power, the capital of a kingdom. That power was largely based on the king's monopoly of trade and control of routes to the coast of the Indian Ocean. Great Zimbabwe sold gold, copper, ivory and possibly slaves, and imported glass beads, Celadon and Ming porcelain from China, fine Indian cloth, Persian faience and blue glazed earthenware.

Shona folklore tells of their forefathers, the Mbire, settling in the area of Great Zimbabwe and establishing there the religious centre of worship to their supreme god Mwari and the service of the spirits of the royal ancestors. Great Zimbabwe is only one – though the largest and most impressive – of over 100 ruined stone sites which were possibly dependencies of the royal capital.

The first mention of stone buildings is contained in a letter written in 1506 by Diego de Alcarova to the king of Portugal.[15] Subsequent reports were given in several publications by Portuguese visitors and missionaries. Excavations were started at the end of the nineteenth century and early in the twentieth by personnel of the newly established colonial administration of Cecil Rhodes. Their inexperience in archaeology and their greed resulted in the destruction of much valuable evidence and the looting of gold ornaments and other artefacts. Great damage was done by the ill-advised and disastrous digging undertaken by Hall, an employee of Rhodesia Ancient Ruins Ltd. Many theories based on speculation and romantic association were proffered by him and other inexperienced amateurs about the ruins and the finds.

Serious scientific excavations started in 1905 with MacIver, a pupil of Flinders Petrie; he was followed in 1929 by Gertrude Caton-Thompson, and in the 1950s by Roger Summers, A. Whitty and Keith Robinson, who was the first to use the newly developed radiocarbon dating. The most comprehensive report on all major aspects, based on extensive fieldwork from 1964 to 1970, was written by Garlake.[16]

Although many objects were stolen, the various reports by researchers have resulted in a fairly detailed description of items of art from Great Zimbabwe and related sites. Pottery vessels, both polished and graphited, were found. Some are sophisticated in shape and decoration but with limited variations. The greatest discovery was of seven birdlike figures, and the lower half of an eighth, all carved from dark green or grey-green soapstone, about 35 centimetres high and surmounting columns

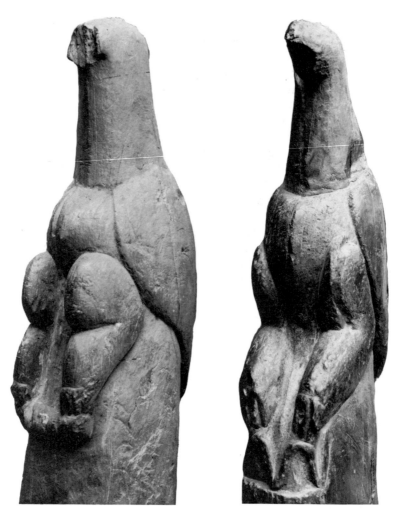

257. Two bird figures. From Great Zimbabwe. Steatite. Museum of Mankind, London. Photo: courtesy Trustees of the British Museum.

about one metre tall. Nothing quite like these representations of birds is known from any other part of Africa. These stylized figures with plump legs, toes instead of claws, wings and beaks indicated only by incisions, symbolized either royalty or deities. Now they have become the symbol of the modern state of Zimbabwe. Two small bird figures [257] are in the Museum of Mankind in London. A figure in soapstone in the Tishman Collection in New York and a related figure in the Museum of Mankind are the only known anthropomorphic representations associated with Great Zimbabwe. Since neither of these human figures were found

in controlled excavations, there is no evidence of Zimbabwe origin for either. However, geometric incisions on the London figure resemble the markings on a soapstone monolith from the Dhlo Dhlo ruins north-east of Leopard's Kopje. The other soapstone birds, which had been removed to South Africa, have recently been returned to Zimbabwe and are now housed in the Site Museum at Great Zimbabwe.

A large number of monoliths, usually slabs of granite or soapstone about one metre high, were found in different parts of the ruins; some of them, made of soft soapstone, were incised with a variety of hatchings and chevron patterns. They may have had a religious significance or served as memorials to the dead.

Figures made of baked clay, some in phallic form and others clearly anthropomorphic, were found alongside small pottery sculptures of cattle and goats in Early Iron Age remains at Great Zimbabwe as well as at Leopard's Kopje and other areas of Matabeleland and Mashonaland. They may all have been connected with a cult of the settlers who lived there during the early era. Other artefacts found at Great Zimbabwe are soapstone dishes carved with simple herringbone patterns or with elaborate bas-reliefs depicting animals and humans, and these are probably from the fourteenth and fifteenth centuries. Iron gongs and other iron implements were unearthed at Great Zimbabwe and at Ingombe Ilede in the Zambesi Valley. The gongs may have originated in Zambia or Zaïre, or the skills to make them locally may have been introduced by itinerant craftsmen from those countries.

Overpopulation eventually caused shortages of food, wood and salt, and the decline of Great Zimbabwe began in the mid fifteenth century. The ruler at the time of the crisis, Mutota, moved north to the Dande area of the middle Zambesi. There he established the centre of the *mwene mupata* empire, based on the wealth of alluvial gold in the Zambesi Valley, the rich gold-belt in the north of Zimbabwe, and the control of trading routes through the Mazoe Valley. The power of the widespread empire declined in the seventeenth century and shifted to the Rozwi (Lozi) with their capital at Dhlo Dhlo.[17]

Excavations during the years from 1933 to 1940[18] at Mapungubwe and near-by Bambandyanalo (or K2), both in northern Transvaal, unearthed a culture closely related to Leopard's Kopje and Great Zimbabwe. Bambandyanalo had been occupied from the eleventh century, while the richer site of Mapungubwe was dated to the fourteenth or fifteenth century A.D. Gardner's conclusion of Khoi involvement at K2 is regarded as invalid by Fagan[19] and Rightmire,[20] but the actual identity of the people of this culture in the Limpopo Valley has not been established.

Pottery constitutes the largest part of the finds of art objects on the two sites. Coarse domestic ware was unearthed, and fine terracotta vessels, many beautifully decorated and burnished a deep black, were recovered

from graves. The best of these have a brilliant sheen, though none were burnished with graphite. The shapes vary from straight or flared bell beakers to lugged, spouted and spherical bowls or pots with base and handles. Some clay figurines, mainly depicting animals, were also dug up. They could have been toys, or used in cults similar to those in Great Zimbabwe and adjacent areas. Large quantities of shell, stone, pottery and glass beads were found, and the latter are assumed to have been imported. A variety of artefacts made of gold sheeting were unearthed at Mapungubwe, of which the most exciting is a sculpture of a rhinoceros and a finely shaped bowl with a diameter of about 10 centimetres. Other objects of gold were bangles, beads, wire and tacks. The gold objects were possibly imported from Great Zimbabwe, whose rulers controlled the mines and the trade routes. An alternative explanation to the trading of finished objects across the Limpopo[21] is the import of the raw material from the north and the fashioning of the objects at Mapungubwe. Yet another possibility is that the gold used was mined in the Transvaal. Whatever the facts, the similarity of the products of the 'industries' between the Zambesi and the Limpopo and those of northern Transvaal point to a close inter-relationship of the peoples of the areas.

Epilogue

This journey through thousands of years of Africa's art history, from the Early Stone Age to the beginning of the twentieth century, has provided but a glance at the splendid cultural achievements of some of the peoples of Africa. The terms 'Darkest Africa' and 'Primitive Art' were given when the world was largely ignorant of the continent's magnificent artistic heritage, evidence of which has been slowly coming to light. In the attempt made here to reconstruct that art history, we have shown the relationship in style, form and iconography of peoples who lived in proximity and the cultural connections between those more remote from each other. In particular the links of Nubia, Egypt and other areas in the north with the rest of Africa have been explored.

The changes and developments caused by the great Bantu migrations across the continent and the impact of Arab invasions, the spread of Islam and the arrival of the Europeans, have been demonstrated.

The arts of Africa were not of an eclectic nature but part of the people's life, whether the purpose was for tribal or royal institutions, for religious or secular use. Style, form and iconography were of individual character for each tribe or nation, yet they were united by specific African traits. Sculpture, as the continent's greatest artistic contribution, has been given the leading place; but the maximum available space has been devoted to dress, body art, pottery, household objects, architecture and painting or engraving on rock.

The background against which the art was used is important to non-Africans, so that they may endeavour to understand the art through the eyes of those by whom and for whom it was made. This implies the need to study the organic connection of artefacts with rites, and the unity of mask and costume with dance, music, recital of oral history and mythology.

With the end of the Second World War, great changes occurred in the political and social structure of the entire continent of Africa. After the long period of colonization, one country after another achieved independence. The traditional societies based on tribal chiefdoms and divine kingdoms were suddenly replaced by nation-states within borders which had been arbitrarily drawn in colonial times. The consequent decline and,

indeed, almost total demise of artistic creation linked to the old social order came more swiftly than even the most knowledgeable observers could have anticipated.

Africa has entered the industrial age and is now politically and economically interdependent with the rest of the world. This will have a major effect on the future of Africa's arts, which will, by nature of these developments, become part of the international world of art but – it is to be hoped – retain an African flavour. Africa's leaders and scholars have recognized the need for the exploration and preservation of the art of their past, and in this monumental task they are being assisted by devoted western experts. The result will be a priceless heritage for future generations of Africa and the whole world.

List of Illustrations

32. King Shabaqo. Ancient Kush. 8th century B.C.
33. Ceremonial spoon in form of swimming girl. Nubia. 8th-7th century B.C.
34. Leg of Kushitic funeral bed.
35. Mirror of King Amani-natake-lebte. Napatan/Kushite.
36. Handle of vessel in form of young girl. Nubia. 5th-3rd century B.C.
37. The great enclosure at Musawwarat as Safra. Nubia. Early Meroitic.
38. Ram and lions. Musawwarat as Safra. 3rd-2nd century B.C.
39. Ba-statue. Nubia. 3rd-2nd century A.D.
40. Head of man. Nubia. 3rd-2nd century A.D.
41. 'Venus of Meroë.' Nubia. 3rd-2nd century B.C.
42. Shield-ring. Meroë. 1st century B.C.
43. Ornament. Nubia. 1st century B.C.
44. Vessel with painted decoration. Meroë. 3rd-2nd century A.D.
45. Relief with Christian motifs. Nubia. 7th century A.D.
46. Drawing, St Menas on horseback. Nubia. *c.* A.D. 1000.
47. Head. Nok culture.
48. Head. Nok culture.
49. Small head with blown-up cheeks. Nok culture.
50. Head. Nok culture.
51. Elongated head. Nok culture.
52. Small kneeling male figure. Nok culture.
53. Female bust. Nok culture.
54. Figure of seated male. Yelwa. 2nd-7th century A.D.
55. Female seated on upturned pot. Nok culture.
56. Roof finial. Gwari. North-east Nigeria.
57. Great Friday Mosque, Mopti, Western Sudan.
58. Repairs to a village mosque.
59. Private house, Jenne.
60. Bust of man. Ancient Jenne.
61. Kneeling woman. Segou style.
62. Two figures. Ancient Jenne.
63. Embracing couple. Ancient Jenne.
64. Equestrian figure. Ancient Jenne.
65. Equestrian figure. Dogon.
66. Equestrian figure. Ancient Jenne.
67. Miniature mask. Ancient Jenne.
68. Pendant. Dogon.
69. Neckrest. Tellem.
70. Neckrest. Tellem/Dogon.
71. Shelter support. Mossi.
72. Hunter's or warrior's tunic. Dagomba.
73. Mask. Bobo.
74. Three pendants. Lobi.
75. Sono staff. Guinea-Bissau.
76. *Pomdo*. Kissi.
77. *Pomdo*. Sherbro.
78. *Pomdo*. Sherbro.
79. *Nomoli*. Mende.

128. Three Akwanshi monoliths.
129. Headdress. Akparabong, Ikom.
130. Head of an Oni. Ife.
131. Head of an Oni. Ife.
132. Mask, said to represent Oni Obalufon. Ife.
133. Statue of an Oni in full regalia. Ife.
134. Royal couple. Ife.
135. Two staffs with human heads. Ife.
136. Seated male figure. Tada.
137. Head, said to represent Lajuwa. Ife.
138. Abstract representation of human head. Ife.
139. Head of a queen. Ife.
140. Potlid, head of mythical animal. Ife.
141. Head of man. Ife.
142. Fragment of head of man, with 'cat's whiskers'. Ife.
143. Seated figure. Ife.
144. Ram's head. Owo.
145. Fragment of small statue of dwarf. Owo.
146. Fragment of figure. Owo.
147. Fragment from ritual pot. Owo.
148. Head and part of torso. Owo.
149. Ovoid bowl and cover. Owo.
150. Two bracelets. Owo.
151. Seated mother feeding her child. Owo.
152. Detail of Gara figure. Probably Owo.
153. Bowman. Probably Owo.
154. Crescent-shaped pendant. Probably Owo.
155. Royal attendant. Probably Owo.
156. Appliqué cloth. Dahomey.
157. Lion. Dahomey.
158. Royal sceptre. Dahomey.
159. Detail of statue of Gŭ, god of war. Dahomey.
160. Seated male figure. Esie.
161. Seated figure. Esie.
162. Bracelet. Nupe.
163. Lidded vessel on base. Nupe.
164, 165. Dagger with cruciform bronze hilt. Nupe.
166. Bracelet, ram's head. Yoruba.
167. Loincloth. Yoruba.
168. Cloak made of beads. Yoruba.
169. Twin figures. Yoruba.
170. Female figure representing Onile. Yoruba.
171. Two *edan* Ogboni staffs. Yoruba.
172. *Epa* headdress. Yoruba.
173. Face mask. Yoruba.
174. Cephalomorphic bell. Yoruba.
175. Armlet. Yoruba.
176. Lidded bowl. Yoruba.

Figures

Abbreviations

The following abbreviations are used for journals in the Notes and Bibliography.

A.A.	*African Arts*
A.A.N.	*Arts d' Afrique Noire*
A.J.P.A.	*American Journal of Physical Anthropology*
C.A.	*Current Anthropology*
J.A.H.	*Journal of African History*
J.H.S.N.	*Journal of the Historical Society of Nigeria*
J.R.A.I.	*Journal of the Royal Anthropological Institute*
J. Soc. African.	*Journal de la Société des Africanistes*
J.S.A.I.M.M.	*Journal of the South African Institute of Mining and Metal-lurgy*
S.A.A.B.	*South African Archaeological Bulletin*
S.A.J.S.	*South African Journal of Science*
W.A.J.A.	*West African Journal of Archaeology*

Notes

I. INTRODUCTION

1. Pierre Demargue, *The Birth of Greek Art*, New York, 1964, p. 1.
2. The Meroitic script has been deciphered, but not the language itself; nor has the ancient script of the Berbers, ancestral to the Tuaregs' *tifinagh*, been – as yet – of help in the reconstruction of African history.
3. F. Van Noten, 'La plus ancienne sculpture sur bois de l'Afrique Centrale', *Africa-Tervuren*, XVIII, 3-4, 1972, pp. 133-6.
4. W.Y. Adams, *Nubia: Corridor to Africa*, London, 1977.
5. G. P. Murdock, *Africa. Its Peoples and Their Culture History*, New York, 1959.
6. W. Fagg and J. Picton, *The Potter's Art in Africa*, London, 1970; and especially revised edition, 1978.
7. K.-H. Striedter, 'Architekturtypen Süd-Marokkos', *Paideuma*, 27, 1981, pp. 7-44.
8. 'Bantu' is a linguistic term, and the 'Bantu' and Nigritic languages share a common origin.
9. J.H. Greenberg, *The Languages of Africa*, Bloomington, 1963.
10. J.H. Greenberg, 'Linguistic evidence regarding Bantu origin', *J.A.H.*, XIII, 2, pp. 189-216.
11. M. Guthrie, *Comparative Bantu*, 4 vols., Farnborough, 1967-71.
12. M. Guthrie, 'Contributions from comparative Bantu studies to the pre-history of Africa', in D. Dalby (ed.), *Language and History in Africa*, London, 1970, pp. 20-49 (Chapter 21).
13. D.W. Phillipson, *The Later Prehistory of Eastern and Southern Africa*, London, 1977, pp. 210-27.
14. R.F. Thompson, *The Four Moments of the Sun*, Washington, D.C., 1981: 33, quoting Fu-Kiau Bunseki.
15. S. Wolf, 'Afrikanische Elfenbeinlöffel des 16 Jahrhunderts im Museum für Völkerkunde Dresden', *Ethnologica*, n.f., 2, Cologne, 1960, pp. 410-25.
16. The institution of divine kingship developed in Egypt as it did in Kongo and many other African states, from the Kuba in southern Zaïre to the forest kingdoms of Ife, Owo, Benin, Jukun, Nupe, Asante and many others. It is a phenomenon known throughout the ages and in the history of many peoples, including the Sumerians and the Hittites, from whom it may have come to Africa in the first place; or parallel developments may have occurred in several places. As to the argument of diffusion from Egypt to western Africa (or vice-versa), Herodotus wrote in 450 B.C. that Egypt's cultural origins lay in continental Africa; and – referring to circumcision, another feature common to both – he said that 'as between the Egyptians and Ethiopians (black Africans) I should not like to say which learned from the other'.

2. THE ROCK ART OF AFRICA

1. Museen der Stadt Köln, *Sahara, 10,000 Jahre zwischen Weide und Wüste*, Cologne, 1978.
2. J. Ki-Zerbo, 'African prehistoric art', UNESCO *General History of Africa*, Vol. I, 1981, p. 680.
3. Carson I. A. Ritchie, *Rock Art of Africa*, London, 1979, p. 27.
4. Henry Lhote, *The Search for the Tassili Frescoes*, London, 1959.
5. Henry Lhote, *Vers d'autres Tassilis*, Paris, 1976.
6. André Leroi-Gourhan, *Préhistoire de l'art occidental*, Paris, 1965.
7. Marina Lupacciolu, 'The absolute dating of the earliest Saharan rock art', *Paideuma*, 24, 1978, pp. 43-51.
8. F. Mori, 'The earliest Saharan rock-engravings', *Antiquity*, XLVIII, 197, 1974, pp. 87-92.
9. Henriette Camps-Fabrer, 'Matière et art mobilier dans la préhistoire nord-africaine et saharienne', *Memoirs du Centre de Recherches Anthropologiques, Préhistoriques et Ethnographiques*, v, Paris, 1966.
10. H. Breuil, 'Restes d'une sépulture en grotte au Sahara', *J. Soc. African.*, 24, 2, 1954, pp. 113-17.
11. J.D. Clark, 'The problem of Neolithic culture in Subsaharan Africa', in W.W. Bishop and J.D. Clark (eds.), *Background to Evolution in Africa*, Chicago, 1967, pp. 601-27.
12. Dr Karl-Heinz Striedter, personal communication to the author, 9 September 1982.
13. At Sefar, 'Greek God with Praying Women'; Lhote, *The Search for the Tassili Frescoes*, colour plate II.
14. Lhote, *The Search for the Tassili Frescoes*, p. 191; and Fabrizio Mori, 'Zur Chronologie der Sahara-Felsbilder', in Museen der Stadt Köln, op. cit., p. 253 ff.
15. ibid.
16. Lhote, *The Search for the Tassili Frescoes*, colour plate II.
17. Highly schematized figures, some with bird heads, were seen by Lhote, who attributed them to Egyptian influences. However, recent researchers report that these paintings have now disappeared, and the objects Lhote saw may have been fakes. (Dr Karl-Heinz Striedter, personal communication to the author.)
18. Paul Huard and L. Allard, 'Contributions à l'étude des spirales au Sahara central et nigéro-tchadien', *Bulletin de la Société Préhistorique Française*, 63, 2, 1966, pp. 433 ff. and figs. 2-9.
19. Paul Huard, 'Influences culturelles transmises au Sahara tchadien par le Groupe C de Nubie', *Kush*, 15, Khartoum, 1974, pp. 84-124.
20. Camps-Fabrer, op. cit.
21. W.B. Fagg, *Nigerian Images*, London, 1963, p. 21.
22. J.H. Chaplin, 'The prehistoric rock art of the Lake Victoria region', *Azania*, IX, 1974, pp. 1-50.
23. R.C. Soper, 'Rock gongs and a rock chute in Mwanza region, Tanzania', *Azania*, III, 1968, p. 175.
24. Pavel Červiček, 'Felsbilder Oberägyptens und Nubiens', in Museen der Stadt Köln, op. cit., pp. 279-85.
25. W.M. Davis, in 'Dating prehistoric rock drawings in Upper Egypt and Nubia', *Current Anthropology*, 1978, 19/1, pp. 216-17, presents a hypothesis that geometrical designs (wavy and curling lines, circle and dot, etc.) date back to 8000-7000 B.C., antelopes and hunting scenes to 6500 B.C., cattle earliest, to 5000 B.C.
26. Walter F.E. Resch, *Die Felsbilder Nubiens*, Graz, 1967.
27. G. Schweinfurth, 'Über alte Tierbilder und Felsinschriften bei Assuan', *Zeitschrift für Ethnologie*, 44, Berlin, 1912.
28. D.W. Phillipson, 'Zambian rock paintings', *World Archaeology*, 3, 3, February 1972, pp. 313-27.

29. D.W. Phillipson, *Prehistoric Rock Paintings and Engravings of Zambia*, Livingstone, 1972.
30. Ritchie, op. cit., p. 107.
31. Wendt, W.E., '"Art mobilier" from the Apollo 11 cave, South West Africa: Africa's oldest dated works of art', *S.A.A.B.*, 31, 1976, pp. 5-11.
32. A.R. Willcox, *The Rock Art of South Africa*, Johannesburg, 1963.
33. Patricia Vinnicombe, *People of the Eland*, Pietermaritzburg, 1976, p. 111.
34. ibid.
35. J.D. Clark, *The Prehistory of Southern Africa*, London, 1959.
36. Roy Sieber, 'African art and culture history', in C. Gabel and N.R. Bennett (eds.), *Reconstructing African Culture History*, Boston, 1967, pp. 117-37.
37. J.D. Lewis-Williams, *Believing and Seeing Symbolic Meanings in Southern San Rock Paintings*, New York, 1981.
38. Willcox, op. cit., plate 11.
39. Vinnicombe, op. cit.

3. THE ANCIENT NUBIANS

1. J. Ki-Zerbo, 'African prehistoric art', UNESCO *General History of Africa*, Vol. I, 1981, p. 676.
2. Paul Huard and L. Allard, 'Contributions à l'étude des spirales au Sahara central et nigéro-tchadien', *Bulletin de la Société Préhistorique Française*, 63, 2, 1966, p. 449.
3. A. Arkell, 'Dating early Khartoum', in 'Ägypten und Kusch', *Schriften zur Geschichte und Kultur des Alten Orients*, 13, Berlin, 1977, pp. 53-5.
4. H.Å. Nordström (ed.), *Neolithic and A-Group Sites*, Scandinavian Joint Expedition to Sudanese Nubia, III, Uppsala, 1972.
5. William Y. Adams, *Nubia: Corridor to Africa*, London, 1977, p. 3.
6. Steffen Wenig, *Africa in Antiquity*, II, Brooklyn, 1978, cat. no. 1.
7. ibid., cat. no. 3.
8. ibid., cat. no. 12.
9. H.S. Smith, 'The Nubian B-Group', *Kush*, 14, 1966, pp. 69 ff.
10. Wenig, op. cit., cat. no. 142, 143.
11. A. Badaway, 'An Egyptian fortress in the Belly of Rock. Further excavations and discoveries in the Sudanese island of Askut', *Illustrated London News*, 245, 1964, pp. 86-8.
12. A. Badaway, 'Askut: a Middle Kingdom fortress in Nubia', *Archaeology*, 18, 2, 1965, pp. 124-31.
13. Wenig, op. cit., cat. no. 13.
14. Paul Huard, 'Influences culturelles transmises au Sahara tchadien par le groupe "C" de Nubie', *Kush*, 15, Khartoum (1967-68) [1973], pp. 84-124.
15. Wenig, op. cit., cat. figs. 7, 18-19, 26 and p. 129.
16. ibid., cat. no. 20.
17. ibid., cat. fig. 7 and cat. nos. 21, 22.
18. ibid., cat. no. 37 and p. 141.
19. ibid., cat. no. 60. Sudan National Museum, Khartoum, no. 1036.
20. ibid., cat. nos. 61-7.
21. J. Wallert, *Der Verzierte Löffel*, Wiesbaden, 1967.
22. Museum of Fine Arts, Boston, Mass., 21. 339 a-b.
23. ibid., 23. 333.
24. A.H. Sayce, *University of Liverpool Annals of Archaeology and Anthropology*, IV, 1911, p. 55.
25. B. Trigger, *African Historical Studies*, II, 1969, pp. xx and 49.

26. Hermann Amborn, 'Die Bedeutung der Kulturen des Niltals für die Eisenproduktion im Subsaharischen Afrika', *Studien zur Kulturkunde*, 39, Wiesbaden, 1976.

27. P.L. Shinnie, 'On radiocarbon chronology of the Iron Age in sub-Saharan Africa', *C.A.*, 10, 1969, pp. 229-30.

28. P.L. Shinnie, *The African Iron Age*, Oxford, 1971, pp. 89-107.

29. D.W. Phillipson, 'Notes on the later prehistoric radiocarbon chronology of eastern and southern Africa', *J.A.H.*, 11, 1970, pp. 1-15.

30. R.C. Soper, 'New radiocarbon dates for eastern and southern Africa', *J.A.H.*, 15, 1974, pp. 175-92.

31. British Museum, no. 65222.

32. Sudan National Museum, Khartoum, no. 24397.

33. Wenig, op. cit., p. 265.

34. The Noba are a Nubian-speaking people not to be confused with the modern Nuba of Niger-Kordofanian origin.

35. William Y. Adams, 'Ceramics', *Africa in Antiquity*, I, Brooklyn, 1978, p. 133.

4. THE NOK CULTURE

1. Steffen Wenig, *Africa in Antiquity*, II, Brooklyn, 1978, p. 21.

2. H.Å. Nordström (ed.), *Neolithic and A-Group Sites*, Scandinavian Joint Expedition to Sudanese Nubia, III, Uppsala, 1972, pp. 11, 80.

3. Bernard Fagg, *Nok Terracottas*, Lagos, 1977, p. 39.

4. Unfired clay as used in Benin, and by the Yoruba, Ife, Fon, etc., is, in technological terms, similar to Nok and Ife traditions. J. Picton, personal communication, 2 June 1982.

5. R.T.D. Fitzgerald, 'Dakakari grave pottery', *J.R.A.I.*, LXXIV, 1944, pp. 43-57.

6. Allen Bassing, 'Grave monuments of the Dakakari', *A.A.*, VI, 4, 1973, pp. 36-9.

7. Fagg, op. cit., p. 22.

8. This would not apply to those sculptures that are open; Nok pottery is built up from clay coils, which makes it likely that the artists were women, who use this method all over Africa. J. Picton, personal communication, 2 June 1982.

9. Frank Willett, *African Art*, London, 1971, p. 73. (See also W.B. Fagg, *Nigerian Images*, London, 1963.)

10. There is also a rival claim from Bihaya, north-western Tanganyika. Personal note from Thurstan Shaw.

11. Bernard Fagg, 'Recent work in West Africa. New light on the Nok culture', *World Archaeology*, 1 (1), 1969, pp. 41-50.

12. Thurstan Shaw, *Nigeria*, London, 1978, p. 80.

13. Ekpo Eyo, *2,000 Years of Nigerian Art*, Lagos, 1977, pp. 33, 34, 35.

5. THE KINGDOMS OF THE WESTERN SUDAN

1. Andrew B. Smith, 'Preliminary report of excavations at Karkarichinkat Nord and Karkarichinkat Sud, Tilemsi Valley, Republic of Mali, spring 1972', *W.A.J.A.*, 4, 1974, pp. 33-5; plates VIII-XIII.

2. The megaliths of Senegambia are not as old as was once believed; the stone circle at Wassu, Gambia, was dated to A.D. 750 ± 110. (R. Mauny, 'Trans-Saharan contacts and the Iron Age in West Africa', in *The Cambridge History of Africa*, Vol. 2, 1978, p. 312 and n.)

3. Nehemia Levtzion, 'The early states of the Western Sudan', in J.F.A. Ajayi and M. Crowder (eds.), *History of West Africa*, Vol. I, 1971 (reprint 1979), pp. 118-19.

4. Al Bakri, *Kitab el-Masalik*, Alger, 1911; Al Umari, French translation – *L'Afrique moins l'Egypte*, Paris, 1927, 64, p. 5; Ibn Battuta (translation and Arab text), *Voyages*, Paris, 1922, IV, pp. 403-7.

5. Dorothee Gruner, 'Der Traditionelle Lehmbau und seine Problematik', *Paideuma*, 27, Wiesbaden, 1981.
6. Raymond Mauny, 'Trans-Saharan contacts and the Iron Age in West Africa', in *The Cambridge History of Africa*, Vol. 2, 1978, pp. 338-9.
7. As reported by Ibn Battuta, who visited in 1352-3, i.e. after Mansa Musa's death.
8. Exhibition catalogue, *Ancient Treasures in Terracotta of Mali and Ghana*, The African-American Institute, New York, 1981, pp. 46-7.
9. Roderick J. and Susan K. McIntosh, 'Terracotta statuettes from Mali', *A.A.*, XII, 2, 1979, pp. 51-3.
10. Lab. No. RL 806: 830 ± 140 B.P.
11. B. de Grunne, *Terre cuites anciennes de l'Ouest Africain*, Louvain, 1978.
12. Levtzion, op. cit., p. 119.
13. C. Monteil, 'La Légende de Ougadou et l'origine des Soninke', in *Mélanges Ethnologiques*, Mem. de l'Ifan, 23, Dakar, 1953, pp. 359-408.
14. McIntosh, op. cit., p. 53.
15. C. Monteil, 'Dienné, une cité soudanaise', *Anthropos*, Paris, 1971, pp. 136-7.
16. Ibn Battuta, op. cit., pp. 411-14.
17. Nehemia Levtzion, *Ancient Ghana and Mali*, London, 1973, p. 114.
18. R. Bedaux, *Tellem*, Berg en Dal, 1977.
19. ibid.
20. ibid.
21. John Picton and John Mack, *African Textiles*, British Museum, London, 1979, p. 109.
22. Venice Lamb, *West African Weaving*, London, 1975.
23. Venice and Alastair Lamb, *The Lamb Collection of West African Narrow Strip Weaving*, Halifax, 1975.
24. Renée Boser-Sarivaxévanis, *Les Tissues de l'Afrique occidentale*, Vol. I, Basle, 1972.
25. Bedaux, op. cit., p. 78.
26. Elsy Leuzinger, *Die Kunst von Schwarz-Afrika*, exhibition catalogue, 1970-71, Kunsthaus, Zurich, fig. D.3, p. 65.
27. Some Mossi elders claim that their first ruler, Oubri, lived in the eleventh or twelfth century.
28. Christopher Roy, 'Mossi masks and crests', Ph.D. dissertation, University of Indiana, 1979.
29. Annemarie Schweeger-Hefel, *Steinskulpturen der Nyonyosi aus Ober-Volta*, Munich, 1981, p. 13.
30. In 1945 and 1969 by Wilhelm Staude and Annemarie Schweeger-Hefel and in 1978-80 by the latter alone.
31. Schweeger-Hefel, op. cit., fig. 1, p. 24.
32. ibid., p. 103.
33. ibid., fig. 16.
34. ibid., fig. 22 a-c.
35. ibid., figs. 9, 10, 11, 12.
36. ibid., fig. 14.
37. Annemarie Schweeger-Hefel, 'L'Art Nioniosi', *J. Soc. African.*, 36, 1966, pp. 251-332.
38. Leuzinger, op. cit., pl. C.1.
39. Jean Laude, *African Art of the Dogon*, New York, 1973, figs. 89, 91, 98, 100, 102.
40. Robert Goldwater, *Senufo Sculpture from West Africa*, New York, 1964, nos. 67 and 78.
41. Schweeger-Hefel, *Steinskulpturen der Nyonyosi aus Ober-Volta*, p. 24.
42. Norman Skougstad, *Traditional Sculpture from Upper Volta*, New York, 1978.
43. Annemarie Schweeger-Hefel, 'Les Insignes royaux des Kouroumba', *J. Soc. African.*, 32, 1962, pp. 275-326.

44. A. Teixeira da Mota, 'Descoberta de Bronzes Antigos na Guiné Portuguesa', *Boletim Culturae da Guiné Portuguesa*, 59, XV, Bissau, 1960, pp. 625-62.
45. Ezio Bassani, 'Sono from Guinea Bissau', *A.A.*, XII, 4, 1979, pp. 44-7.
46. V.H. Koroma, 'The bronze statuettes of Ro-Ponka, Kafu Bolom', *Sierra Leone Studies*, 22, September 1939, pp. 25-8.
47. Bassani, op. cit., pp. 46-7.
48. ibid., p. 47.

6. THE ARTS OF THE SHERBRO, BULOM AND KISSI

1. J.D. Fage, 'Upper and Lower Guinea', in *The Cambridge History of Africa*, Vol. 3, 1977, p. 509.
2. T.J. Alldridge, *The Sherbro and its Hinterland*, London, 1901.
3. Yves Person, 'Les Kissi et leurs statuettes de pierre dans le cadre de l'histoire ouest-africaine', *Bulletin de l'I.F.A.N.*, XXIII, B-1, Dakar, 1961.
4. ibid, p. 37.
5. See *Arts premiers d'Afrique noire*, exhibition catalogue, Crédit Communal de Belgique, Brussels, 1977, pl. 16.
6. W.B. Fagg, *African Sculpture*, Washington, D.C., 1970, p. 17.
7. Ezio Bassani, 'Gli olifanti afroportoghesi della Sierra Leone,' *Critica d'Arte*, 163, 5, 1979, pp. 177-201.
8. A.F.C. Ryder, 'A note on the Afro-Portuguese ivories', *J.A.H.*, London, 1964.
9. Philip Allison, *African Stone Sculpture*, London, 1968, p. 41.
10. Fagg, op. cit., p. 17, cat. no. 2.
11. Allison, op. cit., pl. 69.
12. Person, op. cit., p. 43, quoting a letter from Antoine Malfante, Genoese merchant, written in 1447.

7. KANEM-BORNO AND THE 'SAO' CULTURE

1. H.R. Palmer, *History of the first twelve years of the reign of Mai Idris Alaoma of Bornu, by his Imam* (translated from Arabic), Lagos, 1926.
2. J.-P. and A. Lebeuf, *Les Arts des Sao*, Paris, 1977.
3. ibid., p. 46.
4. Graham Connah, *Three Thousand Years in Africa*, Cambridge, 1981.
5. ibid., fig. 10.9, p. 238.

8. 'KORÓRÓFA' - THE JUKUN AND RELATED PEOPLES

1. Arnold G. Rubin, 'The arts of the Jukun-speaking peoples of Northern Nigeria', Ph.D. dissertation, University of Indiana, 1970, pp. 4 ff., quoting: Charles Kingsley Meek, *A Sudanese Kingdom: An Ethnographical Study of the Jukun-speaking Peoples of Nigeria*, London, 1931; H. R. Palmer, 'Notes on the Kororofawa and Jukon', *Journal of the African Society*, 11, 1911, pp. 401-15, and *Sudanese Memoirs*, 3 vols., Lagos, 1928; Roy C. Abraham, *The Tiv People*, Lagos, 1933.
2. Rubin, op. cit., p. 210.
3. Meek, op. cit.
4. ibid., pp. 178-9.
5. On Jukun religion in general, see Rubin, op. cit., pp. 18-26, all based on Meek, op. cit.
6. Rubin, op. cit., pls. 46-58.
7. Roy Sieber, *Sculpture of Northern Nigeria*, New York, 1961, p. 6, ills. 6, 25, 26, 27.

8. On the morphology and iconography of the *Aku-maga* mask: Erich Harold, 'Zur Ikonographie der "Aku-Onu" Masken', *Abhandlungen und Berichte des Staatlichen Museums für Völkerkunde, Dresden*, 34, Berlin, 1975.

9. E. von Sydow, *Afrikanische Plastik*, New York, 1954, pl. 117.

10. Rubin, op. cit., p. 81.

11. ibid., quoting Meek, op. cit., p. 81.

12. Sieber, op. cit., ills. 35, 36.

13. Arnold Rubin, 'Bronzes of the Middle Benue', *W.A.J.A.*, 3, 1973, pp. 221-31.

14. Arnold Rubin, letter to the author, 20 November 1975.

15. Rubin, 'The arts of the Jukun-speaking peoples of Northern Nigeria', pp. 54-5.

9. THE ART OF THE AKAN

1. A. Boahen, 'The origins of the Akan', *Ghana Notes and Queries*, 9, 1966, pp. 3-10.

2. Merrick Posnansky, 'Archaeology and the origins of Akan society', in *History of Ghana: A Series of Lectures*, M. Dodds (ed.), Accra, 1974; pp. 12-20.

3. James Anquandah, 'State formation among the Akan of Ghana', *Sankofa*, 1, 1975, pp. 47-59.

4. Posnansky, op. cit.

5. Herbert M. Cole and Doran H. Ross, *The Arts of Ghana*, Los Angeles, 1977.

6. Merrick Posnansky, 'Redressing the balance – new perspectives in West African archaeology', *Sankofa*, 1975, p. 18.

7. J.D. Fage, *Ghana, A Historical Interpretation*, Madison, 1959.

8. Cole and Ross, op. cit., p. 98.

9. ibid.

10. ibid., figs. 214a and 216.

11. ibid., pp. 109-15.

12. Elsy Leuzinger, *Die Kunst von Schwarz-Afrika*, Zürich, 1970, pl. G.3.

13. Susan M. Vogel, 'People of wood: Baule figure sculpture', *Art Journal*, XXXIII, 1, 1973.

14. Cole and Ross, op. cit., p. 117.

15. Pieter de Marees, 'A Description and Historical Declaration of the Golden Kingdom of Guinea (1602)', trans. by Purchas in his *Pilgrimes*, Hakluyt Society, VI, Glasgow, 1905, pp. 346-7.

16. Margaret Joyce Field, *Akim Kotoku – An Oman of the Gold Coast*, London, 1948 (reprinted 1970), pp. 3, 4, 44, 45.

17. See Cole and Ross, op. cit., pp. 120 ff.

18. Roy Sieber, 'Art and history in Ghana', in Anthony Forge (ed.), *Primitive Art and Society*, London, 1973, p. 71.

19. ibid.

20. ibid., pp. 78-83.

21. ibid., pp. 75-94.

22. ibid., p. 91.

23. Pottery appears in the archaeological record about 2000-1500 B.C.: see Cole and Ross, op. cit., p. 4.

24. ibid., p. 127.

25. R.S. Rattray, *Religion and Art in Ashanti*, London, 1927 (reprinted 1959), pp. 130-31.

26. M.D. McLeod, *The Asante*, London, 1981, colour pl., top, facing p. 96.

27. ibid., p. 116.

28. Cole and Ross, op. cit., pp. 149-51.

29. ibid., fig. 311, and McLeod, op. cit., p. 91.

30. McLeod, op. cit., colour pl., bottom, facing p. 96, and three following pls.

31. Cole and Ross, op. cit., colour pl. XII.

32. John Donne, 'West African goldwork', *Connoisseur*, 194, 780, London, 1977, p. 106.
33. Cole and Ross, op. cit., p. 158.
34. Ivor Wilks, *Asante in the 19th Century*, London, 1975, pp. 470-74.
35. McLeod, op. cit., p. 95.
36. A.A.Y. Kyerematen, *Ashanti Royal Regalia*, Oxford, 1966, pp. 130, 211, 260 (doctoral dissertation).
37. Cole and Ross, op. cit., p. 166.
38. W.J. Müller, *Die Afrikanische auf der Guineischen Gold-Cust gelegene Landschaft Fetu*, Hamburg, 1673.
39. Ibn Battuta, *Travels in Asia and Africa, 1325-54* (ed. H.A.R. Gibb), London, 1929, pp. 326, 328.
40. T.S. Crawford, *A History of the Umbrella*, Newton Abbot, 1970, p. 65.
41. Cole and Ross, op. cit., p. 168.
42. Posnansky, 'Archaeology and the origins of Akan society', p. 19.
43. T.E. Bowdich, *Mission from Cape Coast Castle to Ashantee*, London, 1819 (reprinted London, 1966), pp. 34-5.
44. Renée Boser-Sarivaxévanis, *Textilhandwerk in West Afrika*, Basle, 1972/3, p. 200.
45. L.F. Rømer, *The Coast of Guinea* (1760), trans. K. Bertelsen, Institute of African Studies, Legon, 1965.
46. Graham Connah, 'Archaeology in Benin', *J.A.H.*, XIII, 1, 1972, p. 31.
47. See Chapter 5.
48. Cole and Ross, op. cit., p. 44.
49. Bowdich, op. cit., p. 271.
50. Cole and Ross, op. cit., figs. 65, 66, 69.
51. Steffen Wenig, *Africa in Antiquity*, II, Brooklyn, 1978, cat. no. 24, p. 131.
52. Roy Sieber, *African Textiles and Decorative Arts*, New York, 1972, p. 123.
53. Good selections are illustrated in Cole and Ross, op. cit., colour pls. VI and VII, pp. 31 and 33-7, and figs. 17, 19, 20.
54. Charles Ratton, *Fetish Gold*, University Museum, Philadelphia, 1975.
55. Samuel Purchas, *Pilgrimes*, Glasgow, 1905, quoting de Marees, op. cit.
56. J.W. Blake, *Europeans in West Africa, 1450-1560*, London, 1941, p. 343.
57. Timothy F. Garrard, *Akan Weights and the Gold Trade*, London, 1980, pp. 180, 181 (fig. 25), 187-8.
58. A. and John Churchill (eds.), *Collection of Voyages and Travels*, Vols. 5, 6, London, 1744/6, v. 262, quoting John Barbot, 'A description of the Coasts of North and South Guinea and of *Aethiopia inferior*, vulgarly Angola'.
59. Garrard, op. cit., pp. 290, 291.
60. ibid., p. 276.
61. ibid., Chapter 9, pp. 274 ff., ills. 32-60.
62. ibid., pp. 239, 333.
63. The Egyptian *rattle* or *rotl* in use today is approximately 1 lb (453 gr); an *okiya* is $\frac{1}{12}$ of the *rattle* (37.75 g). The *mithkal* used to be $\frac{1}{24}$ of an *okiya* or $1\frac{1}{2}$ *dirham*, the smallest measure for weighing precious metals. The *mithkal* is no longer in use, but in the Koran it simply means 'weight' or a whit, jot or iota. The *rattle* in pre-Israel Palestine was 3-3.5 kg, depending on the town, i.e. totally different from Egyptian standards.
64. A.D. Hewson, *New Developments in Statistical Quantum Theory*, London, 1978.
65. McLeod, op. cit., p. 123.
66. Peggy Appiah, *Asante Goldweights, Proverbs and Folklore*, Accra (n.d.).
67. Brigitte Menzel, *Goldgewichte aus Ghana*, Berlin, 1968.
68. Garrard, op. cit., pp. 204-10.
69. Cole and Ross, op. cit., p. 65.
70. R.S. Rattray, *Ashanti*, Oxford, 1923, pp. 51-3.

71. Rattray, *Religion and Art in Ashanti*, p. 74.

72. Cole and Ross, op. cit., fig. 137, p. 67.

10. IGBO-UKWU, THE NIGER DELTA AND THE CROSS RIVER

1. J.O. Field, 'Bronze casting found at Igbo, Southern Nigeria', *Man*, 40, London, 1940, pp. 1-6.

2. G. I. Jones, 'Ibo bronzes from the Awka Division', *Nigerian Field*, 8 (4), 1939, pp. 346-54.

3. Thurstan Shaw, *Igbo-Ukwu, an Account of Archaeological Discoveries in East Nigeria*, 2 vols., London, 1970.

4. Frank Willett, *Ife in the History of West African Sculpture*, London, 1967, pl. 23.

5. Thurstan Shaw, *Nigeria, its Archaeology and Early History*, London, 1978, fig. 73.

6. Robert G. Armstrong, 'A possible function for the bronzed roped pot of Igbo Ukwu', *W.A.J.A.*, 4, 1974, pp. 177-8, pl. LXXIV.

7. Shaw, *Nigeria, its Archaeology and Early History*, pl. 78.

8. Babatunde Lawal, 'Archaeological excavations at Igbo-Ukwu – a reassessment', *Odu*, n.s., 8, 1972, pp. 72-97.

9. Babatunde Lawal, 'The Igbo-Ukwu bronzes: a search for the economic evidence', *J.H.S.N.*, 6 (3), 1972, pp. 1-8.

10. David Northrop, 'The growth of trade among the Igbo before 1800', *J.A.H.*, 13 (2), 1972, pp. 217-36.

11. Merrick Posnansky, 'Review of Igbo-Ukwu: an account of archaeological discoveries in eastern Nigeria', *Archaeology*, 6 (4), 1973, pp. 309-11.

12. Thurstan Shaw, 'Those Igbo-Ukwu radiocarbon dates: facts, fictions and probabilities', *J.A.H.*, 16 (4), 1975, pp. 503-17.

13. Denis Williams, *Icon and Image*, London, 1974.

14. Shaw, *Igbo-Ukwu*, Vol. 1, p. 88, figs. 30 and 31.

15. M. A. and B. O. Onwuejeogwu, 'The search for the missing links in dating and interpreting the Igbo-Ukwu finds', *Paideuma*, 23, 1977, pp. 169-88.

16. Timothy F. Garrard, 'Myth and metrology: the early trans-Saharan gold trade', *J.A.H.*, 23, 1982, pp. 443-61.

17. Thurstan Shaw, 'The prehistory of West Africa', in J. F. A. Ajayi and M. Crowder (eds.), *History of West Africa*, London (1971), 1979, p. 64.

18. Copper was mined and worked in West Africa by the first half of the first millennium B.C.; see Merrick Posnansky, 'Brass casting and its antecedents in West Africa', *J.A.H.*, XVIII, 2, 1977, p. 294.

19. Graham Connah, *Three Thousand Years in Africa*, Cambridge, 1981, p. 187.

20. The metal objects from Cameroon and Chad excavated by Lebeuf were mainly leaded bronzes with tin content varying from 2.2 to 18.2 per cent, with some items of pure copper and some of zinc alloy brass. Igbo-Ukwu copper alloys used in lost wax castings are predominantly leaded bronzes, with varying additions of tin, while the objects produced by hammering and chasing are 97 per cent copper. Most of the Ife and Benin castings are copper zinc alloys, i.e. brasses.

21. Jean Hiernaux, *The People of Africa*, London, 1974, p. 170.

22. It is not yet established that the Igbo-Ukwu were the occupants of the actual sites; according to folklore the Oreri may have been there at the time (Shaw, *Igbo-Ukwu*, p. 271).

23. Copper also occurs in Abakaliki-Afikbo areas, and tin in Calabar (Onwuejeogwu, op. cit., p. 175).

24. See illustrations in J.-P. and A. Lebeuf, *Les Arts des Sao*, Paris, 1977, nos. 87, 89, 90,

and especially no. 91, which is a single-handled oval calabash bowl similar to types from Igbo-Ukwu.

25. Robin Horton, 'A note on recent finds of brasswork in the Niger Delta', *Odu*, 2, 1, July 1965, pp. 76-91.

26. Leon Underwood, *Bronzes of West Africa*, London, 1968, pl. 61.

27. Arnold Rubin, 'Bronzes of the Middle Benue', *W.A.J.A.*, 3, 1973, pp. 221-31.

28. Keith Nicklin, 'Archaeological sites in the Cross River region', *Nyame Akuma*, University of Calgary, 16, 1980.

29. Philip M. Peek, 'Isoko bronzes and the Lower Niger bronze industries', *A.A.*, XIII, 4, 1980, pp. 60-66.

30. Frank Willett, 'The Benin Museum collection', *A.A.*, VI, 4, 1973, p. 11.

31. Rubin, op. cit., p. 228 and pl. XIII (a) and (b).

32. Lebeuf, op. cit., pls. 81, 82, 87, 89.

33. Horton, op. cit., p. 78.

34. Nancy Neaher, 'Nigerian bronze bells', *A.A.*, XII, 3, 1979, pp. 42-7.

35. Hiernaux, op. cit., p. 170.

36. Keith Nicklin, in *Guide to the National Museum, Oron*, p. 10, states: 'The Iwo Eleru site [where 'Eleru Man' was discovered - author] was inhabited from about 9000 to 1500 B.C., and in the most recent phase around 3000 B.C., tools of the Late Stone Age and pottery were discovered.'

37. K. Nicklin and S. J. Fleming, 'A bronze "carnivore skull" from Oron, Nigeria', *Masca*, University Museum of Pennsylvania, 1, 4, 1980.

38. K. Nicklin and S. J. Fleming, 'Analysis of two bronzes from a Nigerian *Asunaja* shrine', *Masca*, in press.

39. Shaw, *Nigeria, Its Archaeology and Early History*, p. 101, figs. 53a, b, c.

40. Philip Allison, *African Stone Sculpture*, London, 1968, p. 32.

41. F. Neyt, *L'Art Eket*, Paris, 1979.

42. K. Nicklin and Jill Salmons, review of *L'Art Eket* by F. Neyt, *A.A.*, XIII, 2, 1980, pp. 24-7, 83.

43. Keith Nicklin, personal communication to the author.

44. Ekpo Eyo, *2,000 Years of Nigerian Art*, Lagos, 1977, p. 204.

45. Hélène Kamer, *Ancêtres M'bembe*, Paris, 1974.

46. Kurt Krieger, *Westafrikanische Plastik II*, catalogue no. 236, ills. 235-6, p. 86.

47. Allison, op. cit., p. 28.

48. ibid.

49. Ekpo Eyo and Frank Willett, *The Treasures of Ancient Nigeria*, New York, 1980, pl. 100, p. 158.

50. Allison, op. cit., pls. 37, 44.

51. Keith Nicklin, 'Nigerian skin-covered masks', *A.A.*, VII, 3, 1974, p. 8.

52. P. A. Talbot, *In the Shadow of the Bush*, London, 1912, p. 261.

53. Herbert Cole, *African Arts of Transformation*, Santa Barbara, 1970, p. 50.

54. Nicklin, 'Nigerian skin-covered masks', p. 8.

55. Keith Nicklin, 'Skin-covered masks of Cameroon', *A.A.*, XII, 2, 1979, pp. 54-9.

11. THE YORUBA AND THEIR NEIGHBOURS

1. William Fagg, 'The Yoruba and their past', in *Yoruba Sculpture of West Africa*, New York, 1982, pp. 25-6.

2. Frank Willett, 'A survey of recent results in the radiocarbon chronology of western and northern Africa', *J.A.H.*, 12, 3, 1971, pp. 339-70.

3. Wai B. Audah, 'West Africa before the seventh century', UNESCO *General History of Africa*, Vol. II, 1981, p. 613.

4. A.F.C. Ryder, 'A reconsideration of the Ife–Benin relationship', *J.A.H.*, VI, 1, 1965, pp. 28, 29.

5. ibid., p. 30.

6. W.B. Fagg, *Nigerian Images*, London, 1963, p. 28.

7. Ryder, op. cit., p. 37.

8. Thurstan Shaw, *Nigeria, Its Archaeology and Early History*, London, 1978, p. 160.

9. Philip Allison, *African Stone Sculpture*, London, 1968, p. 15, pl. 7.

10. B.E.B. and W.B. Fagg, 'The ritual stools of ancient Ife', *Man*, 1960.

11. Fagg, *Nigerian Images*, pl. 3.

12. Leo Frobenius, *The Voice of Africa*, 2 vols., London, 1913.

13. W.B. Fagg and L. Underwood, 'An examination of the so-called "Olokun" head of Ife, Nigeria', *Man*, 49, 1949, pp. 1–7.

14. Fagg, *Nigerian Images*, pl. 8.

15. Frank Willett, *Ife*, London, 1967, pl. III, rear view.

16. ibid., fig. 9 and pls. I, V, VI.

17. ibid., figs. 19, 20.

18. Shaw, *Nigeria, Its Archaeology and Early History*, p. 134.

19. Willett, *Ife*, p. 29.

20. Peter Garlake, 'Excavations at Obalara's Land, Ife, 1974', *W.A.J.A.*, 4, pp. 127–9.

21. Ekpo Eyo, 'Odo Ogbe Street and Lafogido: contrasting archaeological sites in Ile-Ife, Western Nigeria', *W.A.J.A.*, 4, 1974, pp. 99–109.

22. Frank Willett, 'Ife and its archaeology', *J.A.H.*, 1960, 1, pp. 231–48.

23. Garlake, op. cit., pp. 111–48.

24. Peter Garlake, 'Excavations on the Woye Asiri Land in Ife', *W.A.J.A.*, 7, 1977, p. 57.

25. Peter Garlake, *Kingdoms of Africa*, 1978, pp. 132–3.

26. Willett, *Ife*, pp. 104–5, figs. 16, 17.

27. Thurstan Shaw, 'Ife and Raymond Mauny', in *2,000 Ans d'histoire africaine*, Paris, 1981, pp. 109–35.

28. Garlake, *Kingdoms of Africa*, p. 133.

29. Willett, *Ife*, pp. 21, 22, 26.

30. ibid., pl. 2.

31. Frank Willett, 'On the funeral effigies of Owo', *Man*, I, 1, March 1966, pp. 34–45.

32. Willett, *Ife*, p. 72.

33. ibid., pl. 23.

34. Personal communication to the author, 22 August 1982.

35. W.B. Fagg and Frank Willett, 'Ancient Ife', *Odu*, VIII, 1960, pp. 21–35.

36. Frank Willett, *Baubles, Bangles and Beads*, 13th Melville J. Herskovits Memorial Lecture, Centre of African Studies, Edinburgh, 1977, p. 16.

37. C.C. Davison, *Glass Beads in African Archaeology*, Lawrence Radiation Laboratory, Berkeley, California, 1972.

38. Willett, *Ife*, p. 24.

39. Willett, *Baubles, Bangles and Beads*, p. 16.

40. Shaw, *Nigeria, Its Archaeology and Early History*, p. 156.

41. Willett, *Ife*, p. 24.

42. Allison, op. cit., p. 16, pls. 10, 11.

43. Shaw, *Nigeria, Its Archaeology and Early History*, p. 97.

44. Ekpo Eyo, *2,000 Years of Nigerian Art*, Lagos, 1977, p. 34.

45. Shaw, 'Ife and Raymond Mauny', p. 129.

46. *W.A.J.A.*, 6, 1976, p. 37.

47. Roger de la Burde, 'Ancestral ram's heads of the Edo-speaking peoples', *A.A.*, VI, I, 1972, pp. 29–34.

48. W.B. Fagg, in *Man*, 79 and 145, 1949.

49. W.B. Fagg, 'Tribal sculpture and the Festival of Britain', *Man*, 124, June 1951.

50. National Museum of Denmark, Copenhagen, *Ethnographic Objects in the Royal Danish Kunstkammer, 1650-1800*, Copenhagen, 1980, p. 46, nos. EDC 26, 27.

51. Fagg, *Nigerian Images*, pl. 38a. Fagg states: '. . . a spreadeagled bird with snakes instead of wings which does not otherwise occur in Benin iconography but is found on two important figures at Jebba and Tada.'

52. Douglas Fraser, 'The Tsoede bronzes and Owo Yoruba art', *A.A.*, VIII, 3, 1975, pp. 30-35.

53. W. Fagg, Christie's catalogue, 3 April 1981, p. 65.

54. William Fagg (in a personal communication): 'I have an unpublished photograph by the late R.E. Bradbury showing seven or eight ivories belonging to the Oromila (Ifa) priest of which half are in the characteristic Benin City style, the others (the same type as this) clearly in the more imaginative style of Owo.'

55. See Fagg, *Nigerian Images*, pl. 100.

56. See ibid., pl. 26.

57. The Tada group consists of seven figures, four human, two ostriches and one elephant.

58. R.F. Thompson, 'The figure of the Divine King', in Fraser and Cole (eds.), *African Art and Leadership*, Madison, 1972.

59. R.F. Thompson, *Black Gods and Kings: Yoruba Art at U.C.L.A.*, Los Angeles, 1971, p. 3.

60. Thompson, 'The figure of the Divine King', 1/1-1/5.

61. B. Lawal, *The Present State of Art-Historical Research in Nigeria* (unpublished), University of Ife, 1973.

62. Thurstan Shaw, 'A note on trade and the Tsoede bronzes', *W.A.J.A.*, 3, 1973, pp. 233-8.

63. Willett, *Ife*.

64. Ekpo Eyo and Frank Willett, *Treasures of Ancient Nigeria*, New York, 1980, p. 126.

65. Fraser, op. cit., p. 91.

66. Willett, *Ife*, pls. 98, 99.

67. Werner Gillon, *Collecting African Art*, London and New York, 1979, pl. III, facing p. 22.

68. W.B. Fagg, *Propyläen Kunstgeschichte*, Berlin, 1979, pp. 134 f.

69. W.B. Fagg, *Nigerian Tribal Art*, catalogue of Arts Council Exhibition, London, 1960.

70. Federal Department of Antiquities, Lagos, 1958-62, 31, fig. 1.

71. Ryder, 'A reconsideration of the Ife-Benin relationship', p. 34.

72. Roy Sieber, *African Textiles and Decorative Arts*, New York, 1972, pp. 144-5.

73. Ade Obayemi, 'The expansion of Oyo and the rise of Dahomey 1600-1800', in *The History of West Africa*, Vol. I, London, 1979, p. 373 and nn.

74. Sir Richard Burton, *A Mission to Gelele, King of Dahomey*, London, 1966 (first published 1864), p. 297.

75. Melville Herskovits, *Dahomey*, 2 vols., New York, 1938, Vol. II, pp. 248-9.

76. Norbert Agheci, 'Emblèmes et chants', *Anthropos*, 27, 1932, pp. 417-22.

77. M.D. McLeod, 'Verbal elements in West African art', *Quaderni*, 1, Poro, Milan, 1976, pp. 85-102.

78. Herskovits, op. cit., Vol. II, p. 315.

79. ibid., p. 333.

80. Moni Adams, 'Fon appliquéd cloths', *A.A.*, XIII, 2, 1980, pp. 28-41.

81. J.A. Skertchly, *Dahomey As It Is*, London, 1874, pp. 193-4.

82. ibid., pp. 287-8.

83. Herskovits, op. cit., Vol. II, p. 345.

84. ibid., pp. 344-53.

85. Christian Merlo, 'Les "Botchio" en civilisation béninoise', Musée d'Ethnographie, Geneva, *Bulletin*, 20, 1977, pp. 97-115.

86. Herskovits, op. cit., Vol. II, pl. 73a and b.

87. M. Leiris and J. Delange, *Afrique Noire*, Paris, 1967, pls. 264, 265, pp. 232/3.

88. Leon Underwood, *Bronzes of West Africa*, London, 1968, pl. 62.

89. Herskovits, op. cit., pl. 68.

90. ibid., p. 354.

91. See brass figures in Herskovits, op. cit., pls. 91, 92, and silver guinea fowl in Leiris and Delange, op. cit., pl. 349, p. 305.

92. Leiris and Delange, op. cit., pl. 266, p. 234.

93. Daniel J. Crowley, 'Bêtises: Fon brass genre figures', *A.A.*, XV, 2, February 1982, p. 56.

94. Leo Frobenius, *Und Afrika Sprach*, 3 vols., Berlin, 1912, Vol. 1, p. 400.

95. Phillips Stevens Jr, *The Stone Images of Esie*, Ibadan, 1978, p. 28.

96. Allison, op. cit., p. 21.

97. Stevens, op. cit. p. 70.

98. ibid., pp. 31 ff.

99. Willett, *Ife*, p. 177.

100. Stevens, op. cit., p. 82.

101. W.B. Fagg, 'On a stone head of variant style at Esie, Nigeria', *Man*, London, 1959.

102. Stevens, op. cit., p. 69.

103. ibid., p. 83.

104. W.A. Snelgrave, *New Account of Some Parts of Guinea and the Slave Trade*, London, 1734.

105. I.A. Akinjogbin, 'The expansion of Oyo and the rise of Dahomey 1600-1800', in *History of West Africa*, Vol. 1, London, 1979, p. 404.

106. Stevens, op. cit., p. 59.

107. ibid., p. 71.

108. K. Dittmer, 'Prähistorische Steinfiguren aus Sierra Leone und Guinee', *Baessler Archiv*, N.F., XV, 1967, p. 184.

109. Stevens, op. cit., p. 76.

110. Ryder, 'A reconsideration of the Ife-Benin relationship', p. 34.

111. See Fagg, *Nigerian Images*, pl. 140.

112. Peter Göbel, 'Die Elo Masken der Nupe', in *Jahrbuch des Museums für Völkerkunde zu Leipzig*, Berlin, 1968, pp. 103-19.

113. See W.B. Fagg, *Tribes and Forms in African Art*, New York and Paris, 1965, pl. 88.

114. Peter Göbel, 'Bemerkungen zu den "Buchdeckeln" der Nupe', in *Jahrbuch des Museums für Völkerkunde zu Leipzig*, XXIX, Berlin, 1973, pp. 191-227, pls. XVII-XXXI.

115. Arnulf Stöszel, *Nupe, Kakanda, Basa-Nge*, Galerie Biedermann and Fred Jahn, Munich, 1981.

116. W.B. Fagg and J. Picton, *The Potter's Art in Africa*, London, 1970, p. 29.

117. Frobenius, op. cit., Vol. 2, pp. 360-61.

118. C.K. Meek, *The Northern Tribes of Nigeria*, Vol. 1, London, 1925, p. 157.

119. S.F. Nadel, *A Black Byzantium*, London, 1951, p. 274.

120. ibid., p. 406.

121. Peter Göbel, 'Nupeglas im Museum für Völkerkunde zu Leipzig', in *Jahrbuch des Museums für Völkerkunde zu Leipzig*, XXVI, Berlin, 1969, pp. 229-46.

122. Frobenius, op. cit., Vol. 2, pls. Bronzearbeiten IV and V and p. 89.

123. Peter Göbel, 'Gelbschmiedearbeiten der Nupe im Museum für Völkerkunde zu Leipzig', in *Jahrbuch des Museums für Völkerkunde zu Leipzig*, XXVII, Berlin, 1970, pp. 266-319.

124. Bernard Fagg, *Nok Terracottas*, Lagos, 1977, pl. 17.

125. The *agbada* is most probably of Hausa origin; it was officially adopted for all Nigerian men in about 1940 (personal communication from W. Fagg).

126. Kate P. Kent, *West African Cloth*, Denver Museum of Natural History, 1971, p. 3.

127. William Fagg, *Yoruba Beadwork*, New York, 1980.

128. William Fagg and John Pemberton III, *Yoruba Sculpture of West Africa*, ed. Bryce Holcombe, New York, 1982, pp. 47-8, fig. 54.

129. Some say it is the face of Orunmila, i.e. *Ifa* (personal note from John Picton).

12. BENIN – THE ART OF THE EDO CITY STATE

1. R.E. Bradbury, 'The Benin kingdom and the Edo-speaking peoples of S.W. Nigeria', *Ethnographic Survey, Western Africa*, XIII, London, 1957.
2. J.V. Egharevba, *A Short History of Benin*, Ibadan, 1960 (3rd edn).
3. A.F.C. Ryder, 'A reconsideration of the Ife–Benin relationship', *J.A.H.*, VI, 1, 1965, pp. 28–9.
4. ibid., pp. 3, 28, 33, 34.
5. F. von Luschan, *Altertümer von Benin*, Berlin, 1919, Vol. III, pl. 81.
6. J. Dupuis, *Journal of a Residence in Ashantee*, London, 1824.
7. S.F. Nadel, *A Black Byzantium*, Oxford, 1924.
8. Ryder, op. cit., p. 35.
9. R.E. Bradbury, *Benin Studies*, London, 1973, pp. 8 ff.
10. Paula Ben-Amos, *The Art of Benin*, London, 1980, pls. 10 and 11, p. 15.
11. On the chronology of that dynasty see S. Wolf, 'Benin Königslisten', *Annals of the Náprstkovo Museum*, Prague, 1963, pp. 215–18.
12. Not counting Oranmiyan.
13. Brass was used too, hammered and chased; some thirteenth-century bronze bracelets were also excavated (Graham Connah, *The Archaeology of Benin*, London, 1975).
14. A. Rubin, *Art Bulletin*, 52, 3, 1970, pp. 348–54.
15. Brass is an alloy of copper and up to 30 per cent zinc with, in this case, lead added.
16. Frank Willett, *Baubles, Bangles and Beads*, 13th Melville J. Herskovits Memorial Lecture, Centre of African Studies, Edinburgh, 1977.
17. O. Werner and Frank Willett, 'The composition of brasses from Ife and Benin', *Archaeometry*, 17, 2, 1975, pp. 141–56.
18. F. Willett, 'The analysis of Nigerian copper alloys retrospect and prospect', *Critica d'Arte*, XLVI, n.s., 178, 1981, pp. 35–49.
19. M. Posnansky and R. McIntosh, 'New radiocarbon dates for northern and western Africa', *J.A.H.*, 17, 2, 1976, pp. 161–95.
20. D. Calvocoressi and N. David, 'A new survey of radiocarbon and thermoluminescence dates for West Africa', *J.A.H.*, 20, 1, 1979, pp. 1–29.
21. Denis Williams, *Icon and Image*, London, 1974, Chapter 18.
22. William Fagg, *Nigerian Images*, London, 1967, pp. 32–7.
23. Philip J.C. Dark, *An Introduction to Benin Art and Technology*, Oxford, 1973.
24. Frank Willett, 'The Benin Museum collection', *A.A.*, VI, 4, 1973, p. 17 and figs. 12, 18.
25. Paula Ben-Amos, in review of *An Introduction to Benin Art and Technology* by Philip J.C. Dark, *A.A.*, VIII, 1, 1974, pp. 70–72.
26. Ben-Amos, *The Art of Benin*, p. 18, pl. 16.
27. Willett, 'The analysis of Nigerian copper alloys', p. 43.
28. Fagg, op. cit., pl. 25.
29. Bradbury, *Benin Studies*, pp. 251–70.
30. See Fagg, op. cit., pl. 15.
31. Ben-Amos, *The Art of Benin*, p. 17, pl. 12.
32. ibid., p. 63, pl. 66.
33. Graham Connah, *The Archaeology of Benin*, London, 1975.
34. Graham Connah, 'Archaeology in Benin', *J.A.H.*, XIII, 1, 1972, p. 31.

13. THE ART OF THE SOUTHERN SAVANNA

1. Jan Vansina, in Curtin, Feierman, Steven, Thompson, Leonard and Vansina, *African History*, Boston, 1978, p. 258.
2. Albert Maesen, *Art of the Congo*, Walker Art Center, 1967, p. 21.

3. Joseph C. Miller, 'Requiem for the "Jaga" ', *Cahiers d'études africaines*, XIII, 1, 44, 1973, pp. 121-49.

4. Royal Belgian State Archives, A.A.R. Rekenkamer, No. 1925, fo. 348.

5. Filippo Pigafetta (Rome 1591), *Kingdom of Kongo and the Surrounding Countries*, trans. Margarite Hutchinson, London, 1881, p. 35.

6. Royal Kunstkammer, National Museum of Denmark, Copenhagen, EN 38 A7.

7. William Fagg and Margaret Plass, *African Sculpture*, London, 1964, p. 118.

8. Ezio Bassani, 'Antichi avori africani nelle Collezioni Medicee I' and 'II' in *Critica d'Arte*, XL, n.s., 143, 1975, pp. 69-80 and XL, n.s., 144, 1975, pp. 8-23. Also 'Oggetti africani in antiche collezioni italiane 1' and '2', *Critica d'Arte*, XLII, n.s., 154/6, 1977, pp. 187-202 and XLII, n.s., 151/3, 1977, pp. 151-82.

9. Robert F. Thompson, *The Four Moments of the Sun*, Washington, D.C., 1981, p. 213.

10. Robert Verly, 'La Statuaire de pierre du Bas-Congo', *Zaïre*, IX, 5, May 1955, pp. 451-528.

11. Ezio Bassani, 'I mintadi del Museo Pigorini', *Critica d'Arte*, 146, 1976, pp. 49-64.

12. Vansina points to evidence which both implicitly and explicitly places the cult of stones, the carving of stones and the existence of grave monuments to at least A.D. 1652; see review of *The Four Moments of the Sun* by Robert F. Thompson, *A.A.*, XVI, 1, 1982, p. 28.

13. Zdenka Volavka, 'Insignia of the divine authority', *A.A.*, XIV, 3, May 1981, pp. 43-51.

14. Adolf Bastian, *Die Deutsche Expedition an der Loango Küste*, Vol. I, Jena, 1874, pp. 79, 214-15, 218.

15. Volavka, op. cit., p. 51.

16. Huguette Van Geluwe in a personal communication to the author.

17. A. Maesen, *Umbangu, Art du Congo au Musée du Congo Belge*, Tervuren, n.d., pl. 2.

18. Thompson, op. cit., p. 216.

19. ibid., pp. 76 ff.

20. John Pinkerton, *Voyages and Travels, London 1814: Voyage to the Congo by Angelo and Carli*, p. 171.

21. Group II pottery from Dimba cave, dated 1440 and 1700 (Thompson, op. cit., p. 78).

22. ibid., pp. 66-7.

23. Thompson (op. cit., p. 52 and figs. 15, 16) quotes Jean-François de Rome, *La fondation de la Mission des Capucins au Royaume de Congo* (1648) and Degrandpré's *Voyage à la Côte Occidentale d'Afrique fait dans les années 1786 et 1787*.

24. Robert L. Wannyn, *L'Art ancien du métal au Bas-Congo*, Champles par Wavre, 1961, quoted by Thompson, op. cit., p. 62.

25. Wannyn, op. cit., quoted by Thompson, op. cit., p. 62.

26. Maesen, op. cit., pl. 1.

27. Ezio Bassani, 'Due grandi artisti Yombe', *Critica d'Arte*, XLVI, n.s., 178, 1981, pp. 66-84.

28. J. Maes, 'Figurines na Moganga de Guérison', *Pro-medico*, 3 and 4, Paris, 1927.

29. J. Maes, 'Figurines Npezo', *Pro-medico*, 2, Paris, 1929.

30. J. Maes, 'Les Figurines sculptées du Bas-Congo', *Africa*, III, 3, London, 1930.

31. J.H. Weeks, *Among the Primitive Bakongo*, London, 1914.

32. E.G. Ravenstein (ed.), *The Strange Adventures of Andrew Battel of Leigh, in Angola and the Adjoining Regions*, London, 1901, pp. 56-8.

33. J.K. Tuckey, *Narrative of an Expedition to explore the River Zaïre*, London, 1818, p. 180.

34. Torday was told that Shyaam was the 93rd king, but this remains uncorroborated.

35. E. Torday and T.A. Joyce, 'Notes ethnographiques sur les populations, habitant les bassins du Kasai et du Kwango oriental', *Annales du Musée du Congo Belge*, Ethnographie Série III, Tome II/2, Brussels, 1922, p. 347.

36. L. de Sousberghe, *L'Arte Pende*, 1958, p. 3.
37. ibid., p. 4.
38. The Pende did not themselves smelt iron but were good smiths. The Hungana were the metal-casting specialists in the area (P. de Sousberghe, in 'Cases cheffales du Kwango', *Bulletin of the Société Royale Belge d'Anthropologie et de Préhistoire*, Congo Tervuren, 1960, VI, 1, pp. 10-16).
39. The oldest wooden artefact so far found in Africa (see pl. 236) was excavated by the Leakeys in Kenya. It is a decorated wooden vessel made by unknown Stone Age people and was dated to the ninth century B.C. See Mary D. and L.S.B. Leakey, *Excavations at the Njoro River Cave*, Oxford, 1950, figs. 2, 3, 15; and Roy Sieber, *African Furniture and Household Objects*, Bloomington, 1980, p. 175.
40. Frank Willett, *African Art*, London, 1971, p. 84.
41. Ezio Bassani, 'Les Sculptures Vallisnieri', *Africa-Tervuren*, XXIV, 1978, 2, pp. 15-22.
42. Fr. Bontinck, 'La Provenance des sculptures Vallisnieri', *Africa-Tervuren*, XXV, 4, 1979, pp. 88-91.
43. J. Nenquin, 'Dimple-based pots from Kasai, Belgian Congo', *Man*, 1959, p. 242.
44. Pierre de Maret, 'Les trop fameux pots à fossette basale du Kasai', *Africa-Tervuren*, XXVI, 1980, 1, pp. 4-12.
45. J. Nenquin, *Excavations at Sanga, 1957*, Tervuren, 1963.
46. J. Hiernaux, E. Maquet and J. de Buyst, 'Excavations at Sanga 1958', *S.A.J.S.*, 64, 1968, pp. 113-17.
47. P. de Maret, F. van Noten and D. Cahen, 'Radiocarbon dates from West Central Africa: a synthesis', *J.A.H.*, XVIII, 4, 1977, pp. 481-505.
48. P. de Maret, 'Sanga: new excavations, more data, and some related problems', *J.A.H.*, XVIII, 3, 1977, pp. 321-37.
49. Jan Vansina, *Kingdoms of the Savanna*, Madison, 1966, pp. 70 ff.
50. François Neyt, *La Grande Statuaire Hemba du Zaïre*, Louvain-la-Neuve, 1977, pp. 468-79.
51. Vansina, op. cit., p. 78.
52. J.C. Miller, *Kings and Kinsmen: Early Mbundu States in Angola*, Oxford, 1976.
53. Marie-Louise Bastin, *La Sculpture Tshokwe*, Meudon, 1982, pp. 31 ff.
54. Marie-Louise Bastin, *Statuettes Tshokwe du héros civilisateur Tshibinda Ilunga*, Arnouville, 1978, p. 287.
55. Bastin, *La Sculpture Tshokwe*, pp. 285-6.
56. ibid., p. 284.
57. Jan Vansina, *The Children of Woot*, Madison, 1978, pp. 43-4.
58. ibid., p. 16.
59. E. Torday and T.A. Joyce, *Notes ethnographiques sur les peuples communément appelés Bakuba, ainsi que les peuplades apparentées, Les Bushongo*, Bruxelles, 1910.
60. Vansina, *The Children of Woot*, Madison, 1977, p. 217.
61. ibid., p. 64.
62. ibid., p. 212.
63. Joseph Cornet, *Art of Africa: Treasures from the Congo*, London, 1971, pl. 72.
64. Torday and Joyce, op. cit., p. 25.
65. E. Torday, 'Note on certain figurines of forged iron', *Man*, 24, 1924, p. 17.
66. Adriaan Claerhout, 'Two Kuba wrought-iron statuettes', *A.A.*, IX, 4, 1976, pp. 60-64.
67. John Picton and John Mack, *African Textiles*, London, 1979, pls. 204-7, colour pls. 27, 28, and pp. 198 ff.
68. Vansina, *The Children of Woot*, p. 220.
69. Belepe bope Mabintch, 'Les Oeuvres plastiques africaines comme documents d'histoire', *Africa-Tervuren*, XXVII, 1, 1981, p. 10.
70. Werner Gillon, *Collecting African Art*, London, 1979, pl. 146.

71. Vansina, *The Children of Woot*, p. 201.
72. Belepe, op. cit., pp. 9-17.
73. ibid., p. 9.
74. ibid., pp. 12, 13.
75. ibid.
76. Vansina, *The Children of Woot*, pp. 246-7.
77. Belepe, op. cit., pp. 10-11.
78. Vansina, *The Children of Woot*, p. 214.
79. Jean B. Rosenwald, 'Kuba king figures', *A.A.*, VII, 3, 1974, pp. 26-31.
80. Vansina, *The Children of Woot*, p. 219.

14. EASTERN AFRICA

1. *The Periplus of the Erythraean Sea*, trans. W.H. Schoff, New York, 1912.
2. D.W. Phillipson, *The Later Prehistory of Eastern and Southern Africa*, London, 1977, pp. 91-2.
3. Y.M Kobishanov, 'Aksum: political system, economics and culture, first to fourth century', UNESCO *General History of Africa*, Vol. II, Paris and London, 1981, pp. 395-7.
4. Phillipson, op. cit., p. 94.
5. F. Anfray, 'The civilisation of Aksum from the first to the seventh century', in UNESCO *General History of Africa*, Vol. II, Paris and London, 1981, pp. 365-6.
6. Neville Chittick, 'Excavations at Aksum,' *Azania*, IX, 1974, pp. 161, 191.
7. ibid., pp. 180-81, 202.
8. ibid., pp. 175-9.
9. ibid., p. 200 (n. 38, quoting Eike Haberland, *Untersuchungen zum äthiopischen Königstum*, Wiesbaden, 1965, p. 172.
10. Kobishanov, op. cit., pp. 394-9.
11. ibid.
12. *Religiöse Kunst Äthiopiens*, catalogue, Stuttgart, 1973.
13. Eike Haberland, *Altes Christentum*, Peabody Academy of Science, Ethiopia, 1978.
14. Roger McKay, 'Ethiopian jewellery', *A.A.*, VII, 4, 1974, pp. 36-9 (illustrations show fine examples).
15. Roy Sieber, *African Furniture and Household Objects*, Bloomington, 1980, p. 18.
16. M.D. and L.S.B. Leakey, *Excavations at Njoro River Cave*, Oxford, 1950.
17. Phillipson, op. cit., p. 76.
18. ibid., p. 108.
19. D.W. Phillipson, 'The early Iron Age in Zambia - regional variants and some tentative conclusions', *J.A.H.*, 9, 1968, pp. 191-211.
20. D.W. Phillipson, 'Excavations at Twickenham Road, Lusaka', *Azania*, 5, 1970, pp. 77-118.
21. Roland Oliver, 'The emergence of Bantu Africa', in *Cambridge History of Africa*, Vol. 2, Chapter 6, 1978, pp. 378-9.
22. Jean Brown, 'Traditional sculpture in Kenya', *A.A.*, VI, 1, 1972, pp. 16-20, 58.
23. Joy Adamson, *The Peoples of Kenya*, London, 1967.
24. Werner Fischer and M.A. Zirngibl, *African Weapons*, Passau, 1978, pp. 39-40.
25. David Parkin, Roy Sieber and Ernie Wolfe III, *Vigango, the Commemorative Sculpture of the Mijikenda of Kenya*, African Studies Program, Bloomington, Indiana, 1981, p. 10.
26. Thomas K. Spears, *The Kaya Complex: History of the People of the Kenya Coast*, Nairobi, 1978.
27. Leon Siroto, 'A Kigangu figure from Kenya', *Detroit Institute of Arts Bulletin*, 57, 3, 1979, pp. 104-13.

28. Jean Lucas Brown, 'Mijikenda and memorial sculptures', *A.A.*, XIII, 4, 1980, pp. 36-9.
29. Roy Sieber, in *Vigango*, p. 19.
30. William Fagg, *Tribes and Forms in African Art*, New York, 1965, p. 115.
31. Ladislaw Holy, *Masks and Figures from Eastern and Southern Africa*, London, 1967, pls. 21-3.
32. ibid., pls. 37a and b.
33. Werner Gillon, *Collecting African Art*, London, 1979, pls. 188-9.
34. James de Vere Allen, *Lamu*, Nairobi, n.d.
35. Usam I. Ghaidan, 'Swahili art of Lamu', *A.A.*, V, 1, 1971, pp. 54-5.
36. J. de Vere Allen, 'Swahili culture reconsidered', *Azania*, IX, 1974, pp. 105-38, pl. IV.
37. H.N. Chittick, 'Notes on Kilwa', *Tanganyika Notes and Records*, 1959, pp. 179-203.
38. P.M. Verin, 'Les recherches archéologiques à Madagascar', *Azania*, I, 1966, pp. 119-37.
39. Phillipson, *The Late Prehistory of Eastern and Southern Africa*, p. 217.
40. O.C. Dahl, *Malgache et Maanjan, une comparison linguistique*, Oslo, 1951.
41. Neville Chittick, 'The East Coast, Madagascar and the Indian Ocean', in *The Cambridge History of Africa*, Vol. 3, 1977, p. 217 and n.

15. ARTS OF SOUTHERN AFRICA

1. R.J. Mason, 'The origin of South African society', *S.A.J.S.*, 61, 7, July 1965, p. 263.
2. G.P. Rightmire, 'Iron Age skulls from southern Africa re-assessed by multiple discriminant analysis', *A.J.P.A.*, 23, 1970, pp. 147-68.
3. Brian Fagan, 'The Greefswald sequence', *J.A.H.*, 5, 3, 1964, pp. 327-61.
4. David Birmingham and Shula Marks, 'Southern Africa', *Cambridge History of Africa*, Vol. 3, 1977, pp. 618-19.
5. R.J. Mason, *Prehistory of the Transvaal*, Johannesburg, 1962.
6. Nicholas J. van der Merve and Robert T.K. Scully, 'The Phalaborwa story: archaeological and ethnographic investigation of a South African Iron Age group', *S.A.J.S.*, 3, 2, October 1971, pp. 178-96.
7. K.L. von Bezing and R.R. Inskeep, *Man*, 1, 1, March 1966.
8. R.R. Inskeep and T.M. Maggs, 'Unique art objects in the Iron Age of the Transvaal, S.A.', *S.A.A.B.*, 30, 1975, pp. 114-38.
9. R.R. Inskeep, *S.A.J.S.*, 67, 1971, pp. 492-3.
10. T.M. Evers and J.C. Vogel, *S.A.J.S.*, 76, May 1980, pp. 230-31.
11. Tim Maggs and Patricia Davison, 'The Lydenburg Heads and the earliest African sculpture south of the Equator', *A.A.*, XIV, 2, February 1981, pp. 28-33.
12. D.W. Phillipson, personal communication to the author.
13. B.V. Brottem, 'Zulu beadwork', *A.A.*, VI, 3, 1973, pp. 8-13.
14. Birmingham and Marks, op. cit., p. 577.
15. *Documents on the Portuguese in Mozambique and Central Africa*, Vol. I, Lisbon, 1962, p. 395.
16. Peter Garlake, *Great Zimbabwe*, London, 1973.
17. ibid., pp. 197-200.
18. Leo Fouché and Guy A. Gardner, *Mapungupwe, Ancient Bantu Civilization on the Limpopo*, Vol. I, Cambridge, 1937, and Vol. II, Pretoria, 1963.
19. Fagan, op. cit.
20. Rightmire, op. cit.
21. Fouché and Gardner, op. cit.

Bibliography

CHAPTER 1: GENERAL WORKS ON ART AND HISTORY

AJAYI, J. F. A., AND CROWDER, MICHAEL (eds.), *History of West Africa*, 2 vols., London, 1979 (first published 1971).

ALLISON, PHILIP, *African Stone Sculpture*, London, 1968.

ANKERMANN, B., 'Die Afrikanischen Musikinstrumente', *Ethnologisches Notizblatt*, 3, 1, 1901, pp. 1–134.

BALANDIER AND HOWLETT (eds.), *L'Art nègre*, Paris, 1966 (first published Paris, 1951, in *Présence Africaine*, 10/11).

BASCOM, W. R., *African Art in Cultural Perspective*, New York, 1973.

BASCOM, W., AND GEBAUER, P., *West African Art*, Milwaukee, 1953.

BASSANI, EZIO, 'Antichi avori africani nelle Collezioni Medicee, I, *Critica d'Arte*, XL, n.s., 143, 1975, pp. 69–80.

—, 'Antichi avori africani nelle Collezione Medicee II', *Critica d'Arte*, XL, n.s., 144, 1975, pp. 8–23.

—, *Scultura africana nei musei italiani* (*Musei d'Italia - Meraviglie d'Italia*), Bologna, 1977.

—, 'Oggetti africani in antiche collezioni italiane 1', *Critica d'Arte*, XLII, n.s., 151/3, 1977, pp. 151–82.

—, 'Oggetti africani in antiche collezione italiane 2', *Critica d'Arte*, XLII, n.s., 154/6, 1977, pp. 187–202.

BAUMANN, H., *Afrikanische Plastik und Sakrales Königtum*, Munich, 1969.

—, *Die Völker Afrikas und ihre traditionellen Kulturen*, I and II, Wiesbaden, 1975, 1979.

BAUMANN, H., THURNWALD, R., AND WESTERMANN, D., *Völkerkunde von Afrika*, Essen, 1940.

BIEBUYCK, DANIEL, *Tradition and Creativity in Tribal Art*, Los Angeles, 1969.

BODROGI, T., *Afrikanische Kunst*, Vienna, Munich and Budapest, 1967.

BOAHEN, A. ADU, 'Kingdoms of West Africa', in *Horizon History of Africa*, New York, 1971.

BOHANNAN, PAUL, 'Artist and critic in an African society', in Marian W. Smith (ed.), *The Artist in Tribal Society*, London, 1961.

—, *African Outline*, London, 1966.

BOSER-SARIVAXÉVANIS, RENÉE, *Textilhandwerk in West-Afrika*, Basle, 1972.

BRAVMANN, RENÉ, *West African Sculpture*, Seattle, 1970.

—, *Open Frontiers: The Mobility of Art in Black Africa*, 1973.

—, *Islam and Tribal Art in West Africa*, Cambridge, 1974.

Cambridge History of Africa (general eds. J.D. Fage and Roland Oliver).
> Vol. 1: J. Desmond Clark (ed.), *From the Earliest Times to c. 500 B.C.*, Cambridge, 1982.
> Vol. 2: J.D. Fage (ed.), *From c. 500 B.C. to A.D. 1050*, Cambridge, 1978.
> Vol. 3: Roland Oliver (ed.), *From c. 1050 to c. 1600*, Cambridge, 1977.

CLARK, J. DESMOND, *The Prehistory of Africa*, London, 1970.

COLLINS, ROBERT O., *Problems in African History*, Englewood Cliffs, 1968.

COLOGNE RAUTENSTRAUCH-JOEST MUSEUM, *Exotische Kunst*, Cologne, 1967.

DAVIDSON, BASIL, *Africa, History of a Continent*, New York, 1966.

D'AZEVEDO, W. L. (ed.), *The Traditional Artist in African Societies*, Bloomington, 1973; 2nd edn, 1975.

DELANGE, JACQUELINE, *Arts et Peuples de l' Afrique Noire*, Paris, 1967.

—, *The Art and Peoples of Black Africa*, New York, 1974.

DEMARGUE, PIERRE, *The Birth of Greek Art*, New York, 1964.

DENYER, SUSAN, *African Traditional Architecture*, New York and London, 1978.

EBIN, VICTORIA, *The Body Decorated*, London, 1979.

EINSTEIN, C., *Afrikanische Plastik*, Berlin, 1915.

—, *Negerplastik*, Munich, 1920.

ELISOFON, E., AND FAGG, W. B., *The Sculpture of Africa*, London, 1957.

FAGG, WILLIAM B., *The Webster Plass Collection of African Art*, British Museum, London, 1953.

—, 'The study of African art', *Bulletin of the Allen Memorial Art Museum*, 1955.

—, *Tribes and Forms in African Art*, New York, 1965.

—, *African Tribal Images: The Katherine White Reswick Collection*, Cleveland, 1968.

—, *Divine Kingship in Africa*, British Museum, London, 1970.

—, *Miniature Wood Carvings of Africa: Herman Collection*, New York, 1970.

—, *African Sculpture*, Washington, D.C., 1970.

—, *African Sculpture: The Tara Collection*, Southbend, Indiana, 1971.

—, 'African tribal sculpture', in Sainsbury, Robert (ed.), *Robert and Lisa Sainsbury Collection*, London, 1978, pp. 99-135.

—, *Masques d' Afrique*, Geneva, 1980.

—, *African Majesty from Grassland and Forest*, Toronto, 1981.

FAGG, W. B., AND PICTON, JOHN, *The Potter's Art in Africa*, London, 1970; revised edn, 1978.

FAGG, WILLIAM, AND PLASS, M. WEBSTER, *African Sculpture: An Anthology*, London, 1964.

FAGG, WILLIAM B., AND UNDERWOOD, LEON, 'An examination of the so-called "Olokun Head of Ife", Nigeria', *Man*, 49, 1949.

FAGG, WILLIAM B., AND FOREMAN, W. AND B., *Vergessene Negerkunst; Afroportugiesische Elfenbeinschnitzereien*, Braunschweig, 1960; English edn, *Afro-Portuguese Ivories*, London, 1959.

FISCHER, WERNER, AND ZIRNGIBL, MANFRED A., *African Weapons*, Passau, 1978.

FORGE, A. (ed.), *Primitive Art and Society*, London, 1973.

FRASER, D., AND COLE, H., *African Art and Leadership*, Wisconsin, 1972.

FROBENIUS, LEO, *Die Masken und Geheimbünde Afrikas*, Halle, 1898.

—, *Und Afrika Sprach*, Vols. I-III, Berlin, 1912-13.

—, *The Voice of Africa*, 2 vols., London, 1913.

—, *Das Unbekannte Afrika*, Munich, 1923.

—, *Kulturgeschichte Afrikas*, Zürich, 1954.

FRY, ROGER, *Last Lectures*, London, 1939; republished Boston, 1962.

General History of Africa (UNESCO), Paris, London and Berkeley, 1981.

 Vol. I: J. Ki-Zerbo (ed.), *Methodology and African Prehistory*.

 Vol. II: G. Mokhtar (ed.), *Ancient Civilizations of Africa*.

GERBRANDS, A. A., *Art as an Element of Culture*, Leiden, 1957.

—, *Afrika, Kunst aus dem Schwarzen Erdteil*, Recklinghausen, 1967.

GILLON, WERNER, *Collecting African Art*, London and New York, 1979.

GOLDWATER, R., *Traditional Art of the African Nations* (in the Museum of Primitive Art), New York, 1961.

GOMBRICH, E. H., *The Story of Art*, London, 1950; 13th edn, 1978.

GREENBERG, J. H., *The Languages of Africa*, Bloomington, 1963.

—, 'Linguistic evidence regarding Bantu origin', *J. A. H.*, XIII, 2, 1972, pp. 189-216.

GUILLAUME, PAUL, AND MUNRO, THOMAS, *Primitive Negro Sculptures, from the Collection of the Barnes Foundation at Merion, Pennsylvania*, 1926; reprinted New York, 1968.

GUTHRIE, M., 'Some developments in the pre-history of Bantu language', *J.A.H.*, III, 2, 1962, pp. 273–82.

—, *Comparative Bantu*, 4 vols., Farnborough, 1967–71.

—, 'Contributions from comparative Bantu studies to the pre-history of Africa', in D. Dalby (ed.), *Language and History in Africa*, London, 1970, Ch. 2, pp. 20–49.

HEROLD, E., *Ritualmasken Afrikas aus den Sammlungen des Náprstkovo-Museum in Prag*, Prague, 1967.

HERSKOVITS, M. J., *Background of African Art*, Denver, 1945.

HIERNAUX, J., 'Bantu expansion', *J.A.H.*, IX, 4, 1968.

—, *The People of Africa*, London, 1974.

HIMMELHEBER, HANS, *Negerkünstler*, Stuttgart, 1934.

—, *Negerkunst und Negerkünstler*, Brunswick, 1960.

—, 'The concave face in African art', *A.A.*, IV, 3, Spring 1971.

HONOUR, HUGH, AND FLEMING, JOHN, *A World History of Art*, London, 1982.

HOOVER, ROBERT L., *The Origins and Initial Migrations of the Bantu*, University of Colorado Museum of Anthropology, Miscellaneous Series No. 34, 1974.

HUET, MICHEL, *The Dance, Art and Ritual of Africa*, London, 1978.

JEFFERSON, LOUISE E., *The Decorative Arts of Africa*, New York, 1973.

JENKINS, J. L., *Musical Instruments*, Horniman Museum, London, 1970.

KECSKÉSI, MARIA, *Kunst aus dem Alten Afrika*, Innsbruck, 1982.

KJERSMEIER, C., *Centres de style de la sculpture nègre africaine*, 4 vols., Paris and Copenhagen, 1935–8.

KRIEGER, KURT, *West Afrikanische Plastik*, I, Berlin, 1965; II, III, Berlin, 1969.

KRIEGER, KURT, AND KUTSCHER, GERDT, *Westafrikanische Masken*, Berlin, 1960.

LAUDE, J., *The Arts of Black Africa*, Berkeley, 1971.

LEIRIS, M., AND DELANGE, J., *Afrique Noire*, Paris, 1967.

—, *African Art*, London, 1968.

LEUZINGER, ELSY, *Die Kunst von Schwarz-Afrika*, exhibition catalogue, Kunsthaus, Zürich, 1970.

—, *The Art of Black Africa*, London, 1972.

LOMMEL, A., AND KECSKÉSI, MARIA, *Africanische Kunst*, Munich, 1976.

MCNAUGHTON, PAT, 'The throwing knife in African history', *A.A.*, III, 2, Winter 1969.

MAQUET, JACQUES, *Afrique, les civilizations noires*, Paris, 1962.

MEAUZÉ, PIERRE, *African Art* (sculpture), Cleveland, London and New York, 1968.

MERRIMAN, ALAN P., 'African music', in William Bascom and Melville J. Herskovits (eds.), *Continuity and Change in African Cultures*, Chicago, 1959.

MIDDLETON, JOHN, AND TRAIT, DAVID, *Tribes without Rulers*, London, 1958.

MUENSTERBERGER, W., *Sculpture of Primitive Man*, New York, 1955.

—, *Universality of Tribal Art*, Geneva, 1979.

MURDOCK, GEORGE PETER, *Africa. Its Peoples and Their Culture History*, New York, 1959.

NATIONAL MUSEUM OF DENMARK, *Ethnographic Objects in the Royal Danish Kunstkammer*, Copenhagen, 1980.

NOTEN, F. VAN, 'La plus ancienne (?) sculpture sur bois de l'Afrique Centrale', *Africa-Tervuren*, XVIII, 3-4, 1972, pp. 133–6.

NYENDAEL, D. VAN, published in Bosman, W., *Nawkeurige Beschrijvinge van de Guinese*, Utrecht, 1704; English, 1705. *A new and accurate description of the coast of Guinea*, London, 1705; reprinted London, 1907.

OLDEROGGE, DMITRIJ A., *Iskusstvo narodov zapadnoj Afriki v muzejah sssr* (*L'Art des peuples d'Afrique occidentale dans les collections des musées Soviétiques*), Leningrad-Moscow, 1958.

OLDEROGGE, DMITRIJA., AND FORMAN, WERNER, *The Art of Africa, Negro Art from the Institute of Ethnography, Leningrad*, London, 1969.

PAULME, DENISE, *African Sculpture*, London, 1962.

PICKET, ELLIOT, 'The animal horn in African art', *A.A.*, IV, 4.

PLASS, M. WEBSTER, *African Tribal Sculpture*, University Museum, Philadelphia, 1956.

RACHEWILTZ, BORIS DE, *Introduction to African Art*, New York, 1966.

RICE, D. TALBOT, *The Background of Art*, London, 1939.

ROBBINS, WARREN, *African Art in American Collections*, New York and London, 1966.

RUBIN, ARNOLD, *African Accumulative Sculpture*, catalogue, Pace Gallery, New York, 1974.

SAINSBURY, ROBERT (ed.), *Robert and Lisa Sainsbury Collection*, London, 1978.

SCHWEEGER-HEFEL, ANNEMARIE, *Plastik aus Afrika*, Museum für Völkerkunde, Vienna, 1969.

SIEBER, ROY, *Sculpture of Northern Nigeria*, Museum of Primitive Art, New York, 1961.

—, 'Masks as agents of social control', *African Studies Bulletin*, 5, 2, 1962, pp. 8–13.

—, 'African art and culture history', in C. Gabel and N.R. Bennett (eds.), *Reconstructing African Culture History*, Boston, 1967, pp. 117–37.

—, *African Textiles and Decorative Arts*, New York, 1972.

—, *African Furniture and Household Objects*, Bloomington, 1980.

SIEBER, ROY, AND RUBIN, A., *Sculpture of Black Africa: The Paul Tishman Collection*, Los Angeles, 1968.

SIEBER, ROY, AND CELENKO, T., 'Rayons X et art africain', *A.A.N.*, 21, 1977.

SIROTO, L., *African Spirit Images and Identities*, New York, 1976.

SMITH, M. (ed.), *The Artist in Tribal Society*, London, 1961.

SWEENEY, JAMES JOHNSON (ed.), *African Negro Art*, Museum of Modern Art, New York, 1935.

SYDOW, ECKART VON, *Afrikanische Plastik*, ed. Gerdt Kutscher, Berlin, 1930; reprinted Berlin and New York, 1954.

THOMPSON, ROBERT FARRIS, *African Art in Motion*, U.C.L.A. Art Council, Berkeley and Los Angeles, 1974.

TROWELL, M., *Classical African Sculpture*, London, 1954; 2nd edn, 1964.

—, *African Design*, London, 1960; 2nd edn, 1965.

UNDERWOOD, LEON, *Figures in Wood in West Africa*, London, 1947/1964.

—, *Masks of West Africa*, London, 1948/1952.

—, *Bronzes of West Africa*, London, 1949/1968.

UNESCO, see *General History of Africa*, above.

VANSINA, JAN, 'Les Zones culturelles de l'Afrique', in *Africa-Tervuren*, 7, 2, 1961.

—, *Kingdoms of the Savanna*, Milwaukee, 1966.

—, 'Inner Africa', in *Horizon History of Africa*, New York, 1971, p. 267.

—, *Art History in Africa: An Introduction to Method*, London, 1984.

VOGEL, S. M. (ed.), *For Spirits and Kings: African Art from the Tishman Collection*, New York, 1981.

WASSING, R. S., *African Art: Its Background and Tradition*, New York, 1968.

WILLETT, FRANK, *African Art*, London, 1971; reprinted 1975.

—, 'An African sculptor at work', *A.A.*, XI, 3, 1978.

WILLETT, FRANK, AND FLEMING, STUART J., 'A catalogue of important Nigerian copper-alloy castings dated by thermoluminescence', *Archaeometry*, 18, 2, 1976, pp. 135–46.

WILLETT, FRANK, AND EYO, EKPO, *Treasures of Ancient Nigeria*, New York, 1980.

WILLIAMS, DENIS, *Icon and Image, A Study of Sacred and Secular Forms in African Classical Art*, New York, 1974.

WINGERT, PAUL S., *The Sculpture of Negro Africa*, New York, 1950.

—, *Primitive Art: Its Traditions and Styles*, New York, 1962.

—, 'Further style analysis in African sculpture', *A.A.*, VI, 1, Autumn 1972.

CHAPTER 2: THE ROCK ART OF AFRICA

BANDI, H. G., et al., *The Rock Art of the Maghreb and the Sahara*, London, 1961.

BARICH, B. E., *Les faciés de l'Oued Avis (Acacus, Libye) et les problèmes du milieu Saharien*, *Artes du IX Congrès de l'U.I.S.P.P.*, Nice, 1976.

BREUIL, H. L'ABBÉ, 'Restes d'une sépulture en grotte au Sahara', *J. Soc. African.*, 24, 2, 1954.

—, *Les Roches peintes de Tassili-n-Ajjer*, Paris, 1954.

CAMPS-FABRER, HENRIETTE, 'Matière et art mobilier dans la préhistoire nord-africaine et saharienne', *Memoirs du Centre de Recherches Anthropologiques, Préhistoriques et Ethnographiques*, V, Paris, 1966.

—, *Les Civilisations préhistoriques de l'Afrique du Nord et du Sahara*, Paris, 1974.

ČERVIČEK, PAVEL, 'Felsbilder Oberägyptens und Nubiens', in Museen der Stadt Köln, *Sahara*, 1978, pp. 279–85.

CHAPLIN, J. H., 'The prehistoric rock art of the Lake Victoria region', *Azania*, IX, 1974, pp. 1–50.

CLARK, J. D., 'The problem of neolithic culture in sub-Saharan Africa', in W.W. Bishop and J.D. Clark (eds.), *Background to Evolution in Africa*, Chicago, 1967.

—, *The Prehistory of Southern Africa*, London, 1959.

—, *Prehistory of Africa*, London, 1970.

FROBENIUS, LEO, *Madzimu Dsangara*, Berlin, 1932.

GABUS, JOHN, *Au Sahara*, Vol. I: *Les Hommes et leurs utils*, Vol. II: *Art et symboles*, Neufchâtel, 1956/7.

HUARD, PAUL, 'Influences culturelles transmises au Sahara tchadien par le Groupe C de Nubie', *Kush*, 15, Khartoum, 1974.

HUARD, PAUL, AND ALLARD, L., 'Contributions à l'étude des spirales au Sahara central et nigéro-tchadien', *Bulletin de la Société Préhistorique Française*, 63, 2, 1966, pp. 433 ff. and figs. 2–9.

—, 'Les peintures rupestres du Sahara et du Nil', *Études Scientifiques*, Cairo, 1978.

KI-ZERBO, J., 'African prehistoric art', UNESCO *General History of Africa*, Vol. I, 1981, pp. 656–86.

KUNZ, JÜRGEN, 'Neue Felsbildfunde in dem Westlichen Tassili-n'Ajjer', *Paideuma*, 23, 1977, pp. 1–17.

LAJOUX, JEAN-DOMINIQUE, *The Rock Paintings of Tassili*, London, 1963.

LECLANT, J., *Une Province nouvelle de l'art saharien: Les gravures rupestres de Nubie, Maghreb et Sahara*, Paris, 1973.

LEROI-GOURHAN, ANDRÉ, *Préhistoire de l'art occidental*, Paris, 1965.

LEWIS-WILLIAMS, J. D., 'The economic and social context of southern San rock art', *C.A.*, 23, 4, August 1982, pp. 429–49.

—, *Believing and Seeing Symbolic Meanings in Southern San Rock Paintings*, New York, 1981.

LHOTE, HENRY, *The Search for the Tassili Frescoes*, London, 1959.

—, 'L'Art pré-historique. Saharien', *Objets et Mondes*, II, Paris, 1962.

—, *Vers d'autres Tassilis*, Paris, 1976.

LUPACCIOLU, MARINA, 'The absolute dating of the earliest Saharan rock art', *Paideuma*, 24, 1978.

MARLIAC, ALAIN, *Les Petroglyphs de Bidzar* [Eastern Cameroon], Paris, 1981.

MASONOWICZ, DOUGLAS, 'Tassili', *A.A.*, II, 1, 1968.

MORI, F., 'Some aspects of the rock-art of the Acacus (Fezzan Sahara) and data regarding it', in *Prehistoric Art of the Western Mediterranean and Sahara*, Chicago, 1964.

—, *Tadrart Acacus: Arte rupestre e culture del Sahara preistorico*, Turin, 1965.

—, 'Prehistoric Saharan art and cultures in the light of discoveries in the Acacus massif', *Libya in History*, 1968.

—, 'Proposition d'une chronologie absolue de l'art rupestre du Sahara d'après les fouilles du Tadrart Acacus', *Valcamonica Symposium; Actes du Symposium Préhistorique*, 1970.

MORI, F., 'Proposta per una attribuzione alla fine del Pleistocene della fase più antica dell'arte rupestre Sahariana', *Origini*, V, 1971.

—, 'The earliest Saharan rock-engravings', *Antiquity*, XLVIII, 1974, p. 197.

—, 'Zur Chronologie der Sahara-Felsbilder', in Museen der Stadt Köln, *Sahara*, 1978, pp. 253 ff.

MUSEEN DER STADT KÖLN, *Sahara, 10,000 Jahre zwischen Weide und Wüste*, Cologne, 1978.

PHILLIPSON, D. W., *Prehistoric Rock Paintings and Engravings of Zambia*, Livingstone, 1972.

—, 'Zambian rock paintings', *World Archaeology*, 3, 3, February 1972, pp. 313-27.

POYTO, R., AND MUSSO, J. C., 'Corpus des peintures et gravures rupestres de Grande Kabylie', *Memoirs du Centre de Recherches Anthropologiques, Préhistoriques et Ethnographiques.*, Vol. XII, Paris, 1969.

REDINHA, J., *As Gravuras Rupestres do Alto-Zambeze*, Lisbon, 1948.

RESCH, WALTER F. E., *Die Felsbilder Nubiens*, Graz, 1967.

RITCHIE, CARSON I. A., *Rock Art of Africa*, London, 1979.

SCHWEINFURTH, G., 'Über alte Tierbilder und Felsinschriften bei Assuan', *Zeitschrift für Ethnologie*, 44, Berlin, 1912.

SOPER, R. C., 'Rock gongs and a rock chute in Mwanza region, Tanzania', *Azania*, III, 1968, p. 175.

—, 'Petroglyphs in Northern Kenya', *Azania*, III, 1968.

STRIEDTER, K. H., 'Zeichentheoretische Aspekte der Felsbilder Nordafrikas', *Paideuma*, 22, 1976.

UCKO, P., AND ROSENFELD, A., *Paleolithic Cave Art*, London, 1967.

VINNICOMBE, PATRICIA, *People of the Eland*, Pietermaritzburg, 1976.

WENDT, W. E., ' "Art mobilier" from the Apollo 11 cave, South West Africa: Africa's oldest dated works of art', *S.A.A.B.*, 31 1976.

WILLCOX, A. R., *The Rock Art of South Africa*, Johannesburg, 1963.

WILLETT, FRANK, *African Art*, London, 1971.

CHAPTER 3: THE ANCIENT NUBIANS

ADAMS, WILLIAM Y., *Nubia: Corridor to Africa*, London, 1977.

ALDRED, CYRIL, *Old Kingdom Art in Ancient Egypt*, London, 1949.

AMBORN, HERMANN, 'Die Bedeutung der Kulturen des Niltals für die Eisenproduktion im Subsaharischen Afrika', *Studien zur Kulturkunde*, 39, Wiesbaden, 1976.

ARKELL, A., *A History of the Sudan from the Earliest Times to 1821*, London, 1955.

—, 'The pre-history of the Nile Valley', *Handbuch der Orientalistik*, Abt. 7, Vol. I, Leiden and Cologne, 1975.

—, 'Dating early Khartoum,' in 'Ägypten und Kusch', *Schriften zur Geschichte und Kultur des Alten Orients*, 13, Berlin, 1977, pp. 53-5.

BADAWAY, A., 'An Egyptian fortress in the Belly of Rock. Further excavations and discoveries in the Sudanese island of Askut', *Illustrated London News*, 245, 1964, pp. 86-8.

—, 'Askut: a Middle Kingdom fortress in Nubia', *Archaeology*, 18, 2, 1965, pp. 124-31.

BROOKLYN: The Brooklyn Museum, *Africa in Antiquity*, Brooklyn, 1978.
 Vol. I: *The Essays*.
 Vol. II: Steffen Wenig, *The Catalogue* (with comprehensive bibliography).

EMERY, W. B., *Nubian Treasure: An Account of the Discoveries at Ballana and Qustul*, London, 1948.

HUARD, PAUL, 'Contributions à l'étude des spirales au Sahara central et nigéro-tchadien', *Bulletin de la Société Préhistorique Française*, 63, 2, 1966.

—, 'Influences culturelles transmises au Sahara tchadien par le groupe "C" de Nubie', *Kush*, 15, Khartoum (1967-8 [1973]), pp. 84-124.

KI-ZERBO, J., 'African prehistoric art', UNESCO *General History of Africa*, Vol. I, 1981, pp. 656-86.

MICHAŁOWSKI, K. (ed.), *Nubia: Récentes Recherches*, Warsaw, 1975.

PHILLIPSON, D. W., 'Notes on the later prehistoric radiocarbon chronology of eastern and southern Africa', *J.A.H.*, 11, 1970, pp. 1-15.

SAYCE, A. H., *University of Liverpool Annals of Archaeology and Anthropology*, IV, 1911.

—, *Reminiscences*, London, 1923.

Scandinavian Joint Expedition to Sudanese Nubia (ed. Torgny Säve-Söderbergh), Copenhagen, etc. Published so far:

 Vol. I, part 1 and 2: Pontus Hellström, *The Rock Drawings*, 1970.

 Vol. II: Anthony E. Marks, *Preceramic Sites*, 1970.

 Vol. III, part 1 and 2: Hans-Åke Nordström, *Neolithic and A-group Sites*, 1972.

 Vol. V, part 1: Rostislav Holthoer, *New Kingdom Pharaonic Sites: The Pottery*, 1977.

 Vol. VI: Torgny Säve-Söderbergh, *Late Nubian Cemeteries*, 1981.

 Vol. VII: C. J. Gardberg, *Late Nubian Sites: Churches and Settlements*, 1970.

 Vol. VIII: Ingrid Bergman, *Late Nubian Textiles*, 1975.

 Vol. IX: Ole Vagn Nielsen, *Human Remains: Metrico and non-metrico, and anatomical variations*, 1970.

SHINNIE, P. L., 'Meroë. A civilization of the Sudan', *Ancient Peoples and Places*, 55, New York, 1967.

—, 'On radiocarbon chronology of the Iron Age in sub-Saharan Africa', *C.A.*, 10, 1969.

—, *The African Iron Age*, Oxford, 1971.

SMITH, H. S., 'The Nubian B-Group', *Kush*, 14, 1966, pp. 69-124.

SOPER, R. C., 'New radiocarbon dates for eastern and southern Africa', *J.A.H.*, 15, 1974, pp. 175-92.

TRIGGER, B., *Nubia under the Pharaohs*, Boulder, Colorado, 1976.

WENDORFF, F. (ed.), *The Prehistory of Nubia*, 2 vols., Dallas, 1968.

WENIG, STEFFEN, 'Meroitische Kunst', paper presented to *Journées internationales d'études Méroïtiques*, Paris, 10-13 July 1973.

—, *Africa in Antiquity*, Vol. II, Brooklyn, 1978.

CHAPTER 4: THE NOK CULTURE

BASSING, ALLEN, 'Grave monuments of the Dakakari', *A.A.*, VI, 4, 1973, pp. 36-9.

BRETERNITZ, D. A., 'Rescue archaeology in the Kainji Reservoir area 1968', *W.A.J.A.*, 5, 1975, pp. 91-151.

EYO, EKPO, *2,000 Years of Nigerian Art*, Lagos, 1977.

EYO, EKPO, AND WILLETT, FRANK, *Treasures of Ancient Nigeria*, New York, 1980.

FAGG, ANGELA, 'A preliminary report on an occupation site in the Nok Valley, Nigeria', *W.A.J.A.*, 2, 1972, pp. 75-9.

FAGG, BERNARD, 'A life-size terracotta head from Nok', *Man*, LVII, 1956, p. 95.

—, 'The Nok terracottas in West African art history', *Actes du IVème Congrès Panafricain de Préhistoire*, Tervuren, III, 1962, pp. 445-50.

—, 'Radiocarbon dating of the Nok culture, northern Nigeria', *Nature*, January 1965, pp. 205-12.

—, 'Recent work in West Africa: new light on the Nok culture', *World Archaeology*, 1 (1), 1969, pp. 41-50.

—, *Nok Terracottas*, Lagos, 1977.

FITZGERALD, R. T. D., 'Dakakari grave pottery', *J.R.A.I.*, LXXIV, 1944, pp. 43-57.

PRIDDY, A. J., 'RS/63/32. An Iron Age site near Yelwa, Sokoto Province: preliminary report', *West African Archaeological Newsletter*, 12, 1970, pp. 20-32.

SHAW, THURSTAN, 'The Nok sculptures of Nigeria', *Scientific American*, 244, 2, February 1981, pp. 154-66.

CHAPTER 5: THE KINGDOMS OF THE WESTERN SUDAN

AL UMARI (French translation), *L'Afrique moins l'Egypte*, Paris, 1927.

BASSANI, EZIO, 'Sono from Guinea Bissau', *A.A.*, XII, 4, 1979, pp. 44–7.

BEDAUX, R., *Tellem*, Berg en Dal, 1977.

BOSER-SARIVAXÉVANIS, RENÉE, *Les Tissues de l'Afrique occidentale*, Vol. 1, Basle, 1972.

EVRARD, J., *Archéologie ouest africaine: les figures en terre cuite du Mali*, 3 vols., Louvain, 1977 (master thesis Université Catolique de Louvain).

GOLDWATER, ROBERT, *Bambara Sculpture from the West Sudan*, New York, 1960.

—, *Senufo Sculpture from West Africa*, New York and Greenwich, Conn., 1964.

GRIAULE, M., *Masques Dogon*, Paris, 1938.

GRUNER, DOROTHEE, 'Der traditionelle Lehmbau und seine Problematik', *Paideuma*, 27, Wiesbaden, 1981.

GRUNNE, B. DE, *Terres cuites anciennes de l'Ouest africain*, Louvain, 1978.

IBN BATTUTA (French translation and Arabic text), *Voyages*, IV, Paris, 1922.

KOROMA, V. H., 'The bronze statuettes of Ro-Ponka, Kafu Bolom', *Sierra Leone Studies*, 22, September 1939, pp. 25–8.

LAMB, VENICE AND ALASTAIR, *The Lamb Collection of West African Narrow Strip Weaving*, Halifax, 1975.

LAMB, VENICE, *West African Weaving*, London, 1975.

LAUDE, JEAN, *African Art of the Dogon*, New York, 1973.

LEVTZION, NEHEMIA, 'The early states of the Western Sudan', in J.F.A.Ajayi and M. Crowder (eds.), *History of West Africa*, Vol. 1, 1971 (1979), pp. 118–19.

—, *Ancient Ghana and Mali*, London, 1973.

LIGERS, Z., 'Un Laocoon soudanais', *Revue Archéologique*, 1961, 1, pp. 203–9.

MCINTOSH, RODERICK J. AND SUSAN K., 'Terracotta statuettes from Mali', *A.A.*, XII/2, 1979, pp. 51–3.

MOTA, A. TEIXEIRA DA, 'Descoberta de bronzes antigos na Guiné Portuguesa', *Boletim Cultural da Guiné Portuguesa*, 59, XV, Bissau, 1960, pp. 625–62.

MONTEIL, C., 'La Légende de Ougadou et l'origine des Soninke', in *Mélanges Ethnologiques*, *Mem. de l'Ifan*, Dakar, 23, 1953, pp. 359–408.

—, 'Dienné, une cité soudanaise', *Anthropos*, Paris, 1971, pp. 136–7.

PICTON, JOHN, AND MACK, JOHN, *African Textiles*, London, 1979.

ROY, CHRISTOPHER, *Mossi Masks and Crests*, Ph.D. dissertation, University of Indiana, 1979.

SCHWEEGER-HEFEL, ANNEMARIE, 'Les Insignes royaux des Kouroumba', *J. Soc. African.*, 32, 1962, pp. 275–326.

—, 'L'Art Nioniosi', *J. Soc. African.*, 36, 1966, pp. 251–332.

—, *Steinskulpturen der Nyonyosi aus Ober-Volta*, Munich, 1981.

SKOUGSTAD, NORMAN, *Traditional Sculpture from Upper Volta*, New York, 1978.

SMITH, ANDREW B., 'Preliminary report of excavations at Karkarichinkat and Karkarichin-kat Sud, Tilemsi Valley, Republic of Mali, spring 1972', *W.A.J.A.*, 4, 1974, pp. 33–5, pls. VIII-XIII.

VIELLARD, G., 'Sur quelques objets en terre cuite', *Bulletin de l'I.F.A.N.*, 3, 1940, pp. 347–50.

ZAHAN, DOMINIQUE, *The Bambara*, Leiden, 1974.

CHAPTER 6: THE ART OF THE SHERBRO, BULOM AND KISSI

ALLDRIDGE, T. J., *The Sherbro and its Hinterland*, London, 1901.

BASSANI, EZIO, 'Gli olifanti afroportoghesi della Sierra Leone', *Critica d'Arte*, 163, 5, 1979, pp. 177–201.

D'ALMADA, A., *Tratado breve dos Rios da Guiné do Cabo-Verde* (1594), Lisbon, 1946.

DITTMER, K., 'Bedeutung, Datierung und Kulturhistorische Zusammenhänge der "prähistorischen" Steinfiguren aus Sierra Leone und Guinée', *Baessler Archiv*, Berlin, 1967.

FAGE, J. D., 'Upper and Lower Guinea', in *The Cambridge History of Africa*, Vol. 3, 1977, p. 509.

KUP, P., *A History of Sierra Leone: 1400-1787*, Cambridge, 1962.

PAULME, D., *Les Gens du Riz*, Paris, 1954.

PERSON, YVES, 'Les Kissi et leurs statuettes de pierre dans le cadre de l'histoire ouest-africaine', *Bulletin de l'I.F.A.N.*, XXIII, B-1, Dakar, 1961.

RYDER, A. F. C., 'A note on the Afro-Portuguese ivories', *J.A.H.*, London, 1964.

TAGLIAFERRI, ALDO, AND HAMMACHER, ARNO, *Fabulous Ancestors*, New York, 1974.

CHAPTER 7: KANEM-BORNO AND THE 'SAO' CULTURE

ADELEYE, R. A., 'Hausaland and Bornu 1600-1800', in *History of West Africa*, Vol. 1, 1971, pp. 484-530.

CONNAH, GRAHAM, *Three Thousand Years in Africa*, Cambridge, 1981.

JANSEN, G., AND GAUTHIER, J. G., *Ancient Art of the Northern Cameroons: Sao and Fali*, Oosterhout, 1973.

LEBEUF, A. AND J. P., 'Datations au C. 14 des sites Sao (Cameroon et Tchad)', *Notes Africaines*, 128, 1970, pp. 105-6.

LEBEUF, JEAN-PAUL AND ANNIE, *Les Arts des Sao*, Paris, 1977.

LEBEUF, JEAN-PAUL AND ANNIE, FRANÇOISE TREINEN-CLAUSTRE AND JEAN COURTIN, 'Le Gisement Sao de Mdaga (Tchad)', *Fouilles* 1960-1968; Paris 1980.

PALMER, H. R., *History of the First Twelve Years of the Reign of Mai Idris Alaoma of Bornu, by his Imam* (translated from Arabic), Lagos, 1926.

CHAPTER 8: 'KORORORFA' - THE JUKUN AND RELATED PEOPLES

ABRAHAM, ROY C., *The Tiv People*, Lagos, 1933.

HAROLD, ERICH, 'Zur Ikonographie der "Aku-Onu" Masken', *Abhandlungen und Berichte des Staatlichen Museums für Völkerkunde, Dresden*, 34, Berlin, 1975.

MEEK, CHARLES KINGSLEY, *The Northern Tribes of Nigeria*, 2 vols., London, 1925.

—, *A Sudanese Kingdom: An Ethnographical Study of the Jukun-speaking Peoples of Nigeria*, London, 1931.

—, *Tribal Studies in Northern Nigeria*, 2 vols., London, 1931.

MEULEMEESTER, J. D., 'De Jukun, een status questionis van hun Geschiedenis', *Africa-Tervuren*, XVI, 1970/71, pp. 18-24.

PALMER, H. R., 'Notes on the Kororofawa and Jukon', *Journal of the African Society*, 11, 1911, pp. 401-15.

—, *Sudanese Memoirs*, 3 vols., Lagos, 1928.

RUBIN, ARNOLD G., *The Arts of the Jukun-speaking Peoples of Northern Nigeria*, Ph.D. dissertation, University of Indiana, 1970 (unpublished).

—, 'Bronzes of the Middle Benue', *W.A.J.A.*, 3, 1973, pp. 221-31.

—, 'Bronzes of Northeastern Nigeria', in *The Art of Metal in Africa*, African-American Institute, New York, 1982.

CHAPTER 9: THE ART OF THE AKAN

ANQUANDAH, JAMES, 'State formation among the Akan of Ghana', *Sankofa*, 1, 1975, pp. 47-59.

APPIAH, PEGGY, *Asante Goldweights, Proverbs and Folklore*, Accra, n.d.

—, 'Akan symbolism', *A.A.*, XIII, 1, 1979.

ARKELL, J., 'Gold Coast copies of fifth-sixth century bronze lamps', *Antiquity*, 24, London, 1950.

BARBOT, J., *A Description of the Coasts of North and South Guinea*, in A. and John Churchill, *A Collection of Voyages and Travels*, Vol. 5, 3rd edn, London, 1744/6.

BASSING, A., AND KYREMATEN, A. A. Y., 'The enstoolment of an Asantehene', *A.A.*, V, 3, 1972.

BLAKE, J. W., *Europeans in West Africa 1450–1560*, London, 1941.

BOAHEN, A., 'The origins of the Akan', *Ghana Notes and Queries*, 9, 1966, pp, 3–10.

BOWDICH, T. E., *Mission from Cape Coast to Ashantee*, London, 1819.

CALVOCORESSI, D., 'European trade pipes in Ghana', *W.A.J.A.*, Legon, 1975.

—, 'Excavations at Kommenda, Ghana', *W.A.J.A.*, 5, 1975, pp. 153–64.

CARTER, P. L. AND P. J., 'Rockpainting from Northern Ghana', *Transactions of the Historical Society of Ghana*, 7, 1964, pp. 1–3.

CHURCHILL, A. AND JOHN, *A Collection of Voyages and Travels*, Vols. 5 and 6, 3rd edn, London, 1744/6.

COLE, HERBERT M., AND ROSS, DORAN H., *The Arts of Ghana*, Los Angeles, 1977.

CRAWFORD, T. S., *A History of the Umbrella*, Newton Abbot, 1970.

CROWLEY, DANIEL J., 'Forowa: Ghanaian brass shea butter boxes', paper read at annual meeting of the African Studies Association, Philadelphia, 1972.

DAVIES, O., *Archaeology in Ghana*, London, 1961.

—, 'A West African stool with gold overlay', *Annals of the Natal Museum*, 20, 3, Natal, 1971.

DONNE, JOHN, 'The Celia Barclay collection of African art', *Connoisseur*, 180, London, 1972.

—, 'West African goldwork', *Connoisseur*, 194, 780, London, 1977, p. 106.

DUPUIS, JOSEPH, *Journal of a Residence in Ashantee*, London, 1824.

ELISOFON, ELIOT, 'Africa's ancient splendour still gleams in the Akan people's golden art', *Smithsonian*, 3, 10, Washington, D.C., 1973.

FAGE, J. D., *Ghana, A Historical Interpretation*, Madison, 1959.

FAGG, W. B., 'Ashanti gold', *Connoisseur*, 185, 743, London, 1974, pp. 41–8.

FIELD, MARGARET JOYCE, *Akim Kotoku – An Oman of the Gold Coast*, London, 1948; reprinted 1970.

FISCHER, E., AND HIMMELHEBER, H., *Das Gold in der Kunst Westafrikas*, Zürich, 1975.

FRASER, DOUGLAS, 'The symbols of Ashanti kingship', in D. Fraser and H. Cole (eds.), *African Art and Leadership*, Madison, 1972.

GARRARD, TIMOTHY F., *Akan Weights and the Gold Trade*, London, 1980.

GOODY, J., 'The Mande and the Akan hinterland', in J. Vansina, R. Mauny and L.V. Thomas (eds.), *The Historian in Tropical Africa*, London, 1964.

HEWSON, A. D., *New Developments in Statistical Quantum Theory*, London, 1978.

IBN BATTUTA, *Travels in Asia and Africa, 1325–1354*, ed. H.A.R. Gibb, London, 1929.

KJERSMEIER, C., *Ashanti Goldweights in the National Museum*, Copenhagen, 1941.

—, *Ashanti – Vaegtlodder*, Copenhagen, 1948.

KYEREMATEN, A. A. Y., *Ashanti Royal Regalia: Their History and Function*, D.Phil. dissertation, Oxford, 1966.

—, 'The royal stools of Ashanti', *Africa*, XXXIX, 1, London, 1969.

LAMB, VENICE, *West African Weaving*, London, 1975.

MCLEOD, M. D., 'Verbal elements in West African art', *Quaderni Poro*, Milan, 1976.

—, 'T.E. Bowdich: an early collector in West Africa', in R. Camber (ed.), *Collectors and Collections, The British Museum Yearbook*, 2, London 1977.

—, *The Asante*, London, 1981.

MAREES, PIETER DE, 'A Description and Historical Declaration of the Golden Kingdom of Guinea (1602)', trans. by Purchas in his *Pilgrimes*, Hakluyt Society, VI, Glasgow, 1895 and 1905.

MENZEL, BRIGITTE, *Goldgewichte aus Ghana*, Berlin, 1968.

—, *Textilien aus Westafrika*, Berlin, 1972/3.

MEYEROWITZ, E. L. R., *The Sacred State of the Akan*, London, 1951.

—, *Akan Traditions of Origin*, London, 1952.

—, *The Early History of the Akan States of Ghana*, 1974.

MÜLLER, W. J., *Die Afrikanische auf der Guineischen Gold Cust gelegene Landschaft Fetu*, Hamburg, 1673.

PAULME, D., 'Les poids - proverbes de la Côte d'Ivoire au Musée de l'Homme', *J. Soc. African.*, 11, 5, Paris, 1941.

—, 'A propos des Kuduo Ashanti', *Présence Africaine*, 10-11, Paris, 1951, pp. 156-62.

PEREIRA, DUARTE PACHECO, *Esmeralda de Situ Orbis*, trans. and ed. G.H.T. Kimble, Hakluyt Society, London, 1937.

PLASS, MARGARET WEBSTER, *African Miniatures: Goldweights of the Ashanti*, New York, 1967.

POSNANSKY, MERRICK, 'Archaeology and the origins of Akan society', in M. Dodds (ed.), *History of Ghana, A Series of Lectures*, Accra, 1974, pp. 12-20.

—, 'Redressing the balance - new perspectives in West African archaeology', *Sankofa*, 1975, p. 18.

PRESTON, GEORGE NELSON, *The Akan: The Style and Importance of Their Terracotta Funerary Art*, M.A. thesis, Columbia University, 1967.

—, *Twifo-Heman and the Akan Leadership Complex*, dissertation, Columbia University, 1972.

PRUSSIN, LABELLE, *Architecture in Northern Ghana*, Berkeley, 1969.

—, 'Traditional Asante architecture', *A.A.*, XIII, 2, Los Angeles, 1980.

RATTON, CHARLES, *Fetish Gold*, University Museum, Philadelphia, 1975.

RATTRAY, R. S., *Ashanti Proverbs*, Oxford, 1916.

—, *Ashanti*, Oxford, 1923.

—, *Religion and Art in Ashanti*, London, 1927; reprinted 1959.

RØMER, L. F., *The Coast of Guinea, 1760*, trans. K. Bertelsen, Institute of African Studies, Legon, 1965.

ROSS, DORAN H., 'The verbal art of Akan linguist staffs', *A.A.*, XVI, 1, 1982, pp. 56-66.

SHAW, THURSTAN, 'Archaeology in the Gold Coast', *African Studies*, 2, 1943, pp. 139-47.

—, 'Excavations at Dawu: report on an excavation in a mound at Dawu, Akuapim, Ghana', London, 1961.

SIEBER, ROY, 'African art and culture history', in C. Gabel and N. Bennett (eds.), *Reconstructing African Culture History*, Boston, 1967.

—, 'Kwahu terracottas, oral traditions and Ghanaian history', in D. Fraser and H. Cole (eds.), Madison, 1972, pp. 173-83.

—, 'Art and history in Ghana', in A. Forge (ed.), *Primitive Art and Society*, London, 1973.

VOGEL, SUSAN M., 'People of wood: Baule figure sculpture', *Art Journal*, XXXIII, 1, 1973.

WENIG, STEFFEN, *Africa in Antiquity*, Vol. II, Brooklyn, 1978, p. 131.

WILKS, IVOR, *The Northern Factor in Ashanti History*, Legon, 1961.

—, *Asante in the 19th Century*, London, 1975.

ZELLER, R., 'Die Goldgewichte von Asante', *Baessler Archiv*, 3, 1972.

CHAPTER 10: IGBO-UKWU, THE NIGER DELTA AND THE CROSS RIVER

ARMSTRONG, ROBERT, G., 'A possible function for the bronze roped pot of Igbo-Ukwu', *W.A.J.A.*, 4, 1974, pp. 177-8, pl. LXXIV.

COLE, HERBERT, *African Arts of Transformation*, Santa Barbara, 1970.

CONNAH, GRAHAM, *Three Thousand Years in Africa*, Cambridge, 1981.

EKEJIUBA, F. I., 'Preliminary notes on brasswork of Eastern Nigeria', *African Notes*, 4, 1967, p. 2.

EKPO, V. I., 'New archaeological materials from Calabar, Nigeria', *Nigerian Field*, 42, 1977, p. 4.

FIELD, J. O., 'Bronze casting found at Igbo, Southern Nigeria', *Man*, 40, London, 1940, pp. 1–6.

GOUCHER, C., 'Ancient Nigerian "bronzes", lead isotope studies of metal sources', *Nature*, 1976.

HORTON, ROBIN, 'A note on recent finds of brasswork in the Niger Delta', *Odu*, 2, 1, July 1965, pp. 76–91.

JONES, G. I., 'Ibo bronzes from the Awka Division', *Nigerian Field*, 8, 4, 1939, pp. 346–54.

KAMER, HÉLÈNE, *Ancêtres M'bembe*, Paris, 1974.

LAWAL, BABATUNDE, 'Archaeological excavations at Igbo-Ukwu; a reassessment', *Odu*, n.s., 1972, pp. 72–97.

—, 'The Igbo-Ukwu bronzes: a search for the economic evidence', *J.H.S.N.*, 6, 3, 1972, pp. 1–8.

NEAHER, NANCY, 'Nigerian bronze bells', *A.A.*, XII, 3, 1979, pp. 42–7.

NEYT, F., *L'Art Eket*, Paris, 1979.

NICKLIN, KEITH, 'Nigerian skin-covered masks', *A.A.*, VII, 3, 1974, p. 8.

—, *Guide to the National Museum, Oron*, Lagos, 1977.

—, 'Skin-covered masks of Cameroon', *A.A.*, XII, 2, 1979, pp. 54–9.

—, 'Archaeological sites in the Cross River region', *Nyame Akuma*, University of Calgary, 16, 1980.

—, 'The Cross River bronzes', in *The Art of Metal in Africa*, African–American Institute, New York, 1982.

NICKLIN, KEITH, AND FLEMING, S. J., 'A bronze "carnivore skull" from Oron, Nigeria', *Masca*, University Museum of Pennsylvania, 1, 4, 1980.

—, 'Analysis of two bronzes from a Nigerian *Asunaja* shrine', *Masca*, in press.

NICKLIN, KEITH, AND SALMONS, JILL, review of *L'Art Eket* by F. Neyt, *A.A.*, XIII, 2, 1980, pp. 24–7, 83.

NORTHROP, DAVID, 'The growth of trade among the Igbo before 1800', *J.A.H.*, 13, 2, 1972, pp. 217–36.

ONWUEJEOGWU, M. A. AND B. O., 'The search for the missing links in dating and interpreting the Igbo-Ukwu finds', *Paideuma*, 23, 1977, pp. 169–88.

PEEK, PHILIP M., 'Isoko bronzes and the Lower Niger bronze industries', *A.A.*, XIII, 4, 1980, pp. 60–66.

POSNANSKY, MERRICK, 'Review of Igbo-Ukwu: an account of archaeological discoveries in eastern Nigeria', *Archaeology*, 6, 4, 1973, pp. 309–11.

—, 'Brasscasting and its antecedents in West Africa', *J.A.H.*, XVIII, 2, 1974, p. 294.

RUBIN, ARNOLD, 'Bronzes of the Middle Benue', *W.A.J.A.*, 3, 1973, pp. 221–31; pls. XIII a and b.

SHAW, THURSTAN, 'Spectographic analyses of the Igbo-Ukwu and other Nigerian bronzes', *Archaeometry*, 8, 1965, pp. 86 ff.

—, *Igbo-Ukwu, an Account of Archaeological Discoveries in East Nigeria*, 2 vols., London, 1970.

—, 'Those Igbo-Ukwu radiocarbon dates: facts, fictions and probabilities', *J.A.H.*, 16, 4, 1975, pp. 503–17.

—, 'The prehistory of West Africa', in J. F. A. Ajayi and Michael Crowder (eds.), *History of West Africa*, London, 1971, 1979, p. 64.

TALBOT, P. A., *In the Shadow of the Bush*, London, 1912, p. 261.

VOLAVKA, ZDENKA, 'Art and metal', in *Proceedings of the 11th conference of the Canadian Association of African Studies*, Vol. 1, Vancouver, pp. 154–5, 157–8.

WARNIER, J. P., AND FOWLER, I., 'A nineteenth-century Ruhr in Central Africa', *Africa*, 49, 1979, p. 4.

CHAPTER 11: THE YORUBA AND THEIR NEIGHBOURS

ABIMBOLA, W., *Ifa: An Exposition of Ifa Literary Corpus*, Ibadan, 1976.

—, *Ifa Divination Poetry*, New York, 1977.

ABIMBOLA, W. (ed.), *Yoruba Oral Tradition, Ife*, Department of African Languages and Literature, University of Ife, 1975.

ADAMS, MONI, 'Fon appliquéd cloths', *A.A.*, XIII, 2, 1980, pp. 28-41.

ADANDE, A., 'Les récades des rois du Dahomey', *Ifan*, Dakar, 1962.

AGHECI, NORBERT, 'Emblèmes et chants', *Anthropos*, 27, 1932, pp. 417-22.

AKINJOGBIN, I. A., 'The Oyo empire in the 18th century - a reassessment', *J.H.S.N.*, 3, 3, 1966, pp. 449-60.

—, 'The expansion of Oyo and the rise of Dahomey 1600-1800', in *History of West Africa*, Vol. 1, London, 1979, p. 404.

AUDAH, WAI B., 'West Africa before the seventh century', in UNESCO *General History of Africa*, Vol. II, 1981.

AWOLALU, J. O., *Yoruba Beliefs and Sacrificial Rites*, London, 1979.

BASCOM, W. R., *Ifa Divination: Communication between Gods and Men in West Africa*, Bloomington, 1969.

BEIER, U., 'God of iron', *Nigeria*, 49, 1956, pp. 118-37.

—, *Sacred Wood Carvings from a Small Yoruba Town*, Lagos, 1957.

—, 'The Egungun cult among the Yoruba', *Présence Africaine*, 1958, pp. 17-18, 33-6.

—, 'A year of sacred festivals in one Yoruba town', *Nigeria Magazine*, Lagos, 1959.

BIOBAKU, S. O., *Sources of Yoruba History*, Oxford, 1973.

BRETERNITZ, DAVID A., 'Rescue archaeology in the Kainji Reservoir area', *W.A.J.A.*, 5, 1968, pp. 91-151.

BRINCARD, M. T., *Les Bracelets Ogboni: analyse iconographique et stylistique*, Thèse maîtrise d'art et d'archéologie, Université de Paris, Sorbonne, 1980.

—, 'Two bracelets: continuing questions', in *The Art of Metal in Africa*, African-American Institute, New York, 1982.

BURDE, ROGER DE LA, 'Ancestral rams' heads of the Edo-speaking peoples', *A.A.*, VI, 1, 1972, pp. 29-34.

BURT, BEN, *The Yoruba and Their Gods*, British Museum, London, 1977.

BURTON, SIR RICHARD, *A Mission to Gelede, King of Dahomey*, London, 1966 (first published 1864), p. 297.

CALVOCORESSI, D., AND DAVID, N., 'A new survey of radiocarbon and thermoluminescence dates for West Africa', *J.A.H.*, 20, 1, 1979, pp. 1-29.

CARROLL, L. K., *Yoruba Religious Carving*, London, 1967.

CHAPPEL, T. J. H., 'Yoruba cult of twins in historical perspective', *Africa*, 44, 3, 1974, pp. 250-65.

COLE, H. M., AND THOMPSON, R. F., *Yoruba Sculpture Bibliography*, Museum of Primitive Art, New York, 1964.

CONNAH, G., *Ife. Lectures on Nigerian Prehistory and Archaeology*, ed. Thurstan Shaw, Ibadan, 1969, pp. 47-53.

CORDWELL, J. M., 'Naturalism and stylization in Yoruba art', *Magazine of Art*, 46, 5, 1953, pp. 220-25.

CROWLEY, DANIEL J., 'Bêtises: Fon brass genre figures', *A.A.*, XV, 2, February 1982, p. 56.

DAVISON, C. C., *Glass Beads in African Archaeology*, Lawrence Radiation Laboratory, Berkeley, 1972.

DITTMER, K., 'Prähistorische Steinfiguren aus Sierre Leone und Guinee', *Baessler Archiv*, n.f., XV, 1967, p. 184.

DREWAL, H. J., 'Gelede masquerade: imagery and motif', *A.A.*, VII, 4, 1974, pp. 8-19, 62-3, 95-6.

—, *African Artistry: Technique and Aesthetics in Yoruba Sculpture*, Atlanta, 1980.

DREWAL, M. T. AND H. J., 'Gelede dance of the Western Yoruba', *A.A.*, VIII, 2, 1975, pp. 36-45, 78-9.

EYO, EKPO, 'Odo Ogbe Street and Lafogido: contrasting archaeological sites in Ile-Ife, Western Nigeria', *W.A.J.A.*, 4, 1974, pp. 99-109.

—, *Recent excavations at Ife and Owo and their implications for Ife, Owo and Benin studies*, Ph.D. thesis, Ibadan, 1974.

—, *Two Thousand Years of Nigerian Art*, Lagos, 1977.

EYO, EKPO, AND WILLETT, FRANK, *The Treasures of Ancient Nigeria*, New York, 1980.

EYO, E., FAGG, W. B., AND HAMMER, J. (eds.), *Yoruba Carving Styles, Ere Ibeji*, National Commission for Museums and Monuments, Lagos (forthcoming).

FAGG, B. E. B. AND W. B., 'The ritual stools of ancient Ife', *Man*, 1960.

FAGG, W. B., 'Tribal sculpture and the Festival of Britain', *Man*, 124, June 1951.

—, 'De l'art des Yoruba', *L'art Nègre* (*Présence Africaine*, Vols. 10-11), Paris, 1951, pp. 103-35.

—, 'On a stone head of variant style at Esie, Nigeria', *Man*, London, 1959.

—, *Nigerian Tribal Art*, catalogue of Arts Council exhibition, London, 1960 (first adumbrated in F.R. Pleasants (ed.), *Masterpieces of African Art*, Brooklyn, 1954).

—, *Nigerian Images*, London, 1963.

—, *Propyläen Kunstgeschichte*, Berlin, 1979, pp. 134 ff.

—, *Yoruba Beadwork*, New York, 1980.

—, Christies' catalogue, 3 April 1981, p. 65.

—, Descriptive catalogue entries in S.M. Vogel (ed.), *For Spirits and Kings: African Art from the Tishman Collection*, Metropolitan Museum of Art, New York, 1981, pp. 102-6, 112-13, 123-6, 128-30, 132-3.

FAGG, W. B., AND PEMBERTON, JOHN, III, *Yoruba Sculpture of West Africa*, ed. Bryce Holcombe, New York, 1982.

FAGG, W. B., AND WILLETT, FRANK, 'Ancient Ife', *Odu*, VIII, 1960, pp. 21-35.

FORBES, F. E., *Dahomey and the Dahomans: Being the Journals of Two Missions to the King of Dahomey, and residence at his Capital in the Years 1849-1850*, 2 vols., London, 1851.

FRASER, DOUGLAS, 'The Tsoede bronzes and Owo Yoruba art', *A.A.*, VIII, 3, 1975, pp. 30-35, 91.

GARLAKE, PETER, 'Excavations at Obalara's Land, Ife', *W.A.J.A.*, 4, 1974, pp. 127-9.

—, *Kingdoms of Africa*, Oxford, 1978.

—, 'Excavations on the Woye Asiri Land in Ife, W. Nigeria', *W.A.J.A.*, 7, 1979.

GÖBEL, PETER, 'Die Elo Masken der Nupe', in *Jahrbuch des Museums für Völkerkunde zu Leipzig*, Berlin, 1968, pp. 103-19.

—, 'Nupeglass im Museum für Völkerkunde zu Leipzig', in *Jahrbuch des Museums für Völkerkunde zu Leipzig*, Vol. XXVI, Berlin, 1969, pp. 229-46.

—, 'Gelbschmiedearbeiten der Nupe im Museum für Völkerkunde zu Leipzig', in *Jahrbuch des Museums für Völkerkunde zu Leipzig*, Vol. XXVII, Berlin, 1970, pp. 266-319.

—, 'Bemerkungen zu den "Buchdeckeln" der Nupe', in *Jahrbuch des Museums für Völkerkunde zu Leipzig*, Vol. XXIX, Berlin, 1973, pp. 191-227, pls. XVII-XXXI.

HERSKOVITS, MELVILLE, *Dahomey*, 2 vols., New York, 1938.

HERSKOVITS, MELVILLE, AND HERSKOVITS, F., 'The art of Dahomey. 1: Brass casting and appliqué cloths', *American Magazine of Art*, 27, 1934, pp. 67-76.

HILL, J. H., 'Ogboni sculpture: a critical appraisal of its creative attributes', in D. Brokensha and M. Crowder (eds.), *Africa in the Wider World*, Oxford, 1967, pp. 36-55.

HOLCOMBE, BRYCE (ed.), *Yoruba Sculpture of West Africa* (W. Fagg and John Pemberton III), New York, 1982.

HOULBERG, M. H., 'Ibeji images of the Yoruba', *A.A.*, VII, 1, 1973, pp. 20-27, 91-2.

—, 'Egungun masquerades of the Remo Yoruba', *A.A.*, XI, 3, 1978, pp. 20-27, 100.

IDOWU, E. B., *Olodumare: God in Yoruba Belief*, London, 1962.

JOHNSON, S., *The History of the Yorubas*, London, 1921; reprinted Lagos, 1973.

KENT, KATE P., *West African Cloth*, Denver Museum of Natural History, 1971.

LAWAL, B., *Yoruba Sango Sculpture in Historical Retrospect*, Ann Arbor, 1970, University Microfilms.

—, *The Present State of Art - Historical Research in Nigeria* (unpublished), University of Ife, 1973.

—, 'Some aspects of Yoruba aesthetics', *British Journal of Aesthetics*, 14, 3, 1974, pp. 239-48.

—, 'The living dead: art and immortality among the Yoruba of Nigeria', *Africa*, 47, 1, 1977, pp. 50-61.

—, 'New light on Gelede', *A.A.*, XI, 2, 1978, pp. 65-70, 94.

LEURQUIN-TEFNIN, A., 'Eshu, l'insaisissable: le "trickster" dans la pensée religieuse des Yoruba du Nigeria', *A.A.N.*, 36, 1980, pp. 26-37.

MCCALL, D. F., 'The marvellous chicken and its companion in Yoruba art and mythology', *Paideuma*, 24, 1978, pp. 131-46.

MCLEOD, M. D., 'Verbal elements in West African art', *Quaderni Poro*, Milan, 1976, pp. 85-102.

MAUNY, R., 'A possible source of copper for the oldest brass heads at Ife', *Journal of the Historical Society of Nigeria*, 2, 1962, pp. 393-5.

MERCIER, P., 'Evolution de l'art dahoméen', in A. Diop (ed.), *L'Art Nègre (Présence Africaine)*, 1951, pp. 185-93.

MERLO, CHRISTIAN, 'Les "Botchio" en civilisation béninoise', Musée d'Ethnographie, Geneva, *Bulletin*, 20, 1977, pp. 97-115.

MORTON-WILLIAMS, P., 'The Yoruba Ogboni cult in Oyo', *Africa*, 30, 4, 1960, pp. 42-7, 95.

MURRAY, K. C.,'Nigerian bronzes: work from Ife', *Antiquity*, 15, 1941, pp. 71-80.

MYERS, O., 'Excavations at Ife, Nigeria', *W. African Archaeological Newsletter*, 6, 1967, pp. 6-11.

NADEL, S. F., *A Black Byzantium*, London, 1951.

NEAHER, N. C., 'Nigerian bronze bells', *A.A.*, XII, 3, 1979, pp. 42-7, 95.

OBAYEMI, ADE, 'The expansion of Oyo and the rise of Dahomey 1600-1800', in *History of West Africa*, Vol. I, London, 1979, p. 373 and nn.

OJO, G. J., *Yoruba Palaces: A Study of Afins of Yorubaland*, London, 1966.

OJO, J. R. O., 'Ogboni drums', *A.A.*, VI, 3, 1973, pp. 50-52, 84.

PARRINDER, E. G., *The Story of Ketu, an Ancient Yoruba Kingdom*, Ibadan, 1956.

PEMBERTON, J., III, 'To praise Ogun: two festivals', in *Selected Papers presented at the 22nd Annual Meeting of the African Studies Association Los Angeles*, Los Angeles, 1979 (U.C.L.A.) African Studies Association, 1.7.

—, Descriptive Catalogue Entries in S.M. Vogel (ed.), *For Spirits and Kings: African Art from the Tishman Collection*, Metropolitan Museum of Art, New York, 1981, pp. 84-5, 98.

PEMBERTON, JOHN, III, AND FAGG, W., *Yoruba Sculpture of West Africa* (ed. Bryce Holcombe), New York, 1982.

POSNANSKY, M., AND MCINTOSH, R., 'New radiocarbon dates for northern and western Africa', *J.A.H.*, 20, 1, 1979, pp. 1-29.

ROACHE, L. E., 'Psychophysical attributes of the Ogboni Edan', *A.A.*, IV, 2, 1971, pp. 48-53.

RUBIN, A., *Yoruba Sculpture in Los Angeles Collections*, Claremont, Calif., Montgomery Art Center, Pomona College, 1969.

RYDER, A. F. C., 'A reconsideration of the Ife-Benin relationship', *J.A.H.*, 6, 1, 1965.

SHAW, THURSTAN, 'The analysis of West African bronzes: a summary of the evidence', *Ibadan*, 28, 1970, pp. 80-89.

—, 'A note on trade and the Tsoede bronzes', *W.A.J.A.*, 3, 1973, pp. 233-8.

—, *Nigeria, Its Archaeology and Early History*, London, 1978.

SHAW, THURSTAN, 'Ife and Raymond Mauny', in *2,000 Ans d'histoire africaine*, Paris, 1981, pp. 109–35.

SIROTO, L., 'The twins of Yorubaland', *Bulletin of the Field Museum of Natural History*, Chicago, 38, 7, 1967, pp. 4–8.

SKERTCHLEY, J. A., *Dahomey As It Is*, London, 1874.

SMITH, R. S., *Kingdoms of the Yoruba*, London, 1969.

SNELGRAVE, W.A., *New Account of Some Parts of Guinea and the Slave Trade*, London, 1734.

SOPER, R., 'Some comments on the site of Old Oyo', *Archaeologist*, Ibadan, 2, 1975, pp. 47–52.

STEVENS, PHILLIPS, JR, *The Stone Images of Esie*, Ibadan, 1978.

STOLL, M. AND G., AND KLEVER, U., *Ibeji: Twin Figures of the Yoruba*, Munich, 1980.

THOMPSON, R. F., *Black Gods and Kings: Yoruba Art at U.C.L.A.*, Los Angeles, 1971.

—, 'The figure of the Divine King', in D. Fraser and H. Cole (eds.), *African Art and Leadership*, Madison, 1972.

UNDERWOOD, LEON, *Bronzes of West Africa*, London, 1949/1968.

VOGEL, SUSAN, 'Nigerian bronze rings', in *The Art of Metal in Africa*, African–American Institute, New York, 1982.

—, 'Rapacious birds and severed heads: early bronze rings from Nigeria', in Art Institute of Chicago Centennial Lectures, *Museum Studies*, 10, forthcoming.

WERNER, O., AND WILLETT, FRANK, 'The composition of brasses from Ife and Benin', *Archaeometry*, 17, 2, 1975, pp. 141–56.

WESTCOTT, J., 'The sculpture and myths of Eshu-Elegba', *Africa*, 32, 4, 1962, pp. 336–53.

WILLETT, FRANK, 'A hunter's shrine in Yorubaland, Western Nigeria', *Man*, 59, 1959, pp. 215–16.

—, 'Ife and its archaeology', *J.A.H.*, I, 1960, pp. 231–48.

—, 'On the funeral effigies of Owo', *Man*, I, 1, March 1966, pp. 34–45.

—, *Ife in the History of West African Sculpture*, London, 1967.

—, 'New light on the Ife–Benin relationship', *African Forum*, 3 (4), 4 (1), 1968, pp. 28–34.

—, 'A survey of recent results in the radiocarbon chronology of western and northern Africa', *J.A.H.*, 12, 3, 1971, pp. 339–70.

—, 'Archaeology', in S.O. Biobaku (ed.), *Sources of Yoruba History*, Oxford, 1973.

—, *Baubles, Bangles and Beads*, 13th Melville J. Herskovits Memorial Lecture, Centre of African Studies, Edinburgh, 1977.

—, 'An African sculptor at work', *A.A.*, XI, 2, 1978, pp. 28–33, 96.

WILLETT, FRANK, AND FLEMING, S. J., 'A catalogue of important Nigerian copper-alloy castings dated by thermoluminescence', *Archaeometry*, 18, 2, 1976, pp. 135–46.

WILLIAMS, D., 'The iconology of the Yoruba Edan Ogboni', *Africa*, 34, 2, 1964, pp. 139–65.

—, 'Two brass masks from Oyo-Ile', *Odu*, 3, 1966, pp. 61–3.

CHAPTER 12: BENIN – THE ART OF THE EDO CITY STATE

BEN-AMOS, PAULA, 'Men and animals in Benin art', *Man*, II, 2, June 1976.

—, *The Art of Benin*, London, 1980.

BRADBURY, R. E., 'The Benin kingdom and the Edo speaking peoples of S.W. Nigeria', *Ethnographic Survey, Western Africa*, 13, London, 1957.

—, 'Divine kingship in Benin', *Nigeria*, LXII, 1959.

—, 'Chronological problems in the study of Benin history', *J.H.S.N.*, I, 1959.

—, 'Ezomo's Ikegobo and the Benin cult of the hand', *Man*, 61, 1961.

—, *Benin Studies*, ed. P. Morton-Williams, London, New York, Ibadan, 1973.

CONNAH, G., 'Archaeology in Benin', *J.A.H.*, XIII, 1, 1972, pp. 25–38.

—, *The Archaeology of Benin*, Oxford, 1975.

DAPPER, O., *Nawkeurige Beschrijvinge der Afrikaensche Gewesten*, Amsterdam, 1668.
—, *Description de l'Afrique*, trans. from Flemish, Amsterdam, 1686.
DARK, PHILIP, *The Art of Benin*, Chicago, 1962.
—, *An Introduction to Benin Art and Technology*, Oxford, 1973.
DARK, PHILIP, AND FORMAN, W. AND B., *Benin Art*, London, 1960.
EGHAREVBA, J. V., *A Short History of Benin*, Ibadan, 1960 (1934).
FORMAN, W. AND B., AND DARK, PHILIP, *Benin Art*, London, 1960.
FRASER, D., 'The fish-legged figure in Benin and Yoruba art', in D. Fraser and H. Cole
(eds.), *African Art and Leadership*, Madison, 1972, pp. 261–94.
KAPLAN, FLORA S. (ed.), *Images of Power, Art of the Royal Court of Benin*, New York, 1981.
LUSCHAN, F. VON, *Die Altertümer von Benin*, 3 vols., Berlin, 1919.
STRUCK, B., 'Chronologie der Benin Altertümer', *Zeitschrift für Ethnologie*, 55, 1923.
WILLETT, FRANK, 'The Benin Museum Collection', *A.A.*, VI, 4, Summer 1973.

CHAPTER 13: THE ART OF THE SOUTHERN SAVANNA

BASSANI, EZIO, 'Antichi avori africani nelle Collezioni Medicee I', *Critica d'Arte*, XL, n.s.,
143, 1975, pp. 69–80.
—, 'Antichi avori africani nelle Collezioni Medicee II', *Critica d'Arte*, XL, n.s., 144, 1975,
pp. 8–23.
—, 'I mintadi del Museo Pigorini', *Critica d'Arte*, 146, 1976, pp. 49–64.
—, 'Oggetti africani in antiche collezioni italiane 1', *Critica d'Arte*, XLII, n.s., 154/6, 1977,
pp. 187–202.
—, 'Oggetti africani in antiche collezioni italiane 2', in *Critica d'Arte*, XLII, n.s., 151/3,
1977, pp. 151–82.
—, *Scultura italiana nei musei italiani (Musei d'Italia-Meraviglie d'Italia)*, Bologna, 1977.
—, 'Due grandi artisti Yombe', *Critica d'Arte*, XLVI, n.s., 178, 1981, pp. 66–84.
—, 'Les Sculptures Vallisnieri', *Africa-Tervuren*, XXIV, 1, 1978, pp. 15–22.
BASTIAN, ADOLF, *Die Deutsche Expedition an der Loango Küste*, Vol. I, Jena, 1874, pp. 79,
214–15, 218.
BASTIN, MARIE-LOUISE, *Art Décoratif Tshokwe*, Lisbon, 1961.
—, 'Arts of the Angolan peoples, Chokwe', *A.A.*, II, 1, 1968.
—, 'Arts of the Angolan peoples, Lwena', *A.A.*, II, 2.
—, 'Arts of the Angolan peoples, Songo', *A.A.*, II, 3.
—, 'Arts of the Angolan peoples, Mbundu', *A.A.*, II, 4, 1969.
—, 'Les Styles de la sculpture Tshokwe', *A.A.N.*, 19, 1976.
—, *Statuettes Tschokwe du héros civilisateur Tschibinda Ilunga*, Arnouville, 1978.
—, *La Sculpture Tshokwe*, Meudon, 1982.
BELEPE, BOPE MABINTCH, 'Les Oeuvres plastiques africaines comme documents d'histoire',
Africa-Tervuren, XXVII, 1, 1981, pp. 9–17.
BONTINCK, FR., 'La Provenance des sculptures Vallisnieri', *Africa-Tervuren*, XXV, 4,
1979, pp. 88–91.
CLAERHOUT, ADRIAAN, 'Two Kuba wrought-iron statuettes', *A.A.*, IX, 4, 1976, pp. 60–64.
CORNET, JOSEPH, *Art of Africa: Treasures from the Congo*, London, 1971.
—, *Art from Zaïre*, exhibition catalogue, New York, 1975.
—, *A Survey of Zaïran Art, The Bronson Collection*, Raleigh, North Carolina, 1978.
—, *Art Royal Kuba*, Milan, 1982.
HIERNAUX, J., MACQUET, E., AND DE BUYST, J., 'Excavations at Sanga 1958', *S.A.J.S.*,
64, 1968, pp. 113–17.
JOYCE, T. A., 'On a carved wooden cup from the Bakuba, Kasai District', *Man*, 1909.
—, 'On a wooden portrait-statue from the Bushongo people of the Kasai District', *Man*,
1910.

MAES, J., 'Figurines na Moganga de Guérison', *Pro-medico*, 3 and 4, Paris, 1927.

—, 'Figurines Npezo', *Pro-medico*, 2 Paris, 1929.

—, 'Les Figurines sculptées du Bas-Congo', *Africa*, III, 3, London, 1930.

—, 'Les Statues des rois', *Beaux Arts*, Brussels, October 1936.

MAESEN, A., 'Style et expérience esthétique dans la plastique congolaise', *Problèmes d'Afrique Centrale*, Antwerp, 1959, p. 44.

—, *Umbangu, Art du Congo au Musée du Congo Belge*, Tervuren, n.d.

—, *Art of the Congo*, Walker Art Center, Minneapolis, 1967.

MARET, PIERRE DE, 'Sanga: new excavations, more data, and some related problems', *J.A.H.*, XVIII, 3, 1977, pp. 321-37.

—, 'Les Trop Fameux Pots à fossette basale du Kasai', *Africa-Tervuren*, XXVI, 1, 1980, pp. 4-12.

MARET, PIERRE DE, VAN NOTEN, F., AND CAHEN, D., 'Radiocarbon dates from West Central Africa: a synthesis', *J.A.H.*, XVIII, 4, 1977, pp. 481-505.

MILLER, JOSEPH C., 'Requiem for the "Jaga"', *Cahiers d'études africaines*, XIII, 1, No. 44, 1973, pp. 121-49.

—, *Kings and Kinsmen: Early Mbundu States in Angola*, Oxford, 1976.

NENQUIN, J., 'Dimple-based pots from Kasai, Belgian Congo', *Man*, 1959, p. 242.

—, *Excavations at Sanga, 1957*, Tervuren, 1963.

NEYT, FRANÇOIS, *La Grande Statuaire Hemba du Zaïre*, Louvain-la-Neuve, 1977.

—, *Arts traditionnels et histoire au Zaïre*, Brussels, 1981.

OLBRECHTS, F. M., *Les arts plastiques du Congo Belge*, Brussels, 1959.

PICTON, JOHN, AND MACK, JOHN, *African Textiles*, London, 1979.

PIGAFETTA, FILIPPO, *Kingdom of Kongo and the Surrounding Countries* (Rome 1591), trans. Margarite Hutchinson, London, 1881.

PINKERTON, JOHN, *Voyages and Travels, London 1814: Voyage to Congo by Angelo and Carli*, p. 171.

RAVENSTEIN, E. G. (ed.), *The Strange Adventures of Andrew Battel of Leigh in Angola and the Adjoining Regions*, London, 1901.

ROSENWALD, JEAN B., 'Kuba king figures', *A.A.*, VII, 3, 1974, pp. 26-31.

RYDER, A. F. C., 'A note on the Afro-Portuguese ivories', *J.A.H.*, 5, 3, 1964, pp. 87-107.

SOUSBERGHE, L. DE, *L'Art Pende*, 1958.

THOMPSON, ROBERT F., *The Four Moments of the Sun*, Washington, D.C., 1981.

TORDAY, EMIL, 'Note on certain figurines of forged iron', *Man*, 24, 1924, p. 17.

—, *On the Trail of the Bushongo*, Philadelphia, 1925.

TORDAY, E., AND JOYCE, T. A., *Notes ethnographiques sur les peuples communément appelés Bakuba, ainsi que les peuplades apparentées, Les Bushongo*, Brussels, 1910.

—, 'Notes ethnographiques sur les populations habitant les bassins du Kasaï et du Kwango oriental', *Annales du Musée du Congo Belge, Ethnographie Série III*, II, 2, Brussels, 1922.

TUCKEY, J. K., *Narrative of an Expedition to Explore the River Zaïre*, London, 1818.

VANSINA, JAN, 'Initiation rituals of the Bushongo', *Africa*, XXV, 2, 1955, pp. 138-52.

—, 'Réflexions sur le rôle de l'art dans la société Kuba', *Folia Scientifica Africae Centralis*, December 1958, III, 4, 1958.

—, 'Recording the oral history of the Bakuba', *J.A.H.*, I, 1, 2, 1960.

—, *Geschiedenis van de Kuba*, Tervuren, 1963.

—, *Kingdoms of the Savanna*, Madison, 1966.

—, 'Ndop: royal statues among the Kuba', in D. Fraser and H. Cole (eds.), *African Art and Leadership*, Madison, 1972.

—, *The Children of Woot*, Madison, 1978.

VERLY, ROBERT, 'La Statuaire de pierre du Bas-Congo', *Zaïre*, IX, 5, May 1955, pp. 451-528.

VOLAVKA, ZDENKA, 'Insignia of the divine authority', *A.A.*, XIV, 3, May 1981, pp. 43-51.

WANNYN, ROBERT L., *L'Art ancien du métal au Bas-Congo*, Champles par Wavre, 1961.

WEEKS, J. H., *Among the Primitive Bakongo*, London, 1914.

WOLF, S., 'Afrikanische Elfenbeinlöffel des 16 Jahrhunderts im Museum für Völkerkunde Dresden', *Ethnologica*, n.f., 2, Cologne, 1960, pp. 410-25.

CHAPTER 14: EASTERN AFRICA

ADAMSON, JOY, 'Kaya und Grabfiguren der Küstenbantu in Kenya', *Paideuma*, 6, 1957, pp. 251-6.

—, *The Peoples of Kenya*, London, 1967.

ALLEN, JAMES DE VERE, *Lamu*, Nairobi, n.d.

—, 'Swahili culture reconsidered', *Azania*, IX, 1974, pp. 105-38, pl. IV.

ANFRAY, F., 'The civilisation of Aksum from the 1st to the 7th century', UNESCO *General History of Africa*, Vol. II, Paris and London, 1981, pp. 362-80.

BROWN, JEAN LUCAS, 'Traditional sculpture in Kenya', *A.A.*, VI, 1, 1972, pp. 16-20, 58.

—, 'Mijikenda and memorial sculptures', *A.A.*, XIII, 4, 1980, pp. 36-9.

ČERVIČEK, P., AND BRAUKÄMPER, U., 'Rock paintings of Laga Gafra, Ethiopia', *Paideuma*, 21, 1975, pp. 47-60.

CHITTICK, NEVILLE, 'Notes on Kilwa', *Tanganyika Notes and Records*, 1959, pp. 179-203.

—, 'Excavations at Aksum', *Azania*, IX, 1974, pp. 159-205.

—, *Kilwa: an Islamic Trading City on the East African Coast*, 2 vols., Nairobi, 1974.

—, 'The Book of Zenj and the Mijikenda', *International Journal of African Historical Studies*, 9, 1976, pp. 68-73.

—, 'The East Coast, Madagascar and the Indian Ocean', *Cambridge History of Africa*, Vol. 3, 1977, p. 217 and n.

DAHL, O. C., *Malgache et Maanjan, une comparaison linguistique*, Oslo, 1951.

GAGERN, AXEL, FREIHER VON, KOLOSS, HANS JOACHIM, AND LOHSE, WULF, *Ostafrika, Figure und Ornament*, Hamburgisches Museum für Völkerkunde, Hamburg, Linden-Museum, Stuttgart and Rautenstreich-Joest-Museum, Cologne, 1974.

GARLAKE, P. S., *The Early Islamic Architecture of the East African Coast*, Nairobi, 1966.

GHAIDAN, USAM I., 'Swahili art of Lamu', *A.A.*, V, 1, 1971, pp. 54-5.

HABERLAND, EIKE, *Galla Süd Äthiopiens*, Stuttgart, 1963.

—, *Altes Christentum*, Peabody Academy of Science, Ethiopia, 1978.

HOLY, LADISLAW, *The Art of Africa: Masks and Figures from Eastern and Southern Africa*, London, 1967.

KOBISHANOV, Y. M., *Aksum*, University of Pennsylvania, 1979.

—, 'Aksum: political system, economics and culture, first to fourth century', UNESCO *General History of Africa*, Vol. II, Paris and London, 1981.

LEAKEY, M. D. AND L. S. B., *Excavations at Njoro River Cave*, Oxford, 1950.

LEAKEY, M. D., OWEN, W. E., AND LEAKEY, L. S. B., 'Dimple-based pottery from central Kavirondo', *Occasional Papers of the Corydon Museum*, 2, Nairobi, 1948.

MCKAY, ROGER, 'Ethiopian jewellery', *A.A.*, VII, 4, 1974, pp. 36-9.

NENQUIN, J., 'Contributions to the study of the prehistoric cultures of Rwanda and Burundi', *Africa-Tervuren*, 1967, pp. 257-87.

OLIVER, ROLAND, 'The emergence of Bantu Africa', *Cambridge History of Africa*, Vol. 2, Ch. 6, 1978.

PARKIN, DAVID, SIEBER, ROY, AND WOLFE, ERNIE, III, *Vigango, the Commemorative Sculpture of the Mijikenda of Kenya*, African Studies Program, Bloomington, 1981.

PHILLIPSON, D. W., 'The early Iron Age in Zambia - regional variants and some tentative conclusions', *J.A.H.*, 9, 1968, pp. 191-211.

—, 'Excavations at Twickenham Road, Lusaka', *Azania*, 5, 1970, pp. 77-118.

—, *The Later Prehistory of Eastern and Southern Africa*, London, 1977.

Religiöse Kunst Äthiopiens, catalogue, Stuttgart, 1973.

SCHOFF, W. H. (trans.), *The Periplus of the Erythraean Sea*, New York, 1912.

SCHWEINFURTH, GEORG, *The Heart of Africa*, 2 vols., London, 1874; New York, 1974.

SIEBER, ROY, PARKIN, DAVID, AND WOLFE, ERNIE, III, *Vigango, the Commemorative Sculpture of the Mijikenda of Kenya*, African Studies Program, Bloomington, 1981.

SIROTO, LEON, 'A Kigangu figure from Kenya', *Detroit Institute of Arts Bulletin*, 57, 3, 1979, pp. 104-13.

SOPER, R. C., 'Kwale: an early Iron Age site in south-eastern Kenya', *Azania*, 2, 1967, pp. 1-17.

—, 'Petroglyphs in N. Kenya', *Azania*, 3, 1968.

—, 'New radiocarbon dates for eastern and southern Africa', *J.A.H.*, 15, 1974, pp. 175-94.

SPEARS, THOMAS K., *The Kaya Complex: History of the People of the Kenya Coast*, Nairobi, 1978.

VERIN, P. M., 'Les recherches archéologiques à Madagascar', *Azania*, 1, 1966, pp. 119-37.

WOLFE, ERNIE, III, PARKIN, DAVID, AND SIEBER, ROY, *Vigango, the Commemorative Sculpture of the Mijikenda of Kenya*, African Studies Program, Bloomington, 1981.

CHAPTER 15: ARTS OF SOUTHERN AFRICA

ANGAS, GEORGE FRENCH, *The Kaffirs illustrated in a series of drawings taken among the Amazulu, Amaponda and Amakoza tribes*, London, 1849.

BEZING, K. L. VON, AND INSKEEP, R. R., *Man*, I, 1, March 1966.

BIRMINGHAM, DAVID, AND MARKS, SHULA, 'Southern Africa', in *Cambridge History of Africa*, Vol. 3, 1977, pp. 618-19.

BROTTEM, BRONWYN V., 'Zulu beadwork', *A.A.*, VI, 3, 1973, pp. 8-13.

Documents on the Portuguese in Mozambique and Central Africa, Vol. I, Lisbon, 1962, p. 395.

EVERS, T. M., AND VOGEL, J. C., *S.A.J.S.*, 76, May 1980, pp. 230-31.

FAGAN, BRIAN, 'The Greefswald sequence', *J.A.H.*, 5, 3, 1964, pp. 327-61.

FOUCHÉ, LEO, AND GARDNER, GUY A., *Mapungupwe, Ancient Bantu Civilization on the Limpopo*, Vol. I, Cambridge, 1937; Vol. II, Pretoria, 1963.

GARLAKE, PETER, *Great Zimbabwe*, London, 1973.

HAMMOND-TOOKE, W. D. (ed.), *The Bantu-Speaking Peoples of Southern Africa*, London, 1974.

HOLY, LADISLAW, *The Art of Africa: Masks and Figures from Eastern and Southern Africa*, London, 1967.

HUFFMAN, T. N., 'The early Iron Age and the spread of the Bantu', *S.A.A.B.*, 25, 1970, pp. 3-21.

—, 'The rise and fall of Zimbabwe', *J.A.H.*, 13, 1972, pp. 353-66.

—, *The Leopard's Kopje Tradition*, Salisbury, 1974.

INSKEEP, R. R., AND MAGGS, T. M., 'Unique art objects in the Iron Age of the Transvaal, S.A.', *S.A.A.B.*, 30, 1975, pp. 114-38.

MAGGS, TIM, AND DAVISON, PATRICIA, 'The Lydenburg Heads and the earliest African sculpture south of the Equator', *A.A.*, XIV, 2, February 1981, pp. 28-33.

MASON, R. J., *Prehistory of the Transvaal*, Johannesburg, 1962.

—, 'The origin of South African society', *S.A.J.S.*, 61, 7, July 1965, p. 263.

MERVE, NICHOLAS J. VAN DER, AND SCULLY, ROBERT T. K., 'The Phalaborwa story: archaeological and ethnographic investigation of a South African Iron Age group', *S.A.J.S.*, 3, 2, October 1971, pp. 178-96.

RIGHTMIRE, G. P., 'Iron Age skulls from southern Africa reassessed by multiple discriminant analysis', *A.J.P.A.*, 23, 1970, pp. 147-68.

WAGNER, A., 'Further notes on ancient bronze smelters in the Waterberg District, Transvaal', *S.A.J.S.*, 26, 1929, pp. 563-74.

Index

Index

Index

Index

Index